THE LAMBERTS
GEORGE, CONSTANT & KIT

By the same author

POEMS
The Pleasure Steamers
Independence
Secret Narratives
Dangerous Play: Poems 1974–84

CRITICISM
The Poetry of Edward Thomas
Philip Larkin

EDITED, WITH BLAKE MORRISON
The Penguin Book of
Contemporary British Poetry

THE LAMBERTS

George, Constant & Kit

ANDREW MOTION

Farrar Straus Giroux

New York

Copyright © 1986 by Andrew Motion
All rights reserved
First published in 1986 by Chatto & Windus, London
First American edition, 1987
Printed in the United States of America
Library of Congress Cataloging-in-Publication Data
Motion, Andrew.
The Lamberts: George, Constant & Kit.
1. Lambert family. 2. Arts—Biography. I. Title.
NX93.L36 1987 709'.2'2 [B] 87—32

To Carmen Callil
who gave me the idea
for this book

Contents

List of illustrations

Plates between pages 300 and 301.

Acknowledgements

Four books were indispensable to me while I wrote this biography: *George Washington Lambert A.R.A.: Thirty Years of an Artist's Life* by Amy Lambert (Society of Artists, Sydney, Australia, 1938, reprinted 1977); *Constant Lambert* by Richard Shead (Simon Publications, London, 1973, and Thames Publishing, 1986); *The Who: Maximum R and B* by Richard Barnes (Eel Pie Publications, London, 1982); *Before I Get Old: The Story of The Who* by Dave Marsh (St Martin's Press, New York, and Plexus, London, 1983). Among the large number of other books and articles, the following were also especially useful: *The Art of George Washington Lambert, A.R.A.* (Art in Australia Ltd, Sydney, 1924); *Gallipoli Mission* by C. E. W. Bean (Australian War Memorial, Canberra, 1948); *In Search of Diaghilev* by Richard Buckle (Sidgwick & Jackson, 1955); *The Sadler's Wells Ballet* by Mary Clarke (A. & C. Black, 1955); *The Australian Imperial Forces in Sinai and Palestine* by H. S. Gullett (Angus & Robertson, Sydney, 1923); *Australia in Palestine* by H. S. Gullett and Charles Barrett (Angus & Robertson, Sydney, 1919); *The Art of Australia* by Robert Hughes (Penguin, Harmondsworth, 1980); *The Art and Life of George Washington Lambert* by James MacDonald (Alexander McCubbin, Melbourne, 1920); *The Story of Australian Art* by William Moore (Angus & Robertson, Sydney, 1934); *Australian Artists at War* by John Reid (Sun, Melbourne, 1977); *Australian Painting 1788–1960* by Bernard Smith (Oxford University Press, Melbourne, 1962). I would also like to acknowledge *Constant Lambert: 1905–1951* (a catalogue of the exhibition held at the South London Art Gallery, 17 September–7 October 1976).

I am grateful to the following institutions for their assistance: The Australian War Memorial, Canberra; The Art Gallery of New South Wales, Sydney; The BBC Script Library, and the BBC Written Archives Centre; The British Library; Christ Church College Library, Oxford; Christ's Hospital School; King's College Library, Cambridge; Lancing College; The National Gallery of Victoria, Melbourne; The National Sound Archive; The Royal College of Music; The Royal Opera House Archive Office; The Victoria and Albert Theatre Museum.

A very large number of people have been helpful to me in the course of my research. I am very grateful to them all for their assistance and — where appropriate — for their permission to interview and quote them. The sources of all quotations are acknowledged in the text. The following have been particularly kind and generous: Christine Downer; Robert Fearnley-Whittingstall; Georgie Hammick; Camilla Hole; Jenny Koralek; Annie Lambert; Angus Morrison; Anthony Powell; Dulcie Stout; Jane Swingler; Pete Townshend. I am especially grateful to Isabel Rawsthorne for permission to quote from her unpublished Memoirs, and to my wife, Jan Dalley.

Others to whom I am indebted for their advice, opinion and reminiscences include: Elizabeth Ayrton; Donald Bancroft; Penelope Barman; Frank Barsalona; Don and Susie Bennetts; Jonathan Benson; John Brackenreg; Richard Brain; Richard Buckle; Audrey Chadwick; Jonathan Chadwick; William Chappell; Tom Clark; John Cody; Mrs Julian Baxter Coghill; Clement Crisp; John Dancy; Dame Ninette de Valois; Mary Eagle; John Edwards; Leslie Edwards; Biddy Fletcher; Felix Fonteyn; Dame Margot Fonteyn; Anya Forbes-Adams; Alan Frank; Philip French; Patricia Fullerton; Anne Galbally; Sidonie Goossens; Anne Gray; Geoffrey Grigson; Patrick Halsey; Edmund Harvey; Robert Heber-Percy; Robert Helpmann; John Hemming; Pauline Holdrup; Alan Hollinghurst; Ros Hollinrake; Spike Hughes; Marsha Hunt; Gordon Jacob; Clytie Jessop; Adrian Jose; Julie Kavanagh; Pat Kavanagh; Louis Kentner; Lincoln Kirstein; Sonia Lane; Nancy Lewis; Jack Lindsay; John Lindsay; Frank MacDonald; Dame Alicia Markova; Bill Mason; Betty O'Neil McCorman; Jan Minchin; Arthur Murch; Andy Newman; K. Harvey Packer; Cleo Palmer; Tony Palmer; Sir Peter Pears; John Pettavel; Pickles; David Platz; Tristram Powell; Ursula Prunster; Peter Quennell; John Rayner; Deirdre Redgrave; Alistair Riley; Dave Ruffell; Kenneth Sharpe; Countess Daria Shuvaloff; Michael Sissons; Sir Sacheverell Sitwell; Deborah Smart; Sir Eldred Smith-Gordon; Sten Snekker; Michael Somes; Martin Terry; Daniel Thomas; Peter Thompson; Thea Wadell; Lady Walton; Peter Way; Anne Wealden; Eric Westbrook; Gillian Widdicombe; Ann Winchester; Miriam Wornum; William Yates.

I am grateful for permission to quote from the following: *The Who: Maximum R and B* by Richard Barnes (Eel Pie Publications, London, 1982); *The Sadler's Wells Ballet: A History and an Appreciation* by Mary Clarke (Da Capo Press, Inc., New York and A. & C. Black Ltd., London, 1955); *Ruling Passions* by Tom Driberg (licensing agents: David Higham Associates Ltd.); 'This Be The Verse' from *High Windows* by Philip Larkin (Faber & Faber, London, 1974); *Before I Get Old: The Story of The Who* by Dave Marsh (St Martin's Press, New York and Plexus, London, 1983); *To Keep the Ball Rolling* by Anthony Powell (William Heinemann, London, 1983); *Constant Lambert* by Richard Shead (Simon Publications, London, 1973, and Thames Publishing, London, 1986. Quotations are from the first edition. Licensing agents: Watson, Little Ltd.)

I am also grateful to the following for their permission to reproduce illustrative material: The Art Gallery of New South Wales, Sydney, 5, 6, 9; Mrs Michael Ayrton 20; Camera Press 29; Covent Garden Archive 27; the Fitzwilliam Museum, Cambridge (lent anonymously) 28; John Hemming 32; Camilla Hole 19, 21, 40; Mitchell Library, Sydney, 8, 12, 13 and page 23; Chris Morphet 34, 37; Angus Morrison 4, 15, 22; National Gallery of Victoria, Melbourne 10; National Portrait Gallery of London 17; Pictorial Press 33; Rex Features 41; Countess Daria Shuvaloff 38, 39; Dulcie Stout 3, 14, 23, 24, 26; Pete Townshend 36; Theatre Museum, Victoria and Albert Museum 25.

Family tree

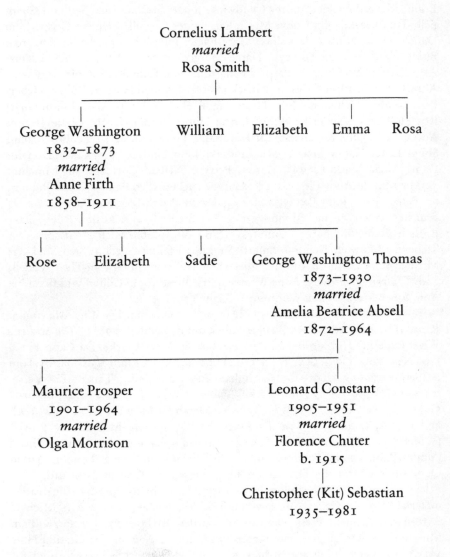

Cornelius Lambert
married
Rosa Smith

George Washington
1832–1873
married
Anne Firth
1858–1911

William Elizabeth Emma Rosa

Rose Elizabeth Sadie George Washington Thomas
1873–1930
married
Amelia Beatrice Absell
1872–1964

Maurice Prosper
1901–1964
married
Olga Morrison

Leonard Constant
1905–1951
married
Florence Chuter
b. 1915

Christopher (Kit) Sebastian
1935–1981

Introduction

Families are societies in miniature. Generation by generation they cling to the hope that they might function more smoothly than society in general, but the small scale which seems to make this possible is often the means by which their efforts are thwarted. Opportunities for understanding breed a desire for discretion; similarities provoke jealousies; and differences create incomprehension. The instinct for coherence and harmony is repeatedly sabotaged by the wish for variety and change – a wish which is fired as much by intrinsic domestic tensions as it is by developments in the world at large. The difficulties thus created form a truth which can be universally acknowledged: rows and restlessness are inseparable from tenderness and the yearning for stability.

Philip Larkin, in his poem 'This Be The Verse', makes the point with famous bluntness. 'They fuck you up, your Mum and Dad', he begins, speaking for children who realise that parents visit on their offsprings' heads the things which they suffered themselves when young. Unhappy families, Larkin goes on to say, are unhappy at least in part because their consciences prevent them from readily pinning blame on each other. They cannot easily make an assuaging condemnation, but must settle, instead, for distress which can only be ended by refusing even the possibility of improvement:

> Man hands on misery to man.
> It deepens like a coastal shelf.
> Get out as early as you can,
> And don't have any kids yourself.

The Lambert family conforms closely to Larkin's fatalistic model. Although its several generations spent comparatively little of their short lives in each other's company, each child inherited – and exacerbated – the conditions and characteristics which had blighted his parents. If their story were simply an account of accumulating misery and early death, it would hardly be worth extended treatment. In fact, their unhappiness was an inspiration and a controlling energy. The qualities which made them feckless and unreliable at home made them inventive and exciting away from it, and thrust them into the front rank of the various artistic and social worlds to which they aspired.

George Washington Lambert (1873–1930) was born in St Petersburg,

Russia, of an American father, and after a peripatetic childhood which included a period working as a jackaroo in the outback of New South Wales, became the most famous Australian painter of his day. During his time in London in the early years of this century he was acknowledged to be one of the leading lights of the *belle époque*, and as an Official War Artist in Palestine and Gallipoli during the First World War he recorded the heroism and suffering of the Australian Imperial Forces more memorably than any of his contemporaries. During his final decade in Sydney in the 1920s he became the keeper of Australia's artistic conscience.

George's elder son Maurice (1901–64) became a distinguished sculptor and R.A., although his achievement does not make him worthy to be considered here in the same detail as other members of his family. George's younger son Constant (1905–51) became one of England's most important twentieth-century composers and conductors, and a pioneering exponent of jazz techniques. When only twenty-one he was commissioned by Diaghilev to write a ballet for the Ballets Russes, and later, as musical director of the Sadler's Wells Ballet, he did more than all but a handful of others to establish and cultivate the tradition of dance in England. His fame as a wit and *bon viveur* matched his celebrity as a musician. Amusing, hard-drinking and iconoclastic (Anthony Powell used him as the model for Hugh Moreland in *A Dance to the Music of Time*), he was a central figure in Fitzrovian London, and its most articulate arbiter of taste.

Constant's son Kit (1935–81), after a chaotic early life – which included, among several bizarre episodes, a disastrous attempt to travel down the longest undescended river in the world, in Brazil – discovered and then managed one of the most successful bands in the history of rock and roll: The Who. He founded the first influential independent record label, Track; was Pete Townshend's 'Svengali'; owned a Palazzo in Venice; and spent ten years on heroin. His life dramatically crystallised the Lamberts' ability to create sensational achievements and astonishing catastrophes.

Anyone contemplating the extraordinary lives of these three men, and their extraordinary achievements, is bound to ask themselves why the family is not better known. The question is easiest to answer when applied to Kit. The work that he did to create The Who was prodigiously successful, but it is the fate of rock and roll managers to attract less attention than performers. Indeed, it was an essential part of Kit's function to make the members of his band seem autonomous, rather than

dependent on his manipulation and promotion. Although the rock and roll fraternity have always acknowledged his importance, it has not been widely recognised by the public at large. For the fame that he brought The Who, for the help that he gave Pete Townshend, and for the drama of his life, Kit deserves to be as much of a household name as Brian Epstein.

Constant and George have fallen into relative obscurity for more complicated reasons. As far as Constant is concerned, there is – as there is for Kit – at least one practical explanation. The enormously influential work that he did for English ballet (as a conductor, arranger and musical director) has dropped from sight as repertoires have changed and the generation of dancers who knew him have retired or died. Like Kit, he has paid the price for being 'a figure behind the scenes'. His fame as a composer, too, has declined steadily since the 1930s and is now eclipsed – among English musicians – by William Walton, Benjamin Britten and Michael Tippett. Why this should have happened is discussed in the following pages – but it is worth saying at the outset that his fate is not a just one. Constant was not a great composer, but he was pioneering and influential. His music brilliantly distilled the chic, jazzy, metropolitan mood of England in the 1920s and 1930s. In doing so it brought him celebrity among his contemporaries, and condemned him to suffer neglect when times and tastes changed. Now, with the benefit of a long historical perspective, we are able to evaluate his work more objectively, and to give him the praise that he earned.

George's fall from the public eye is more spectacular than his son's and grandson's. In England, at least, the reasons are not hard to find: very few of his paintings survive here, and those that do are in private collections. In Australia, where a great deal of his work is on permanent display in major galleries, his neglect has more to do with matters of contemporary artistic opinion than his intrinsic qualities. Since George's death, Australian art critics have tended to favour modernist, abstract works, and to frown on representational 'old-fashioned' ones. George typifies all that is disparaged: his paintings are academic, patrician and European in their references. He was no more a great artist than Constant was a great composer, but he was both a better and a different painter than his existing reputation suggests.

Critical reappraisal, then, is one of the principal justifications for this book. Other justifications are of a more obviously human kind. In their day, George, Constant and Kit were greatly admired for their wit and theatrical flair, and greatly pitied for their self-destructiveness and tragically early deaths. The comedy and drama of their lives – and their

3

sadness – deserve to be remembered. Furthermore, the careers of all three men shed a clear light on their fascinating times and their (often famous) contemporaries. To investigate the family is to contemplate a compelling human document and to watch the evolution of most of the major arts through the course of this century. The Lamberts themselves took pride in being able to talk knowledgeably about arts other than the one which occupied them most, and anyone telling their history has to encompass a huge range of reference. Admitting this is a way of paying tribute to their diversity, and so is recognising the other difficulties of doing them justice. As well as illustrating with great clarity the fact that most families are tangled networks of loyalty, deceit, contradiction and love, the Lamberts scattered themselves (and therefore information about themselves) energetically around the world, and also helped to shape – and fell victim to – enormously different social, cultural and individual pressures.

These pressures produce at least two paradoxes which are crucial to the biographer. The first concerns the women in the Lamberts' story, and George's wife, Amy (1872–1964) in particular. She was expected by her husband to play as self-denying a role as other women of her age and class, but was lured by George's professional and emotional demands into a life which was neither entirely subservient nor fully independent. As her years advanced, shifting attitudes loosened but did not completely dissolve her constraints. Denied a self-contained function in the wider world, she could only strengthen her voice within the family: the submissive wife became a domineering mother and finally a well-meaning but iron-willed grandmother. These roles never allowed her part in the family's achievements to be properly acknowledged. As a result, the story of George's, Constant's and Kit's success always seemed to revolve, as it seems to still, round someone they were anxious to keep hidden or actually to escape. The Lamberts is a book about men, but one held together by the lives of women who were allowed to show little sign or to leave much evidence of their own importance.

The other paradox is more humdrum. In a narrative which covers as much ground and time as this one, it would be reasonable to suppose that its facts might be more easily determined as it approaches the present. The reverse is true. George, because he was celebrated and because he spent considerable amounts of time away from home, was written about a great deal and also kept up a voluminous correspondence with his wife. Large quantities of information about him survive. Kit, on the other hand, wrote very few letters (most of which have disappeared), communicated almost entirely by telephone, and was, anyway, debilitated by drugs and

drink for much of his final decade. It is a curious feature of the family, and of the ages through which it lived, that its recent history is, in certain respects, more obscure than its remote past.

<div align="center">II</div>

Beyond George is silence of quite another sort from that which enveloped Kit's last years. It is still possible to establish the sequence and circumstances of Kit's life, even at its most shambolic, by interviewing his friends and associates. But the lives of his distant forebears are undeviatingly fugitive and enjoy only a flickering, intermittent career in records offices and family archives. George – who was born in 1873 shortly after his father's death – kept so nearly absolute a silence about his background that it is hard not to suspect indifference or even embarrassment. He did once admit that 'some of my ancestors came from Scandinavia, via the north of England', but he took no concerted interest in establishing a precise pedigree.

This is understandable, in view of the fact that the origins of the name 'Lambert' are confusingly diverse. As 'Lambeth', 'Lambard', 'Lamburd', 'Lamberth' and 'Lambert' it is found throughout Scandinavia, England, France and Germany. In its several forms, the name is still ubiquitous in all these countries, and by the early eighteenth century it was common in America too, introduced there by numerous early settlers. It was during the eighteenth century that George's branch of the family emigrated to America from their home near Halifax, Yorkshire, for reasons that can no longer be definitely established. But since we know that they settled near the port of Baltimore, in Maryland, it is easy to imagine that they were attracted by the district's opportunities for trade. Their interests and their names are lost to us now; it is only in the first quarter of the nineteenth century, with the marriage of Cornelius Lambert to Rosa Smith that the picture begins to clarify. (Kit, a devotee of the Babar stories, would have enjoyed his great-great-grandfather's name, had he known it.)

Cornelius and Rosa had five children. The eldest, George Washington (Senior) was born in 1833 and christened to prove that the family were good citizens of the new world in general (the year of his birth was the centenary of George Washington's birth), and of Maryland in particular: Baltimore has a large statue of Washington at its centre. Like his brother William and his sisters, Elizabeth, Emma (who died aged sixteen) and Rosa, George remains a shadowy figure until his early manhood. The district in which he lived gave him an ample choice of careers. Although

<div align="center">5</div>

the family seems to have been brought up in the small town of New Windsor (population then 400) in Carroll County, Baltimore was only twenty-eight miles away and therefore within comparatively easy reach of international news (via the port) and sophisticated urban pleasures. When Fanny Trollope visited Baltimore in the mid-century, she found

one of the handsomest cities to approach in the Union. The noble column erected to the memory of Washington, and the Catholic cathedral, with its beautiful dome, being built on a commanding eminence, are seen at a great distance. As you draw nearer, many other domes and towers become visible, and as you enter Baltimore Street, you feel that you are arrived in a handsome and populous city.

Baltimore's prestige depended largely on its status as a railway town. The Baltimore and Ohio Railroad was the first chartered and fully organised railroad company in America, was incorporated by an act of the Maryland legislature on 28 February 1827, and completed its first connecting line with the capital, Washington, in 1835. Once this initial structure had been created, and its value proven, expansion followed very speedily. The Western Maryland Railroad, for instance, also connecting Baltimore with Washington, was chartered in January 1852, and reached the Potomac River in 1873. So fast and furious was the company's growth – there were 8,590 miles of rail laid in America by 1850, 30,794 miles by 1860 – that had it not been restrained during the Presidency of John W. Garrett, and stabilised by its usefulness in the Civil War, its extent would have disastrously outstripped the demands made on it.

The effect of the railroad was dynamic. George Lambert, according to company records, was one of thousands to be attracted by the op-portunities it offered for work and adventure. By 1855, when he was twenty-three, he had moved from New Windsor to Baltimore, and was enrolled with the Baltimore and Ohio as a machinist (that is, working in the shop, not on the track) for a wage of $1.72 a day. The city archives give no indication of his accommodation, and while he must have spent most of his time in Baltimore itself, he also had good reasons for returning regularly to New Windsor. The registration of his first marriage, to Mary M. Harman on 20 October 1859, tells us that he still considered New Windsor his home.

George's marriage, like his employment by the Baltimore and Ohio, are isolated rocks of fact in a sea of supposition. Except that Mary died young we know nothing about her, just as we can glean no hint of George's work or personality from the records of the Baltimore and Ohio. It is not until the outbreak of the Civil War that he is again caught up in a

bureaucracy which gives some clear shape to his career. Baltimore's role in the Civil War was uniquely important, partly because its railways provided an essential means of transport and partly because its geographical and trading position put it exactly and vulnerably on a line between the conflicting interests of north and south. The state itself, and many individual families, were painfully divided in their loyalties. The Lamberts were no exception. George's brother William declared for the Confederates and became a private in K Company of the First Virginia Cavalry; George himself was mustered into I Company of the (Unionist) Coles Independent Maryland Cavalry on 22 March 1864, by a Captain Offley, in Baltimore. There is no explanation as to why he was enrolled so late in the war – his eventual enlistment was probably a response to the President's appeal for 500,000 new recruits on 1 February 1864 – and only the obvious geographical reason for his joining Coles Cavalry: it was comprised entirely of men from his neighbourhood, among them, no doubt, some of his friends and relations (a Sergeant Adam Lambert was mustered the day after George).

Coles Cavalry had a distinguished record. It had been formed under its commanding officer, Henry A. Cole, in August and November 1861, and three years later its initial composition of three companies (which had served as a battalion) was expanded to twelve. Shortly after George joined, the Cavalry – in which every man was mounted – joined General David Hunter at Piedmont, Virginia, on 5 June and won what its official historian called a 'splendid victory'. A month later, after a series of skirmishes, Cole's men encountered troops advancing under the command of the Confederate General Early, who was attempting to capture Washington, and retreated to the Kanawha Valley. When they were joined by the Sixth and Nineteenth Army Corps, they engaged and defeated Early's men and pursued them southwards. As soon as victory seemed secure, the Sixth and Nineteenth Army Corps returned to Washington, leaving Coles Cavalry with the Army of West Virginia at Winchester. In July they weathered several fresh attacks by Early's troops, and were compelled to retreat the following month under heavy shelling into the Blue Ridge Mountains. When Early was eventually seen off by General Sheridan's forces, Coles Cavalry moved – in the mid-winter of 1864 – to Western Virginia for duty against General John Moshy's Partisans, where they served until the end of the war.

Army records give only the simplest outline of the careers of lowly soldiers, and it is impossible to do more than infer most of George's

activities in the war. But even the sketchiest historical records differ radically from the stories later told by his family. Both Constant and Kit were wont to say that George had a successful military career, and fought at the battle of Gettysburg. In fact George was enlisted eight months after Gettysburg, and the surviving details of his service life are comically unglamorous. At his mustering in as a corporal on 22 March 1864, he is described as a blue-eyed, fair-complexioned, sandy-haired, five foot seven-and-a-half inch tall 'bricklayer' (this was a mis-transcription of 'bridgelayer' which is the correct occupation given at his mustering out). Subsequent references to him paint a picture of disobedience which would have appealed strongly to his great-grandson. On 12 April 1864 he was 'reduced to ranks', on 30 April he was simply 'present', on 1 May he was again 'reduced to ranks', and on 15 September, at Sandy Hook, he deserted – only to be arrested a week later at Frederick. At his mustering out, on 28 June 1865, he was 'considered a straggler'.

Clearly George was a reluctant soldier, but as soon as the Civil War ended he returned to his job with the Baltimore and Ohio, where his career prospered. Constant and Kit were to boast that they were descended from the inventor of 'the Lambert Shoe' (a brake for trains) and 'the Lambert Wet Sander' – the stories varied. If George did indeed have a hand in developing a new braking system, it was likely to have been the Westinghouse automatic air brake, which was worked by a steam pump mounted on the locomotive – likely because the company which pioneered it had offices not only in America but in St Petersburg, where George spent the last years of his life.

Compared to England and America, Russia was slow to develop a railway system, and looked to foreign examples for ideas and assistance. The Baltimore and Ohio was intimately involved. In 1828 in Baltimore the engineer Ross Winans had devised a truck axle which, by moving with the wheels, dramatically reduced friction and improved performance. The Russian ambassador to Washington, Baron Krudener, was so impressed that he sent a model of one of Winans' new trucks to the Czar in St Petersburg, with the result that Winans' sons Thomas and William – also engineers – were invited to superintend the installation of the earliest Russian railways. Their first task was to build the line connecting St Petersburg to Moscow, and to do this they brought with them a large number of Americans to staff the locomotive works. (By a pleasing coincidence – in view of the fact that George's son, the painter, was to be born in St Petersburg – the American appointed to manage their operation was James McNeill Whistler's father.)

Once Russia had decided to develop railways at all, it did so with the same zeal that other countries had already shown. In the state factory near St Petersburg Whistler oversaw the production of 162 twenty-five ton engines, 2,500 freight cars and 70 passenger cars in the first years of his incumbency. The St Petersburg to Moscow line opened in 1851, only ten years after the commission to study its feasibility had been set up, and it immediately became the model for one of the largest national rail networks in the world. By the late 1870s, fifty-three independent Russian railway companies were in operation.

It is impossible to establish the exact date of George's departure for Russia. We know only that he went to St Petersburg in the late 1860s, as part of the Baltimore and Ohio contingent, and that his freedom to do so was increased by the death in Baltimore of his first wife. They had no children. The city he encountered on arrival was a romantic contrast of hardship and elegance. It was cold, isolated and damp – it had been built by Peter the Great on a swamp – and was subject to disastrous flooding by the River Neva. It could pride itself on being a city designed to display an emperor in the most resplendent fashion – it was the court capital and the Czar was based there – and yet could also seem dauntingly crude. Even by the end of the century, its luxuries were notoriously compromised. Lord Frederick Hamilton, an English diplomat stationed there shortly before the Revolution, wrote:

I had pictured St Petersburg to myself as a second Paris, a city glittering with light and colour, but conceived on an infinitely more grandiose scale ... The atrociously uneven pavements, the general untidiness, the broad thoroughfares empty except for a lumbering cart or two, the absence of foot passengers, and the low cotton wool sky, all this gave the effect of unutterable dreariness.

George's time in St Petersburg coincided with the beginning of the outstanding period for Russian railway building. Between 1866 and 1900 the extent of common carrier rail increased from 5,000 kilometres to 53,200 kilometres – the most intense activity being between 1866 and 1877. In these eleven years 19,000 kilometres of track were built, most of them radiating from St Petersburg, Moscow, or the grain areas. George, as an engineer, would have spent a certain amount of his time in the St Petersburg factories, but the few glimpses of him that history now gives us also suggest that his job allowed him to travel a good deal – round Russia to supervise developments, and to England on several occasions to consult engineers. He also seems to have made the most of his free time: a distant collateral relative, living in America, still has a permit granting

George the right to hunt on the estate of a Russian prince outside St Petersburg – where his experiences in a cavalry regiment presumably stood him in good stead. We also know that the various organisations involved in building the railways formed a coherent and mutually supportive community, and that among this community George met his second wife, Annie, the only child of Thomas Firth, an engineer from Yorkshire, who was the head of an English construction company in St Petersburg.

Annie Firth was only twenty when she married George in 1868 (he was thirty-five) and the five years of their life together seem to have allowed her little time for more than having babies and looking after them. She had three daughters in quick succession (Rose, Elizabeth and Sadie), and then, on 13 September 1873, a son, christened George Washington Thomas. The boy's names were chosen not simply to honour his father, but to commemorate him. Two months earlier, in July, George Washington Lambert senior had died of heart failure while on a visit to London with his wife. Several years later, when Annie wrote to one of his sisters to commiserate about the death of his mother, she dovetailed the two scenes: 'I could too well realise how great was her suffering and how you all must have suffered to see hers for it was just like poor George's last sufferings no rest day or night from pain and shortness of breath. I trust dear mother's final struggle with mortality was as quiet as her poor dear boy's.' George was buried in Brompton Cemetery, where his headstone records only the barest facts of his life: 'Sacred to the Memory of George Washington Lambert, of Baltimore, USA, who died in London 25 July 1873, aged 40 years.'

Short as it was, and obscure as it has become, George's life anticipated several of the interests and characteristics which were adopted or adapted by his descendants. His skill as an engineer, for instance, was to be transmuted into a passion for artistic technique, and his truculence as a soldier was developed – particularly by Kit – into a hatred of conformity and regulation. These things alone are sufficient justification for beginning a story of definite achievements with an account of a life which has to depend greatly on guesswork for its surviving shape. Although we can now only see George darkly, he is clear enough to seem a suitable and sympathetic founding father of an extraordinary dynasty. Like his son, grandson and great-grandson, he was adventurous in his ideas and his travels, wide ranging in his experience, and rebellious in his individuality. Moreover, his work for the railways showed an ability to match his own interests to developments in the world at large. Like his descendants he died tragically young, but – like them too – he both reflected and helped to create the spirit of the age in which he lived.

PART I

George

One

I know little of my father, for I am a posthumous son, born a month [*sic*] after his death – though I do not accuse this fact of giving me what is called the artistic instinct. My mother, with that carelessness about domestic details which characterises the wives of pioneering engineers, gave birth to me in St Petersburg. She apologised to me for years without cause or reason.

George Lambert's few references to his earliest days adopt a tone which is both throwaway and proud. Throughout his life he took pleasure in being – technically speaking – of no legally defined nationality, and in seeming independent of particular people and places. Yet he relished the fact that his father was a 'pioneer' (and saw himself as similarly intrepid), and was pleased to have been born somewhere as romantic as St Petersburg. Although he was only two when he left Russia, he was able to remember 'vast white fields, a frozen river', and 'a train in a cage'. This train was in fact a model of Stephenson's 'Rocket' in his father's factory.

When his widowed mother Annie returned from London to Russia the month before George was born, she took her three children to live in her parents' house. George was born there on 13 September 1873, and christened ten days later at the British-American Congregational church by the minister, James Key. Annie's widowhood made her completely reliant on her parents, and while they seem always to have had her best interests at heart, their life was relentlessly nomadic. When her father left Russia two years later, to take up the job of director of the locomotive works at Esslingen, Württemberg, in Germany, she gathered up her brood and followed him.

In the account of George's life written in 1938 by his widow Amy, the six years that George spent in Esslingen comprised 'a carefree and picturesque experience. Music and his mother's singing, woodland wanderings in company with the family, country fairs, market places, dogs and flowers, satisfied more fully than was possible later the restless cravings of his developing interests.' George himself said nothing about these apparently idyllic days, but according to one of his mother's few surviving letters, they were spent in style. Thomas Firth rented 'an old castle' (Schloss Hohenkrenz) 'on the summit of a hill in the midst of vineyards and orchards', installed his daughter, her children and their nurse, and left them to enjoy themselves. 'The castle,' Annie wrote,

13

is not much like one, having no tower or turret or battlements. It looks more like an old-fashioned squire's house. There are several barns, stables and buildings surrounding it. The castle is in the centre building three storeys high with a large gravelled square or courtyard, with a fountain in the centre and grass and flowers around. Iron railings in front, the big iron entrance gates at one corner and on one side an entrance into the garden, on the other an entrance into the farmyard, big barn, drinking fountain of spring water and the steward's house.

The garden is very large being quite a long walk all around [and has a] fountain, a great quantity of trees and shrubbery, mostly apple and pear trees which are loaded with fruit . . . Our house is well and comfortably furnished with every convenience from garret to cellar. The rooms are large and lofty with furniture that is large and comfortable and [have] many elegances in the form of fine mirrors and gilt chairs. Plenty of dishes for the dining room and pots, pans and tubs for the large, light kitchen which contains a nice stove. The large pantry is suitably furnished, also the laundry and washhouse with everything to hand necessary for use there. There is even a game of croquet in the garden; we play nearly every evening as Pa is very fond of it.

George's German childhood set a standard of ease and security which he later found hard to recreate. Yet its pleasures were always provisional. Although he admitted that he did not actually miss his father, never having known him, the family thought of themselves as outsiders in a strange country, dependent on the continuing charity of Thomas Firth. Firth himself, as the only other male in the household, provided George with an example which was energetic and, in a mild way, tyrannical. He encouraged George, who was often rather sickly, in what were considered the 'manly' pursuits of walking, riding and boxing, while at the same time making it quite clear that his affections were not what a real father's might have been.

Difficulties between George and his grandfather only became marked when Firth retired from his directorship and took the family to England, in 1881. They settled in Yeovil, Somerset, where his wife's parents ran a small business. By this time – he was eight – George was beginning to feel impatient with the dominating presence of his three elder sisters, and his grandfather both expected and inhibited his rebellion against them. On one holiday at Seaton in Devon, George was reprimanded for swimming round the point which divided the beach from the neighbouring village of Beer; on another occasion, he had to clean every window in the house 'as an antidote to the sin of pride'. The blame for these disagreements did not lie entirely with his grandfather. Partly because he was spoiled by his

mother, and partly because his natural abilities distinguished him, George was a vain and smug child. To judge by the evidence of an early photograph, the 'sickly' child who had worried his mother in Germany had grown into a robust little boy: tall for his age, lean, his fair hair (which was soon to darken to brown) cut short above his ears, his wide blue eyes gazing confidently at the camera.

As a day boy at Kingston College, Yeovil, George was known as 'Cocky' Lambert – the main reason for his pride being that the principal, Miss Tate, 'softly held me up as an example of good performance in drawing'. In later life George was blasé about his first introduction to the gift which made his name: 'My drawing developed but along quite the wrong lines as we were made to copy crayon drawings by indifferent artists.' The standard of his tuition was unexceptional, but it did not prevent him from winning first prize when he sent up some sketches of leaf forms to a South Kensington under-twelve drawing competition. 'My mother,' he remembered, 'thought I was a marvel.'

This success made him even cockier at school, but he did not have long to show it. Firth, bored with 'the quiet of Yeovil' after his adventurous life, decided to make a move as dramatic as his original departure for Russia. He wrote to his brother Robert, who owned a sheep station called Eurobla, near Nevertire in New South Wales, and invited himself to live there with his entourage. Robert, who had emigrated from England in 1882, was delighted by the prospect of help from his brother and great-nephew. The idea of emigrating to Australia provoked mixed feelings in George. On one hand it brought a premature end to his 'not unexciting schooling'; on the other, the outdoor life of Nevertire appealed immensely. While it meant foregoing one of his earliest ambitions (to be a boat builder) it meant making another (to be a horse breaker) a distinct possibility. It meant, too, the chance to live in a climate where his health, which was still 'a source of anxiety' to his mother, would benefit.

At the time when Thomas Firth decided to emigrate, Australia loomed in the popular English imagination as a potent blend of strangeness and familiarity. Geoffrey Blainey tells us in *The Tyranny of Distance* that throughout the nineteenth century 'Australia and New Zealand depended so much on Britain, were in most senses imitations of Britain, that their geographical position near the end of Asia's tail and near the islands of Oceania, seemed irrelevant'. This paradox was matched by another: the opportunities offered by Australia were as great as its hardships. It was rugged, male-dominated, remote, and its inhabitants were still awkwardly aware that their home had first developed as a penal colony.

But the country was also able to offer excitement, social mobility, and the means of getting rich quick. Tom Collins, in his classic *Such Is Life*, records an exchange between his narrator and an English friend, Willoughby, in Sydney in the early years of this century which well summarises this combination of qualities. In answer to the question 'You find the colonies pretty rough?' Willoughby answers:

I do, Collins; to speak frankly, I do. Even in your cities I observe a feverish excitement, and a damnable race for what the Scriptures aptly call 'filthy lucre'; and the pastoral regions are – well – rough indeed. Your colonies are too young ... Cultivated leisure is a thing practically unknown. However, the country is merely passing through a necessary phase of development.

George's journey to Australia in 1883 was momentous not only for its own sake, but because it was the occasion of his first watercolour – a view of the Thames through a cabin porthole as his ship, the *Bengal*, prepared to embark for the six months' voyage. Remembering the event later, he was keen to make it seem natural, rather than inspired. 'It is difficult for me to say whether it was the stimulus of the impression or the desire to use a quite decent set of watercolours that had been presented to me by some sort of relative that drove me to artistic effort.'

Judging by the frequency with which George mentioned this now vanished painting, it is obvious that he regarded it as a landmark. It was done without guidance from his teachers, and it seemed to license temperamental 'artistic' behaviour on the boat.

From the time I got this desire to do Art, I became a most objectionable kid in every way; moody, disobedient, dirty, noisy in flashes, a prig, a little beast, and it says much for the tolerance of both crew and passengers ... that I was considered full of possibilities though difficult.

One of the crew, a 'blond Plymouth man' called Davies, was a great deal more than simply tolerant. He advised George to sell his sketches, which he was producing regularly by the time the *Bengal* reached the Suez Canal, fed him biscuits and lemonade, and told him 'to be an artist'. George was anxious not to allow 'art' to connote anything cissy: he gambolled round the decks of the boat playing games with the children of other passengers, browned in the sun as the long voyage reached its end, and later praised Davies as a 'very manly chap'.

The family's decision to emigrate depended entirely on Robert Firth's welcome and goodwill, but they did not go immediately to Eurobla once they arrived in Sydney. They spent their first few weeks at Hurshales,

outside the city, where with the beach to entertain him George 'wagged it on every possible occasion' – fishing, swimming and making model dinghies. His grandfather soon decided to impose some discipline. He moved all his charges inland to Burwood – then a small village, within easy reach of Sydney – 'where life was duller', George complained, 'and there was not the same range of physical activities', and then took his young grandson alone to meet Robert Firth at Eurobla. The rest of the family rented a house from a photographer, Bayliss, in the Sydney suburb of Stanmore. With the two men away, the small house seemed spacious and, being built of Victorian red brick, comfortingly similar to the home they had left in England.

George was only eleven years old when he first saw Eurobla, and hardly prepared for the rigours of life there. Although he prided himself on his fitness and athleticism, his sickliness as a child had left an indelible mark. He was a skinny, gangling boy, with his mother's high forehead and fine hair – which his grandfather made him brush back from his face. He was eager to please but impetuous, hard-working but excitable, 'cocky' but unconfident. His grandfather's conversations about Eurobla had made him regard the sheep station as 'my castle in Spain, from childhood', and although he was apt to exaggerate the length of time he actually spent there (his first stay was only eight months, from the late summer of 1884 to the spring of the following year), its impact on his imagination was overwhelming. Arthur Jose, who was later to become his brother-in-law, described George's trip to Eurobla as a journey to a primitive but unspoilt paradise. The sheep station itself was a rough and ready affair – a low straggling house built of wood and corrugated iron, with a jumble of outbuildings and shearing sheds behind, and a tatty garden dotted with eucalyptus trees. Beyond the confines of the house, thick clusters of trees broke the view over flat, baking scrub. 'It was an unkempt bush then,' Jose wrote, 'covered with timber as yet un-ringbarked and occasionally broken into by small townships – Warren [then little more than a village] was the one he came upon.' ('Ring-barking' was the method used to extract gum from eucalyptus trees: it killed the trees.)

The source of Jose's information is George's own unpublished account of his arrival:

The central division in those days was a deal more picturesque though a deal more uncomfortable than today. The ring-barking had only just started . . . We drove out with the evening of a very hot semi-stricken day through bush that was much

the same as when it was first seen by white men. A catalogue of all that then sunk into my mind would be wearisome but it interests me to wonder if the hold it still has upon me is somewhat uncanny or is share[d] by others who have had like experience.

George's precise memories of that day included 'dogfights in which semi-sober bushmen wagered heavily' and 'a black tracker [who] was put up to ride bareback a bad tempered blood mare for fifty pounds'. The bush may have seemed like paradise, but it was a violent paradise. When George reached Eurobla itself he needed to summon up all his youthful faith in the value of 'manliness'.

He was delighted to do so. For eight months he took intense pleasure in what he called his 'playful jackarooing' – herding sheep, building fences, helping with the shearing, riding and learning how to break horses. (At Gallipoli, twenty-five years later, his skilful handling of horses was a source of envy and amazement.) He also enjoyed the bush for other and less purely physical reasons. Its remoteness and simplicity allowed him to develop a sense of home and of his own distinct personality. It gave him, he said later, 'my first real fill of Nature and practically my starting point for the goal which the young aspirant [painter] feels he can reach with so little effort and which seems to recede further and further the more he progresses'. If this remark conveys disappointment as well as affection, it is largely because his adult life prevented him from becoming the 'bush artist' he wished to be. But the wish itself is a tribute to the effect of Eurobla: it made him feel Australian, it gave him a sense of the numinous, and it drew his attention to a vast and largely untreated subject.

The reasons why George was unable to produce many paintings of the bush in later life were mainly social and financial. At this early stage they were practical. He was too busy looking after sheep. The 'very little [time for] drawing and painting' that his work allowed was reduced still further by his grandfather, who 'generally behaved like a domestic tyrant' and thought art an unsuitable occupation. George was later to refer to the treatment he received as a 'rather pathetic lack of sympathy and support from my own people', but Firth's behaviour is not altogether surprising. He had supported Annie Lambert and her four children for ten years, and had an unwavering belief in 'the parental roof sheltering the women of the family until marriage provided another home'. He urged George to begin fulfilling his 'masculine' responsibilities: he told him, that is to say, to get a job.

For the next five years, between the ages of eleven and sixteen, George,

who was still only a child, was crushed by his efforts to fulfil the role of an adult. The job he found, as a clerk in the drapers Macarthur & Co. of York Street, Sydney, was poorly paid and monotonous: five shillings a week for writing out invoices. The tedium, combined with the difficulties of living with his family in their crowded house in Stanmore, made him, he said, 'slack', 'very temperamental' and ill. The only relief for his imagination was the chance that his basement office provided, during his idle moments, of filling his notebooks with drawings – mainly of the human and animal legs he could see from his window. While these drawings brought him a degree of entertainment, they also persuaded his bosses that he was an unsuitable employee, and in 1888 – after working for four years – he was given the sack.

His boredom at Macarthur's had done nothing to soften his grandfather's heart, and since his own resistance to further education was 'violent', other employment had to be found at once. His search led him, with help from William McMillan, the head of Macarthur's Sydney branch, to the government shipping office – an imposing, labyrinthine building at Sydney docks – and another job as a clerk. The work, for the short while that he endured it, was comparatively congenial. Being near the docks meant that he was able to indulge his continuing fascination with boats (Circular Quay, from Davis Point to Fort Macquarie, was crowded with clipper ships), and since his office stood opposite the bustling Flemington wool sale yards he could easily revive and elaborate memories of the bush. Furthermore, because the hours were shorter than at Macarthur's, he was able to spend more time drawing. His own version of his achievements at this time is engagingly and – for him – unusually modest: 'As the American sensationalist would put it, I had not "received the call". I knew no one either interested in or connected even remotely with the Arts. I took my own talent in drawing for granted, looking upon it as I would an accomplishment graceful but not uncommon.'

It is easy to read loneliness and frustration between the lines of this remark. Elsewhere he is more candid. 'I was distinctly disturbed by a burning desire to get away from city life,' he wrote later, and the Flemington yards, with their enormous stacks of wool bales, 'stirred up what I mistook for a burning desire to devote my life to the back country and the breeding of sheep and all the serenity and absorbing work and thought that hangs thereto.' 'I can see,' he added, with what sounds like wisdom after the event, 'that it was the artist's romantic longing for the light and colours and arrangement of form.'

Eventually his grandfather's sternness melted as Annie exerted on

George's behalf what little influence she was allowed to have. The few reminiscences of her that survive suggest that she doted on her son. (She was a 'musical and sensitive woman', and George used to take part in the amateur entertainments she organised at home in Stanmore.) Because she thought that a return to the bush would allow him time to develop his interest in drawing, as well as building up his strength, she urged her father to let him go.

It is one of the formative ironies of George's early life that his second spell at Nevertire promised him abundant freedom but gave him very little opportunity to enjoy it. The year that he returned – in 1890, when he was seventeen – was, as Arthur Jose remembered, 'one of despondency out back; wool was down, the shearers were out, already men foresaw the bad days of 1892–3 . . . times were bad, and living arduous, and the bush people persistently silent and melancholy'. Judging by George's own description, his great-uncle's station was not spared the general hardship. In the remote and gruelling outback his work, which would normally have been arduous to say the least, now 'meant manual labour from dawn to dusk' every day including Sunday. 'When the morning chores were done,' Jose says, 'the tired body could not respond to his eager desires, and order or design seemed unattainable among the crowd of impressions that jostled each other in the brain.'

On his first visit to the station, George 'was allowed to run wild, intoxicated by the great skies, the sun and trees, the sheep and horses'. Now he was restricted by the demands of work. Since arriving in Australia his health had benefited enormously, and he was put to work shearing, butchering and horse-breaking without any concessions being made for his youth. He was already nearly six foot – tanned, tousle-haired, loose-limbed and energetic – but his obvious aptitude for the work could not make him entirely happy. In fact what had formerly been a paradise seemed, within weeks of his arrival, a torment: 'the boundary fence would represent the bars of a prison wherein the prohibition of the exercise and development of a special talent became a punishment of great severity.' Even his admiration for the place's beauty and his pride in outdoor life were barely enough to sustain him – if, that is, his own account of the time is entirely to be trusted. According to Amy, it suited him very well in later life to say that his childhood was exclusively rugged and pioneering. In fact his labours provided him with at least a few opportunities to draw. 'Pencil and sketchbook,' Amy says, 'were never far from his hands and the collection of bush studies of men and horses is a notable one. He had heard of studies from the nude and on more than one

occasion he induced a bearded shearer to expose a muscular torso and pose for him during a precious day of rest.'

George's perseverance with his drawing at this stage of his career is remarkable. With no formal training, great practical difficulties to overcome, no like-minded companions, and no reason for confidence except a blind faith in his own facility, he cultivated a stubborn belief in the value of close observation and diligence. But what were such things without a society in which to explore and develop them? He felt that it would take a miracle to set him free from Eurobla – not only because the world of art was altogether elsewhere, but because the sheep station exerted a strong and genuine fascination over him. He had, moreover, absorbed from his grandfather a feeling that any clearcut choice 'to be an artist' or accept it as his 'destiny' would be laughably pretentious. The prospect of taking even the most tentative steps towards resolving his dilemma filled him with alarm. Years later he suggested that for most people the discovery of an artistic vocation is exciting, 'but for me it was so inexpressibly sad and untidy, so surrounded by circumstance and untoward atmosphere, family, and other ties antipathetic, that it is difficult for me to go through the pain of putting down even a reduced memory of the main points.'

In the end, his 'ties antipathetic' were broken partly by luck and partly by that special bravery which is the prerogative of the ignorant. On his occasional visits from Eurobla to stay with his family in Sydney, George took every opportunity to examine the limited holdings of the galleries, and to study the more popular and accessible forms of art that appeared in magazines.

By far the most respected and influential of these magazines was the *Bulletin*. During the 1890s, the *Bulletin* had established itself as the mouthpiece of Australia's emerging nationalist movement. Although it realised the value of certain parliamentary and trade links with England, it insisted that these need not imply wholesale cultural and political domination. Issue by issue, articles promoted independent Australian views and attitudes, and many of these had an artistic – and not simply a polemical – dimension. Literary self-awareness, the *Bulletin* made clear, was a crucial aspect of nationhood. Not surprisingly, many of the magazine's stories and articles had a distinctly local flavour, celebrating Australian city life and – more frequently and emphatically – life in the bush. The bush, in fact, was given almost mythical status, and its remote, unspoiled beauty was made to sound like an antipodean Garden of Eden: wild, peaceful (though rugged) and innocent. The editorial policy

vigorously denied that 'being an Australian' was a 'barbaric fate', and the magazine's gifted team of writers readily proved the point. Two of the most prominent were Australia's best known poets – Henry Lawson 'the bush poet', and Banjo Paterson, whose ballads of life in the outback included 'Waltzing Matilda'. The poet and horse-breaker 'Breaker' Morant, who has since become the subject of a famous film, was another regular contributor.

It was a special characteristic of the *Bulletin*, as it was of magazines in Europe and America, to have its stories illustrated. Originally these illustrations were differentiated from 'art proper', but during the 1880s and 1890s, as Robert Hughes says in *Art in Australia*, the 'hard line between fine and commercial art [became] fluid. Artists had to apply the elaborate technical equipment of their serious paintings to a more menial task.' Among the indigenous 'fine' artists who accepted this challenge, Lionel Lindsay and the portraitist B. E. Minns were preeminent, but their work was to a large extent overshadowed by American illustrators such as Howard Pyle and Charles Gibson, whose work was frequently reproduced alongside their own. The 'rapier facility and sparkling blacks' of the Americans, says Hughes, 'were the envy of every *Bulletin* artist'.

Australian magazine illustrations exerted a powerful influence on George's work in the 1890s, not simply because 'finer' drawing was difficult to find, but also because they were produced by the most exciting artistic community that Sydney had to offer. When George finally plucked up the courage to obey his instincts, it was to the *Bulletin* that he turned. On a visit to Sydney in 1895 – when he was twenty-two – he introduced himself to Minns, who as well as contributing frequently to the magazine was also on its staff, and showed him the portfolio of work that he had done in the last five years.

Minns was intrigued by George's history and his appearance. Working at Eurobla had turned the gangling boy into a tough, muscular young man. He had a clear, quick voice (from which his family had snobbishly encouraged him to exclude any trace of an Australian accent), his hair had been baked gold by the sun, and his skin was a dark healthy brown. But while 'playful jackarooing' had given him considerable physical self-confidence, he was ill at ease in Minns' company. George's fine-featured face and thin long-fingered hands conveyed a distinct impression of awkward sensitivity. Minns liked him, and was impressed by his work. 'You have a great feeling for drawing,' he told him. 'It's uncommon.' He accepted several of George's drawings for the *Bulletin*, and urged him to

A WOMAN'S USES.

He (teased about sweethearts): "I'm never going to get married. What's
the good of a wife?"

His Thoughtful Sister: "But, then, if a burglar comes, who'll hold him
down while you beat him?"

POINTS OF VIEW.

The Man: "I say, hasn't the new model a jolly fine figure?"
The Woman: "I don't know; I have not seen her with her clothes on!"

Two of George Lambert's illustrations for the *Bulletin*, both reproduced in the
magazine on 1 June 1930, after his death.

make a final choice between life in the bush and devotion to art. George was later to remember his reaction with pompous solemnity: 'It was the saddest hour of my life. The hour wherein I realised at last that I was not as other men. That before me stretched the long and weary road that is trodden by those who would attain greatness in the Arts – a veritable giving up of all that makes life bearable for the sake of chasing the ever-receding goal of achievement.'

George also brought Minns an oil painting he had done earlier in the year when staying with his second cousin Joseph Nield, at Meryon, a sheep station outside Sydney. The painting was called 'Bush Idyll' and shows one of Nield's children, Grace, surrounded by a family of goats clustered in a clearing among gum trees. It is, as Hughes says, 'a pleasant if papery effort' – the paint unconfidently flat, and the subject mawkish. But its grey-blue tones (which owe a great deal to the wash techniques of the *Bulletin* illustrators) and its celebration of Australian bush life were calculated to appeal to Minns. Minns recommended that George should enrol in Sydney's thriving Art Society classes, which were run by Julian Ashton, a dapper, small-featured man much admired in Sydney for the intricate technique of his draftsmanship. George's willingness to meet Ashton was increased by his excitement at having 'Bush Idyll' – when he submitted it for exhibition – bought for twenty pounds by the New South Wales Art Gallery. Yet nothing could disguise the fact that when he introduced himself to Ashton, early in 1896, he was still an almost entirely untaught, uneducated and unformed artist.

In recent years, Ashton's reputation as a teacher has suffered a sharp decline, largely because his hostility to modernism significantly cramped the development of Australian painting in the early years of this century. But the advice, inspiration and material help that he gave George were crucial. George readily acknowledged this, and Ashton, in turn, always referred to George as his best pupil. At the time of their first meeting, Ashton was giving his classes to the Art Society in cluttered, ill-lit rooms in Vickery's Chambers in Pitt Street, Sydney. George – 'a slim youth with steady eyes and long, silky fair hair, and quite an assured manner for one so young' – appeared unannounced, and asked to sign on for night classes. They ran from 7 p.m. to 9.30 p.m. three nights a week. Ashton, by way of checking George's credentials, placed the head of the Apollo Belvedere on the stand.

'Draw that,' I said, 'full size, a strong, clean, hard outline, no shading, and I'll see you again later'; and with that I turned to my task and forgot all about him until

at 9.30, with the classroom almost empty, I found him, forgetful of everything, hard at work. After a glance at what he had done: 'Didn't you tell me you had not drawn before?'

'Nor have I like this; only just on odd bits of paper.'

Those who remember that head of Apollo, its poise, the straight nose and sharply defined nostrils, the clear cutting of the upper and lower lips of that bow-shaped mouth, will understand my surprise upon seeing a raw beginner handle so difficult a subject in so spirited a manner. 'Well,' I said, 'until next Wednesday, goodnight!' And as I went home I thought, 'I believe we have found a draughtsman at last.'

Ashton's enthusiastic welcome was one of the most important events in George's career. It gave him pride in himself, 'a fresh buoyancy to his step and a new ring to his contagious laughter', and a sense of purpose which easily outweighed the tedium of the jobs he still depended on for income. (At the same time as he joined Ashton he became the accountant to a grocer at Darling Point.) When, in April 1896, Ashton hired a large room in Beaumont Chambers, King Street, and equipped it 'in the most approved fashion for drawing', George arranged for the entire student body to attend on the opening night, and encouraged Ashton to re-christen them 'The Sydney Art School'. From the time that he began attending the School, his energy and commitment were integral to its success: he set a standard of punctuality and diligence which galvanised his peers as well as his instructor. Although 'full of high spirits and the exuberance of youth', Ashton recalled, 'never would he, while drawing or painting in the class talk to any other student, or make use of the model rests, except for an initial examination of his own work, or the work of those around him; but when the class was over, he would take the stairs into the street four at a time, hooting like a Red Indian, or singing some topical song at the top of his voice.'

George's contribution to the school was unstinting, but what could the school offer him? It is difficult to imagine, now, the artistic deprivation endured by Australia in the 1890s. George himself described the Sydney art world as 'in great measure a mutilated replica in miniature of the chaotic outlook of London' – but the plain fact was that the vast body of western art was unknown, or known only in poor quality reproductions. Moreover, the country's dependence on Europe in general and Britain in particular was such that it tended to undervalue its own developing native tradition. The earliest nineteenth-century painters of Australia – the likes of John Glover, Eugene von Guerard and Conrad Martens – had not been Australian at all, but émigrés whose versions of Antipodean light and

scenery owed less to what they could actually perceive than to what they could remember of their own Romantic European origins. Martens's work in and around Sydney in the 1870s, for instance, though skilful, more often than not obscures the actual character of its subject with reminiscences of Turner. It was only in the last years of the century that authentic home grown work began to emerge. Significantly, it did so not in fierce isolation but in response to an increased knowledge of the western tradition.

By far the most celebrated and influential of these earliest authentic Australian painters grouped themselves under the title of the Heidelberg School (after the district of Heidelberg outside Melbourne, where they spent a good deal of time working *en plein air*). The members of the school – Frederick McCubbin, Tom Roberts, Arthur Streeton and Charles Conder – forced themselves into the public eye in August 1889, with a show at Buxton's Gallery, Melbourne, which they called an 'Exhibition of Nine by Five Impressions'. The measurements were those of the cigar box lids on which their works had been painted. The subjects (predominantly bush scenes which were familiar to George – panoramas of scrubby flat lands broken by eucalyptus trees and outcrops of massive light-brown rock) appealed to the same nationalistic taste as the *Bulletin*. But the press sneered. Australian art critics, such as they were, only respected European precedents – and those precedents did not include the Impressionists.

The initial reaction to the Heidelberg School is a useful measurement of the conservatism of late nineteenth-century Australian artistic taste. Strictly speaking, Roberts, Streeton *et al.* were not Impressionists at all. Their work incorporated a free version of forms, but stopped short of truly fragmented interpretation. Although their subjects were emphatically local and patriotic, their presentation of landscape embodies traditional attitudes of middle-class alienation and commercial ownership. Nevertheless, the Heidelberg School's ideas seemed radical in comparison to those propounded by Ashton. Ashton was hostile to the Impressionists, and among his fellow teachers in Sydney, only Antonio Dattilo Rubbo wholeheartedly supported the modern French movement. Ashton tirelessly advocated unemotional technical skill, hard outlining and the virtues of solid expressive form embodied in the work of the Old Masters.

For anyone with George's naturally observant eye and skill at accurate drawing, Ashton's theories were bound to have advantages. They removed the danger of creating any successful effects by sleight of hand. But they also allowed George to concentrate on superficial, and therefore

weightless appearances. This danger was intensified by the steadily increasing amount of work that he was asked to do for the *Bulletin*. The magazine's technical requirements encouraged him to use flat washes and static, definite forms – mainly to illustrate jokes or depict types such as bar floosies, party-goers and horse-riders. George was so successful at producing exactly what his editors wanted that within a short time of starting with Ashton, he was able to resign from his job as a grocer's accountant and survive as a freelance illustrator. The *Bulletin* paid him two pounds a week. He also, with his fellow artist Syd Long, took a studio in 88 King Street, and liberated his mother from grandfather Firth by setting up a home with her in a modest two-storey brick house with a small garden in Potts Point. She supplemented his income by giving music lessons.

The comparative freedom of these new arrangements provided him with a secure world in which to live and work, but it was the *Bulletin* which gave him the most rewarding society. Artists and writers who had only been names when he submitted his first drawings now became friends and companions. Many of these were people whose contemporary fame has long been eclipsed – Livingstone Hopkins ('Hop'), the illustrator; Frank Morton, who wrote spicy yarns of Australian derring-do; and the quaintly versifying Roderic Quinn. Their company made him feel part of a conspicuous and creative world, and he quickly adapted his looks and behaviour to suit its fashions. He still clung to the standards of practical 'manly' good sense that he had learnt at Eurobla, but began to combine the straight-backed down-to-earth manner of a jackaroo with a more flamboyant style. He grew his hair longer, began smoking cigarettes, took to wearing a cravat and cloak when striding around Sydney, and produced mildly outrageous remarks whenever a suitable occasion presented itself.

But George was careful not to be caught talking about art too intellectually. It was a craft, he believed, depending principally on technique. Accordingly, he refused to develop a sophisticated philosophy to sustain it and vigorously pursued an active physical life – swimming, boxing and riding. A letter to 'Breaker' Morant, written in 1897 when Morant was staying at Lower Kurrajong, illustrates the no-nonsense personality that George was building for himself. 'Awfully sorry about your "purler",' the letter opens, 'I hope it only means animation temporarily suspended', then continues by referring to Morant's poem 'Beelzebub': 'Went to town on Saturday and saw Jesus Stephens who was somewhat on his literary pedestal – during our conversation in eulogy of

your "jingling" powers I mentioned your "Beelzebub" and he asked to see it damn his eyes and then condemned it.'

George's new-found flamboyance was a form of shyness – a way of masking the sensitivities on which his art depended, and of deflecting attention from the passionate commitment he felt to it. This commitment showed itself in the furiously hard work he did with Ashton, and in the efforts he made to organise and enliven the Sydney art world in general. His impatience with the standard of painting it habitually chose to praise even spilled over into dissatisfaction with the *Bulletin*. Although he remained grateful to the magazine for commissioning him as an illustrator, he came to feel it did not publish the best work that he and his friends were producing. With help from his studio companion Syd Long and a recent young recruit to the Art School, Thea Proctor, he founded a magazine which was intended to rival the *Bulletin*, and tempted some of its regular contributors to join him: Christopher Brennan, Arthur Adams, Ambrose Pratt and William Beattie.

George invited each of them to make whatever financial contribution they could afford, and in March 1899 they launched their magazine under the title the *Australian Magazine*. They began with a nominal capital of £1,000, a real one of £100, a devout wish to promote their own work, and high hopes of raising the standard of art criticism. (For the first issues they hired the *Daily Telegraph* art critic and when this was frowned upon by the paper's editors, George took over the job himself.) However exalted the aims of the *Australian Magazine* may have been, the cover of its first number indicates its nature. It shows a naked, laurel-brandishing youth astride a black charger. The contents themselves exhibit the same blend of Ninety-ish decadence, and hearty vigour. Paintings celebrating the outdoor life are jumbled in with others embalming a played-out European notion of whimsical pastoral: naked women skipping through woods, and Pan tootling on his pipes in gum glades.

The magazine died in September 1899, after only six issues, and by far its most memorable contribution was the piece George wrote, anonymously, about the painting which had preoccupied him for most of the year: 'Across The Black Soil Plains'. This painting, George's first major work, which he had completed when still only twenty-six, is a simple but powerful image of Australian rural life. Its broad canvas shows a team of thirteen horses dragging a heavily-loaded wool waggon across bare, miry flat-lands. In the foreground, the teamster is silhouetted against a massive grey. It was, like almost all George's work, based on close observation of facts, and these can still be reconstructed. The horses

belonged to a rancher called Harry Sharkey but when George encountered them – on a visit to the outback east of Bourke – they were hired out to the transport firm of Rouse Brothers. George had in fact first sketched the team while living at Eurobla but it was not until studying with Ashton, and living with his mother in the Sydney suburbs, that he began the painting. He worked in the garden shed, which was so small that the canvas had to be set up diagonally, and even then could not be unfurled to its furthest extent. George did not see the whole of his picture at once until it was exhibited in the Art School's gallery in Vickery Chambers.

'Realism was his aim,' Amy later said of 'Across The Black Soil Plains', 'and his achievement.' The finished product is proof of more than George's clear eye – it also expresses his by now well-developed belief in 'masculine' virtues. 'The movement and action are "all there",' he boasted, soon after hearing that the painting had won the £27 Wynne Prize and had been bought by the Gallery of New South Wales for £100. Its manner and technique are clear indications of the progress he had made since 'Bush Idyll' three years previously: it is rhetorical, dramatic and confident in its use of striking contrasts. The predominant browns and buffs are briskly applied and invest what might seem merely a piece of nationalist propaganda with a genuinely involving sense of strain and struggle. George himself, in his anonymous review, was justifiably pleased:

'Across The Black Soil Plains' is considered . . . to be the 'picture of the year'. We do not go as far as that, though we are ready to say a good deal in praise of it. It is strong, 'masculine' if you like; the horses are well drawn and painted . . . the teamster (and his dog) are realistic, the sky is good, the colour is harmonious, the subject is popular . . . When G. W. Lambert has studied and worked hard for a few more years, both here and abroad (as we hope he will) – well, then he may paint 'the picture of the year'.

As this implies, George knew by the time he finished 'Across The Black Soil Plains' that he had outgrown the Ashton school. The further instruction he realised was necessary could only be found in Europe. But how was he to get there? His grandfather, who had never shown any sign of encouraging George to become a painter, was now actually unable to help him. Firth had been badly hit by the Australian depression of the 1890s, and was eventually to suffer even more acutely when the assets he had left behind in Russia were confiscated during the Revolution.

For once, George benefited from an accident of history. During the late 1890s, as part of their developing spirit of nationalism, the New South

Wales government had been investigating ways of subsidising the arts, and when they eventually began providing money in 1899, the Sydney Society of Artists, following an example set by their equivalent society in Melbourne, decided to create a travelling scholarship: £150 a year for three years. George immediately applied. He submitted a subject painting ('Youth and the River' – another piece of whimsical pastoral showing a nude boy and girl on horseback, stepping into a river swarming with Pre-Raphaelite faces and dotted with black swans); a small landscape with gum trees; and a portrait of his mother. It was this portrait which most impressed the judges, E. Phillips Fox, Frederick McCubbin and John Longstaff. When they awarded George the prize his friend William Beattie sent him a delighted telegram: 'Won by a head'. In fact, he had won by several lengths – he had only had three other applicants to beat.

George understood that he was being rewarded for his potential rather than his achievement. 'I am inclined to think it must have been discernment on the part of the judges . . . that is, the weighing of the possibilities in my work more than the actual work.' He knew that while the Ashton School had given him an appreciation of 'the excellence of craftsmanship' he was still far from showing that he could demonstrate it as a matter of course. He had learned to subdue his natural facility to the demands of accuracy, he had been taught the essential requirements of form, and he had acquired a passionate love for a subject – the bush – to which he never did proper justice. He lacked, however, a mature understanding of tone, colour and light, and he had an inadequate knowledge of the western tradition. Europe – and London and Paris in particular – glittered in the distance like a promised land where all these deficiencies could be made good. 'I am,' he wrote to a friend, 'longing' for Paris.

The circumstances under which George left Australia suggest that his longing was mingled with a good deal of nervousness. His solution to the problem of impending loneliness was dramatic and unexpected: immediately before he sailed for London, he got married. When George first met her in 1898, Amelia Beatrice Absell (known always as Amy) had already acquired a reputation as a bluestocking, largely because of the short stories she had published – two of them in the *Australian Magazine* – and because she was stubbornly, and some thought shockingly, 'anti-church'. She was a tall, thin, elegant woman, a year older than George and – if photographs taken of her at the time are anything to go by – strikingly beautiful and stylish. Her open face, with its dark eyes, slightly up-turned nose and full pouting mouth looks confident and intelligent under the

ornamental hats she chose to wear against the heat. With her hat off, she was crowned by a head of luxuriant black hair, which she usually swept back into a heavy bun.

Her father, Edward Robert Absell, had brought his family to Australia from Hackney in east London during the early 1890s, hoping to continue his career as a cooper. He had started a small coopering business in London, but shortly after reaching Sydney had foundered, lost most of his money, and taken a clerk's job with the water board. His eight children quickly had to shift for themselves: the eldest, Edward, entered the government savings bank, and Marian, Evelyn and Amy – who had been born in Shoreditch on 23 September 1872 – were employed by Falks, the photographers, as retouchers. Marian, the most ambitious of the 'high-spirited girls', attended Ashton's art school in the evenings and was immediately drawn to its most gifted student, George, whom she was soon asking home to meet her family in the suburbs of Sydney at Hornsby. Amy realised that the Lamberts had a good deal in common with the Absells (as, of course, they had with every family who had recently arrived in Australia). Their families were both, she said, 'transplanted from [their] native soil and undergoing a rather painful period of acclimatisation and mental readjustment' – and this natural sympathy was deepened by George's charismatic charm:

Tall, fair-haired, blue-eyed, broad shouldered and extremely swift in his move-ments, there was something exhilarating in his presence. His friend Beattie . . . used to laughingly call him 'a job-lot Apollo' and compared a Sunday morning's walk with him round about Hornsby to 'being attached to a comet'. He had always a touch of remoteness which made us feel that he was with us but not of us . . . He always seemed to travel further than his companions on any line of thought or emotion and to return reluctantly to the shackles of time and circumstance.

It was not only George's dynamism which attracted Amy. According to her niece, Dulcie Stout (who was not born until 1898), Amy 'had the choice between two young men and once said "George needed me most" – you know that sort of woman's attitude'. What Amy discerned in George's youthful character was eventually to crush her: his need for independence required that someone else should provide him with the necessary practical support. To start with, at least, she was lovingly willing to provide it. The couple were married on 4 September 1900 by the Reverend Stephen Child in St Thomas's Church, North Sydney. Two days later they were aboard the ss *Persic*, bound for London via Melbourne, Cape Town and Tenerife.

At Melbourne, the young Australian artist Hugh Ramsay – who had been working at the Melbourne Art School under Bernard Hall – became a fellow passenger for the long voyage to England. Ramsay had been awarded second prize in the Melbourne Art School travelling scholarship, and had raised the money to pay his own way to London, inspired by the same hopes that filled George. Ramsay was a lean-faced, pallid and quiet young man of Scottish descent, and in spite of being more reserved than George, and without any of his 'manliness', took to his fellow painter warmly and at once. The two men had already met several times, and George's knowledge of Ramsay's work was detailed enough for him to share the widely held opinion that Ramsay was the most gifted Australian painter of his generation. On board the *Persic* they worked hard – George producing several sketches, and Ramsay spending most of his time on a large Pre-Raphaelitish portrait, 'Consolation', of the fiancée he had left behind. By the time the *Persic* reached London, on 11 November, Ramsay and George had made plans to meet up again in Paris as soon as possible. It was the start of a friendship which, though cut short by Ramsay's death at the age of twenty-nine, was to be of the very greatest value to George. Ramsay came closer than anyone to being a brother to George, and his work during the 1900s set a standard and style which George spent all his life trying to match. 'Ramsay's superiority,' he was pleased to admit towards the end of his life, 'could not be denied.'

Two

Although the time that George and Amy spent in London was brief – they left for Paris in February 1901 – its effect was everything they could have wished. They rented a cheap studio in St Petersburgh Mews, Notting Hill, in West London, and he had no difficulty in topping up the first instalment of his scholarship money. He arranged to illustrate stories for *Cassell's Magazine*, and regularly sent back drawings to the *Bulletin*. He also painted his first self-portrait to mark the beginning of a new and distinct phase in his life: a full-faced and straightforward image (his only self-portrait without a beard) with, as Amy says, 'a touch of youthful arrogance in the challenging eyes and dilated nostrils'. His athletic build and broad-browed, tanned face – his hair was already beginning to recede – suggest the vigour of his life as a jackaroo had added a detail which he felt stamped him as an artist: on the boat from Australia he had grown a moustache. It was ginger, and immaculately waxed and up-turned.

The painting is a milestone in the development of George's technique, since it is the first important work he produced after visiting the major London galleries. In its pose, tone and manner, it shows all the signs of an under-trained but naturally brilliant craftsman, humbling himself before the example of the Old Masters. The records he left of his first visits to the National Gallery underline this: in each of them, he searches for ways of preserving the Old Masters' standards in a modern idiom. Hogarth's 'Shrimp Girl', for instance, he says, 'fairly carried me off my feet. It seemed to make a natural bridge between the traditional technique of the more academic Hogarth and the modern methods in vogue at [the] time – Sargent, Carolus Duran and such.'

George and Amy were in London for four months. The life they led was impecunious but determinedly 'artistic': George, usually in a cape and spats, spent his days visiting galleries, and working in their cramped lodgings at sketches of the works he had seen, or pencil portraits of Amy. Amy herself abandoned the literary aspirations she had entertained in Sydney and combined her new role of housewife with the equally unfamiliar one of model. Day after day, George lovingly scrutinised her pale, full-mouthed face, made her dress up in her most stylish clothes, scorned regular meal times, and hurried to make up the ground he felt he had lost in Australia.

George and Amy left their studio in London 'the day after the funeral

of Queen Victoria, when the city was still draped in royal mourning and the people moved darkly over the half-melted snow of the roadways', and on John Longstaff's advice found temporary accommodation at the Hôtel de Nice, rue des Beaux Arts. Their search for a more permanent home was urgent – not simply for a sense of belonging, but because Amy was five months pregnant. By March they were installed near Ramsay on the top floor of 83 rue de la Tombe Issoire, in the Latin quarter, in a dingy, cold, three-room flat.

At such a time and in such a place, it would have been hard for George not to think that he was taking part in an artistic gold-rush. In the previous twelve years, from Australia alone, Tom Roberts, Rupert Bunny, E. Phillips Fox, John Longstaff, Charles Conder, George Coates, Arthur Streeton and Max Meldrum had preceded him to Paris, and the conversations between these and other émigré (and indigenous) painters proved to be an invaluable part of his education. 'Swedes, Russians, Rumanians, Americans, English, Australians fraternised amiably,' Amy wrote, 'and to each other's advantage.' George himself felt that he was part of a phenomenon: 'To me . . . the small tragedies of poverty and the other exigences of studentship were distinctly shaded by the fact that I was "landed" at what was then the art centre.'

While the general environment was sympathetic, his formal teaching was a disappointment. Like Ramsay, George could not afford to enrol at one of the great art schools, so they chose Colarossi's, in the rue de la Grande Chaumière, which was well equipped with models but where 'the instruction was practically nil': 'At Colarossi's [where the fees were 500 francs a year] you got little training from those nominally responsible for it [Raphael Collins, Louis Girardot and Gustav Courtois]: such instruction as they gave was methodical and uninspiring, and the neglect to give more was excused by saying that the student "must build up for himself".'

The two painters soon lost patience. After a matter of weeks they moved down the street from Colarossi's to the Atelier Délécluse. Although this provided 'a quieter milieu for the sincerity of their labours', it was similarly frustrating, merely advancing 'the system of training that permitted students to go on painting and repainting on the study until by sheer weight of plastered pigment some sort of imitative appearance was achieved'. George realised that his best bet was to look outside the art schools for his education – at the work of his friends, and in the galleries. The effect of the Louvre was even more explosive than any collection he had seen in London. 'It may be,' he confessed, that 'my studies of the

masterpieces in this wonderful gallery form the most important part of my training. "The Fête Champêtre" by Giorgione and the two frescoes by Botticelli attracted me more than any other works at the beginning . . . later I came to study the intricacies of such persons as Paul Veronese, Rubens, Van Dyck and Velázquez.'

By making Velázquez part of this general catalogue, George obscures his unique importance. In Paris, and subsequently, George looked to him as someone who provided ideal object lessons in colour and tone. He was encouraged in this devotion by the fact that the tercentenary of Velázquez's birth fell in 1899, and began a landslide of appreciative critical comment. Of the (at least) four biographies of Velázquez published between 1895 and 1900, the best respected was by R. A. M. Stevenson (R. L. Stevenson's cousin), of which a copy was owned by Ramsay. Stevenson's judgements coincided with George's independently formed intuitions about technique and form. 'It is not the lover of pictures, but the devotee of his own spiritual emotion who needs to be told that technique is art,' Stevenson says in his book; and again: 'Velázquez, while he revealed new truths about nature, scarcely ever forgot that a picture must be a dignified piece of decoration.' George himself called Velázquez 'the last and most glorious number in the co-ordinated lineage of the Old Masters', and – like Ramsay – he never escaped his influence. George's debt shows, in the most general terms, in what Lionel Lindsay called 'his delight in painting things in themselves paintable'. It is also evident in the haughty splendour of George's portrait figures, and in the dark browns and umbers with which he habitually surrounds them. In several cases, too, the reference George makes to Velázquez is even more specific: in George's later 'Equestrian Group', for instance, the pose of his young son Maurice deliberately mimics 'Don Balthasar Carlos'.

Velázquez was George's single most important artistic influence in Paris, but by no means his only inspiration. Among the other established Old Masters, Bronzino exercised an especially powerful fascination (particularly because of his distinctive treatment of sitters' hands: George was to make flamboyant gesturing with hands a feature of his own work). Among nineteenth-century painters, Courbet and Manet had a similarly decisive impact. Reviewing George's work nearly twenty years later, Lionel Lindsay realised that George not only admired their technical skill; he enjoyed their theatricality as well: 'Lambert has a trait that he shares with his prototype Courbet – the desire to astonish, to emphasise the brilliance of his performance, a certain wilful strangeness in the choice

of subject matter.' Although he respected this characteristic, Lindsay realised that it had its drawbacks: Lambert's

figures seem to be acting. They do not fit unconsciously into the spaces of his vision with that act of inevitability which informs the art of all great minds; and for this we feel that though he has conquered his art and is master of his brush like few of his contemporaries in Europe, he possesses the mind of the historian and is more interested in picturesque gesture than in character and its revelation.

The criticism is worth raising at this early stage in George's career even though most of the works which were to justify or disqualify it had yet to be painted, simply because George's art school days were so crucially formative. They created a cast of mind which was to survive for the rest of his life. They gave him, at one and the same time, enlightening access to an enormous range of painters who convinced him that great art must begin and end with questions of technique, and the encouragement to substitute dramatic surfaces for psychological depths. The wholehearted-ness of his admiration for the Old Masters and their more obvious successors – a result, perhaps, of his long isolation from them in Australia – bred a suspicious dislike of painters who made radical departures from their precepts. His time in Paris overlapped with the period in which the painters we now know as modernists were beginning to make themselves known, and the few indications we have that George knew they existed all suggest hostility. 'Chaos' was his favourite word to describe their work, both now and later. In 1910, for instance, he thought so little of the epoch-making Post-Impressionist show mounted by Roger Fry – which did more than anything else to introduce the English public to European modernism – that he left not a single record of his reaction to it. It was an attitude which was seriously to inhibit the development of his own painting, and was also to have damaging consequences for art in Australia in general when he was living there in the 1920s.

George's commitment to his painting in Paris was intense but not absolute; he played, Ramsay and Amy found, as hard as he worked. Ramsay lived above a soda-water factory at 51 Boulevard St Jacques within sight of George's and Amy's flat, in sparsely furnished rooms he shared with Ambrose Paterson (whose sister was married to the brother of Nellie Melba), James Macdonald, and two Americans – Frederick Frieseke and Henry Tanner. Ramsay and George were constantly in each other's company, visiting galleries, drawing (often using Amy as a model), and arranging musical evenings. In March 1901 Ramsay installed a piano in his rooms, on which he 'fed his soul on the hyacinths

of Bach Fugues' and regularly played an accompaniment for George's 'fine baritone voice'. The night Ramsay's piano arrived, he organised a particularly memorable soirée. Ramsay wrote to a friend 'all the coons in the place came along and we had a dance. Each played the piano until he was tired, whilst the others danced anything on their own till they dropped. Such a lot of idiots I never saw. We each invented our own dance.'

Their lives contained everything that students are supposed to relish: going to concerts (on at least one occasion Ramsay took Amy to hear Rosenthal play in the Salle des Agriculteurs), fooling around (George, who enjoyed mimicry, was frequently required to do his impersonation of Queen Victoria), and conscientiously setting out to *épater les bourgeois*. On one occasion, Ramsay remembered, 'Lambert and I went upon the bust and bought two bananas for 4d and chewed 'em walking proud as Lucifer among the toffs in the Rue de Rivoli.' It was a very similar existence to the one described in du Maurier's novel *Trilby*, which was first serialised in 1894, in its obsession with art, as well as its energetic and now rather naive-seeming high-jinks.

If these were meant to be challenges to convention, they were challenges of a mild kind. Both men, for instance, grew beards. 'I started to grow mine,' Ramsay wrote, 'but Lambert has just told me I look a really awful sight, a dreadful "blighter" he calls me', and both accurately reflected the moderate loosening of constraints in Paris generally. A few months before George and Ramsay arrived, in November 1900, the Exposition Universelle had given the city an air of exoticism (the Eiffel Tower, for instance, had been gilded) which George welcomed, but which he never allowed to overwhelm his pleasure in a simple, active and unaffected life. 'You'd be delighted with Lambert,' Ramsay told his sisters,

there's nothing about wool and station life and sheep and horses and kangaroos and emus and all that that you can teach him. He's had a rather wonderful experience, being for years in the back-blocks. [George had obviously been exaggerating.] He can ride anything, and can draw a horse as well as he can ride it. I never met such a fellow for yarns, he's always got something new.

Ramsay's tributes to George concentrate on his human qualities, rather than his painterly ones. George, by contrast, has little to say about Ramsay the man, but repeatedly praises his work. It is a measure of George's affection for Ramsay that he showed no sign of jealousy.

When I had brought myself not only to accept Ramsay's superiority but to see the

reasons for it, it interested me very much to hear the comments of older and more experienced men. Some said, 'There is firm, straight-forward modern painting – he will acquire soul later'; others said, 'This is evidently modern painting, and the idea behind it is big: he will improve his technique later.'

At Délécluse, as at Colarossi's, George said that Ramsay again 'stood out as the only man who was using paint and not pecking at the thing', and it came as no surprise to him that in the Société Nationale des Beaux Arts annual summer show of 1902, Ramsay had the unprecedented honour of having four paintings exhibited.

Much of George's own work had tackled themes as close to hand as those which attracted Ramsay. His notebooks of the period brim with sketches of Parisian characters (some of which he re-cast for the *Bulletin*), of Ramsay himself (one shows him hunched beside an oil stove in his chilly apartment), and of Amy. For the first time in his life, but by no means for the last, George found that readily available subjects interfered with official requirements. The terms of the scholarship demanded that he complete at least one major work a year for shipping back to Australia, and during his twenty-one months in Paris only the first was completed: 'La Guitariste', an oil painting of Amy seated and holding a guitar. Although it had the distinction of being hung by the Société Nationale (where it was overshadowed by Ramsay's contributions), and was then duly despatched to Sydney in a frame donated by Syd Long, the chief interest of the work lies in the skill with which it shows George assimilating his new influences. Image and treatment both obviously refer to Manet – it is painted in Manet's *manière claire* – and its 'calm, decorative' qualities are derived, by George's own admission, from his admiration for Puvis de Chavannes. It is, in fact, a work in which the elegantly gloomy style insists that the viewer's attention is distracted from the character of its sitter: painting, not personality, is the real subject. Although this means that it has a rather restricted appeal, it is, on its own terms, satisfying. Amy's curved arm, paralleling the curved shape of the guitar, and the clever chiaroscuro, indicate that however slow George might have been to cultivate his heart, he was quick to sharpen his eye. Paris, the painting shows us, had convinced him that he had been right to devote himself to technicalities: 'I joined the religious few whose ritual stated very clearly that it was not the one achievement, not the one egg, the one talent that mattered two whoops in Hell, but the carrying on of the fine mechanism from day to day, the improvements, perfections going on as additions to a really fine, solid structure.'

However nearly 'La Guitariste' fulfilled the standards that George set himself while painting it, he knew that he still had a vast amount to learn. His sense of his own ignorance made him fall behind with the scholarship requirements. He felt that he would be foolish to begin full-scale works until more of the essential groundwork had been completed. But to do this meant making himself his own worst enemy: late in 1901, he gave up his work for the *Bulletin* in order to concentrate on a protracted study of the nude, and thereby decreased still further the money available to support his family.

His timing could hardly have been worse: a few months earlier, on 26 June, Amy had given birth to their first child – a boy. After playing with the idea of christening him Paris, they settled for Maurice Prosper. The christening was more for sentimental than devout reasons. Their hopes, in choosing the child's second name at least, were clear, and so were their fears. George's letters of the period are preoccupied with financial affairs, and with his scholarship. On one occasion he refers to the latter part of his stay in Paris as 'a most uncomfortable time', and when Mackennal and Longstaff visited his studio on behalf of the New South Wales government to make a report on his progress, George was dismayed by their irritation that he had – as he put it – 'stepped backwards to solidify the scaffolding' of his work. They simply wanted results.

George's solution to the problem was to try and make a new start by moving to a new country. Late in 1901 Ramsay – who had no *Bulletin* money, and no scholarship to support him – had decided to capitalise on his success in the Salon by travelling to England in search of portrait commissions. It was a successful but short-lived venture: by September 1902 he had returned to Australia, hoping that the climate would help to stop the advance of the T.B. which was soon to kill him. George and Amy realised that their friend's time in England was likely to be peripatetic, yet the thought of his continuing company helped them to make up their own minds to cross the Channel to London. London would, they hoped, give them a better defined sense of home, it would offer opportunities similar to those that Ramsay had discovered, and it would be comparatively cheap. This last consideration weighed more heavily than any other, and shortly before they were due to leave Paris, it became overwhelming. The original scholarship money had always been scanty, and recently it had been forwarded with increasing irregularity as George fell behind with his commissions. Now, through no fault of George's, it dried up altogether. Amy wrote later

There was a secession of disaffected members from the Art Society of New South Wales, who formed themselves into the Society of Artists. It really was a very sound and stimulating action, providing just that keener competition that was badly needed then in a community too far distant from any continental centres to be other than parochial in tone. But the question of the government subsidy was a vexed one, and a grandmotherly government temporarily withheld its assistance until the wrangling Societies should kiss and be friends again.

When George, Amy and Maurice left Paris for London, in November 1902, the only money they took with them had been realised by the sale of the contents of their apartment. This was supplemented by the £10 that George had been paid for a small studio screen which shows Amy 'peeling the potatoes which were to provide the complete *plat du jour*, while the baby is eating the last biscuit in the locker'. The poverty this painting describes had done nothing to undermine George's devotion to his calling, but it had prevented him from indulging as fully as he would have liked in a fashionably raffish life. 'Melancholy was in the season and the scene,' Amy said when they left Boulogne.

As soon as George arrived in London he set about renewing the contacts he had made during his previous brief stay. On this return visit, as before, the difficulties of finding work and accommodation were eased by London's well-established Australian community. The poet Arthur Adams, Arthur Jose and William Beattie – all of whom George had known in Sydney – rallied to his side with offers of introductions to editors. Another expatriate Australian family, the Halfords, gave help of a more substantial kind. One of the Halford daughters was married to the influential property and art dealer Edmund Davis (he owned a large number of Impressionist works), whom George knew, indirectly, through the Bensusan family in Sydney. Davis was persuaded to lend George a studio in Lansdowne House. This catered for George's professional requirements to an unexpectedly luxurious degree – it was a single, long, well-lit room with a beautiful unvarnished wood floor – and helped to compensate for the straitened condition of his domestic set-up: two rooms in a house in Shepherd's Bush, which he and Amy furnished for £10. The domestic routine they had established on their first stay in London could no longer be maintained. In their meagre lodgings, the time and patience that Amy had for working as George's model was cut short by the needs of their child. Maurice's demands that they should feed, dress and entertain him quickly began to irritate George. Nearly all the sketches he did of his wife at this time show her

40

holding Maurice, and it is impossible not to feel a sense of exclusion as well as love in them.

George was more worried by his shortage of money than these minor family disruptions. To pay the rent, he willingly accepted the illustrative work that his friends arranged for him to do for magazines such as *Cassell's*. Like his work for the *Bulletin*, these new commissions were virtually all for black-and-white line drawings, which he took to signing 'GWL of NSW' to distinguish himself from another illustrator with the initials GWL. As before, the burden of deadlines pressed heavily on him, but to his relief he was able to find time to supplement his income by taking on various commissions to illustrate books – his first was Jose's Australian travel book *Two A-Wheel* – and to press ahead with his scholarship work. In Lansdowne House he finished, early in 1903, 'The Three Kimonos', a studio group against a traditional landscape which obviously owes some debt to his memories of France. It was duly sent off to Australia where it was considered, by his adjudicators, a marked technical advance on 'La Guitariste'.

'The Three Kimonos' was produced with the reluctance that usually marked George's approach to commissioned work, but its completion marked a decisive point in his career. As well as assuaging his guilty conscience about the scholarship, it also, though by coincidence, left him free to respond to a dramatic but complex change in his personal affairs. In the summer of 1903, Thea Proctor, with whom George had worked on the *Australian Magazine*, arrived in London from Sydney, and was welcomed by him with an enthusiasm which suggests something more than simple friendliness. Thus far, George's and Thea's careers had followed similar courses: Thea, who was six years younger than George, had been born in Armidale, New South Wales, and at the age of fifteen had won first prize in the Bowral Art Competition organised by Arthur Streeton. Her success led her to the Ashton School, where she met George regularly both in classes and elsewhere (she was a close friend of his studio-companion Syd Long). Ashton remembered her as 'a charming, amiable youngster and a favourite with everyone in the school, where she remained until she was about twenty'. When she 'entered upon the usual pilgrimage to London', and enrolled at the St John's Wood School, she was twenty-five – a beautiful, tall, dark-haired, languorous and dignified woman doggedly devoted to George's example and personality.

To start with, George greeted Thea as a willing pupil and a friend in need. Both he and Amy well understood the loneliness of an Australian recently arrived in London, and enjoyed the sense of continuity she gave

them with their past. They helped her find a cheap flat in Oakley Street, Chelsea, and welcomed her into their lives. They invited her to meals, and to accompany them on the few visits to concerts and the theatre that their income allowed. George even occasionally allowed her to use his studio, and encouraged her to leave what she considered the 'very bad' St John's Wood Art School and move to the Royal Academy School. At St John's Wood, she told the Australian painter Roland Wakelin in the 1960s, 'drawing was taught by methods popular at that time but which would appear preposterous to students of today. No lines were allowed to establish the contours, but some sort of tonal representation of the model was built up by means of powdered chalk applied with a stump.'

Before Thea could act on George's advice, the long hours in the poorly-lit St John's Wood School caused her to strain her eyes, and the chance of entering the RA School was lost. The injury resulted in her having to wear spectacles, and in the self-portrait she drew soon after adopting them, we have our first clear view of her in London. She looks quizzical and strong-willed, her dark hair combed loosely back from her forehead, her head slightly tilted to one side, her eyes gazing straight out through the round frames of her spectacles. Her nose is slightly snub, and broadens at the nostrils into a delicate flair. Her mouth is narrow and tight-lipped.

Thea's disappointment at not being able to enter the RA School made her rely even more heavily on the Lamberts for company and comfort. While they were still living in Shepherd's Bush – they were shortly to move to Chelsea themselves – she established a pattern of life with them which was to last for the rest of George's time in London. Amy took it for granted that Thea would drop in most days for supper, and George encouraged her to visit him very regularly in his studio to pose for him. Her liking for expensive clothes suited the dressy elegance of his early London works. Amy was relieved to be spared always having to act as a model herself, and was grateful to Thea for any help she gave around the house. George, too, welcomed Thea's regular companionship, as well as her views on painting. These coincided closely with his own; she was a devoted admirer of strictly representational drawing and, like him, revered the Old Masters above all other painters. In later years – and especially in Australia during the 1920s, 1930s and 1940s – her work in portraits and coloured wood-blocks was to become much more fluid and 'rhythmic' than he would have liked. In London, though, fashionable contemporary influences only confirmed their taste for rigid designing. Sixty years later Roland Wakelin was to write that

Miss Proctor has often talked with me about [those early days] in London. Of how she met Charles Conder at a party where Lambert, Ricketts, Shannon and others were present. And there was a luncheon at the home of Lady Davis; a round table (with a Rodin sculpture in the centre) in a large hall, and in a smaller dining room the walls were covered with grey watered silk and hung with pictures by Whistler: 'At the Piano', the 'Symphony in White' and many others. Good taste was the keynote for all this, for Whistler's influence was now being felt. It is not surprising that [she] was profoundly impressed and stimulated by all she saw after what she had been used to in Sydney, and it is not surprising that at that time she would have been strongly influenced by Conder's work. Miss Proctor now deprecates that influence.

Much as Amy enjoyed having the tedium of her life at home broken by calls from Thea, her pleasure became increasingly liable to interruption by outbursts of exasperation. Thea, Amy's niece Dulcie said later, was not good at helping with the baby and with household chores. More seriously, Amy resented Thea's invasion of her marriage. Dulcie remembers Amy frequently asking George, 'Must Thea come here so often?' – not because she nagged or importuned, but simply because she stopped Amy seeing her husband alone. Although Thea and Amy remained friends for the rest of their lives, Amy's affections were always darkened by a feeling that Thea had compromised her marriage. George's paintings were a continual reminder of this conflict – not only because they made the intrusion into her marriage permanent and public, but because they brought home to her with painful clarity the reasons why she might feel jealous of Thea. George's portraits of Thea – now and for the next several years – show a slender, patrician, well-dressed stylist. Amy, in the portraits George painted of her, presents a marked contrast. The delicate good looks she had had as a girl in Australia rapidly disappeared after the birth of her first child. Under its thick swag of hair her face thickened, her figure broadened, her arms grew pudgy, and her mouth lost its charming pout. The sexy young wife, the paintings say, soon turned into a homely matron.

George's attitude to Thea slowly grew similarly ambivalent – but his feelings were more powerful, and more explosive. Initially his absences in his studio meant that he was spared the full force of Thea's effect on his home, and he was more tolerant than Amy of her intense, detailed conversations about painting. As time passed, however, even he was irritated by Thea's languorousness. His wish to lead the life of a dashing young artist-about-town was jeopardised by a double dose of domesticity. One way of glamorising this set-up, of course, would be to say that George and Thea were lovers.

43

The exact nature of their relationship is inaccessible, to say the least. If Amy feared that Thea and George were lovers, she never voiced her thoughts, and Thea and George left no evidence to prove that they were. No confidential diaries and no indiscreet reminiscences survive – and Thea, when she died in 1966 at the age of eighty-seven, burnt all her letters from George. George's own surviving letters are, in relation to Thea at least, models of tact. The nearest he gets to making a tender remark about her is a reference to her as 'the brown-haired girl' when reporting to Jose in May 1904 that she was recovering from measles.

The truth of their feelings for each other is further complicated by a babble of second-hand opinion. One of George's closest companions in the 1920s, still living in Sydney, insists that George and Thea were indeed lovers – 'You just had to see the way they were' – but this version is contradicted by others who saw the couple together. Dulcie is particularly emphatic:

Thea admired George tremendously and I am sure that's all there was from her . . . she was tall, elegant, cool, with a hesitating little voice. It was my impression (but I might be wrong) that she was incapable of feeling any kind of passion or sexual feeling – for anybody. George was capable of it, of course, and he was obviously very fond of her. But she also irritated him – always hanging round him. At least after a bit. Saying 'Oh Lambert', and getting in the way.

This opinion is corroborated by the candour of George's dealings with Thea. She sat for him in his studio, and visited his house without any kind of furtiveness. Amy was not only tolerant of her, but usually actually affectionate towards her. Although Amy's feelings for George were eventually to become so self-sacrificing as to make her life a misery, she was a proud and possessive wife, and was certainly capable of objecting to unfaithfulness. No record exists of any such complaint.

In fact George's sexual behaviour, as we shall see during his time in Australia later in his life, was strictly orthodox and controlled. His masculinity was the sort which flourished on fresh air and exercise – boxing and riding – rather than on lady-killing. Furthermore, he thought that his gifts as an artist depended on sexual abstinence, and his belief is lent a good deal of weight by the portrait of Thea that he began in 1903 in his studio in Lansdowne Road. Its potency depends greatly on its restraint. Thea is shown three-quarter length, wearing a polka-dot dress and wide-brimmed hat, seated in an imaginary parkland which in its energetic but summary treatment is strongly reminiscent of Gainsborough. Like other of George's portraits of the period, it is aristocratic

and gracious, but the handling of the paint – a subtly unified range of browns, blues and whites – is intensely sensuous. The dress is flimsily fluid, the ungloved hands relaxed. In the middle background, beside a small pond, two hounds can be made out pursuing a white stag. No doubt George meant the images to conjure up an almost courtly association, but their symbolic value disturbingly ruffles the poise evident elsewhere in the painting. Far from suggesting that Thea embodies an idea of virtue which is under threat, the hounds raise the thought that George himself felt pursued by the two women in his life. This small detail, taken with the composure of the central image, moderates the painting's erotic charge by suggesting the dangers of involvement. It conspires with everything we know about the attitudes and circumstances which governed George's behaviour, to prompt the conclusion that although Thea had become – and was to remain – one of the two most important people in George's life, her role was confined to performing the offices of friend and acolyte.

The 'Portrait of Thea Proctor' was the first of George's paintings to be exhibited in the Royal Academy (George and Amy later kept it at home, and Amy eventually gave it to Thea in 1946. It now hangs in the Art Gallery of New South Wales.) But this first step in George's progress towards acceptance by the London artistic establishment did little to improve his financial affairs. As long as Davis and the Halfords continued to patronise him, his family was able to enjoy moments of comparative comfort – Davis introduced George to Rodin when the sculptor was in England to arrange a site for 'The Burghers of Calais', regularly entertained the Lamberts to dinner at his house near George's studio in Lansdowne Road (under an Inigo Jones ceiling which is now in the Victoria and Albert Museum), and occasionally asked them to his country retreat, Chilham Castle in Kent. But even Davis's generosity was not boundless and when, in 1904, a tenant was found for the studio he had lent George, the family had to reorganise themselves. Jose came to their rescue. He had recently been appointed *The Times*'s correspondent in Sydney, and offered them the remainder of the lease on a flat he had taken near the Bishop's Palace in Fulham. It was here that Amy had her second child. She records the event in her reminiscences with the same parenthetical casualness that she had used three years earlier to welcome Maurice: 'a second son, Constant, was born in August 1905. He, too, was very soon included in the family portrait groups.'

George needed a studio, as well as a house, and Thea recommended that he look in Chelsea, which was not only her own home, but by then was well established as the centre of London's Bohemian artistic life. He

settled on Rossetti Studios in Flood Street, near Thea's house in Oakley Street. 'The new studio,' Amy said,

> was a furnished one which meant in this case that it was crowded with the neglected yet hoarded accumulata of a woman painter who had married and left London. For this reason it was cheaper than many an unfurnished one, but the space was restricted. What had been designed for a bedroom was a dusty glory-hole crowded with old furniture and canvasses, into which we managed to pack some more derelict pieces to relieve the congestion of the studio.

The room next to this 'glory-hole' was George's centre of operations for the next nine years, and it saw the creation of most of his finest work. Towards the end of his time in Lansdowne Road, his confidence had markedly increased – the change is most obvious in the 'Portrait of Thea Proctor', and in a half-length self-portrait which two members of the International Society, F. Derwent Wood and George Henry, admired so much that they threatened to resign if it was omitted from the Society's annual exhibition. In Rossetti Studios George acquired even greater skills. The rigid manner he had learnt from Ashton was replaced by a simpler style, a more coherent sense of overall design, and a warmer, more luscious use of colour. These developments were quickened by the complexities of his private life. Among the earliest major works produced in the Rossetti Studios, for instance, was 'The Blue Hat'. It shows Amy, seated, surrounded by her children while Thea looks over them wearing an expression which mixes affection with a sense of exclusion. It suggests relief that the children are not hers, to encumber her, and disappointment that she cannot share their mother's intimacy with the painter.

When exhibited in the New Salon in Paris, 'The Blue Hat' was judged 'The Picture of the Year', and so impressed one of those who saw it – the Baron de Neufville – that he commissioned what was to become another of George's outstanding early London works: 'Lotty and the Lady' (1906). This painting, which shows an elegantly-dressed Thea seated in a kitchen attended by an inconspicuously-dressed servant, is less remarkable for the expertise of its technique than for its presentation of the psychological warfare which George was waging with his immediate circle. By placing Thea in a kitchen he allows her stylishness to seem dramatic, and yet also contains it by making her seem superfluous to the family proper. Taken with the several other paintings produced between 1904 and 1910 – among them 'Family Group' (1905), 'The Mother' (1907), 'The Bathers' (1908), 'Portrait Group' (1909), and the 'Holiday in Essex' (1910) – 'Lotty and the Lady' testifies to a family drama which

George never realised, or even mentioned, in other than painterly terms. These works illustrate one of the enduring and unlikeable paradoxes which give a controlling shape to this crucial period of his career: his charm and talent were sufficient to provoke admiring dependency in both Amy and Thea, and his self-regard and wish for objectivity were great enough to allow him to excuse himself from any resulting complications.

Just as George's involvement with his subjects in these early English works is both provocative and detached, so his attitude to technical problems is both inventive and submissive. Throughout his time in London, but especially during the first few years, he welcomed local influences with the same enthusiasm that he had previously shown to others in Paris. As before, his aim was to find a modern idiom in which to express the principles exemplified by the Old Masters. He was encouraged by several of the contemporary artists he now began to meet – notably William Orpen, John Singer Sargent and Augustus John.

Until George began to consort with these fellow-painters, he had done his best to disguise the fact that he felt isolated from the artistic world to which he aspired. He had contented himself with the company of fellow expatriates like Coates, with the mixed blessings of his home life, and with the satisfaction of watching his work improve and find an audience. A more glamorous existence had so far been prevented by his poverty, his knowledge that his early training at Ashton's School in Sydney had set him behind his English contemporaries, and by his awkwardness at being a 'colonial'. But now, three years after he had arrived in London, his reputation had grown, his income had risen, and his hopes of joining the smart Chelsea artistic society had blossomed.

John was the person who attracted him most strongly – and who also influenced him most powerfully, at home and at work. In 1901 John had married Ida Nettleship, and in 1903 they had scandalised polite society – and endeared themselves to their raffish Chelsea colleagues – by forming a *ménage à trois* with Dorothy McNeill ('Dorelia'). This arrangement had been established at almost exactly the same time that Thea arrived in London, and there is no doubt that George had John in mind when organising his own life. (The names of the women involved – Ida and Dorelia, Amy and Thea – obligingly chime with each other.) The John household and the Lambert household rarely mingled (though John lived close to Oakley Street, in Manresa Road) but George was immensely impressed by John's daredevilry, his gypsy looks, and his athleticism (John was a powerful swimmer). In a photograph taken a few years later, George adopts a typically temperamental John-like pose – slumped in a

chair in his studio, wearing a paint-bespattered smock, his hair tousled, his moustache bristling and his beard pointed, a cigarette negligently jutting from one hand, and his gaze moodily refusing to meet the camera's eye.

The amount of time that the two men spent together was never great. Although John recognised George as a kindred spirit, he also sensed that George lacked the decisive confidence, and the selfish restlessness, to make him an intimate companion. They confined their meetings to occasional drinking sprees in Chelsea bars and in the Café Royal (George usually drinking whisky that he could ill afford, in order to impress), and their conversation to art. When they did stray into discussion of their domestic affairs, it was usually to refer to their children rather than their love lives: John was to recommend that George send Maurice and Constant to the Albert Bridge Road School, south of the river from Chelsea, which some of his own children attended.

George never doubted John's pre-eminence as a painter. He shared with him – and with other 'modern masters' like Sargent – a belief in the value of sound representative technique, and a feeling that it should be used to promote drama and flamboyance. This gave a dynamic element to his work, but it also gave scope to his weakness for the superficial gesture. John, in spite of protesting to George in a letter that 'it is always disgusting' to show 'journalistic vulgarity', was a particularly pernicious influence, and even Sargent was not blameless. The flashy slickness which appears in some of Sargent's later work occasionally had the effect of making George rely on facility alone. In his own reminiscences of the time, George acknowledges these temptations, and implies his determination to resist them. He studied Orpen, John and Sargent, he said,

as exponents of the bravura on one hand, George Watts and C. H. Shannon and the like on the other hand, with that charm and desire to reveal the graces of the grand manner, and I really wanted to know the values of each school, and so I traced again the history of how it came into being, and in this research Hogarth was a very charming rest before I dived right back and eventually ended up with the hairy gentleman who carved reindeer on a bit of bone.

To George 'bravura' meant glamour as well as vigour, but the fashionable costumes and poses that he depicts in his work of this period disguises his family's actual condition. Although the paintings' successes won him several portrait commissions, the income he received from them was never enough to bring him the gracious living he created in his pictures. Understandably, he was anxious to put on a brave face. In May

48

1905 he told Jose: 'The situation is . . . not gloomy for me here but promises much better . . . now that I have some standing and it is quite possible that the next International Show will help to convince a highly respectable and suspicious public.' Later in the same letter he admits that his hopes are sustained by a good deal of wishful thinking: 'The portraits do not run as evenly as I would like.' With no guarantee of a regular income, he was forced to search for other work – often knowing that even when it came it would seem menial. 'Am to illustrate Australian stories,' he had told Jose in 1904, 'by some name like Ormond or Armond, Almond or Raison or something – contract eight months eighteen quid a month – better than the proverbial kick.' For the whole of the rest of his time in London he had, occasionally, to lighten the burden of his responsibilities by even more abject means, borrowing books and money from Jose, accepting commissions to illustrate such things as 'a regular blood-curdler by the author of "The Greatness of Josiah Porlick" for the *Pall Mall Gazette*', organising riding lessons in Hyde Park, and giving art classes at home and in the London School of Art. When, in middle age, he said that in London he had struggled 'by the sweat of my brow to continue in Art and to preserve my family in peace' he did not exaggerate his difficulties.

Amy's memoir of George keeps a dignified silence about the family's efforts to make ends meet. But those who saw her were uniformly impressed by her supportive labours. Penelope Barman, a friend and contemporary of Maurice's, remembers feeling shocked by the sight of Amy scrubbing the steps leading from the road to their house (in a household of the Lamberts' pretensions, such jobs would normally have been done by a maid). Amy's niece Dulcie similarly describes Amy's 'passion for "making-do"'. She had served a good apprenticeship in her very early teens, when she had unpicked and turned coats for her sisters. On one occasion, a favourite coat of Dulcie's was seized on by Amy in a fit of parsimony, and 'cut up and made into a smart coat for Constant'.

As George's reputation increased, so his demands for an appropriately elevated company intensified. In 1906 he took practical steps towards creating this by founding 'The Modern Society of Portrait Painters' – a group of thirty-five colleagues who mounted an annual show, without any specific theoretical point to make, but to lend each other support and encouragement. Most of the Society's members were drawn from the friends he had made in Chelsea – and there too, in purely social terms, he began to make his presence felt. He joined the Chelsea Arts Club. This institution, a low, white-stuccoed building in Old Church Street, was

then, and for many subsequent years, the nucleus of London's artistic life: among those with whom George fraternised most regularly were John, Wilson Steer, George Henry, Derwent Wood, Oswald Birley, Orpen, Fred Leist and George Coates. The building was a place for discussion, as well as relaxation – it contained sleeping accommodation in addition to dining-rooms and bars – and flourished in an atmosphere of rowdy flamboyance. George would drink there several evenings a week, standing rounds when he had sold a painting, and quickly establishing himself as a 'character'. His moustache and beard, his cape, and his stories of the Australian outback made him seem exotic, and more vigorous and adventurous than many of his colleagues.

The Arts Club's professional advantages were reason enough for George to join it but, as the covert drama of his family-group paintings show, he had another motive as well. He was embarrassed by his comparative poverty, and guiltily anxious about Thea's regular presence in his house. When Amy described his enrolment into the Arts Club she did so in terms which provide us with the first indication of his unhappiness: 'It was a very necessary stimulus to a man whose early handicap had resulted in what might have been considered an inferiority complex, which occasioned a certain aggressiveness in speech, but was more of a justification addressed to himself than a challenge to others.' Once away from home, George's 'aggressiveness' was no more than ebullience, and it enabled him to enter into the spirit of *la belle époque* with a generous flourish. Until he joined the Arts Club, he had been subdued by a sense of displacement, by a ruthless devotion to the task of learning his craft, and by the absorbing demands of his young family. By 1905, however, he had decided to belong to London, to trust his capabilities as a painter, and to loosen his domestic ties. The decisions marked a return of the high-spirited independence he had shown as a boy, and which had flared briefly in Paris.

George's success as a 'character' can be judged by the number of stories about his antics which appeared in the conversation and reminiscences of his friends. Most of them describe a well-judged mixture of sensational-ism and pragmatism. On one occasion – to prove his masculinity – he boxed Augustus John in the street outside the Arts Club, and knocked him down; on another, when visiting a riding school to do some studies for 'The Old Hunter' (eventually bought by Lord Lansdowne), he mounted, palette in hand, a particularly violent horse, and proudly subdued it, smearing paint over its neck in the process; on a third, he stayed up all night to paint a white rat he had bought on Chelsea Bridge,

1 George, aged eight.
2 Annie, George's mother, painted by George in 1899.
3 The Absell family, shortly after their arrival in Australia. Amy, George's future wife, is third from the left.

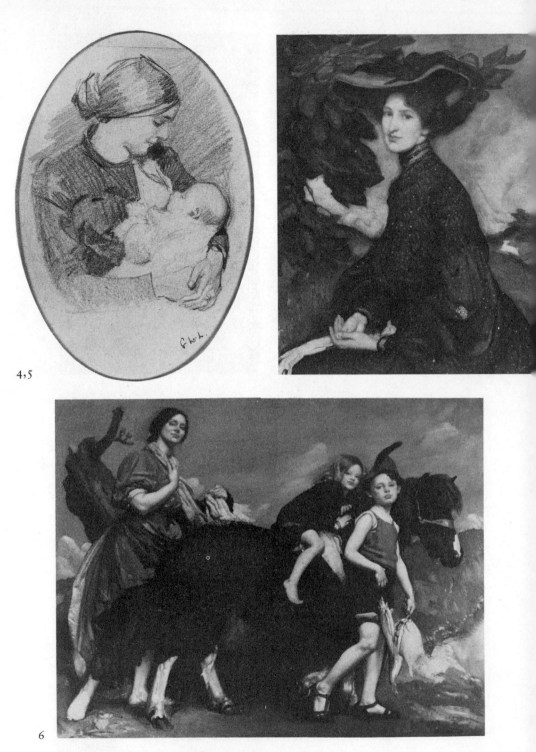

4,5

6

4 Amy and Maurice sketched by George in Paris, 1901.
5 'Portrait of Miss Thea Proctor', 1903.
6 'Holiday in Essex', 1910.

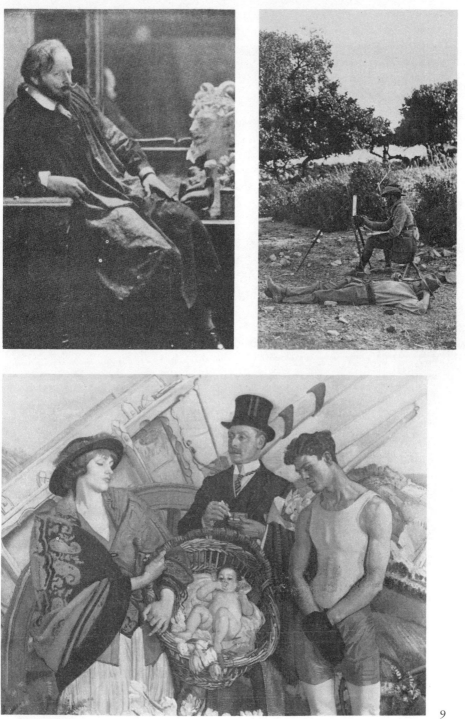

7,8

9

7 George, the society painter in his studio, *c.*1912.
8 George, the war artist in Palestine, 1918.
9 'Important People', begun 1914.

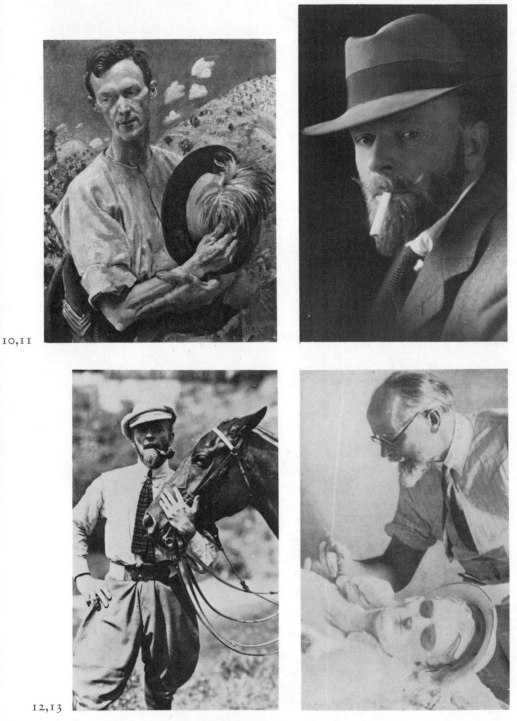

10,11

12,13

10 'A Sergeant of the Light Horse,' 1920.
11 George in Australia, *c.* 1922.
12 George, *c.* 1925.
13 George in Randwick, working on 'The Unknown Soldier'.

then took it to the Arts Club where it lived as a Club pet until Henry Fulwood, after a hard day's monotyping, sat on it and crushed it. Within a short time his friends knew him as eccentric and assertive, but George always tempered these qualities with what he considered to be 'gentle-manliness' – when he ripped the billiard cloth the House Committee of the Arts Club told him, 'It is the first time, to their knowledge, that any member has confessed', and when some dinner companions hauled him bodily along the table he took their ragging with a good grace.

The more eagerly George tried to prove that he was a dashing man-about-town, the more his friends suspected that he was disguising feelings of insecurity. One fellow Australian member of the Arts Club, Hardy Wilson, remembered him

entering one day in full dress with frock coat, gardenia buttonhole, top hat, spats, yellow gloves, having spent an afternoon at the opening of the Modern Portrait Society's exhibition in a Piccadilly gallery. Posing himself in a doorway of the smoking room he revealed in that act his instinctive shyness. Lambert's showing off was nothing more than a cloak to disguise a nervous shyness.

This lack of true self-confidence made his bohemianism more a matter of extravagant words and gestures than decadent deeds. He knew that his happiness depended on combining the independence of his Club life with the stable support of his family.

Amy well understood the degree to which his gadding was a search for reassurance, and was able to provide stability at home. George, in return, saw that the role he had designed for her was a difficult one, and when the first flash of his socialising had abated, he moved her and the children, in 1909, to a house in which she could perform her literal and figurative mothering with more convenience. The house they found – 13 Margaretta Terrace – stood in a pretty street immediately to the east of Oakley Street. It was in a row of grey-brick, three-storey, identical houses, was surrounded by a white balustrade, and – like other houses in the street – had an acacia tree in its small front garden. The new house was large enough to accommodate a further temporary addition to the family, Amy's niece, Dulcie, who was eleven years old. (Amy and George agreed to take her in when her parents separated.) Dulcie has left records of her time there which reinforce the idea that George both needed and felt constrained by family life. 'The main impression,' she remembered later, was

of tremendous vitality everywhere; Amy, always busy and full of energy; George

coming and going from the studio; Maurice, now eight, going every day to the Manor House School on Clapham Common; and little Constant, so pretty at four years old that he used to hide behind his curls with shyness because people took so much notice of him. Money was scarce and, partly because she disliked the stiff, conventional, tweedy clothes more usual for little boys, and partly for reasons of economy, Amy dressed her sons according to her own ideas. Constant had long fair curls to his shoulders and wore smocks and little velvet pants; and poor Maurice, in a black smock reminiscent of Paris days, had earlier had to endure being jeered at . . . by other boys.

Dulcie felt that her status in the household (she stayed on and off for four years) was more than merely charitable. 'I was included,' she wrote,

as the daughter Amy would have liked. She called me Dulcinea. There was a lot of laughter always and I never heard a quarrel, though George used to have terrible black moods of depression. But I always remember him as a vivid and fascinating person. He used to forget his latch-key occasionally and once a policeman on the beat caught him climbing in through the dining room window about midnight which needed a bit of explaining. Once I heard him and flew out of bed in bare feet and nightgown to let him in. He was very touched, and put his arm round me. It was a little difficult to walk along the narrow hall like this and my bare foot stepped on a very cold shoe – but I was somewhere near seventh heaven. Sometimes he took me to a play he wanted to see and these became known as 'silent outings'. He would stride ahead wrapped in his own thoughts and I would keep at his heels like a devoted dog. Once we went in a hansom cab – a lovely way to drive. Amy was rather tied to the boys in the evening and anyway was often very tired. She posed a great deal for George.

Margaretta Terrace allowed George to enjoy his expanded family, and to preserve his ties with the larger artistic society of Chelsea. Nellie Melba, whom he had first met in Paris, often dropped in; Ellen Terry lived round the corner; and Dora Meeson and George Coates were near neighbours. The house was an ideal place from which he could shine as what his friend Beattie called 'one of the leading lights' of the district. To retain his lustre, of course, George had not only to socialise tirelessly but to work successfully as well, and shortly after his move to Chelsea he set himself a task which he hoped would guarantee his eminence. Although his family had suffered 'unremitting economic strain' since arriving in London, George had always insisted that his imagination needed a regular change of scene, and had therefore made a point of taking holidays when time and money allowed. Usually these consisted of accepting portrait commissions for which he would have to travel to stay

with his sitters, but shortly after moving to Margaretta Terrace, he departed from normal practice and took the whole family on an expedition to Mersea Island in Essex – walking, fishing, bathing and boating. Amy, for whom the burdens of family life were now heavier than ever, jumped at the chance. Brief as it was, the holiday was the first time for many years that she had been without Thea to interrupt her enjoyment of her family. She positively welcomed the opportunity of performing alone the domestic chores entailed in looking after her husband, her two children, and Dulcie.

George decided to commemorate the excursion in the 'Holiday in Essex,' and set about preparations for the large canvas with a zeal which indicates his hopes that it would be a major work. It shows, Amy wrote, 'a group of a pony with two bare-footed children [Maurice and Constant] and a woman [Amy herself]; one child [Constant] is astride the pony, the elder boy [Maurice] carries a string of fish, the woman carries towels, a flat landscape suggests the Essex coast, the evening light the end of a perfect day.' George was concerned with technical problems rather than with the difficulties of suggesting the character and personality of his subjects. 'I was,' he wrote, 'determined to emulate the Spanish convention of about Velázquez's time . . . in so far as the placing of my figures and their background were concerned . . . even the light was so polarised as to give me a chiaroscuro as near as possible to that used by the traditional painters of Velázquez's time.' In order to create these effects George built in his studio a set of great elaboration, taking three weeks to construct a platform which would support the weight of his family and the pony, then another three weeks to train the pony to climb the steps and stand still. Once, when work on the painting was in progress, the pony fell off 'from sheer boredom'.

Although George referred to the finished painting with mock-modesty as 'a mere experiment in revivalism', it is in fact a successfully monumental example of the genre. Amy's tawny clothes recall the colours favoured by Peter Lely, and the pony itself has trotted straight out of Velázquez's 'Philip IV'. Although the tonal and formal skills deteriorate on the right hand side of the painting (as they do in many of George's works – did he paint from left to right?), the suffusion of the delicate browns, russets and purples binds up and controls its constituent element. The effort George made to achieve this unity, and the hopes that he had of the work furthering his career, were well satisfied. It was exhibited at the Royal Academy and the Société Nationale des Beaux Arts, and ultimately bought by the Art Gallery of New South Wales in 1979 for $120,000 – at

the time the most expensive purchase ever made by the Gallery. The keeper of the National Gallery in London, reviewing the painting in October 1910, wrote of it exactly as George wished: 'This is a fine advance on any previous work of his; every line has been considered, and every space, and an almost sculptural simplicity attained'.

The 'Holiday in Essex' established George's reputation beyond doubt as one of the leading revivalist painters at work in London – less glamorous than John or Sargent, but capable of being discussed in the same breath. As if to acknowledge the fact, George immediately quickened the tempo of his life, and achieved – in the following year – an equally conspicuous social triumph. It was the Arts Club's custom to punctuate the calendar with events which provided a focus for the Metropolitan artistic community: they had a large dinner on Varnishing Day at the Academy, and at Christmas a huge party in the Albert Hall. Due partly to George's motivating energy, these parties became increasingly lavish throughout the early 1900s and 1910s, until the war made their frivolities seem inappropriate. The stalls were packed with members' friends, and the central performance space was used for dancing, usually in fancy dress. Amy's memories of the parties correctly imply they provided an ideal outlet for George's theatrical inclinations. 'His keenness on pictorial accuracy was so great that . . . he found that he had consumed more time not than the occasion warranted, never that, but than he personally could afford, and so such attractions were abandoned until something irresistible came along.'

Other 'irresistible' distractions came along thick and fast in the years immediately before the war – particularly in the form of public tableaux, pastoral plays, and pageants. They represented the quintessence of the belle époque. On one occasion George took the part of Pan in the pageant The Awakening of Pan, organised by the wife of his painter friend Philip Connard, for which George made his own mask, and stood immobile on a plinth for twenty minutes before he was awoken by Flora's kiss, leapt down, and carried her off. In another, he dressed as Lord Thomas Seymour for the Chelsea pageant – spectacularly endorsing his wish to appear to his contemporaries as a renaissance man – then stayed up all night to paint a full-sized self-portrait, still in costume. Never was his admiration for Velázquez so legitimately indulged. In a photograph he had taken of himself in full costume he stands hands on hips, head tilted up, his right leg (swathed in its red stocking) shifted forward in a pose of arrogant courtliness. It is impossible, under his plumed hat, to see what other photographs taken at the time clearly reveal: that his hair had

receded rapidly in recent years, and his once-wide eyes were creased and darkened with worry-lines.

In a third pageant – in May 1911 – George organised an elaborate series of 'Episodes', with Thea and Amy working 'hard behind the scenes', mustering the community of Australian artists in London to celebrate the visit of the Commonwealth and State Representatives, and members of the Parliamentary Delegation. The 'Episodes' consisted of a short musical programme, played by the Grenadier Guards Band and including works by Wagner and Liszt, followed by seven symbolic tableaux which described the development of Australia from 'The Adventures of Spain' to 'The Coming of the Commonwealth'. George took the part of 'an aboriginal', and sat on stage the entire time so as to supervise the action without disturbing its realism. The result, as Amy said, was 'a triumph', but the success does more than commemorate George's flair as an inspirational coordinator. It suggests, too, a personality fretting at the constraints of a life devoted purely and simply to painting.

By indulging the extrovert, clubbable side of his personality, George was able to feed his imagination and bolster his sense of himself. He was also able to discover considerable practical advantages. His success with the pageants brought him to the notice of more distinguished sitters than he had previously felt able to approach. In 1910, the seal was set upon his respectability when the Imperial Colonial Club commissioned him to paint a commemorative portrait of the King, Edward VII, who died later that year. As soon as the Australian Artists Pageant had been performed in 1911, a more exotic kind of royalty approached him: the Gaekwar of Baroda, who had rented a shooting-box for the season in Ross-shire.

The resulting portrait, like many others that George produced in this period, is technically adroit but makes no attempt to penetrate its sitter's character. In the early part of his European career, George had deliberately concentrated on technique, thinking that its lessons were the ones he most needed to learn. As time passed, and as the complications of his home life increased, he realised that 'craft' was not only a worthy end in itself, but could also be used as a means of containing or actually suppressing emotion. Although the Gaekwar of Baroda – who was unknown to George before the painting was begun – had no special reason to think that the portrait would try to express his personality or explore his feelings, the lack of any such attempt is nevertheless a striking feature of the finished work. It is concerned, purely and simply, with the public face of a public man.

Shortly before leaving for Scotland to paint the Gaekwar, George's reluctance to tangle with his own or anyone else's emotions became dismayingly obvious. A telegram arrived from Australia telling him that his mother had died. George made half-hearted plans to return to Sydney, then abandoned them, retreating into the distractions of work with a speed which Amy recognised as being excessively self-protective: 'That his mother had not lived to receive very substantial evidences of his love and appreciation was very bitter to him, but with characteristic repression of emotion he pulled down a shutter in his mind and flung himself along the line of the interests of the moment.'

While George was in Scotland, Amy took the children to stay with Mrs Halford in Surrey, and received a series of letters from George which return again and again to the question of his emotional 'repression'. 'I have felt most murderous against everything,' he told her. 'Must be tummy or head, these terrible depressions, or perhaps seeing things as an artist does. I'm sure sensitiveness is a great mistake and should be bullied out of the young.' His own involvement with his children was too slight for them to suffer much from this opinion at this stage, but it is perfectly clear that for several years George had been bullying it out of himself and his work. It is too simple to say that when he returned from Scotland – he extended his stay to visit Skye with his [male] friend, Alison Russell, a doctor – these characteristics had suddenly hardened into fact. It is true, though, that the letters written during his trip give an unusually sharp insight into the ways in which his feelings for Amy had altered since their arrival in England. His original love for her had turned into awkward, ungenerous attempts at tenderness: 'I would sooner see you now than my washing.'

Brief as it was, George's time in Scotland gave him an appetite for freedom which was to grow steadily over the next few years. As soon as he returned to London late in 1911, financial worries reasserted themselves, and the tensions accompanying Thea's almost continuous presence at home recreated a familiar pattern of frustration. To earn money he had to accept innumerable unsympathetic portrait commissions and to resume his teaching, first at the London School of Art, then at Camberwell when C. H. Shannon resigned; and to evade the difficulties of his domestic life he regularly took off with his Arts Club friends, drinking in Chelsea with Augustus John and riding in Hyde Park with R. B. Cunninghame Graham – whose great love and knowledge of horses, and 'adventurous spirit and intellectuality' made, Amy says, 'a direct appeal' to him. It is a period of his life which, until the outbreak of war, is distinguished

principally by hard work, a consolidation of his reputation, and a sustained, reluctant retreat from the inspiration which had fired him in the first decade of the century. The principal source of that inspiration, Thea, made matters both better and worse by returning to Australia in 1912 for a two-year visit. Typically, George left no record of his feelings about her departure or her return.

Amy is more than usually reserved in her account of this time, only occasionally interrupting her catalogue of George's commissions – Mrs Henry Dutton, John Procter, Sir George Reid, Lady Beaverbrook – to understate developments in their private life. When, for instance, the family left Margaretta Terrace for 25 Glebe Place in 1913, she mentions it almost as an aside, and calls it 'Lambert's house' – with no mention of her own role in it. The new home was only a few hundred yards west of the old one, but considerably larger: a four-storey, stucco-and-brick corner house with a tiny garden in front, and a yard at the back which was almost entirely filled by a white wooden shed. It was a spacious but not a pretty house and the children had a bedroom each.

George's reasons for moving were simply that he had got fed up with the 'unvarying top-light' in Rossetti Studios, and needed a house large enough to include a studio. Glebe Place fitted the bill, and saved him renting a second establishment, even though it threatened to confine him within the family circle more absolutely than before. (In fact he got tired with this arrangement after a year and rented one of the Avenue Studios in Fulham Road; it was 'lumbered with the clutter of foreign-travel souvenirs, fancy-work, dried poppy heads and flowers'.) At least, by being in Chelsea, Glebe Place allowed George to retain his wide circle of friends. The Arts Club was nearby; Havard Thomas, the Welsh sculptor, lived next door with his Italian wife and large family; and further up the street 'a distinguished old Greek gentleman named Luke Ionides' was always ready to welcome the children with exotic hospitality: halva, and 'thin bread and butter with rose-leaf jam'.

George's studio in Glebe Place was the front room on the first floor, and shortly after moving in he wound himself up – as he had done when painting the 'Holiday in Essex' – to produce another large-scale painting which he hoped would enhance his reputation. Partly because so much of his time was now spent on formal portrait commissions, he chose a subject which would introduce some variety into his life. 'I was,' he said later, 'becoming more and more interested in tapestries, and the amenities of interior or domestic architecture, I wanted to paint a picture that had more affinity with the light.' The result, 'Important People', brought no

great immediate financial reward, and upset many of his critics – except Walter Sickert, who called it 'a noble effort' – and yet it stands out now as one of his finest achievements. It is a reminder that if George's livelihood had not depended so greatly on commissioned portraits, and if the edge of his inventiveness had not been blunted by his relationship to the Old Masters, he might have become a much more original painter than he in fact proved to be.

'Important People' carries George's interest in the revivalist manner to a fascinating extreme. Using colour harmonies ranging from pink to yellow to green to grey, it shows a gipsy woman, a wealthy top-hatted businessman, and a boxer (stripped to the waist, gloves on), grouped round a baby in a rush basket. A large antique cart fills most of the background, and beyond it, rolling down to a shoreline, is a deserted spread of grassy fields. George's intention was to create 'a likeness to a picture of the Botticelli period, but without the finish', and to achieve this he used a thickly loaded brush, working wax and turpentine into the paint 'to do away with shininess and unevenness of surface'. The result is a texture more reminiscent of a mural than a painting, and absolutely in keeping with George's intentions: 'it is a declaration against suavity, dexterity and facility . . . it was the beginning, if you will, of a reverence of rule, of order.'

In fact George's reverence for rule and order was nothing new, and neither was his insistence that work should be considered first for its technical qualities, and only subsequently, if at all, for the characters and states of mind it conveyed. By creating a candidly allegorical subject in 'Important People' he could hardly help inviting speculative interpretation – when the painting was shown in America in 1920, a Professor Whipple, of Pittsburgh, used it as a memory test – and many of these interpretations were contradictory. To unscramble them, it is as well to identify the models. The boxer, though occasionally thought to be modelled on Maurice, is in fact Albert Broadribb, then beginning to make his name as a fighter. (Dulcie remembers him coming to Glebe Place and being waylaid for his autograph by Maurice: 'He allowed Maurice to punch him as hard as he could on his muscular diaphragm. Maurice was most impressed that he didn't even grunt.') The wealthy top-hatter was a London art dealer, Marchant, who had advanced George £100 for the painting and was so horrified by the result that he asked for his money back. And the woman was a young unmarried mother from Battersea whose baby (shown in the rush basket) died while the painting was in progress. George wrote, 'I feel sure its demise was ordained by its feeble

inheritance, or possibly the genial surroundings of my studio, and the warmth and over-nourishment of its mother were so uncongenial as to be totally in opposition to Battersea in which it was ordained to survive.' None of this suffering is registered in the painting – the mother and the boxer stare with such wistful affection at the baby, while Marchant looks on rigidly, that the only possible source of distress seems to have to do with the issue of parentage. Who is the father? This question is a refinement of the one that George was in fact seeking to put: not 'who were the literal parents of the child?' but what were the forces necessary to guarantee what he called 'the world's progress' in general, and the development of art in particular? 'Important People' gives an answer which, in its inflexible delineation of roles, is unflinchingly reactionary. The ingredients necessary for 'progress', it says, are submissive womanhood, pugnaciousness, and wealth.

'Important People' was the last major work George produced in England: shortly after its completion in August 1914, the war broke out. The painting therefore marks the conclusion of a second distinct stage in his career. As an artist he had stayed true to the principles of hard work and technical craftsmanship which he had developed in Australia, and these had brought him obvious rewards. Amy, with justice, was able to say that by 1914 his 'reputation as a line-draughtsman was unassailable'. But the tenacity with which he clung to his original beliefs had its disadvantages. At a time when many English, French and Spanish contemporaries filtered the lessons of their predecessors through distinctly modern sensibilities, George remained studiously traditional. He chose revivalism where they opted for pastiche; he preferred lavish reduplication where they cultivated irony. In the early years of the century, in works like the 'Portrait of Thea Proctor' and the 'Holiday in Essex', George's confidence in his methods allowed him to achieve full-blooded sensuous results. By the early 1910s, his thinner paints, drabber textures and more rigid forms testify to a profound but unstated insecurity about his style and its potential for development.

Amy's admission that George's inflexibility as a painter owes a good deal to his 'inferiority complex' is characteristically acute. As an Australian he felt out of place in Europe, and as someone insufficiently educated he felt he was always running to keep up with the apparently relaxed stroll of his English contemporaries. What is true of his work is true of his private life. The personality he had developed in the outback was immensely robust and outward-going, but concealed an unquenchable anxiety about the proper application of his more sensitive feelings.

By marrying Amy immediately before leaving Australia, he both admitted to this worry and found the means of moderating it. In Paris, and in their early years in London, he was able to move easily and successfully between the outer world of his largely expatriate society, and the inner worlds of his family and his imagination. For a time, judging by the quality of the work he produced under her influence, Thea Proctor was able to lubricate these transitions. But once the initial pleasure of her company had worn off, and the first freshness of her conversation had faded, George came to see her as someone whose regular companionship reinforced the dull domesticity he had originally expected her to invigorate. The more habitual her presence in his house became, the more he kept himself aloof – either by remaining gloomy at home, or by spending long hours in the Chelsea Arts Club. When Thea first arrived in London, she rapidly accelerated the growth of George's talent; by 1914 she had contributed – crucially but inadvertently – to the resistance he had gradually built against intimacy, in his paintings and in his relationships.

Three

'The declaration of war in 1914 threw Lambert into a ferment,' Amy says. 'He was forty-one years of age; what success he had won in his own profession had been merely *un succès d'estime*, his earnings barely sufficing for his necessities and the presentation of a bill for materials used had brought on many a healthful sweat.' It is one of the most common and cutting ironies of the war that the histories of its first volunteers are littered with signs of their innocence about the suffering that it would entail, and with indications that for many it offered a welcome prospect of regular money and a reprieve from home. The disadvantages, of course, were more conspicuous. Almost overnight, George was deprived of the society on which he had depended. Not only did the Arts Club 'now hold a collection of old men, its younger members [being] in the field', but early in 1915 his patron and 'dearly loved friend' Mrs Halford died.

More upsetting still, Constant, who by now was at school at Christ's Hospital, developed a potentially fatal form of septicaemia, and had to endure a series of operations to save his life. Within the family, responsibility for the children had fallen almost entirely on Amy (outside the family Mrs Halford had treated them 'as if they had been the grandchildren she had never known'). At such a crisis not even George could absent himself by pleading involvement with the war. He 'flung his arms' round Amy in 'an ecstasy of relief' when the doctors told him that Constant's operations were 'successful as far as we were able to carry [them]'.

To start with, George's war work seemed frustratingly peripheral, largely because his age disqualified him from fully active service in the British army. His impatience was increased by the knowledge that Australia had been signally prompt to offer help to England: as soon as war was declared, it was the first country in the Empire to compel all its fit males to undergo military training. If the British army did not want him, perhaps the Australian army would? When he reported to the Agent General's office, hoping to enlist in the Australian Imperial Force, he was told that in order to be accepted he had to enrol in Australia itself. Disheartened, he turned instead to a humbler role: helping to teach new recruits in the United Artists Rifle Corps (a Home Defence unit) to ride.

In one respect at least, the war helped George to settle his affairs even before he was eventually able to put on a uniform. So as to be near Constant in the Christ's Hospital infirmary, he and Amy moved into a cottage in Cranleigh owned by his patron Edmund Davis, Mrs Halford's son-in-law. He was immediately besieged with requests to paint a number of small portraits of 'young men in khaki of whom a souvenir was required'. (It was in Cranleigh, too, that he painted 'Convex Mirror' – a virtuoso 'fish-eye' portrait of himself and Amy, among others, in the low, black-beamed parlour of Davis's cottage.) Remunerative as they were, these portraits hardly satisfied George's appetite to make a substantial contribution to the war, and when Sir Alfred Mond, later Lord Melchett – the father of one of his subjects – offered him the chance to increase his involvement, he was quick to take it. Mond was helping to organise Home Timber Supplies for the war effort, and introduced George to the Director General of Timber, Sir Bamfylde Fuller. The practical side of George's personality proved its value. He impressed Fuller, was sent to train near Tunbridge Wells, where he 'acquired the necessary knowledge of the technical and other differences between Australian and English production of timber', and was appointed Divisional Works Officer in Wales.

Although Amy accompanied George to Wales – taking the children with her when they were not at school – the two years they spent there disappointed him. On the one hand he and Amy were relieved to have a regular income. On the other hand George's job was boring, frustrating, isolating and exhausting. Amy was left to herself a great deal. The centre of the Welsh Timber Supplies was in Bangor on the north-west coast, but the distances under George's control spread from Aberystwyth – midway down the west coast – to Haverfordwest in the south-west. This geographical diffusion was matched by the variety of men under his command. Amy's tactful summary of his responsibilities paints a grim picture of muddle and toil:

The men engaged ranged from university professors, at the top, to a collection of Norwegians, Swedes, Danes, many Finns, a few Russians, and Welsh gipsies at the bottom, mostly entirely unpractised in the work demanded of them. The internal crews of foreign vessels were put to the manual labour of felling and hauling, wood had to be acquisitioned, trees counted, marked and measured, horses and stabling found, camps organised, bedding and food provided from stores already depleted or from local shop-keepers, who had yet to realise the urgency of the need.

The inspection and allotting of the timber was carried on under great

difficulties, the woods were dense and had to be traversed on foot, paths were few and the rain fell in a constant deluge.

Convoys of men arrived and were planted down in villages where mutual ignorance of each other's language aroused fear and suspicion.

Lambert insisted on a medical examination, fully justified in its result, although he was peevishly told that it was an unwarrantable expense. But he had had some experience of moving sheep and cattle and was aware of the necessity for a clean bill of health.

As well as having to deal with these complications, George also had to cope with the self-seeking jealousy of his immediate superior, a Canadian, and the problems of his work-force. Among his colleagues, only a Finnish missionary, Eliel Sjoblom, who had been drafted in as a kind of moral tutor, proved a kindred spirit, and helped him to fight the ineptitude of the administration. But Sjoblom could not entirely assuage the misery which gradually settled. George was continually thwarted, his brother-in-law Jose said later, by 'the handicap of his inexperience, his lack of appreciation of the sacredness of old-time administration, and the slow-moving wheels of a department which reverenced its accumulation of moss almost as much as it reverenced the moss on a perfect pine boasting one hundred years'.

Dispirited by petty officialdom, worn out by sheer hard work, and feeling that his early experience in the bush was wasted since he had to spend so much time in an office, George's health and nerves slowly gave way. By the summer of 1917 he decided that his talents for the job were not being used, and that his efforts to purge inefficiencies were being resisted. He resigned. 'I do most fully appreciate,' one of his superiors wrote to him, 'your difficulties in regard to all the many operations which you handled during the time you have been in the Division. It has been an awkward time for all of us and probably you have had more than your share . . . I hope you will not always look back on the whirl of events in Wales as an uninterrupted nightmare.'

George undoubtedly did look back on 'events in Wales' as a nightmare – particularly when he discovered that soon after his departure, the organisation had been simplified, and Haverfordwest made into a single division. But the anger this caused was a little reduced by two offers of far more agreeable work, which came before he had finished 'clearing things up' at Bangor. In October 1917 he was approached by Australia House with an enquiry as to whether he would like to undertake War Records work. Almost immediately afterwards the Canadian War Memorials Fund made a similar offer:

Dear Lambert,

I am authorised to approach you about painting a battle-picture for this Fund. An artist's commission, Major's rank, will be vacant shortly and it can be kept for you until we hear definitely that you would undertake the job. You would get Major's pay, £40 a month and allowances, say, £50 for expenses. John and Cameron have agreed to similar terms and will proceed to the front almost immediately. Likewise Orpen who is being transferred to the Canadians. Altogether it is going to be the biggest thing in Art that has ever been done and you really cannot afford to be out of it.

Appealing as this was, the chance to work with his fellow-Australians obviously had a special attraction, and George cannily waited to see whether the terms of the Australian offer would improve. They did. On 23 November the High Commissioner suggested he might go to France as an Official War Artist and then again, on 4 December, asked, 'Will you please let me know whether you are able to proceed to Palestine in order to make sketches of the Australian Imperial Force there.' It was an idea which seemed to solve all his immediate worries. It meant regular money, a recognised position, a chance to be reunited with his fellow-country-men, a landscape which in many respects resembled the places he had known as a child, and a legitimate leave of absence from his family. After the speediest possible enquiry about the terms of his appointment, he agreed to go.

By the time George left England, the war had less than a year to run. He might never have been approached had not his friend and contemporary Will Dyson, in August 1916, received permission to visit France to make sketches of Australians fighting. In May 1917, Dyson was granted Official War Artist status, and later in the same year Fred Leist, H. Septimus Power and Charles Bryant were sent to join him. Their work in France provoked one of the elder statesmen in the Australian artistic community – Arthur Streeton – to campaign for an expanded Official War Artist programme, and among the names he put forward to the High Commission were George Lambert, A. H. Fullwood, John Longstaff and John Bell. By the time they were enlisted in 1917 terms of employment had become formalised: no one was to visit a front for less than three months; all artists were to be appointed to the rank of Honorary Lieutenant (though George, to lure him away from the Canadians, was offered Honorary Captain); pay was to be £1 a day – a shilling less than that given to equivalent ranks in the AIF itself. The High Commissioner's Office demanded that it should collect all works produced under its auspices, in order that they should eventually be handed over to the Australian War Memorial.

George welcomed every pompously phrased instruction, and happily accepted the terms of his appointment: a £30 allowance for materials, and the requirement to produce 'a picture or composition of a battle scene in which the Australian Imperial Forces are represented, for the sum of £500, the subject to be decided by a committee appointed by the Commonwealth, to which the artist shall submit a sketch of the proposed picture for approval'. The subject eventually chosen was 'The Charge of the Australian Light Horse at Beersheba', but this major work was to be accompanied by 'studies, sketches or drawings which shall not be less than twenty-five in number'. The fact that George actually produced nearly 250 small studies indicates – even more clearly than the excited tone of the letters he was to write home to Amy – just how well the High Commissioner's demands suited his temperament. His energies thrived on recognition of his status, and his skills as a technician enabled him to fulfil expectations that he should work primarily as an accurate recorder of events, and only secondarily as a selective interpreter. One of his fellow officers, David Fulke, described him in Palestine as 'a tradesman who had come out to do a certain job of work'.

George could not have known it, and he certainly did not consciously plan it, but when on Christmas Day 1917 he left for Southampton, he was marking a distinct end to the family life he had depended upon in London. The remaining thirteen years of his life were to be spent almost entirely away from Amy, and his children were to become strangers to him. Amy herself was similarly unaware that George's departure would destroy her married life. Obviously she was sorry to see him go, but the loneliness of Glebe Place – Constant was away at school most of the time, and Maurice was fretfully waiting to enlist – was modified by pride in George's activities, and by the prospect of financial security. To have Thea back in London – she had returned from her two-year visit to Australia in 1914 – became a source of less ambiguous pleasure than before. Thea's visits to Glebe Place had their tiresome moments, but Amy was grateful for company, especially since it did not involve her in a competition for George's attention.

George's liking for his new employment was almost completely unalloyed, particularly when his boat, the ss *Lydia*, had crossed the Channel. 'It is difficult to say,' he wrote, 'if I was more terrified of seasickness or torpedoes. Torpedoes have it, I think.' When, on 13 January 1918, he disembarked at Alexandria, and was taken by troop train to Cairo, even his feeling that the city was 'over-described' could not prevent him from rejoicing in its exotic strangeness:

I should have liked to crack a bottle of the best by way of clearing the palate from the after-taste of ship's cabin and train compartment, and also the mind, upon which, according to your nature, will be imprinted either the oriental grandeur of Egypt, past and present, stimulating in its kaleidoscopic colour-pattern, or else the notorious insistence of the pagan and limited art and outlook which we have been cultivated to call beautiful.

Palestine and Egypt shook George into originality. In London he had increasingly become prey to the demands of portrait commissions, and his absorption in the revivalist manner had hardened into a fixation. Once he was abroad, his constraints fell away. So did his domestic and social anxieties – not simply because his family and Thea had dropped out of sight and could therefore be more easily pushed out of mind, but because the undemanding friendship of his fellow soldiers provoked none of his usual worries about intimacy. When he left Cairo to fulfil his first commissions at the AIF base camp at Moascar, near Ismailia, a few miles west of the Suez Canal, an especially heartening welcome awaited him. His major turned out to be his former colleague on the *Bulletin*, the poet Banjo Paterson.

Paterson, who had not seen George for nearly twenty years, was powerfully struck by the change in his appearance. The clean-shaven, high-spirited coltish young 'aspirant to art' had turned into a bearded, dandified professional. But there were signs that this change had not been easily or happily achieved. George's figure looked thin, rather than fit, in his immaculate uniform, and his face, under its ginger whiskers, was lean and lined. Within days of arriving, however, the George that Paterson had known as a young man began to reappear. As George was reminded of his Australian past, he rediscovered the sensuousness that had characterised his early work. Among his first war paintings was 'Moascar from Banjo Paterson's Tent', and although only small in scale (it was painted on a cigar-box lid – a form which had, for George, an inspirational association with the Heidelberg School), it is a triumph of simplified form. Like George's slightly later work 'The Last Tents at Moascar', the tents themselves – crisply glowing white triangles – appear as a series of geometric shapes under a brilliant sky. Framed by the flaps of Paterson's tent, they create an image of stunned suspension. It is a painting which sets the standard for all George's war commissions. They are quite simply the best work he ever did, and easily stand comparison with the English painter they most resemble in their crafty mingling of accurate observation with metaphorical form: Stanley Spencer.

By 12 February, notwithstanding the temptations of the French Club in Ismailia ('where I had one or two delightful dances, where there is occasionally quite good music, billiards, fair food at enhanced prices, cold soda at 6*d* a small bottle and bad whisky at a cost unspeakable'), he was able to report: 'Have dispatched twenty-three drawings and eleven paintings to Australia House.' A month later he was told that these works had all been lost when the convoy in which they were travelling had been attacked. Not even this disaster could dampen his spirits. He cheerfully followed the AIF east from Moascar and Ismailia over the Suez Canal at Ferry Port, and entered the Sinai. The crossing meant saying 'goodbye to what is known as civilisation', but his journal, instead of whingeing about 'the blazing desert', contains an affectionately humorous portrait of camels:

The camel is beautiful to draw and paint but he is an animal one cannot love. Never attempt to caress a camel. If he should try to caress you, and he will if you are not watchful, hit him with anything that is hard and heavy; the butt of the rifle; an army boot hobnailed; or the Colonel's best armchair. Hit him on the jaw and hit hard. When dismounting screw his neck right round as if you were trying to dislocate it and snub him short so that he cannot bite. His bite is fatal. When on him much may be forgiven for with little crying he keeps up his not unpleasant shamble with regularity and persistence. On dismounting revert to the original antagonistic attitude. The common bond of man and camel is undying hate. A comprehensive treatise on the camel is yet to be written. There was an Australian trooper of exceptional literary and rhetorical accomplishment who went into the matter very thoroughly, describing the animal in detail with a flow of words and an intensity of meaning likely to make Saint Paul and the early saints turn in their honoured graves. I regret that he spoke in a tongue almost impossible to translate.

George was temporarily deprived of the pleasures and pains of camels when, after crossing the Sinai, he went north by rail to Richon le Zion in mid-February. After a brief rest among the oases and olive groves he set off for the headquarters of the Desert Mounted Corps at Talaat ed Dumm, overlooking the Dead Sea. It was here, judging by the even greater intensity which begins to enter his work, that the similarities between the bare, melancholy hills which confronted him, and the landscapes he had encountered in the bush, began to force themselves upon his imagination.

But George's response to Palestine depended upon more than its associations with the Australian desert. He was able to interpret it so profoundly because he was able to appreciate the abstract forms inherent in realistically observed details. At Moascar the 'miles of tents' had

provided 'a continuous but ever-changing problem in colour, line and form'; now the landscape itself gave an equally exciting challenge. When he reached Jebel Saba, for instance, on the slopes of the Judaean Hills, he produced a small oil in which huge boulders and tumbled scree are marvellously observed both as their authentic selves, and as a huddle of shapes. At the end of the month when he had moved on to Romani he wrote to Amy:

The Romani country becomes more and more interspersed with the remains of ancient palm-groves which in early days probably covered the whole of Northern Sinai. Here and there a huge sand-hill or mount rears up as the result of years of influence by the main winds and half buries one or more of the groves or hods. Halfway up some of these sand-hills the green tops of the half-buried palms make decorative accompaniment to the undulating line of the almost knife-edged ridge on the top of the hill, intensely sharp against the blue sky.

A word to those who would paint this country. Leave your gay pigments at home. Approach Nature with a simple palette but an extravagant love of form. The sand-hills take on shapes and curves, cut concave and convex, interwoven into an entrancing pattern, here rhythmical, there jagged and eccentrically posed. With all the knowledge the artist may, nay must, bring to bear, he need only copy and he achieves art; but it takes doing.

When George eventually worked up his sketches and drafts at Romani into a finished commission – which he completed in Australia in June 1927 – he was as good as his word. 'The Battle of Romani' translates the virtues of his smaller canvases into larger terms. The blinding white expanses of the desert, the tufted palm trees, the skirmishing knots of men and horses, enact a fierce conflict not only between armies, but between forms: the static dead and the struggling living; the smoothly eroded hills and the angular horizon.

'The Battle of Romani' asks to be appreciated in strictly painterly terms, but never compromises the other main purpose of George's commission: to record events with documentary clarity. A letter he wrote to Major J. L. Treloar, who ran the 'Home and Territories Department' in the Australian War Museum in the 1920s, is careful to stress the pains he took to be strictly accurate.

The painting is of course good, I did it. The subject is so important that I have left a small margin for modifications . . . To give you details – it has not yet been decided in records whether feathers in a hat was a general issue. Again, bandoliers round horses' necks, water bags round horses' necks, mess tins, billy cans; the eccentricities brought about either by carelessness or swank; men without

leggings, men without tunics – all these little things which matter not a jot to the people who want to see my beautiful painting, but matter so much to the conscientious officer who is attached to War Records – these things we must go into.

Once George had completed his sketches at Romani, he 'reluctantly' left the Sinai proper for the next major battle site: at Magdhaba. His route took him via the 'clean though ancient' town of El Arish, where he was 'sumptuously entertained' by the colonel of the British West Indies Regiment, then on into Northern Sinai for twenty-five miles by camel. Time and again, when faced with these taxing bouts of physical exertion in 'the full blaze of the sun and stifling heat', George took pride in his strength. 'My early training as a horseman in Australia and my experience of celebrations at the Chelsea Arts Club stood me in good stead,' he boasted in his journal, and he arrived 'fit and full of enthusiasm for work'. No doubt his pleasure in his prowess derived largely from the feeling that it confounded traditional expectations of a painter's behaviour. His guide-officer at Magdhaba, for instance, 'had a contempt for artists almost characteristic of the perfect soldier', yet was quickly forced to change his mind when George insisted on 'dragging him over the landscape at high speed'. This was partly a matter of George wanting to impress, and partly a matter of necessity.

George's initial commission of three months was drawing to a close, and several important locations still had to be inspected. He left Magdhaba in what he felt was indecent haste, and on his way to Raafa paused at Wadi El Arish where he produced a small (four by six) oil that he considered a 'masterpiece'. (It was done 'in the heat of the day, a breathless heat that made the camels lie down and look more sorry for themselves than usual'.) At Raafa itself, where British and New Zealand as well as Australian troops had recently seen action, the landscape gave him less austere pleasures – a small oil 'From One Tree Hill' shows a grassy plain rolling to distant pinky-white mountains, lit by a cloudy sky which is more reminiscent of George's few European landscapes than anything he remembered from Australia. It is further proof – although his war work does not need justifying on these grounds – that in Palestine George's first loyalties were to what actually confronted him, and not to the artistic traditions he had worked so hard to assimilate.

Four

George's determination to conform as little as possible to the traditional expectations of limp-wristed 'artistic behaviour' extended to his moments off duty, as well as to his methods of work. When he moved on from Raafa to Gaza, for instance, and found that his stay there coincided with a race meeting organised by the British, Australian and New Zealand troops, he told Amy:

The races equalled, in my mind, any meeting I can recall. Blood-horses, trained to a hair, materialised in a mysterious manner; riders rode in colours not unfamiliar to those who attend race meetings in England. Every yard of the three-mile course was visible from the natural grandstand, a green hill. It was a bright day which made me assume the fatalistic attitude of a soldier, 'here today, gone tomorrow, but let's have a good time while we can'.

It was an interlude he could not afford to prolong. His next port of call, Beersheba, nearly fifty miles south, was one which had seen a particularly bloody encounter between the Australians and the Turks. A troop of the Brigade of Light Horse had charged and captured a complicated Turkish trench system. Here as elsewhere, George's imagination was quickened by 'admiration and reverence' for the men, and by his passionate liking for horses. Knowing that he would eventually convert his studies at Beersheba into a large-scale commission – he began it in England in mid-1920 – he set about studying the place with a care which was, even by his standards, remarkable. He commandeered two guides to show him over the site of the engagement, then

borrowed two horses from an English cavalry regiment which had then occupied the ground, testing the capabilities of each horse at jumping trenches. One was dangerous but the other was a capable charger for this work and I rode the actual course which was ridden by the Light Horse during the famous charge, jumping the redoubts and two trenches and taking a line to Beersheba, all at high speed, and working up considerable excitement, so that, to use a journalistic phrase, I could 'get the spirit of the thing'.

George's scrupulousness was so absolute that it prevented him from giving much time to the other issues one might reasonably expect to have entered his mind: the facts of death and suffering; the political causes which lay behind the conflicts he reconstructed so brilliantly; and the

religious or philosophical associations of the places he passed through. None of his work in Palestine, unlike much he was to produce on his subsequent trip to Gallipoli, attempts to take any sort of attitude to war at all. It simply seeks to describe it as factually as possible. This implies, of course, an appreciation of suffering alongside other aspects of war, but his depiction of it never has the slightest polemical or even overtly pitying aspect.

George would not have worked as well as he did in Palestine if the place itself and his companions had been less sympathetic. But his sense of the country's culture and politics remained steadfastly under-developed. As he left Beersheba, and travelled north through the Judaean Hills to Jerusalem, he came increasingly often into contact with Arab and Jewish communities he made no effort to understand. 'Attractive Arab villages surmount the hills,' he tells us, 'attractive enough from the pictorial point of view . . . but more intimate acquaintance leaves a bad smell in the nostrils and necessitates a liberal use of flea powder.' Again, near Jaffa, 'A passing handshake to the Jewish Colonies . . . my head still buzzes at the memory of the excellent but young wine which we there imbibed in large quantities.' Such entries imply a lack of curiosity which, in Jerusalem itself, became actually blasé. Parodying Christ's entry into the city, he arrived on an ass, wearing 'boots and spurs and riding breeches, but only a cutaway singlet over his shoulder'. The few references that he made to the Egyptians who worked alongside him during his travels with the AIF show a similar arrogance – even allowing for the fact that they embody a typical Empire mentality:

The Gypo as we call him, was properly managed, clothed, fed and very well paid and in a somewhat perfunctory manner he came in for an occasional clout of the ganger's whip. We of the white North, already too energetic, mentally whip and spur ourselves into greater efforts; the Gypo, with his natural indolence, prefers his whipping to be done by properly appointed officials. With the stimulus of weird singing, perfect unity of action, a physique equalling that of our finest athletes, and the aid of the whip, he performed almost miracles of labour.

George's entry into Jerusalem coincided with the end of his initial three-month commission. After a brief excursion to Belah, where he was delighted to discover a distant cousin, Guy Nield, serving in the Third Light Horse Brigade, he returned to Cairo expecting to board ship for England. But no sooner had he prepared to leave than the battle front again became active, and he was asked to travel east to the Jordan Valley. Although this unlooked-for trip did him, he felt, an honour in recognising

his value, it also brought him into serious danger. The heat was particularly intense in the valley, the scrub was bristling with Turkish snipers, and the overcrowded camps were rife with disease. When the worst happened Amy – in her subsequent report – did her best to play it down. 'There was much malaria and Lambert was not immune,' she tells us. In fact George contracted the disease very seriously. He was rushed back from the Jordan Valley to the Brooke Hospital in Cairo and although he made light of his condition in subsequent accounts ('had what you might call a double bout'), he was, for a while, fighting for his life. One of his companions reported that George 'surprised and upset both nurses and doctors and many interested representatives of various religious denominations, by his determination to live'. It was, as he must have feared at the time, an effort he would have to maintain long after the immediate danger was over. The malarial attacks were to recur for the rest of his life.

Before leaving Cairo, George handed over the war work he had already completed, 117 pieces, at the Ghezirek Kit Stores, packed in waterproof containers tied together with rope as an elaborate precaution against the likely effects of enemy submarines. 'This lot is too good to lose, my lad,' he told G. S. Gullett – who became the AIF's official historian – on the quayside. As soon as he reached England, on 7 June 1918, he conveyed his work with what he thought 'justifiable satisfaction' to the Commonwealth Government, and then addressed himself to his outstanding commissions.

Although a major obstacle to his progress – his malaria – was temporarily removed, it was replaced by other sorts of complications. The history of the rest of his year in London is a tale of frustration. The War Records Office, which had been so helpful in creating the initial circumstances of his commission, now prevented him from easily completing it. For one thing, he needed a studio big enough to work on his largest canvases ('The Charge at Beersheba', for instance), and although he was promised one 'either at Tidworth or Parkhurst', nothing materialised. He therefore began working at home in Glebe Place, where Amy had remained during his absence.

The letters George had written to Amy from Palestine, though hardly intimate, had at least been warmly friendly. (If he wrote any to Thea, they have disappeared.) But once back in her company he became preoccupied and distant. She seemed, through no fault of her own, dowdy compared to his dashing and undemanding companions in the army. Even Thea, who on her return from Australia late in 1914 had moved back into her

Chelsea flat, turned out to be as much a source of confusion as a consolation. Her long separation from George – while he worked first in Wales, and then abroad – had done nothing to solve the ambivalence of his feelings for her. After three 'unsatisfactory' months, he was 'still without definite directions or facilities', and starting to worry about the army's interest in his plight, and about how he was meant to support himself. Should he undertake portraits again, and interrupt his war work, or press for a studio to be assigned to him, hurry through the remaining commissions, and wait for the cheque which would follow? On several occasions he wrote to government officials – usually to Gullett and a Captain Smart – for guidance, pointing out, 'I have given to Australia the whole of my time and work, from 25 December 1917 up to about a month back, when I realised that I was being let down. That I am able to maintain myself and my family by private means is not in question [in fact it was], although some time must elapse before I can pick up what, for a better name, I must call my clientele.' To emphasise his feelings of injury, he sent Gullett a meticulous account of his time in Palestine, detailing the work he had produced – which was far greater than the terms of his agreement stipulated – and modestly playing down the hardships under which he had laboured. The government responded with a resounding silence. In the early autumn he was still 'working in a bedroom and praying that a studio would materialise', and more seriously worried than ever by his financial state.

Even Smart, who 'invariably proved himself a tactful and sympathetic intermediary,' Amy says, 'between Lambert and the Australian authorities', was unable to do much more than arrange for George's honorary rank of lieutenant to be extended to December, and for him to be given permission to begin touting round again for portrait commissions. But George's reputation for reliability had been damaged by the demands of his war work – he had broken promises and postponed sittings when he went to Palestine. 'I know you are doing your best,' he wrote to Smart, 'but I begin to think that either patriotism is a mistake or that I am a dupe.' By October, when he was 'engaged in a neck to neck race with bankruptcy', and seemed likely to lose, his situation was desperate. Even when the war at last came to an end, the news did little more than create a brief interlude of cheerfulness. To distract himself more thoroughly from his worries, he offered his services to the organising committee of the British Colonial Society of Artists 'War and Peace' Exhibition held in Burlington House, during November, and exhibited there 127 of his own works. This brought him a sense of achievement, but it did not pay bills.

Shortly after the exhibition opened, Smart arranged for George to receive 'half payment in advance' in order to complete 'The Charge at Beersheba'. But no sooner had the news reached him than he received an invitation to leave the country again. Captain C. E. W. Bean, a senior officer in charge of Australian War Records who subsequently became an official historian of the war, had been impressed by George's work, liked him, and asked him to join an expedition to Gallipoli to make 'certain sketches'. George, following his recent shabby treatment, was understandably reluctant, and it was only when Smart shrewdly sent him a copy of Bean's letter that he considered changing his mind:

Dear Smart,

I am very anxious that Lambert should be the man to go to Gallipoli with me. I will try and take every care that he does not have a rough time, if he will come. The reason why I should like him there is that I shall be going over the place with at least one officer who was there at the landing, and the chance of actually getting the instructions on the spot from one who knows so much about it will never occur again.

I am particularly anxious for Lambert to be the one to paint these special pictures. I could guarantee that he should only, if he cared, actually go to the spot for two or three days, so as to get the actual position, and then re-visit it, if it could be arranged later, after a month or two in Egypt. I do not think there would be any difficulty in arranging this. Will you ask Lambert again?

Flattered by the importunings of such an eminent man, 'and fearing continuing frustrations in London', George agreed to go provided that it was on terms 'which will produce the best results for the Commonwealth, and without which I am afraid the expedition, as far as my work is concerned, is doomed to failure of some sort'. What George meant, specifically, was this: that he should go to Gallipoli in January 1919 to make a preliminary survey, and then return 'at a more suitable time of year'; that he should afterwards return to Palestine to 'get sketches of the ground where the Australian troops carried out notable operations in the push for Damascus'; that the period allowed for the trips and the resulting work should be nine months; that he should produce a minimum of twenty-five colour pieces and only hand over a selection of his pencil sketches; that he should be paid £2 10s a day and advanced £50 for equipment as well as a month's pay as pre-embarkation credit; that he should be commissioned to do two large composition pictures for £500 each; and that he would postpone the completion of 'The Charge at Beersheba' until his Gallipoli work was finished. If these conditions sound

stringent, and perhaps a little money-grubbing, it is only because his suspicion of the army's bureaucracy was as great as his admiration for its soldiers' courage.

It is one of the saddest ironies of the First World War that the British, who are so deeply conscious of their own losses, sometimes fail properly to appreciate the sacrifices that certain allies made on their behalf. Australian and New Zealand casualties in the Anzac landings at Gallipoli – which were inflicted in a show of loyalty deriving more from Britain's colonial manipulation than their own well-reasoned responsibility – were massive. 'Gallipoli', to this day, remains to Australians and New Zealanders a word which triggers intense feelings of sorrow and anger, as well as pride. Every military historian of the period appreciated Gallipoli's immediate significance and its likely consequence, and none was more assiduous than Bean in assembling 'evidence and relics of the disastrous . . . [Anzac] expedition'. It was George's renowned fidelity to facts which made Bean consider him 'the obvious man to do the work' of recording the tragedy of the Australian contingent.

Once George had made up his mind to go, he 'rallied to the cause as though he had been especially honoured', despite his continuing disillusionment with the Commonwealth Government, and the likelihood that his malaria would recur. Bean realised that the commissions he could give George would be congenial: 'He liked to look upon his work,' he knew, 'as that of a soldier. He was free to paint whatever subjects he chose, but he greatly preferred to be given orders. If he received an instruction that a certain battlefield required to be painted, he would set to work as if it were a "minor operation". If the order were a written one, he was all the better satisfied.' Two of these 'written orders' resulted in two of George's most accomplished and moving large-scale works: 'The Landing of the Australian Forces at Gallipoli on 25 April 1915', and 'The Charge of the Light Horse at The Nek on 7 August 1915'.

George reached the Gallipoli peninsula on 15 February 1919. In her memoir, Amy makes no mention of his departure, and we know – once again – nothing about the leave he took of Thea. His journey out on the *Princess Ena* was safer than his voyage to Palestine the previous year (there were no submarines to fear), but it was none the less traumatic. Until he reached the Mediterranean, the weather was terrible – George 'was sick in one of the engineers' cabins', he told Amy, 'but fortunately the men seemed to regard it as an honour' – and the impending sense of grief that Gallipoli was bound to provoke began to weigh on his mind. Even the pleasures of Bean's company could not adequately compensate.

'Bean is very interesting,' George wrote, 'but he is not scientific . . . how can a man be scientific after seeing through the events of the last few years!' Nor could he enjoy the pleasures of the 'wonderful islands' he passed on the way. The mission did not have time to waste, and George's urgent commitment to his work meant that the breaks in his journey, at Taranto, Malta, Crete, Lemnos and Chanak, were not greeted as respites, but as opportunities to complete commemorative studies.

Bean kept copious notes of the Gallipoli mission, and in many of these George makes a distinguished appearance 'with the golden beard, the hat, the cloak, the spurs, the gait, the laugh and the conviviality of a cavalier': George was known by his colleagues as 'Ginger Ziff', on account of his beard and moustache. But as in Palestine, George never let his flamboyance interfere with the business of providing accurate accounts. During the first six weeks on the peninsula, he 'worked over almost every square yard of the ground held by the Australians, and the greater part of the forward Turkish positions', often accompanied by the mission's Turkish officer, Bey, and the official photographer, G. H. (later Sir Hubert) Wilkins, 'a splendid adventurous Australian, half knight errant, half philosopher, and wholly devoted to his country's cause'. George's sense of his own personality was always subject to his tasks as a war artist. 'There was no trace of affectation in the sincerity with which he set to his work,' Bean said. 'Whatever his other gods, when it came to painting, he was completely ruled by some high motive within, which governed him more absolutely than the King's Regulations. No desire to please would induce him to draw a line which would not satisfy his own high standard.'

The standards George set himself in Gallipoli were even more rigorous than those he had created in Palestine. The reason for this is one which indicates an important shift in his sensibility. Where he had previously been impressed by military dash and heroism, he was now all but overwhelmed by a sense of tragic futility. Although he was careful to preserve his jokiness ('The Turks here are a most murderous-looking lot, awfully like [a] Gilbert and Sullivan opera'), and to cultivate a role as a friend of the common man ('I appointed myself cook's orderly,' he boasted to Amy), he was also afflicted by an intense sense of loss.

He had ample opportunity to develop it: for the last two weeks of February, and for the first week in March, he inspected the area 'at a terrific pace', talking to survivors, and sketching the bleak, rock-strewn battlegrounds inland and others along the coast, usually in foully cold wet weather. In every case, the evidence of 'big deeds of heroism' is heavily

outweighed by 'damned melancholy'. Bean noticed that George was 'more sensitive than the rest of us to the tragedy – or at any rate the horror – of Anzac', and George's own notes repeatedly bear this out. Describing the no man's land between the Turkish and Anzac troops, for instance, in his first days after arriving, he wrote: 'At one place, only about thirty yards were between the opposing Jacko and us; a perfect rabbit warren and too ghastly to people with the image of fighting'; and again, when making preliminary sketches for the 'terrific sacrifice' of the Australian charge at the Nek, he noted, 'Descriptions are all too true; evidence grins coldly at us non-combatants and I feel thankful that I have been trained by circumstances of the past to stop my emotions at the borderline.' The war may have been over in fact, but his task of bringing it back to life was made painfully easy. The painting he eventually produced of The Nek is an eloquent witness to these feelings. Its restraint is not the evasive superficiality which had begun to afflict his work in London before the war, but a resonant tactfulness. At no point is pain or suffering relished to make a polemical point – instead, the sharply-observed forms of men among the low, scrubby hills are deployed to express vulnerability, as well as value.

George would never have been able to make his point so subtly had he not made such a fetish of accuracy. In order to recreate the precise circumstances of the charge – in which four lines of Australians advanced against Turkish machine gunners across a plateau dotted with boulders and gorse, to distract attention from a (failing) attack by New Zealand troops – he scrutinised the terrain with the same care he had used in preparing the sketches for 'The Landing'. He tirelessly researched the clothes, attitudes and looks of the Australians involved, departing from strict documentary accuracy only in two details: he gave some of the soldiers Australian bush hats rather than 'little round peaked caps', and he refused to show any with sleeves rolled up in case they should look like comic-book heroes. Bean remembered him even leaving camp 'while the rest slept, in order to study the place in the same light as that in which the charge was made'. George's notebooks contain a record of his interview with a survivor of the charge, Lieutenant Robinson, which testifies even more tellingly to his scrupulousness:

Time 4.30 a.m. Light – dim, flat, diffused, no top light from sky predominating. Stars just fading – sky soft lavender to grey. Equipment: helmets 60%, hats soft Australian 15%, caps 25%. Shirts khaki, sleeves either rolled up above elbow or cut out round armpit . . . dust caused by hand bombs, bullets, etc. Turkish

machine guns would be on their flanks and not visible from my point of view. Men fell back into trench.

This last remark (the gunfire was so intense that many soldiers got no further than the parapet) helps us to understand George's reasons for constructing the painting as he did. The furious activity of its foreground – soldiers falling, stooping and writhing into the air as bullets hit them – and the purple-pink calm of the mountainous distance, is not done simply to bring the action of the painting close to the viewer, but to make clear the pointlessness of the engagement. No sooner had the charge begun than it ended. Of the 300 Australian Light Horsemen who took part, only three reached the Turkish trench, and those three fell into it dead.

It was not until long after his return from Gallipoli that George was able to translate his preliminary work on 'The Nek' into the final painting. It was completed, after another prolonged financial wrangle with the government, in September 1924. But the impression that his researches left on him never abated; they profoundly affected the painting itself and the remainder of his war work, as the tone of his journal implies. 'Very cold, bleak and lonely,' one late passage runs:

The jackals, damn them, were chorusing their hate, the bones showed up white even in the faint dawn, and I felt rotten . . . The worst feature of this after-battle work is that the silent hills and valleys sit stern and unmoved, callous of the human, and busy only in growing bush and sliding earth to hide the scars left by the war-disease. Perhaps it is as well that we are pulling out tomorrow; this place gives me the blues, though it is very beautiful.

George left the peninsula on 9 March, making a final sketch at Helles Beach in the morning, then driving down to Kalid Bahr 'by tin Lizzie'. The next day he boarded a French boat for Constantinople. 'I cannot tell you,' he wrote to Amy, 'how pleased I am at getting clear of this graveyard.' George's journal shows him struggling to cheer up. On the boat 'there was a holiday feeling in the air,' he says, 'and I found myself singing in grand opera style to an accompaniment of raucous Lancashire Tommies'. But the remainder of George's journal, describing his journey from Gallipoli to Palestine to fulfil the second stage of his commission, never recovers the high spirits of the previous year. In Constantinople, where they arrived on 11 March, he found: 'Decay of architecture and decay of physiques are very noticeable . . . [the city] does not suggest venerable old age, but rather the remains of a grandiose and fleeting period of pomp and display too artificial to be permanent'; on the rail journey from Scutari to

Adana he complained, 'Crowding is the great trouble, a little loneliness seems priceless'; and as soon as he arrived at Aboussieh, he succumbed to a serious attack of dysentery and was put in hospital. His doctors diagnosed a recurrence of his malaria, and also warned him about his heart. George, who knew that his father had died of heart failure, took their counsel seriously.

Although Amy's account is at pains not to show it, George's second trip to Palestine brought to a crisis the melancholy which had always beset him from time to time in London, and which had become acute in Gallipoli. Weakened by illness and depressed by his recent experience, he brooded during his convalescence on the life that awaited him when his services as a war artist were no longer required. His obvious destination was England, but the prospect was hardly enticing. The 'usual bogey of insufficient means' haunted him and so did the thought of Thea's half-welcomed and half-resented role in his home life. Among the members of his family, only Constant – because he was away at school much of the time – did not seem a threat. Amy seemed in his mind's eye to be more a worrying responsibility than a loving support, and Maurice had yet to establish himself in a career. Amy was later to describe Maurice's dilemma in touchingly euphemistic terms:

[Maurice] was nearly eighteen years of age and had the good fortune to escape war-service. Not but what he would have, or thought he would have, regarded war-service as infinitely preferable to sticking things out at a school too small for him, and spending all his school holidays in some sort of morally enforced labour, either on a farm or in an office. Also, like all young men of his age, he had been mentally derailed by the war, and thoughts of his probable future had been limited to the hope of the war lasting long enough to enable him to enter the Flying Corps. And now a choice, for want of a better word, had to be made. He spent much time in solitary thought, walking miles in much confusion of mind, and finally brought home his conclusion: 'some form of art'.

George's sickbed response to this reveals his shortcomings as a father, and his disappointment with himself. It gives an unhindered view of the unhappiness he had always endeavoured to hide:

If the boy deliberately chooses Art as a career, it is not for me to stop him, even it be possible, and by the same reason I don't see the call on me to assist to go contrary to my advice. As an instructor – and I suppose I am one of the best – I am perfectly willing to give him a short course of training, and there it ends, and he plunges or drifts. As long as he realises that it really is an abyss.

The 'abyss', as George's other letters to Amy written at the same time imply, was the burden of caring for others, and the bitterness of always falling short of self-imposed high standards. The career upon which George had embarked when he left Australia, and which he now saw Maurice undertaking, was one which he felt had condemned him to the pursuit of a goal he could never realise.

For the first time – in writing, at least – George began to think that a return to Australia might allow him to resume his peacetime career with better chances of success than England could offer him. 'I have had quite a stomachful of set-backs, beginning at the age of eleven or thereabouts,' he told Amy, 'and I am determined to look a little after myself; try and find out if I have a self and what it really requires – if it really requires the grass-lands of Australia, the horses and other animals, I hope I shall realise it before I pass out.' If George admitted to himself that this possibility would involve the break-up of his family and great unhappiness for Amy, he never acknowledged it openly. The nearest he came to self-criticism was the admission: 'I am as much frightened of myself and the beastly family in me, the breed that goes stubborn and unforgiving, as I am of what [Maurice] may do that is stupid.'

It was not only the quality of his previous work, and the future of his life with Amy and the children, that came under George's scrutiny in hospital. He also asked himself whether he might not try his hand at something other than painting. Even before the war ended, governments of all the countries involved had begun to plan what memorials they should erect. While still in hospital, George heard that tenders had been invited for a commemorative sculpture to be built at Port Said, and he immediately wrote to sculptor friends to ask their advice about the feasibility of casting a group of men and horses he had drawn. With his usual pride and apparent self-confidence, he discounted his lack of previous experience:

People imagine that one must be a sculptor from the first to be able to do it. To do it like the greatest, yes; but to do it excellently well and get close to Nature, and even supply one's own thought is a matter of drawing. So much for that. If I get the job I can do it. I feel I am the man to do it; only real horses and men will do, and it wouldn't be a bad wind-up with my pictures and all.

George did not hear until much later that his tender had been rejected – not because of the quality of its design, but because its knotted huddle of men and horses would have been prohibitively expensive to cast. In the short term, he told Amy, it 'kept me from going off my chump' in hospital.

Only after he had been there for five weeks could his doctors safely say his 'number' was no longer 'up for the eternity stakes'.

As the AIF in Cairo began to demobilise, George set off in early June for Senakh on the southern shore of the Sea of Galilee, to finish his commissions. From there he travelled the six miles to Tiberias to paint 'the Bedouin reaping their corn all along the flat country of the Jordan Valley or Plain, and Ruth and Boaz . . . scattered all over the landscape, also donkeys, Arab horses and camels', then travelled north of Galilee to cross the Jordan. His pleasure in the 'really lovely – wonderful subjects' increased as his departure for England came closer. 'I may yet live,' he wrote to Amy, only half joking, 'to show you how to drive tacks into linoleum, but it must be my shack in the bush!'

The same mixture of anxiety and excitement is contained in George's letters from Damascus, which he reached in mid-June, and from Cairo, where he returned a month later via Kantara Amman, Es Salt and Moascar. The thought of seeing 'my dear wife and twice mother' gave him – when he could detach her from her associated responsibilities – an occasional sense of the loneliness she had endured for the previous year. 'You will be glad to know,' he told her in a rare moment of thoughtfulness,

that there is nothing hereditary about my cardiac trouble. It was brought about purely by over-athleticism, not by drink or tobacco, but the latter has decidedly increased the trouble. The real reason for the collapse, now almost forgotten, was the Gallipoli tour: too strenuous after what I had been through. However, no more about myself. I am looking forward to nursing *you* a bit, down in Cornwall or some country place, when I return. I am still a bit regretful that I should have increased your worries by over-anxious clucking over the chick.

George enclosed a letter for his 'chick':

Dear Maurice,

I am very glad to learn that you are taking things seriously. You must not be discouraged because I do not altogether swallow your choice of a profession. Seldom are father and son in agreement on this question; but acting on the memory of my own rather pathetic lack of sympathy and support from my own people, I do not wish to obstruct, but only to help.

When I return we can go into the matter in a careful and friendly way, and find out if there is a way to help you, and a way to help your mother and myself to get some satisfaction in watching your progress. It is most satisfactory to learn that you are keeping steady; that is an asset in itself which the employer, namely, the world, gives big money to hire, and gives to the owner of the asset more

satisfaction in later life than the gobbling up quickly of the adventures of life.

It is impossible to separate George's concern for Maurice's welfare from his own guilty worries about money. In Cairo, in mid-July, in 'one of the hottest places on earth [with] the sweat simply streaming out of me', he wrote back to England to haggle over prices and studio spaces as if the pleasures and rewards of his war work had never existed. Would the City of Leeds Training College pay £350, not £250, for a portrait of its principal? Would Amy be able to find a 'place of sorts, no matter how makeshift' outside London where he could work? Would the War Records Office, as it had done before, involve him in muddles once he left Egypt? Would the damage done to his health prevent him from finishing the war work, as well as undertaking new commissions? 'The worst is over,' he told Amy on 7 July from Marseilles, on his way home, 'and I feel that I shall arrive in good trim, possibly four or five days after you receive this.' But it was a forlorn boast. George's subsequent few months in England were among the most miserable he ever had to endure.

The difficulties which faced George when he returned to London had not been created by the war but exacerbated by it. The time that he had spent away from home had given him the chance to assess his family and his work with detachment, and by setting a precedent of separation, they had made more likely a decisive solution to his problems. To say this implies that the war did him nothing but harm: it nearly killed him, twice, and its consequences for his family and himself were violently disruptive. But it would be wrong to deny the pleasures and achievements of his time as a war artist. George's rapport with his fellow soldiers was excellent. He responded to their 'masculine' athleticism with a warmth which shows genuine enjoyment, as well as a wish to submerge the more complicated feelings aroused by his family. One of his colleagues in Palestine revealingly described him as

a shaggy fellow with a jutting yellow beard and ultra-virile affectations . . . An artist among soldiers (even an artist in uniform) is an odd sight, but Lambert's manly bluster carries him along quite easily. Like most painters, he has a remarkable freedom of wit, even if he rather overdoes the part of the rude Australian. He has a lot to say about wild animals, and also about the art of boxing.

Another colleague said:

I never saw him otherwise than cheery, ready to help along sore hearts and weary bodies with some joke or story, ready to share his haversack and flask with

anybody, in fact always exhibiting that keen insight into the nature of those with whom he came into contact that rendered his work from a layman's point of view merely the practical expression of his own mind.

Later judges of his work – laymen and otherwise – commented on the same quality. Once away from England, George's obsession with the grand manner of the Old Masters deserted him. His sense of the immediate importance of his subjects, and the speed with which he had to work, burnt away the constraints of his revivalist manner. As the Australian art historian Bernard Smith has memorably said, George's war sketches have 'the impersonality and brevity of a good military despatch'. George himself, in every account of his adventures, underlines their transforming effect. 'I saw subject crowd on subject,' he told Amy. 'Patrols, packhorses with ammunition, naked Light Horsemen swimming horses across the river, a feast of movement, a feast of colour, and the backgrounds the most refined imaginable . . . Even if I had been inclined to slack myself, the example of the men who never tired forced me to be up early and paint and draw all day.'

In his large-scale works the same qualities, and the same reasons for their existence, are even more obvious. These works are not only reliable documentary accounts, but celebrations of the qualities he commented on so frequently in his letters: personal bravery, the community spirit, emotional discipline, rugged fitness and self-effacing obedience. Although George's admiration for these things was communicated in his paintings with a pristine detachment, it was nourished by a highly personal process of identification. Two years after he left Egypt, he admitted that 'to live again among my fellow-countrymen, among Australian horses in open spaces, in a clear atmosphere of bright sunlight, gave the illusion that I was back on the plains of New South Wales'. For this reason alone it is proper to think of George's war work as authentically Australian.

The more insistently George espouses 'masculine' virtues, the more we wonder whether he achieved them as absolutely as he would like us to think. He protests too much – not because he secretly did not admire them at all, but because he was uncertain about his ability to display them himself, and because he realised that most soldiers have to overcome weak, fearful or simply sensitive elements in their natures. In his war work, this understanding is registered as a profound imaginative rapport, but in a few paintings it blossoms into something akin to erotic tenderness. 'A Sergeant of the Light Horse' is a case in point. The painting

was one of the last of his war commissions to be completed – in Sydney in April 1925 – and took as its model an ex-student of Ashton's, T. H. Ivers, who was introduced to George by Bean. Silhouetted against a brilliant cloud-dotted sky and a ridge of scrubby, sandy hills, Ivers's lean and feminine face glances away from us with an expression of fastidious delicacy. With his jacket off, his forearms bare, his elegant slender neck, and his plumed hat in his long-fingered hands, he looks absolutely unlike the received notion of a hard-bitten, bull-necked cavalry man. He is, in fact, a masterpiece of camp.

'A Sergeant of the Light Horse' is among the best known of George's war works – it hangs in the National Gallery of Victoria, and is virtually an Australian national monument: it has even been used as the image on a stamp – and the one which most graphically explains the reasons for his pleasure and success in the Holy Land and Gallipoli. The war simultaneously licensed and controlled his strongest feelings. It stimulated intense visual excitement; it absolved him from emotional, professional and financial complications; and it reunited him with Australia. But while the value of these things is obvious, it is impossible not to relate them to the cold-heartedness which had marked much of his life and work in England. The qualities which made George a difficult husband, a poor father, and a reserved friend to Thea are precisely the same as those which made him a war artist of such exceptional ability. When his boat eventually reached London, he had already understood – in spite of occasional protestations to the contrary – that he could not remain with Amy for long.

Five

No sooner had George reached London, in the spring of 1920, than he began making excuses to leave for Australia. He did not need to persuade himself of the wisdom of this move – his experiences during the war made him feel that for his own and for his art's sake he had no option. He did, however, have the obstacle of Amy's impending loneliness to overcome. Her pleasure in seeing him, after an interval in which his happiness had excluded her and his ill-health had worried her, was greeted with aloof disdain in her presence, and a guiltily creeping affection in her absence. Even a short holiday they took together in Suffolk was spent 'preparing for my departure'.

George protected himself from Amy's hurt by treating her with a reserve which he hoped would make her almost pleased to see him go. To his relief, though he could not show it, circumstances colluded with his wish to be dissatisfied. His former life in Chelsea society had been irreparably damaged by the war. Friends had been killed or detained abroad, and those who had returned could no longer enjoy their careless raffishness. 'The old time spirit of the Club had gone,' he felt. 'A subtle feeling of sadness now reigned where wit and fun were common in the gin-and-bitters hour.' Furthermore, the time available for his existing commissions was curtailed by invitations to produce more war work. In August the Officers' Mess of the 14th King's Hussars prevailed on him to paint a commemorative picture of the surrender of Kazimain, for which he had to make several fact-finding visits to the regiment's barracks at Tidworth; and the following month one of the Hussars' senior officers, Major Mocatta, arranged for his mother to sit for George. These requests allowed George to complain that his work was prey to distractions, and he was able, too, to say with a clear conscience that he did not have a studio large enough to continue working properly. Glebe Place, crowded with his family, was obviously unsuitable, so he rented a 'large, gloomy place in Warwick Road, Kensington, one time the property of Byam Shaw'. It was no more than a stop-gap. He moved in the 'souvenirs of foreign travel' he needed as props, persuaded an Italian model, Luigi di Luca, to pose for him, and enlisted the help of his son Maurice. Since Maurice was now training as an art student, he was happy to perform instructive menial tasks – squaring up and transferring sketches, and even modelling. One day, which Maurice spent prone as a dead Turk, he told

his mother: 'I feel almost as if I had landed at Gallipoli myself, only that I have also defended it.'

The studio was completely unsuited to George's need to recreate *plein air* effects. With mounting irritation, he cast around again for a more satisfactory solution. The place he chose turned out to be no better than its predecessor. One of his Arts Club cronies, Algernon Talmage – an R.A. who worked in the High Commissioner's office on the National War Records Committee – had taken a house at Bossiney near Tintagel in Cornwall to work in, and in May 1920 he invited George to stay. The place allowed George space to work on 'The Landing' and 'The Charge at Beersheba', and at least the possibility of the bright sun and open air that he demanded to revive his memories of Gallipoli and Palestine. For most of the time he was there, though, it poured with rain. His letters to Amy made the most of his bad luck: 'Tonight it howls and rains forty cats to the dozen – there can't be much left above'; and again, 'I am having a bad time chiefly due to the weather'; and yet again, 'Weather here still damnable and painting very difficult.' The complaints came thick and fast all summer, and they obviously register a genuine frustration. But they also, not quite so obviously, constitute another way of legitimising his plans to leave England. Although George's letters contain occasional moments of tenderness – he confessed to feeling 'a slump at the thought of leaving you' – and intermittently admit to hoping 'that you will either follow quickly or I shall come back quickly', they never deviate for long from his wish to leave for Australia alone. Uncertainties about Maurice's career are repeatedly pointed out as reasons for Amy staying in England, and the need 'to get good light, to get as models the true type of Digger who fought in the east' are continually urged as reasons for his going.

When, after three months in Cornwall, George returned to London – ostensibly to continue work on his major commissions, and to repair minor damage done to his model for the Port Said memorial after its passage from Cairo – he pulled every available string in order to arrange the earliest possible concessionary passage to Australia. When one was booked, in November, he hurriedly abandoned his Warwick Road studio, and began to close down his life in England. As if to rub salt into the wound of Amy's distress, he spent his last few days in England painting a self-portrait – ' A Souvenir of the Light Horse' – which clearly yearns for the recent past he had enjoyed without her.

In her memoir, Amy remains silent about George's departure, but the final sentence of her description of his last few days is powerfully expressive. George, normally so ambitious to see the fruits of his labours,

could not be bothered to inspect 'A Souvenir of the Light Horse' hanging in the exhibition to which he submitted it: 'The date of the private view,' she says, 'was the day after he sailed for Australia.' We know nothing about his farewell to Thea, and nothing about the plans they made for their future.

Even allowing for the justice of George's complaints about the English climate, and even supposing that Maurice and Constant could not have been left behind (or taken to Australia), his treatment of Amy cannot help seeming selfish. In his letters to her he consistently puts himself before others, disguises his heartfelt wishes as practical requirements, and holds out the promise of an eventual reunion which he apparently had no coherent thought of fulfilling. His treatment of Amy, in fact, shows all the signs of emotional cowardice. The actual circumstances of his time in London shortly before the war and the implications of his happiness in Palestine all point to the likelihood of his eventual separation from her, but at no point did he bring himself to confront and discuss this openly. Instead, he encouraged a situation to develop in which he could slide away from her protesting that it was a temporary measure which would improve his reputation and his income, and so lead to their eventual mutual advantage. More accurately, it was the latest and most decisive instance of his inability to deal with the complex consequences of his own actions.

As so often before, George found himself able to show strong feeling only when he was removed from the circumstances which had prompted it. While his boat – the s s *Mantua*, P & O Line – made its slow way to Australia, he bombarded Amy with letters which professed affection and the hope that she would soon join him. On 16 February 1921 from Port Said, for instance: 'It seems so strange to me that after the many separations I still have the feeling that it is hard luck. But fortunately I realise that what's got to be cannot be shirked, and the hope eternal – though worked pretty hard – can still be called on.' Again and again, at the same time as he reports his pleasure in ship-board singing and dancing, he casts himself in the role of the heroic exile, determinedly undergoing suffering in order to create the conditions for a better life.

It may be useful when I say that we decided for the best when we decided that this was 'a man's job'; for despite the extreme loneliness I wouldn't like to see you again being buffeted about as you have been for so long and I only hope that the future holds a chance for me to get a fairly soft cushion for you to rest on while I hold your handy.

This last remark, which aims at cosiness, sounds mawkishly sentimental. It is a tone which continues to appear in his letters once he reached Melbourne in April. In the last few years he had done little that was openly affectionate for his family, but he now became blusteringly anxious about their affairs. 'I hope the boys are well,' he wrote just before landing, 'and that Maurice is fast becoming a reliable sculptor, if not a worthy son, perhaps both.' (In fact Maurice, now aged nineteen, was at the end of his first year as a student of art at the Chelsea Polytechnic, and had recently been taken on as an assistant by Francis Derwent-Wood, the Professor of Sculpture at South Kensington Royal College of Art, so he was safely set up. Constant, only fifteen years old, engaged his father's interest less profoundly by provoking fewer worries – for the time being, at least.) Amy, whose loyalty to George remained unflinching throughout her life, is understandably keen to preface her account of his arrival in Melbourne with signs of his continuing care for the family. But by the time 'the sight of the Australian coast and the shore-lights of Fremantle thrilled him with a sense of his homeland' he had safely confined his feelings to expressions of testy concern. His mind was free to concentrate on his welcome.

After a London career in which he felt his achievements had been insufficiently rewarded, and a war service in which support from the military establishment had seemed inadequate, George now found himself unambiguously honoured. The country he had left twenty years before had done little during the intervening period to lose its sense of isolation from the social and artistic capitals of Europe, and greeted him as a hero. He had met the famous names that most Australians had only read about, and his naturally flamboyant spirits were fanned to a new assertiveness. He installed himself amidst old-world comforts in Scott's Hotel, Melbourne, and held court. 'Streeton, George Coates and George Bell have come along and made me welcome; Major Treloar (War Records) most obliging and courteous and repaying my passage,' he told Amy. Politicians, writers and artists of all descriptions sought him out for his stories, and he renewed contact, too, with friends like the Ryries and the Pitt-Riverses (whom he had known in London, and who had occasionally crossed his path in the war) and Nellie Melba, finding time to send her an invitation 'between an avalanche of acclamation for the great Lambert and a mountain of correspondence and responsibility'. The remark is much more of a boast than a complaint. Although George had always had high hopes of his return, he had hardly anticipated his immediate social pre-eminence. Similarly rapturous acclaim was given to

his work. His first-hand knowledge of European artistic traditions gave him the status of a guru. George's reaction to the most recent and experimental of those traditions had, of course, been less than wholly sympathetic – but the fact that he had encountered them at all made him seem modern by association. Anyone thinking at all carefully about the self-portrait he painted soon after arriving would have immediately doubted his claims to seem 'modern'. It is a work of extraordinary self-admiration. Dressed in a velvet robe, his now almost completely bald head bare, George poses against a black background with one hand on his hips and the other dramatically raised with its fingers spread. On a level with his groin, and pointing in a spray towards him, is a bunch of gladioli. It is a preposterously theatrical image of the artist as potent creator.

George's first opportunity to measure accurately the reverence which was suddenly shown him came within a month of his arrival. The Melbourne Fine Art Society organised a one man show, which was opened on 11 May. It contained a large amount of recent war work, as well as earlier pieces from England – including 'Important People' – and was a dazzling success. For one portrait, 'The Fair Lady', he asked and got £600, and the Melbourne Gallery itself bought another two portraits – a pencil drawing, and a sketch for 'The Surrender of Khazimain'. On the afternoon of the opening George threw an extravagant party, filling, the local paper said, 'great bowls . . . most artistically with the loveliest of autumn blooms' and arranging for a string quartet to play. It set a standard of style and theatricality which he maintained for the rest of his life.

The reception flattered George's sense of himself, but it did not stop him from working for long. 'Everybody [here] seems to think my mission in life [is] to sit back and talk old memories and pat old friends on the back,' he told Amy. 'I don't sit back, I work. I go forward.' The first significant work that he produced in Australia, 'Weighing the Fleece', gives this last sentence the lie. He worked unwaveringly hard throughout his time in Australia, but as far as the techniques and subjects of his paintings were concerned, he edged backwards from the expressive freedom of his war work, rather than 'going forward'. While still based in Melbourne, he went to stay on a nearby sheep station with some friends, the Lee Falkeners, to collect details for 'Weighing the Fleece'. Then, in eight days, he produced what he called 'a masterpiece of small portrait grouping': five figures and two sheep under a timber roof, the figures watching a sixth weigh a huge creamy bundle of wool. In subject and treatment the painting is strongly reminiscent of Tom Roberts's 'Shearing

the Rams' (1888–90), which was already regarded as a classic image of Australian bush life – with the difference that the figures in Roberts's picture are equally and sympathetically involved in their task, whereas in George's they are painted with steadily decreasing clarity as they descend the social scale. If this, combined with the inflexibly traditional manner of the work, did not alert us to its reactionary spirit, one other ingredient could hardly fail to make the point. In the left foreground, seated on a woolsack, the landowner's wife stares proudly at the suspended fleece. What she seems not to realise is that within the world of the painting she is as much a property as the wool. She has been brought along to the weighing not to share her husband's responsibility but to emphasise his power as an owner – her loose wool coat is even similar in tone to the brown of the unshorn sheep in the right foreground. The painting has no qualms about this; there is no irony to point up her passivity, simply an implied collusion by George with the social structure he perceived. It expresses an attitude which leads us to feel that his much-vaunted sorrow at leaving Amy was not accompanied by any decision to revise the submissive role that he had designed for her.

Thea, lacking the burden of a family, and the static bind of being called wife, could not be so easily subjugated. Although George had often claimed to be irritated by her in London, and had not used her regularly as a model for some time, he had done nothing to shake her off as he had done Amy. In mid-June, by which time he could rest assured that his reputation in Melbourne was firmly established, he moved to Sydney and found Thea waiting. The reasons why she left England are self-evident: she loved him, and she shared his belief that a career which had been only moderately successful in London might flourish in Australia. Her hopes, eventually, were more fully realised than George's. In the thirty years that she lived, taught and worked in Sydney after his death, her reputation slowly emerged from his shadow. Her ability to 'see the subject in terms of design' allowed her to discover a more fluid line in her portraits and coloured woodblocks than any that can be discerned in George's late paintings, and the modernist artists and critics who condemned him to obscurity after his death were more tolerant of her work.

Whether or not Thea and George actually made a plan to meet in Sydney is impossible to establish. They certainly did nothing as un-ambiguous as share a house together. Thea took an apartment in George Street, while George stayed in a series of hotels. As at other times in their lives, they left virtually no trace of their joint intentions and activities. Yet until George's death, Thea played the role of regular companion to him.

Amy made no articulate objection to this – in fact her memoir makes no reference to it at all. During and after the war Amy had come to realise that for her the usual kinds of marital intimacy were impossible, but she clung loyally to the notion of a companionable co-existence. Now even this hope was overturned. In Glebe Place, struggling to care for her children by supplementing the money George sent her with the small income she occasionally made from taking in lodgers, she resigned herself to a drab and pinched life, enlivened only – and it was a mixed blessing – by news of her husband's successes thousands of miles away.

Sydney greeted George as warmly as Melbourne had done. In late June he was given an official dinner by the Society of Artists, which twenty years before had funded his scholarship to Europe. Even the menu was designed to honour him: 'The Mask Cocktail', 'Salade Lambertienne', 'Important Peaches', 'Café Chelsea'. In London his society had been almost entirely artistic, in Sydney it was patrician. For the first few weeks of his stay – with the Allens in their elegant town house first, then at the Union Club, then at the resplendent Cliveden Mansions – he was exhaustingly wined and dined by members of the government, wealthy landowners, War Records officials, his old teacher Ashton, and his relatives the Joses. It was, he told Amy, 'tremendous, tremendous, tremendous'. As in Melbourne, he revelled in these flatteries for their own sociable sake, and because they introduced him to likely patrons for portraits. They also provided him with a platform from which he could proselytise about art. With Thea to support him – he called her 'the second finest draughtsman in Australia' – he soon became increasingly dogmatic, condemning Australian insularity, advancing the virtues of craft, and reviling the modernists

who offer you a circle, two triangles and a smudge as 'A Portrait of a Cabaret Singer Emerging Smiling from a Taxi' . . . The trouble is that they are not content to put the thing forward as a decoration; they insist on giving it a title and meaning, and answer all criticism by alleging that failure to see that meaning is the result of lack of vision . . . That way madness lies.

This kind of judgement – and the many interviews which George gave in the months following his arrival are littered with others like it – now seems unattractively and woodenly dismissive. But while accurately representing George's opinions, it also strikes a hectic note which alerts us to a strain that he would not admit openly. Enjoyable as it undoubtedly was, George's 'jazzing' and party-going threatened his already poor health. The weariness this produced – having endlessly to maintain the

appearance of a *bon viveur* – was exacerbated by more familiar worries. He could not find a suitable studio, he missed Chelsea society, he was behind with his war commissions, and his plasticine model for the Port Said memorial was 'practically destroyed' in transit from England and had to be entirely remodelled. He also missed Amy. Early in 1922 he responded to her complaints about her own loneliness by saying,

I don't mind you cursing the situation so that you understand. By understand I mean the sympathy and understanding of my difficulties of being out here generally though even you dear thing never will be able to understand the difficulties of my work. Why should you? . . . the last few days I have been practically paralysed with the everlasting thought of your welfare and that of the boys. Result stoppage of output and therefore bad for you as well as myself. If I could only be an artist reckless and irresponsible. The sort of creature that everyone when they meet me thinks I am . . . I would if I could ask all the busybodies and the well-wishers and those who are foolish enough to love me to mark me down as a mental and moral failure; then what little I have of merit would look quite creditable on a clean slate.

This letter is typical of his tone throughout the first year of his separation from Amy: painfully self-conscious and self-contradictory. Vanity jostles with humility, and selfishness with generosity. George invariably struggled to resolve these conflicts in his own favour by expelling Amy from his conscience. As month followed month, his letters gradually suppressed his finer feelings. In February 1922: 'I find if I give way to longings everything here goes sour and I lose my dash'; in March, 'I know you will understand when I say that sometimes the thought of writing to you gives me a kick in the heart so I put it off'; and by the same month the following year,

I certainly can say that I conform to the public's description of a genius in that I live for my work. But I find it is fatal to dwell for more than a few minutes upon the subject of our enforced separation [enforced, that is, by his insistence that the boys – now aged twenty-one and sixteen – needed her daily supervision] . . . So much can a man do and think but beyond is madness and I do think it is vulgar to go off one's chump. It isn't done.

These hardenings of George's heart are interspersed with promises that Amy might soon join him or that he might return to England, but none of his blandishments ring true. As his society in Australia became more established, and his work more admired, his determination to remain in Australia alone became more fixed.

Two things, in particular, made him decide to stay. One was the rekindling of his love for the bush. General Sir Granville Ryrie, who had been involved with the Official War Artists' Commission, invited him out to his family's sheep station, Michalago, in 'the Monaro country' outside Sydney almost as soon as George reached the city. The country gave George a greater sense of belonging than any he had experienced since boyhood, even though the comforts of the place were a far cry from the rugged makeshift conditions he had known at Eurobla in the 1890s. He returned to Michalago very regularly until the Ryries returned to London in the late 1920s, and every subsequent visit confirmed the impressions of this first one:

bulls, stallions, rams, rolling country, snow-capped mountains, horses to ride, Palestine to fight again, mosquitoes, flies, running rivers, silence of the mornings before the sun brings the call to life and strife, the soft notes of birds, their voices muted as if in reverence to the mystery of Australia, or is it that I read all this and more into the land and sky which, truly, like a mistress beautiful but cunning, has got hold of me, and barring moments now and then, still hurts my nerves with callousness and lack of purpose or ideals. Should ever come the chance to show a just retaliation I'll paint her, drab but powerful and, when the storm of indignation bursts, leave her.

He even went so far as to celebrate the place in a poem which, like the others he wrote, is studiously unimaginative, and stiff with reactionary romanticism. It begins:

> The sun is down and 'Michalago' is at rest
> Like Chinese silk of faded gold, the grass
> And all the hills like breasts of turtle-doves.
> A prehistoric silence holds the land
> Where black men speared the first white pioneers.
>
> And, shuffling quietly, our horses walk
> The track that leads us to the twinkling light
> Where, 'neath the giant poplars close and dark,
> Surrounded well with flower-garden quaint
> And rough-hewn old-time timbered offices,
> With old-world dignity the Homestead stands
> A perfect monument of well-earned peace,
> A symbol of a sound prosperity.

George neither looked for nor received any honour for his poems. But

the second and equally crucial reason why he decided to stay in Australia stemmed entirely from the honour he coveted above all others. In November 1922 he received news from England that he had been made an Associate of the Royal Academy. To several of his friends this seemed long overdue – one of them wrote that 'even artists had failed to appreciate the skill of the painter under his cloak donned for self-defence' – but the fact remained that no other Australian painter had been so rewarded, and George was delighted. (The Australian sculptor Bertram Mackennel was promoted to RA in the same election.) Although the distinction had been conferred by the country he had recently abandoned, it enormously enhanced his reputation in Australia, and therefore increased his chances of getting profitable work. 'I now know,' he told Amy, 'so many people, have so much to do, and the awful loneliness is intermittent and negligible.' By crowing about his celebrity ('I am acclaimed – I am known'), George meant to reassure her that his stability was guaranteed, and that the money he could send her would be adequate. Not surprisingly, he also excited her hopes of his return, and prompted her to ply him with questions which made him squirmingly imply that it was now impossible. 'Dealing briefly with the apparently all-important business of my return,' he wrote, 'to protect myself, my sanity and general well-being upon which I suppose depends yours to a large extent I can only say after much dodging and screwing myself up to the pitch – I don't know – I don't know!'

But he did know, of course, perfectly well. Becoming an ARA had intensified still further the almost idolatrous respect he had been shown on his arrival in Australia, and had immediately encouraged him to develop what he considered an appropriate public persona. Even before news of his election broke he had organised a 'Persian Gardens Tableau' at the Theatre Royal, Sydney, directing the performance and designing the scenery. Throughout the rest of this and the following year he carried the same high spirits into all corners of his life. As in Chelsea, he made a point of scandalising polite society with an aggressive stylishness – dressing up in formal morning clothes for his early meetings, riding in Centennial Park in the full fig, regularly making himself conspicuous at the opera in white tie, tails and shot silk cape, and assiduously grooming and pointing his beard (which he knew connoted raffishness).

His extravagant stylishness became legendary. On one occasion, meeting Melba in Bond Street, Sydney, 'he gave a Beau Brummel bow' and swept his hat off. 'That'll do, Ginger,' Melba told him. His niece Dulcie, who had travelled out from England to Australia in 1914,

remembers him living in a whirl of glamorous popularity, and other friends testify that he took as much trouble to seem sensational in his conversation as he did in his appearance. The sculptor Arthur Murch (who was not to meet and work with him until 1926) recalls the procedure: 'If he went out to a luncheon or dinner he would prepare his jokes. He might recite three or four jokes . . . in different ways and ask in which way we thought he should tell them. After several renderings we would vote for the one we thought best.' Another colleague, Edmund Harvey, describes a typical result: 'Once he and Thea Proctor were walking in Coogee when they passed two girls, one of whom, seeing the unaccustomed beard, nudged the other and said something about Daddy Christmas. Lambert promptly raised his hat and said, "Yes my dear, I see your stockings are well filled."'

George's efforts to *épater les bourgeois* in social terms were paralleled by his professional pronouncements. Once he was settled in Sydney, he was co-opted by Julian Ashton to appear at the art school as guest instructor, and this allowed him publicly to extol the virtues of craft and dexterity, and 'to preach and practise a gospel of drawing'. On a number of occasions he gave demonstration classes, making sure that he created an impression of almost priestly devotion. 'Except for a word or two of direction to the model, [he] painted in silence . . . Even the lighting of the endless chain of cheroots and pipes and cigarettes seemed subconscious with him, so completely was he held by the spell of the work.' When these well-disciplined displays seemed insufficient, George reinforced their effect by more direct (and disagreeable) means: he once crept up to Elioth Gruner who was scrupulously eking out a tube of particularly expensive paint, and squeezed it over Gruner's palette, telling him, 'Don't be scared.' Another time, he handed out even more brutal instruction during a class at the art school to the young Henry Gibbons, who occasionally worked as his assistant. Another student remembers:

Gibbons was painting a small still life. Lambert came up behind him and commented, 'Not bad, Gibbons. Not bad at all.' Gibbons unwisely replied, 'Yes, Mr Lambert, I think it must have been a fluke.' At that Lambert stiffened, took a palette knife and a rag, and scraped slowly across the picture, wiping off the paint. Then he turned to an ashen Gibbons and said, 'Gibbons, no accidents here. Do it again.'

However unappealing they might be, such stories at least bear witness to George's commitment to his art. But his overriding wish – to become an authentically Australian painter by painting the bush – suffered badly

from the distractions his fame brought him. It was damaged, too, by the portrait commissions he accepted to guarantee his income, and by the requirements to finish overdue war work. A short while after landing in Sydney, he told Treloar: 'I have passed through a somewhat trying time since my arrival [in Australia] and the thought of all my work for your museum lying in arrears has been a very disturbing element.' By the following year, his guilt had become acute; he was, he said, 'loath to dodge the shackles you dangle as a decoration', and as time passed, his guilt itself became a destructive burden. In 1924, five large commissions, including 'The Battle of Romani', were still unfinished, and as late as 1926 the official historian of Victoria Barracks, Sydney, reported: 'It is clear that he cannot do them all. He is fairly advanced with "Romani", but had forgotten the names of the others.' Three major works were still outstanding at his death.

The War Artists' Commissioners were partly to blame for this delay. For one thing, they regularly made additions to George's already long list of commissions, and for another they became annoyingly agitated about the loan of equipment he needed as props. George soon came to think that silence was the best response, prompting a store manager to complain that 'Mr Lambert is a most difficult bird to do business with as he takes no notice of letters addressed to him.' These concerns, pressing on a personality which prided itself on hard work, demoralised him, and since Australia had done nothing to repair his health, it was not long before he began to show the strain, as well as to feel it. The celebrations which followed his appointment as an ARA 'gave me,' he said, 'a delightful holiday in hospital', and a few months later, as he struggled to complete 'The Nek', he again had to endure 'a rather trying convalescence after a "cure" necessitated by being somewhat played out and overworked'. On both these occasions, and subsequently, George made light of his illness, hoping to pass it off as a predictable consequence of high living and extreme artistic diligence. But its cause was in truth perfectly simple: the malaria that he had contracted in Palestine recurred at regular intervals, and relentlessly drained his health as well as his spirits.

Six

At the same time as the War Artists' Commissioners weighed George down with new obligations, they failed to help him discover the best means of completing them. Since arriving in Sydney he had worked at whichever temporary address he happened to occupy, hoping that the Commissioners might provide him with an adequate permanent studio. They suggested various possibilities and he rejected them all – usually on the grounds of poor light, inaccessibility, or lack of space. But he had another and less obvious motive. The work that he had done in Cairo preparing a model for the Port Said Memorial had convinced him that he had natural and neglected abilities as a sculptor. Developing this gift would, he thought, confirm his sense of himself as a man capable of anything. He felt sure – he was wrong – that his talents as a draughtsman were a guarantee of sound construction, and deserved to be extended into another medium. Egged on by letters from Maurice, he also believed that sculpture would give him a sensuous involvement with his materials which paint could no longer provide.

There lurks behind this feeling a rare but fascinating suggestion of self-criticism. George had obviously gone out to Australia hoping not just for fame, but for a rush of new energy to enter his work. Apart from his remaining war commissions, however, his paintings continued to show the same slow wasting that had begun in London; his brush is persistently thinly loaded, and cursory in its treatment of warm tones. George recognised these deficiencies more clearly than he ever admitted and hoped that he could compensate for them by turning to sculpture. He wanted not simply to extend his range, but to reinvent himself.

The studio George was eventually offered, free, in a letter he received from Major Treloar of the War Records Office on 25 July 1923, suited him better than anywhere in England or Australia that he had previously known. During the war, the Prince of Wales Hospital at Randwick, in east Sydney, had been commandeered by the army to house war casualties, and as their numbers decreased with the passing of time, so space became vacant. George was invited to take over Ward K, went to examine it in August, pronounced that it 'did excellently well', and moved there in October. Ward K was a simple bare room, 50 feet by 40 feet, 18 feet high, and self-contained within the confines of the rambling Victorian hospital. George curtained off a section to serve as a bedroom (though he

frequently spent his nights in the Union Club, or the Coogee Bay Hotel), and filled the remainder with the tools of his trades – paints, clays, and a jumble of the uniforms and tack he needed to complete his commissions. It was not only the luxury of ample room that made Randwick appeal to him. It also allowed him to play the role of Old Master that Australia had thrust upon him. He used the studio as a base for excursions into Sydney on which he would play the role of 'artist' for all he was worth – striding through the city in billowing coats, stick in hand, and appearing at concerts and fashionable parties in immaculate evening dress. In Randwick itself, he ran what he called his 'shop' – his studio – as if he were a latter-day Tintoretto, keeping strict hours (8.30 a.m. to 5 p.m., with an hour off for lunch), and quickly hiring three young assistants who were pleased to think of him as their *éminence grise*.

The first of the three to join George was a young Swede, Sten Snekker, who arrived in Australia early in 1924 with £50 in his pocket and a strong but unfocussed love for the arts. Snekker applied to Ashton for advice, and was taken to Randwick for lunch. George, typically keen to show himself an imperturbable artist, asked them, 'Do you mind if I carry on working?', and Snekker, with no ulterior motive in mind, handed George the necessary implements. Within days George had employed him on a permanent basis, using him, Snekker recalls, as 'a general factotum: a model one minute [he posed for the portrait 'The Swedish Athlete'], a pupil the next'.

Snekker's value to George extended well beyond the confines of art. Being young, fit and strong – he was an enthusiastic boxer – he appealed to the outward-going element in George's personality, and frequently accompanied him around town as a minder – riding with him in the park, and on one occasion coming to blows on George's behalf with an aggressive drunk. It appealed immensely to George's self-esteem to be so chaperoned, and Snekker, by combining admiration with comradeliness, reminded him of the society he had found so congenial during his time as a war artist.

The other two members of the studio were more orthodox pupils. Arthur Murch, who in 1925 won the travelling scholarship that had been awarded to George in 1900, was approached on his return from Europe with a request for help with the technicalities of casting. On his way out to Europe, Murch had fallen in with a student of Ashton's, Edmund Harvey, and when Harvey returned to Australia in 1926 he too was quickly enlisted into the studio. Together, the four of them (aided by two characters who sound like escapees from Happy Families – an odd-job

boy called Splinter, and a char lady called Olive Broomhead) formed a diligent and disciplined group. George's colleagues provided him with a version of domestic life which he could easily enjoy. Significantly, when Maurice suggested that he might come out and join them, George welcomed the idea in principle, but did nothing to make it a reality. Surrounded by acolytes, insisting on equality but never doubting his superiority, George was free to behave as well or badly as he liked, with no one within easy reach prepared to stand up to him.

Had he wished, George could have pleaded illness as an excuse for some of his behaviour at Randwick. By the time his 'shop' began working late in 1923, his malaria was recurring every two or three months. He worsened its effects by choosing drink, rather than medicine, as his cure. Whenever the illness struck, he took to the bed in his studio and fortified himself with whisky. Snekker, who drank coloured water in case he needed to respond to an emergency, watched over him. The story is more than a touching witness of Snekker's devotion. It also helps to explain a rumour that rapidly spread through smart Sydney society that George was an alcoholic. In London he had often escaped from home to the bar in the Chelsea Arts Club, but his impoverishment prevented him from drinking excessively. In the army, too, there had been little opportunity to drink more than a little. In Sydney, though, as his finances improved and his health worsened, he began to drink more seriously – not with the zeal or regularity that Constant was to show, but enough, sometimes, to alarm his friends. One of them remembers an occasion on which George, dosing himself with whisky to fend off an impending attack of malaria, had hallucinations that spiders were crawling over him.

Devoted and sympathetic as he was, not even Snekker could overlook the fact that George's vanity increased in proportion to his fame, and his bluster in proportion to his self-doubt. One journalist, acutely penetrating George's mask, wrote that he detected 'the squid-like clouding of a modest soul in the sepia of unbridled swagger'. A remark overheard in the Australia Hotel, where George frequently entertained, gives a clear idea of his manner by this time. 'You may criticise my pictures with knowledge of technique or without it,' he told a companion, 'but there is something which will always escape you. It is something called George Lambert.'

The same sort of uncritical brio is evident in his paintings of this period. In a portrait of Hera Roberts (1925), for instance – she was a rich young society woman who dabbled in furniture design, and ran a hat and frock shop called 'June' – he produced a red dress which is glowing without

warmth, a hairline which is inflexibly hard, and a left arm which looks as if it is broken. The National Gallery in Sydney refused to buy it, and when his friend Sir Baldwin Spencer took it for the Melbourne Gallery instead, three other members of the purchasing committee protested. It was a response that the painting entirely merited, but was hardly compatible with George's position as Australia's most famous painter. Ironically, he was confirmed in the role at the same time as he completed 'Hera Roberts': late in 1925 his friend Sidney Ure Smith published a festschrift in his honour – 'George Washington Lambert A R A' – in which every essay resounds with unqualified praise.

George's sculptures, like his late paintings, reflect the boastfulness which he showed in everyday life. All the pieces that he produced are technically efficient, but the strength of their forms is diminished by an element of theatricality. The judges of the Port Said commission, who eventually rejected his submission shortly before he moved into Randwick, realised that George's bravura had led him to produce an unrealistically ambitious model. 'I am sincerely sorry that you did not win the competition,' one of them wrote to him, 'but, as I told you all along, I could not conceive that its execution could possibly come within the amount allowed.'

The damage that this disappointment did to George's ego only made him apply himself to his next assignment, a war memorial for Geelong Grammar, the famous public school in Victoria, with even more furious energy – to start with, at least. The memorial was commissioned in 1923 and not completed until 1927. He made, he told Amy, 'a rather reckless and sudden acceptance of their conditions which binds me to time and money', and took pride in bragging to her about the problems he had set himself. A tall central figure, and a wide-winged symbolic bird at its feet, were described in his letters as 'a piece of geometrical analysis of form [which] is perhaps the stiffest job I have tackled'. In view of the fact that he had never been formally trained as a sculptor, the end product is a remarkable achievement. It is as much a monument to his concern for accuracy as it is a monument to the dead. He addressed himself to the modelling of the bird, for instance, with the same care that he had taken for the pony in the 'Holiday in Essex' – procuring 'a little black hen as a model for the articulation of the joints'.

It was not only George's ignorance of normal sculpting practice, and the damage done to his weak health by the 'great physical labours [of] handling the clay', which proved a trial to him as he struggled to finish the Geelong Memorial. He was also distracted by a row which he had,

in his capacity as the keeper of the country's artistic conscience, initiated almost single-handed. Ever since arriving in Sydney, he had used his membership of the Society of Artists as a means of publicising his views about the insularity of Australian painting. His complaints had never had much effect – partly, no doubt, because they were not supported by any correspondingly radical qualities in his own work. Early in 1926, however, he became involved in attempts to provide a more desperate remedy. Thea, who on her own return to Australia had been dismayed to find the art world 'still dominated by the "blue and gold" landscape tradition', urged him to join her in the creation of a Contemporary Group which would organise yearly exhibitions to challenge prevailing taste. The first show was held that November at the Grosvenor Galleries in Sydney, and included work by those who can reasonably be counted the first fully-fledged Australian modernists: Roland Wakelin, Roy de Maistre, Grace Cossington Smith, Margaret Preston, Adelaide Perry, John D. Moore, Kenneth Macqueen, and Elioth Gruner.

How much credit can George take for this? His pronouncements at the Ashton School suggest that he was as implacably opposed to modernism as Ashton himself, to whom even Van Gogh, Cézanne and Gauguin were anathema. Yet George's crusty dismissals were never uttered in a way which denied the need for Australia to familiarise itself with contemporary European practice. Experimentation was permissible, George felt, so long as it observed the time-honoured requirements of formal skill. His views almost exactly resembled those held by Thea – but because Thea had, especially during the 1920s, done a great deal of work with prints and woodblocks, her understanding of the demand for 'formal skill' included a sense of design which was more adventurous than any adopted by George. When she had seen Roger Fry's Post-Impressionist show in London late in 1910, her dislike of Matisse's and Picasso's distortions had persuaded her to value 'good drawing' above everything else. But by the time she reached Sydney in 1921, she was able to say in an interview that 'the pure colour realism and simplified pattern reform has resulted in new designs of great beauty and freshness . . . and in a revival of the drawing as a thing in itself'. The purified blocks of colour, and vigorous, Conderlike plain patternings of her woodblocks are proof that her practice matched her principles. They presented George with a simplified vision of colour and design which he was able to regard as the acceptable face of modernism. Once she had gained at least this much sympathy from him, she could convince him that her more radical protégés were sympathetic:

revolutionary as they seemed, she told him, they nevertheless upheld the standards he held dear.

Although the principles embodied in the Grosvenor Gallery exhibition were moderate compared to those which were by then widely appreciated in Europe, they nevertheless seemed shockingly unorthodox to their Sydney audience. Because George had helped to organise the show, its impact was far greater than it would otherwise have been. (George himself hung a still life which was entirely traditional in treatment, but at least unexpected in subject: an egg, a carrot and a cauliflower.) It was the first time that the spirit of modernism had been sanctioned by a leading figure in the Australian art establishment, and it gave official notice that henceforth no rearguard action could resist its advance. 'In the following year,' the art historian Robert Hughes has reported, 'Modernist pictures began to sell; and that surest indication of a rising market, the cliché variants, prospered. 1927 may be put as the year in which Post-Impressionism got a firm handhold in Sydney.'

Invaluable as it was, the help George gave in organising members of the contemporary group seriously interrupted his own work. So did the arguments their show provoked. The *Daily Telegraph* was typical of the press reaction: 'Those who exhibit . . . enliven themselves and depress everyone else with their depiction of landscapes in Oxford bags.' But at least this sort of controversy was familiar to George, and a predictable consequence of the fame he courted. What was far less easily anticipated, and also far less easily absorbed into the life he had created, was an encroachment by the past he thought he had forsaken.

Amy, having raised some money by the sale of one of George's paintings in London – 'The Squatter's Daughter', which was bought by Captain Pitt-Rivers – and having satisfied herself that her children could shoulder 'the burden of their own decisions in matters directly concerning themselves', sailed for Australia in the winter of 1925. The phrase she uses in her memoir to describe her decision to return tacitly registers a kind of guilt. It was, she said, 'the indulgence of my long-repressed desire'. Her tolerance, her enforced motherliness, and her enormous capacity for self-sacrifice had made it impossible for her to accept that her marriage was over in all but name. George's commitment to his work had hardened over the years into an obsession, and by the time Amy set sail he had managed to create in Sydney a society which well suited him. He had his fellow artists – painters like Streeton, Roberts and Thea; his clubbable male companions like Ashton and Spencer; his place of retreat – with the Ryries at Michalago; and glittering associates such as Melba when he

wanted a taste of glamour. By the time Orpen, for instance, wrote to him in the mid-1920s, and told him, 'I have been looking forward to seeing you in the old town for years. You brought a vigour along with you like a stiff breeze', it was easy for George to offset the pangs of loneliness by turning to catch the praise of his Australian colleagues. George's reputation may have been inflated, and his characteristic behaviour selfish, but his life by 1926 contained what he considered to be an ideal mixture of hard work and high style.

When Amy reached Australia in April 1926, she could not help but confront George with issues of responsibility and respectability, and prospects of restraint. She seemed, according to Snekker, 'as dull as ditchwater', and a pencil drawing George made of her at the Randwick studio soon after her arrival shows an irredeemably dumpy figure, holding a teacup. In the six years since they had seen each other he had changed little – he was thinner and balder, but healthily browned and athletic. Amy had grown plain and frumpish; her face had lost its delicacy, her hair was greying and done up in braided buns over her ears, and her clothes were old-fashioned. George, who lived in the smartest society that Sydney had to offer, was embarrassed by her. He was also, and unreasonably, resentful, since she brought with her the obligation that he should concern himself with what he had recently shirked: his children's welfare. Ever since the outbreak of war, he had abandoned them to Amy, occasionally firing off letters to them when a crisis threatened. Now he could not avoid giving a set of more detailed responses.

George's disapproval of Maurice's decision to become a sculptor was a well-established part of family lore, and recently he had created a second cause for anxiety. Shortly before Amy left England, Maurice became engaged to the sister of one of Constant's friends: Olga Morrison. George was furious: 'Marriage, for an artist,' he announced, 'is recklessly stupid and immoral.' It was an extreme version of the opinion he had held with increasing strength since travelling to Australia. In 1925, for instance, he had written to Amy:

I am always in a howling funk before I read [your letters] . . . A hero is a chap that does an enormous job of work right away from the multitude including his loving wife and his offspring. All sorts of . . . emotional hiccups are given out by the audience when this self-serving genius works out his immortal creations away in a desert place without a female hand to massage his bald spot, darn his socks, overcook his ham or make him . . . coffee. But the fact that escapes them is that he does this genius stuff and his fifteen hours a day because he's bloody well got to, not because he wants a halo or likes work.

Maurice was enraged by his father's response, and his decision to marry was strengthened. When, soon after Amy landed in Sydney, a telegram arrived announcing that the wedding had taken place, it was only with the greatest difficulty that George could be persuaded to make even a reasonably polite response. 'He extended the olive branch,' Amy says, 'with a request that he might be allowed to buy a specimen of Maurice's work, and after seeing photographs of two pieces offered, decided on the head of William Walton . . . which was duly sent to him, and which met with his qualified approval.'

Although Amy's intentions in travelling to Australia were selfless and charitable, her effect on George was profoundly unsettling. The history of her three-year stay is an almost uninterrupted catalogue of snubs, awkwardnesses and rejections. According to Thea's niece, George prepared for Amy's arrival by building an elaborate display of flowers on a bluff overlooking Sydney Harbour, took her to see it as soon as she had landed, then left her there while he returned to Randwick. Amy had originally thought that she could persuade him to buy a house and live with her as he had done in London. But during the first few weeks of her stay she discovered that he had no intention of departing from his routine of spending most nights in the Randwick studio and only intermittent ones in his club, or in a hotel, or at the house of a friend. To add insult to injury, he made the most of a 'slight accident' he had suffered shortly before her arrival. In falling down some steps he had struck his face, and used the 'dryness of the throat' which followed as a reason not to see her. Amy went to lodge with one of her sisters in a suburb of Sydney, and did her best to hide her feelings.

It was not only George's refusal to recreate the outward and visible aspects of marriage which upset Amy. He also did nothing to renew its intimacy. Snekker remembers a very few occasions on which George left the studio, intending to spend the night with her, and on nearly all of them George was back at Randwick before midnight, shaking his head and saying 'It was "no good".' Snekker also remembers, and so does Dulcie – who had travelled out to Australia shortly before the war – George's extreme short-temperedness when Amy visited him. She wanted to help, but he accused her of getting in the way; she wanted to ease his illness, but her recommendation that he give up whisky infuriated him; she wanted to understand, but he surrounded his art with a web of mystery which he told her she could not penetrate. As if she were merely an acquaintance, she took to writing him letters. They were left scattered about the studio, unopened and unread.

Amy did her best to conceal her disappointment, but her life was clearly a misery. The boring days with her sister, the lack of a family to care for, and George's persistent rejections all made her, within a very short time, baffled, angry and afraid. The one other person who might be counted as a friend, Thea, was more often exasperating than comforting. How could Thea be anything else, when she was able to see George while Amy was snubbed by him? After a few well-meant visits from Thea, Amy decided to avoid her. It may be that George thought he was sparing Amy's feelings by not candidly urging her to leave Australia. If so, it was an act of kindness which produced only miserable uncertainty. As before, he was unable to handle a complicated and potentially painful situation of his own devising. But while this caused Amy great distress – a distress about which she remains resolutely silent in her memoir – she was at least spared one of the familiar indignities of a collapsing marriage. George's reluctance to see her was not a consequence of his living with another woman. Although he was a more or less constant companion to Thea, Amy was still convinced that he and Thea were not lovers. Her belief is corroborated by all but two pieces of evidence. Snekker recalls coming unexpectedly to the studio one day, and finding George and Thea looking flustered, as if they had just jumped to their feet. This is, to say the least, an inconclusive episode, but its implication is confirmed by the testimony of Ros Hollinrake who, when she was married to Barry Humphries, had her portrait painted by Thea: 'Of course George and I were lovers,' Thea told her.

It seems likely that Thea was lying. Although George clearly admired women he was consistently shy of actual physical involvement. All his life, he billed himself as a genius who needed nothing so ordinary as sex. He showed off to women, rather than involving himself with them at all closely. Several of his friends describe a revealing incident: riding in the park one day with a pretty society woman, George's horse stumbled and threw him to the ground. He quickly remounted, cantered on a few hundred yards, then deliberately fell off a second time. This second fall, he told his companion, had been to illustrate the correct way to hit the deck, the first fall was the wrong way. Both falls, he insisted, were intentional.

George's insecurity was deep enough to turn instinctive feelings into hard-and-fast theories. Although much of his time in Australia was spent in the company of rich and chic women, he persistently made a public virtue of chastity. When one of his clients approached him with a suggestion that they might have an affair, he simply and gravely told her, 'I think not.' When another female admirer, desperate for his attentions,

threw all her clothes off in his studio with a recommendation that he might draw her, he merely humiliated her by inspecting her, joint by joint, and then declined to paint the portrait. However strongly he was attracted to women, he was determined to remain self-sufficient.

'I still worship fine women,' he told Amy in the mid-1920s,

but because it is the thing to do, and not as many people think, because my body is still so tremendously strong and young, but because the 'great Law' possesses me. Gossip, of course, there is plenty, but my brain is not capable of giving it much room and nor is my pen to be used in recording it, despite the fact that I hate the knights of old, who used to say 'hush!' at the mention of a woman, and yet spent at least eight hours a day fighting for 'em.

The phrasing here disguises his real opinions with vague flourishes. By far the most candid account of his beliefs occurs in a letter written in 1929, a year before his death, to Pitt-Rivers, who was contemplating remarriage:

I am very direct and unfeeling towards all men and women tonight, so may I say that I am bored stiff with sex subjects, marriages, either man or heaven made, or broken by arrangement or violation. Still I can risk your wrath when I reiterate my old saw that having made a complete balls-up of one marriage, how can another succeed? The Artist type goes to marriage because it is the recognised law among the present day heretics to Nature, and he should realise that at best it can only be a gentlemanly compromise. With a tame husband, wealthy and affectionate, it is a paradise for women. But I ain't going to waste my time on writing on the subject save that it puzzles me to know how you can give up your freedom.

This letter gives a clear idea of the treatment that Amy received from George in Australia. His repeated boast that 'my present life is monastic in its limitations and singleness of purpose', made her feel inconsequential – a fact that she does her best to conceal in her memoir. No reference is made to George's cold-shouldering, and much attention is given to the dutiful notes he wrote her when he was away on holiday with the Ryries, or in Melbourne organising exhibitions. When Amy eventually decided to return to England, she was still clinging to George's polite fiction that he might follow her 'to sign his name in the Royal Academy, and renew contact with his fellow artists', and anxious to pass off her reasons for going as having more to do with concern with her children's welfare than her own. 'Our younger son,' she demurely says, 'was experiencing a rather stale and unprofitable period, after his early success with the ballet [she means *Romeo and Juliet*, which Constant had written for Diaghilev],

and it is true that neither of his parents was feeling particularly happy about his present circumstances or his future prospects.' By the time Amy left Sydney, though – in February 1929 – Constant was nearly twenty-four years old, and building a secure reputation for himself. His need for maternal support hardly seems a plausible reason for her return.

For all its frustration and loneliness, Amy's three years in Australia allowed her to see that George's devotion to his work was absolute. Soon after her arrival he completed 'The Battle of Romani', then moved straight on to 'Barada Gorge', while simultaneously accepting regular portrait commissions, among them a pencil drawing of Banjo Paterson's wife. They are all worthy likenesses executed without passion, but they served their purpose – to confirm him as a darling of the establishment, and to secure him a steady income. With every fresh commission, his hope of becoming an inspired interpreter of Australia shrivelled. Instead of painting its heartland, he painted its public faces – landowners, politicians and social celebrities. George realised this, but also saw that he was in a bind of his own making. Insecurity about his talent led him to obscure his doubts by living extravagantly, and extravagance could only be sustained by the regular acceptance of what was in effect a superior form of hack work. This self-defeating cycle helps to explain the vigour with which he cultivated his ambitions as a sculptor. Sculpture, he felt, would satisfy the need for cash, while also allowing him to prove his versatility.

His experience with the Geelong Memorial taught him that the prestige of mastering a new medium could not be attained at all easily. When Amy first saw him at Randwick, the Memorial had yet to be cast – this was in fact done in Melbourne in April 1927, and the statue was unveiled in June of that year. Before it was finished, he undertook two further commissions – one for an 'Unknown Soldier' to be placed in St Mary's Cathedral, Sydney, and one for a memorial to the bush poet Henry Lawson. For the 'Unknown Soldier' George could at least enlist the help of Murch (whose name was eventually carved with his own on the completed work), but his inexperience still created grave problems. George was anxious to avoid a blandly representative soldier, but was keen to create one which in feature as well as uniform was typically Australian. Murch himself recalls the solution. The prone figure, flat on its back with hands loosely flopped over the chest, and head turned half left with the helmet tipped back,

had been very carefully drawn by Lambert; three beautifully finished drawings were his guide. So we started, with Snekker participating sometimes as a nude

figure, and sometimes in military uniform. [The lean, athletic Snekker, with his brooding, high-cheekboned face, was an ideally heroic model.] I built a clay Snekker which we clothed in a military uniform, and Lambert went all over it giving the folds what he called a Gothic character. I did not at first know what he meant, but he was making nice voluptuous folds in the uniform; where they were rounded he pinched them into a wood-carving Gothic technique. We then sprayed it with clay. So we had a live Snekker in uniform, and a uniform clothed with clay. From this I started to make what was to be the finished clay.

The effect of this method was to combine artful formality with an impression of awkward-looking mortality. For all the cunning of its pose, and the rather sentimental beauty of its gesture and facial expression, the figure appears convincingly crushed and limp. George must take the credit for this achievement, even though it was Murch who, by his own account, had the technical expertise to convert intentions into a finished product.

Once the modelling for the 'Unknown Soldier' had been completed, preparations for the casting began. They were, as Murch recalls,

a difficult business. It was a work of considerable texture, and was cast by a jelly-mould process. This mould was made from Belgian cooling glue, designed to set with the consistency of rubber. It was poured into a frame cavity large enough to accommodate the finished clay model. Both the jelly and the model were covered with shellac, and oiled. The model was cut at the waist, and each half was separately covered with the jelly mould; and when the mould was set it was peeled off the model. The jelly mould was then covered by plaster about an inch thick, to hold it in place. This was sent off to Europe for casting.

Because George was dissatisfied with the casting of his Geelong Memorial in Australia, it was sent, in fact, to England, to Burtons of Thames Ditton, who did the job for £250.

On its eventual return to Sydney the figure suffered a more undignified fate than the patient care of its creation warranted. Although the soldier 'was originally placed in the chapel of St Mary's, in the church proper . . . Archbishop Kelly objected. He had been allocated space for his [own] tomb in the crypt and he thought that was the place for the soldier too.' The solution was a compromise: the 'Unknown Soldier' was placed on a landing on the stairs leading down to the crypt, at the western end of St Mary's. It can best be seen by peering down the stairwell.

If the 'Unknown Soldier's' final resting place seems faintly ignomini-ous, it was at least reached after George's death. His initial response to the completion of the figure was an almost skittish pleasure. He enthusiastic-

ally signed the commission for the Lawson statue, in November 1927, promising delivery in June 1928, and then – in a burst of uncharacteristic kindness – took Amy for a five-day holiday in the bush. Even though their trip – from the Blue Mountains on to Walla Walla – coincided with an appalling drought, George was 'like a schoolboy . . . giving himself up to the charm which bewitched him in his youth'. But five days' holiday was hardly enough to offset the worries about unfinished commissions which assailed him as soon as he returned to Randwick.

He tried to make the burden of his work on the Lawson statue lighter by enlisting the help of a skilled caster from Melbourne, George Perugia, and by asking Amy to cook for his 'shop'. 'My memory,' she said, 'is of large appetites, and much cheerfulness and laughter, and George's voice uplifted in song.' But she knew that his spirits would have been higher still had he not been 'aware of his serious losses on his sculpture commissions to date', and concerned that he was falling behind his schedule 'owing to . . . the breaks necessary to recover from the results of overwork and a seriously lessened capacity for long stretches'. At frequent intervals throughout the early part of 1928 he had to take himself away from Sydney to rest, usually by visiting the Ryries at Michalago, or by staying in a hotel in Leura, in the Blue Mountains. He also – believing that the exercise would do him good – bought a recently retired racehorse, Old Iron, which he transported to stables at the boarding house 'Windermere', at Cobbity, near Camden, where he took regular short holidays. He could hardly have chosen a more dangerous form of relaxation. In a group of photographs taken on one of the expeditions he looks like a man at death's door: his expression still jaunty, a stubby pipe jutting from his mouth, and his hands on his hips. But the canvas belt of his jodhpurs is drawn tightly around a pitifully thin waist, his cheeks are hollow and his black-ringed eyes are sunken.

Seven

By the time Amy returned to England in 1929, George's Lawson commission was eight months late. When questioned about the delay, he made little of his illness, and a good deal of the other demands on his time. The main reason was more pedestrian and embarrassing. Even with expert help with the sculpting and casting from Perugia and Murch, the Lawson statue frustrated George with its technical difficulties. It was both larger and more complicated than the 'Unknown Soldier' – a standing figure of Lawson, a swaggy sitting beside him, and a dog (for which he borrowed a model from the dogs' home in Moore Park). The need to keep the clay model adequately moist proved almost beyond the studio's capabilities. Snekker designed an elaborate wooden frame to surround the model at night, which would allow water to be played upon it when required. Even with this precaution, disaster could not be averted. Early in 1930, when the model was virtually complete, the studio was opened up one morning to reveal that Lawson's head had fallen off. 'The falling of the clay,' George wrote to Amy, 'turned me into a complete and crying nervous wreck.'

If this sounds an extreme reaction, it can easily be explained by the pressures under which George had been working. The more he felt challenged by practical problems, the more he insisted that he could overcome them with innate, rather than acquired skill. He was convinced, for example, that he could use an adze to create a smoother finish than his colleagues could achieve with a plane. The more critical his commissioners were of his delays, the more prickly George became. Whenever the City Librarian called at the studio, Murch recalls, George quarrelled with him openly, calling him 'Mr Official'. There was anxiety, too, about the likeness he was managing to achieve in his model. Although Lawson's daughter Bertha eventually thought, 'Mr Lambert has given Dad that "chuckling" look which we knew and loved so well', Amy realised that 'memory of the man [George] had known at the age at which representation was desired, conflicted with the recent photographs with which he had been supplied.'

Throughout the statue's construction, the commissioners kept up a steady barrage of complaints. In April 1929 they were 'really and reasonably beyond patience'; in August their Chairman, W. H. Ifould, wrote to say he was 'dreadfully concerned about the delay'; in October,

the Committee threatened to cancel his contract; and early in 1930 they accompanied a second threat with a letter from the Crown Solicitor saying that 'the Organising Committee has decided that you be given a period of twenty-eight days ... in which to complete the full-sized model ... and have it cast in plaster and despatched to the foundry ... [or] the Committee will have the work completed by another sculptor'.

This did the trick. By the end of March, after a burst of concentrated activity in the studio, a small party of friends and officials gathered to celebrate the model's despatch to the bronze foundry at Thames Ditton. In a photograph taken of George at the time, and subsequently sent to Amy, he appears shattered by his efforts: the stooped, pale, 'haggard figure, in a dressing gown, was in grievous contrast to his usual spick and span appearance at any function'.

George finished the Lawson statue two years late, but was Ifould justified in telling him that he could have completed it sooner? Although the commissioners' irritation was certainly understandable, they would have been wrong to imply that the delay was simply the result of laziness. Quite apart from the unforeseen interruptions to George's work caused by his deteriorating health, there were the difficulties created by his professional ignorance. These meant that work had to proceed extremely slowly, involved him in expenses he had not previously envisaged – the cost of materials, and the wages for men in his studio. These costs had to be met by taking on many more portrait commissions than he had time to accept if he was to honour the original terms of his contract. George's response to the predicament was the only feasible one: to admit that he had overburdened himself, to sacrifice the time that he might otherwise have had for more agreeable work, and to juggle his other commitments in the forlorn hope that he would not be too disastrously late with any one or other of them.

Ifould's remark, in other words, is perfectly fair: given the demands which were already being made on George's time when he accepted the Lawson commission, he should not have agreed to complete it within eight months. But because he accepted it to extend his range as an artist, his decision is a sympathetic one. Not only sympathetic, in fact, but tragic. The Lawson statue aggravated the authorities George relied upon, destroyed his health, and was produced in circumstances which rendered it, for all the heroic effort of its creation, an unremarkable civic monument.

The Lawson statue, George felt, took him to 'the very lowest depths of a sea of arrears and overdue promises' and even made him wonder, at

times, whether he might not begin a new chapter in his life by returning to England. Amy was convinced that he would benefit from her company, and although her visit to Australia had only stirred up George's doubts about their marriage, he was nevertheless keen to rejoin his fellow-artists in London. He was particularly anxious to enjoy his associate membership of the RA – especially when, in 1929, the President wrote to tell him that 'we are all extremely sorry not to see more of your work here.' By now George was acutely wary of making 'another unfulfilled promise' and carefully confined all talk of his return to the realms of possibility. At least, in Australia, he had the comfort of knowing that while his circumstances prevented him from becoming the painter he ideally wished to be, he was nevertheless able to maintain his reputation by appealing to conservative local taste. Even when the work on Lawson was at its most demanding, he still turned out an impressive number of 'small saleable pictures', and competent likenesses – of the politician Billy Hughes; Julian Ashton; and, in October 1929, the surgeon Hamilton Russell.

In order to finish the latter, George had to visit Melbourne, and although the trip was a brief one, it powerfully reminded him of other reasons why he should stay in Australia. His journey from Sydney was, by coincidence, made on board the ss *Canberra* – 'the very same ship that took me through the German mines and submarines when I first came back from my first visit to the Jordan'. Companionable 'old ghosts', he told Amy, accompanied him on his voyage, and when he reached Melbourne he was welcomed by a more substantial figure from his past – the painter Arthur Streeton, who invited George to his house to finish the Russell portrait. Throughout George's month away from Sydney he was reminded almost continuously of the extent to which Australia itself, and not just one city, had become his home. Even Amy, reading in his letters of plans to visit London or 'Rome, if it's safe', realised that he would never settle permanently in England again.

If George was ever really in two minds about which country he should call his own, the public acclaim he received in Australia was always enough to decide him. During the last few years of his life he was consistently lauded and fêted. Although he and George argued while his portrait was being painted, Billy Hughes, for instance, offered George a knighthood for his services to art – but George refused because Hughes offered it at the same time as he asked for a contribution to party funds. Arthur Streeton, when L. B. Hall retired as Director of the Melbourne Gallery, offered him a less ambiguous honour by putting forward his name as successor.

George's fame also flourished in other walks of life. In polite society he was revered, and in artistic circles he was relied upon as the final arbiter of taste: when, in November 1929, he had a quarrel with Thea about some Contemporary Society business, even she humbly gave way, telling him, in a rare surviving letter: 'You are quite right about me . . . your criticism is the only one I cared about.' Not even commerce was immune to his allure. In the late 1920s when Ford Motors wanted to introduce a new range of colours for their cars, George and Thea were consulted, with the result – the *Sun* of Sydney reported – that 'fourteen colour combinations are available. They run through a variety of greens, with contrasting and toning moulds and stripes, to sands and yellows. Deep blues and purples are also used, and unusual effects have been achieved with coloured mudguards and brightly-hued wheels.'

George's work took an increasingly heavy toll. The letters he wrote to Amy after her return are sprinkled with references to the need for holidays – in Leura, at Cobbity, at the races at Tiranna, or at Michalago. The prime object of these jaunts was to forget, however briefly, the anxieties engendered by his sculptures. But early in 1930, when he at last despatched the model for the Lawson statue, he realised that their effects had never been sufficiently restorative. 'The health is almost gone,' he told Amy in March 1930, 'but there is, I think, yet time to do something for myself.' Although he was being encouraged by Mr Gill of the Fine Art Gallery in Melbourne, to hold a one-man show, and nagged by the War Memorial to complete his outstanding commissions, he put himself into hospital and did nothing more energetic than write and read poems: Yeats, Hardy and 'the Sitwell galaxy'. (The Sitwells were Constant's recommendation. Constant's setting of Sacheverell Sitwell's *The Rio Grande* had been a notorious success in London in 1927.)

George also used his enforced leisure to despatch a series of letters to Amy in which he attempts to clarify his artistic principles, adopting a tone which suggests he is addressing a meeting rather than his wife:

Here and now there is no other occupation for me but writing, unless it be cursing. Presently I may, with more health and a wider range of appreciation, give you some sort of treatise on things generally, including Art tendencies, and why Modern Art stands still. And why, if so, it is Modern, because it is changeless.

All experimenters come at last to the hesitancy of the cross-roads. Only technique and the sweet reasonableness of deep thought interpreted by technique can see a man through, even with good health. But there is no reason at all why the young should not destroy a little, 'tis Nature. They learn thereby or are corrected.

Art, Music, the same thing. The apparently chaotic pattern which is intended

113

and properly designed, if carried too far in the attempt to produce an effect involved and mysterious, if not intentionally misleading and, if you will, vague and alluring, comes perilously near, at times, to the muddled mush of the 'Evasionist'. Extravagance of the mind still makes appeal, especially to the suburban romantic, but good Art and thought have their law and order.

The letter is interesting for more than the light it casts upon George's cold relationship with Amy. It also shows us that the artistic principles he espoused at the end of his life were unchanged from those he had evolved as a very young man. 'Technique', he believed, was the foundation stone of talent – meaning that accurate representation, and a knowledge of tradition, were the prerequisites of greatness. George never elaborated these principles into a complete philosophy. For him, as for his children, such a thing would have seemed merely 'arty'. But he did seize every available opportunity to urge his opinions on others. On the one hand, their effect was reductive and retarding: had he returned to Australia in 1921 with something more subtle than a wish to recreate the forms and methods of the Old Masters as exactly as possible, and with a more knowledgeable tolerance of the Impressionists and the Post-Impressionists, modernism might not have taken as long as twenty-five years to spread from Europe and take hold in Australia. On the other hand he was persuaded by the extreme conservatism he found in Sydney and Melbourne to moderate his views at least a little, and to make established artistic taste more catholic – in general terms by allowing that 'there is no reason at all why the young should not destroy a little', and more particularly by publicising and praising Thea, and by supporting her ideas in the series of Contemporary Artists exhibitions.

This liberalising influence is an improbable legacy. But it is one which makes George an immensely important figure in the development of Australian painting. Present-day Australian art historians tend either to ignore him because the young modernists he encouraged quickly overshadowed his own function as their sponsor, or to revile him because his name is associated with a hidebound version of Edwardian traditionalism. An article in the magazine *Undergrowth*, in October 1925, identified a 'post-Lambertian Brotherhood' comprising Fizelle, Dundas, Byrne, Hawthorne and Hall – but it was Wakelin, De Maistre and Cossington Smith whose personalities and aims dominated the 1930s and 1940s. Yet the work of acolytes does not always accurately reflect the example of their idol. Although he spent most of his life fighting a rearguard action for a style which now seems unduly nostalgic and rigidly

orthodox, and although he made many compromises to satisfy his desire for fame and security, he nevertheless also managed to produce two groups of paintings which entitle him to unambiguous respect. The first group, in which 'Miss Thea Proctor', the 'Holiday in Essex', 'Lotty and the Lady' and 'Equestrian Portrait' figure prominently, is the more disparate – being produced at intervals throughout his time in London before the war. But these works have a significant common virtue. They combine fine craftsmanship and formal decorum with a sensual bravura. The portrait of Thea Proctor, in particular, is a masterpiece of orthodoxy: at every point its traditional structures are filled with warm personal feeling.

The other, and much more coherent group is the very large body of work he produced as a war artist. In big commissioned oils like 'The Battle of Romani' and 'The Nek', his well-developed sense of grand design and the subtlety of his colours create moving panoramas of heroism and suffering. The smaller oils George produced in the field are less concerned with formal niceties, and they are even more feelingly despatched. But when he returned to Australia in 1921, he could find no easy way of maintaining or developing the spontaneous, unselfconscious and daring aspects of his artistic personality. The history of his last nine years as a painter is a history of self-suppression.

As George pretended to himself that he was recovering from the illness which followed his completion of the statue of Lawson, he wrote a final series of letters to Amy which make a poignant appeal for sympathy by never openly admitting the need for it. 'Now that my recovery is certain,' he wrote to her in early May 1930, 'the future of my work seems both interesting and certainly worthwhile.' But when he was discharged from hospital, and took himself off to 'Windermere' at Cobbity to complete his recuperation, he found that 'work' could only consist of 'some small paintings'. His weakness exasperated him. He interrupted his holiday with a visit to Sydney and was distressed, he said, 'to find myself a crock', then returned to Cobbity again, complaining, 'My heart is back in its normal place but will not stand the slightest exertion beyond the very slow indeed.' As if to prove himself the master of even this desperate situation, he made a point of riding each day on Old Iron. His local doctor, Dr Crookston, of Camden – 'a polo man', and a friend as well as a supervisor – warned him repeatedly that any sort of strenuous exercise was dangerous. George respected Crookston's opinion that 'a complete rest' was essential, but he could not bring himself to do what he knew was sensible.

George viewed the prospect of his death with romantic fascination. When entertaining Dulcie on an earlier visit to Cobbity, he had pointed out a huge eucalyptus tree in the grazing, and told her that he wanted to die under its shade. The actual circumstances were mundanely different. On 28 May he took out Old Iron for afternoon exercise, and on his return to the farmyard in which the horse was stabled, filled a wooden feedbox with oats. He was helped by Eileen O'Brien, the daughter of a neighbouring farmer. The horse, impatiently greedy, began pushing the manger along the ground with its nose, and George picked up an axe, thinking to cut a piece of wood to use as a stake. He lifted the axe above his head to cut, swung down, and the effort strained his heart. He followed the axe to the ground. Eileen O'Brien immediately ran for help, but when it arrived George was dead: sprawled in the filthy yard in his immaculate riding clothes. He was five months short of his fifty-seventh birthday.

The public response to George's death was everything that he would have wished – in all but one respect. He chanced to die the same day that Amy Johnson completed her flight to Australia, and her arrival stole the headlines that would otherwise have been his. Nevertheless, his funeral in Sydney's South Head cemetery, was impressively well noticed and well attended. Every newspaper celebrated his achievements with uncritical fervour, and his distinguished pallbearers were chosen to show off the wide range of his connections: General Macarthur Onslow, General Cox, M. M. Bruxnor, and C. E. W. Bean, representing the military; Fred Leist, Henry Fullwood and James Macdonald representing the arts. The Dean of Sydney took the service, and Kipling's poem 'When Earth's Last Picture is Painted' was read to the packed church. But these things could not conceal a coldness. There was no member of his immediate family to see him buried, only a gaggle of fashionable society friends, his colleagues from the 'shop' and, of course, Thea. Her grief was intense and contained. She could – and did, for the rest of her life – admit to her great admiration for George, but her more intimate feelings could not be expressed in public and were never even revealed in private. She destroyed his letters, and restricted her reminiscences of him to discussions of his virtues as an artist and mentor.

The public world, which George had courted, won, depended upon and frequently exasperated, honoured him as it was bound to do, and then, as it was also bound to do, turned its attention elsewhere. The majority of his fellow artists mourned him as a brilliant craftsman, a tireless worker, and someone who (in Elioth Gunner's phrase) kept them from 'the self-satisfied, sluggish atmosphere that prevailed . . . before his

advent'. The praise they gave him was, apparently, unequivocal: Ashton thought 'it was in the last eight or nine years of his life that [he] really found himself'; the *Daily Telegraph* in Sydney wrote, 'he may be regarded as Australia's first Master'; Lionel Lindsay called him 'a great painter and a great virtuoso'; and Hans Heysen said, 'we cannot over-estimate his influence on Australian art'.

But they all knew that George's death marked the end of an old order. It was the modernists, not the 'Post-Lambertian Brotherhood', who held the key to the future, and their ascendancy was signalled a matter of weeks after his death. When a memorial exhibition of works left in George's studio was held in the Education Department in November 1930 (opened by Lionel Lindsay and hailed by the *Morning Herald* as 'a display which is probably unique in the history of art in this country'), the pictures were valued at a disappointing £4,000, and sales were embarrassingly slow. George's achievement, for all its vigour and its scattered excellence, was one which ensured him no obvious heirs. His own last breath was the last gasp (even in Australia) of the pre-modernist, revivalist tradition. To say, as Amy did, that he died 'without a country' makes a cruelly obvious symbolic point, as well as expressing a literal truth.

Amy never meant her remark to seem cruel. She persuaded herself, at the cost of great personal unhappiness, that for George 'individuality means isolation', and recorded as much in the inscription she eventually arranged to have carved on his headstone: 'George Washington Lambert ARA/1873–1930/Painter and Sculptor/Single in Purpose'. The news of his death reached her at Glebe Place in a telegram sent by the Allens, and it was delivered just as Maurice arrived from his studio to visit her. He saw his mother take the telegram, open it, and faint. In her memoir, though, she is resolute.

In the Empire of Art [George] thought imperially, applying a breadth of vision sometimes lacking in more personal relationships; being enslaved, as we all are, by that character which marks out our destinies. Many years before he had written his own epitaph, in a game we were playing with our sons:

> LONG IS THE LIFE, LONGER THE ART
> AND WHEN 'TIS TIME TO DISAPPEAR
> MUCH IS NOT DONE, MUCH BADLY DONE
> BUT YET UPON MY LITTLE SLAB
> ENGRAVED I SEE MY LITTLE CLAIM
> R.I.P. HEREIN LIES A
> TIRESOME MAN WHO LOVED THE BEAUTIFUL.

PART II
Constant

One

Although he only showed it occasionally – and, towards the end of his life, hardly at all – George's main concern for his children was that his faults as a father should not be visited on their heads. But if his long absences from home were intended to spare Maurice and Constant his disagreeable influence, and if his much-vaunted trials as a painter were meant to warn them about the difficulties of becoming an artist, he failed on both counts. The children's restlessness never took them as far afield as their father but their lives, and particularly Constant's life, were simultaneously overshadowed and directed by feelings of insecurity.

Constant was apt to romanticise his origins – he called himself 'A Francophil English composer-conductor born to an Australian painter from St Petersburg' – but the family's circumstances at the time of his birth were far from glamorous. In 1904, during their second year in London, George, Amy and Maurice moved into a flat in Fulham, near the Bishop's Palace. George also rented a separate work place in Chelsea, in Rossetti Studios. The studio was a refuge from the distractions of home, and a base from which he could cultivate a discrete life at the Chelsea Arts Club. The home that he was struggling to maintain, and also to escape, was small and impoverished. Maurice was to remember, with a mixture of shame and pride, how his mother would patch his clothes to save expense.

Late in 1904, Amy discovered that she was pregnant again. She knew that the family could ill afford a second child, but like her husband she longed for a daughter. When the child was born, on 23 August 1905, in St Clement's Nursing Home in the Fulham Palace Road, and turned out to be a boy, she immediately enlisted George's help in foisting on him a mildly androgynous image. They christened him Leonard Constant, always meaning to use the second name: throughout Constant's life he was repeatedly miscalled Constance. (Other reasons for the name are not hard to imagine: his parents wished to invest in him a steadiness they felt they lacked themselves. According to one of Constant's later friends, Angus Morrison, they also liked it because it 'was the nearest they could get' to Connie – the name of one of Mrs Halford's sisters.) They dressed him from the start in fussily 'feminine' clothes, and allowed his thick fair hair to grow girlishly long. Like Maurice, Constant was quickly seized

upon by George as a model, but whereas Maurice is always shown as tough and impish – in 'Mother and Sons', for instance, he leans on Amy's shoulder wearing sensible grey shorts, a black jersey and a brown workmanlike cap – Constant is effeminate and cute. In the same painting, Constant leans back, naked, over his mother's knee, his gold hank of hair hanging free, while she peers lovingly into his face. Both children's later lives elaborated these allegiances. Although Maurice and George were to have frequent rows about Maurice's decision to become a sculptor, and about his marriage, they retained a considerable degree of mutual admiration. 'I miss him quite a lot,' George told Amy from Australia in the mid-1920s, 'both as a son and as a useful possibility for the construction of the Palestine Model.' Constant, on the other hand, was unmistakably a mother's boy.

Or so both his parents were determined to make him seem. George involved himself with Maurice from an early age, not only encouraging him to draw, and recommending what he considered appropriate subjects – 'knights with swords and shields and fierce pointed beards', according to Amy's niece, Dulcie. Similarly, Dulcie remembers, George was proud of Maurice's boyishness:

At one time the Lamberts lived in a flat, one of many in a terrace of tall buildings, and with identical steps up to identical entrances. And young Maurice coming home one day went up the wrong steps, went inside, climbed the long flights of stairs and knocked on the wrong door. It was opened by a strange woman, but the little boy, far from being disconcerted, merely said: 'Do I live here? No, I don't, I hear a little bird singing . . . ' [and] immediately turned away and stumped off down the stairs again. Later, Amy met the woman, who told the story with great amusement.

Also at this tender age, some bigger street boys jeered at Maurice, and he in a rage shouted 'you wait till I'm six!'

This jeer was likely to have been provoked by his clothes: Amy thriftily still dressed him in the black overalls he had worn in Paris. Other children called him 'Fatty Maurice the widow'. Constant was likely to attract a different sort of abuse. A childhood companion remembers him playing rounders in Battersea Park wearing 'an amethyst satin tunic, over his very baggy knee breeches'. In later life Amy took to calling Constant 'my flawed emerald'.

Much as Amy adored and spoilt Constant – indeed, because of it – she also manipulated him. She had been renowned for her single-mindedness before she met George, and in the first years of her marriage she had

cultivated a protective resilience. Now, during Constant's childhood, she sought for ways to compensate for the shortcomings of her relationship with George. Making Constant look effeminate is obviously a case in point: she hoped to create in him the prettiness she felt that she no longer had herself. Since leaving Australia with George in 1900, the strain of her impoverished nomadic life, the burden of her ambiguous feelings for Thea, and the trials of having to care for her young family while also working as a model for George, had quickly tired and aged her. The elegant well-dressed blue-stocking had become plump and drab – her hair drawn back into a tight bun, her thickened figure enveloped in cheap handmade dresses.

Constant soon began to show signs of strain under his mother's domination. The more Amy tried to direct him into interests she thought suitable, the more he combined a desperate wish to please her with a tendency to revolt. Dulcie recalls that Constant was 'always straining to catch up with Maurice and me. He used to march about on tiptoe waving his arms about. We used to ask him difficult questions and he'd say, "I can do it because I've got such a fertile brain."' She also remembers his quick temper. His outbursts were known as 'Westbury Rages', in memory of an early incident when the family and Dulcie were staying at Westbury in Hampshire, and Constant, after a particularly serious explosion, was locked in the broom cupboard as a punishment. Only after a considerable amount of time did his stamping and sniffling subside, to be followed by what he knew would release him: 'I'm good now.'

Once Constant's schooling had begun, he was able to evade his mother's direct intervention more easily. Initially, he followed Maurice to Manor House School, Clapham, but he soon showed such an aptitude for music that his parents immediately cast round for somewhere better suited to his talents. On the recommendation of Augustus John, some of whose own children were there, he was sent to the Albert Bridge School, run by Edith Spenser, the wife of the keeper of minerals at the Natural History Museum. According to Mrs Spenser's daughter Penelope, who later became a distinguished dancer, the school was 'rather go-ahead', and encouraged its pupils to concentrate on their best subjects. She remembers Constant as 'a most beautiful creature, [with] a lovely face and expression'. His long locks had been cut – but only a little, and still hung in fair clusters onto his collar, framing a pale, blue-eyed and delicate face. Compared to his robust brother, he looked frail and ethereal.

As if the school's own concentration on the arts was not enough, Amy and George also arranged for their children to have piano lessons in the

holidays. Accepting financial help from Mrs Halford, they sent them to Elsie Hall, an Australian who, on her arrival in London, had been dubbed 'the Antipodean Phenomenon'. Constant left no reminiscence of these early lessons, nor of the influences they exerted on him. But the zeal with which he responded to his parents' challenge is eloquent. Although George and Elsie Hall both insisted that Maurice had the greater 'natural inclination' for music, Constant's addiction to it was instant.

Whatever George's shortcomings as a loving parent may have been, his diligence undoubtedly set Constant a sympathetic example. Throughout the late 1900s and early 1910s, George was busily establishing himself as a portraitist, and building a reputation as a man-about-town and as an organiser of social functions. In certain respects, his activities on this front parallel those of someone who was later to influence Constant profoundly: Serge Diaghilev. Diaghilev first brought his famous ballet company, the Ballets Russes, to London in 1911, the same year that George organised his own first public function – the 'Episodes', for the Australian Parliamentary Delegates. Although George was never involved in ballet proper, his masques and pageants combined several arts in a coherent unity in much the same way as the Ballets Russes mingled dance, music and decor in a spectacular harmony. George and Diaghilev never met, but they both typified the love of flamboyance, and the desire to reconcile diverse forms, which had characterised the artistic spirit of *la belle époque*.

In 1913 George moved his young family and his small entourage from Margaretta Terrace to 25 Glebe Place, in Chelsea. The house was acquired with a view to its being their home for a long time (Constant used it as a base until 1926). Situated at the corner of the street – where Glebe Place turns from a broad, well-to-do Victorian terrace into a narrow warren of small cottages and studios – it had the appearance of perching at the very edge of Bohemian Chelsea. With its four storeys of high-ceilinged rooms, it had enough space for the family to spread themselves, and was well-placed for George to feel within easy reach of the Arts Club. Most evenings – at the end of days in which his first-floor studio was often crowded with his wife and children serving as models – he would slip out to drink at the Club, leaving Amy to put the children to bed and prepare supper. She never complained about the multiplicity of roles he expected her to perform.

But this new-found security was short-lived. When war was declared, a year after they moved in, the restlessness which George had shown signs of controlling broke out again, and he told Amy to parcel the children off

to school, thereby guaranteeing his freedom of movement. Maurice, until he heard what lay in store for his brother, was content to let his mother leave him at the Manor House School, Clapham. But Constant, who was due to be moved to a more senior school, presented a problem. Since George's income depended largely on commissioned work, and the outbreak of war undermined the demand for this, he was short of funds to pay for further education. On the advice of the Halfords and Edmund Davis, he applied to the Almoners of Christ's Hospital, Horsham, received notice that Constant would qualify as a candidate, and sent him for an interview. Constant was accepted: on 15 September 1915, aged ten, he became a pupil at the preparatory school.

The precocity and the competitive instincts which had been nurtured by his mother and brother stood Constant in good stead. Within a few months, he had won a junior prize for English and another for drawing, and had begun to make a name for himself as a pianist. The piano lessons he had been taking in the holidays, however, came to an unhappy end. Mrs Halford, the whole family's friend and his own first patron, died the same year that he entered the school. This loss was not the only barrier to Constant's smooth progress. He was later to say, 'There were only two things I detested [at school]: a) children my own age b) boredom', but the main interest of the remark lies in its shy omission of what quickly became, and remained, his overwhelming experience at Christ's Hospital: illness.

Throughout his childhood, as his father's portraits and his mother's pampering suggest, his health had been frail, and early in 1916 he developed an acutely painful rash on his body known as Roseola Infantum, or more commonly as Duke's Disease or Forth Disease. This was almost immediately followed by osteomyelitis – or perhaps, according to Constant's biographer Richard Shead, Brodie's Abscess – which, before the invention of antibiotics, had to be treated by surgery. His doctors did well to save his life. Shortly after the osteomyelitis became manifest, Constant was so seriously ill that Amy moved into a cottage near the school owned by Edmund Davis. Her stay was gruelling. She nursed Constant after the first few of what turned out to be, before he left school, eighteen operations, and witnessed the administering of well-meant but inexpert cures. To reduce Constant's pain he was given morphia and other medicine which consisted of nothing more than champagne and burgundy. The portrait that George later painted of Constant in the school's famous 'Bluecoat' uniform shows a sickly, waifish figure, swaddled in the clothes of the charity which sustained him.

His wide blue eyes stare listlessly, his hair is cropped short, and his full mouth is slumped into a pout.

The effects of Constant's illness are not hard to imagine: a sense of vulnerability, and what his later friend Denis ApIvor admitted were 'continual bouts of pain' only mildly assuaged by the sense of being considered 'special'. The visible, physical effects were no less obvious. The operations left Constant deaf in one ear, and lame. He walked for the rest of his life with a stick, and had, according to his friend the composer Elisabeth Lutyens, 'a somewhat rolling sailor-gait'. In addition, and more conjecturally, the early introduction to alcohol 'laid the seed', Shead says, 'of his heavy drinking as an adult. The idea seems far-fetched, but his sister-in-law . . . remembers that he always "made a face" when drinking as if he were taking medicine.'

The cost of Constant's operations was largely met by the school authorities, but his gratitude was mixed with a feeling of forced dependence. 'It was a charity school, and they let you know it,' he complained later, though he realised that his father's long absence – in Wales and with the AIF – made benevolence indispensable. When his illness allowed him, he repaid the kindness by joining in the life of the community energetically. He was exempted from most games and concentrated on intellectual matters instead. By the time he graduated to Lamb House in the Senior School, in 1919, his interest in his work, and the opportunities for reading and thinking that his illness had given him, made him strike even his teachers as an odd-boy-out. His housemaster, A. C. W. Edwards, wrote:

[His lameness] set him apart – [he was] a little bitter – [and made him affect] . . . a cynical, unboyish outlook, and forced him, in a sense, to prove that he was superior in other and more important fields. He was very grown up in his language and ideas. He was a ready speaker with a remarkable quickness of repartee, which he used to accuse, to amaze, and often to hurt . . . He had his admirers and friends, but I would not call him a popular boy.

The headmaster, Dr Upcolt, was similarly struck by Constant's exceptional albeit brittle maturity, and watched his progress through the school with admiration. Constant was an active debater with, a colleague said, 'a taste for exact fact [which] amounts to a disease; he wrote a considerable amount of journalism for the school magazine (he ended up Chairman of its controlling committee); and he published a number of poems.' This is the beginning of his 'Jazz Blues', in which the Sitwellian subject and rhythm anticipate his later allegiances:

Cockatoos!
Cockatoos!
Swinging in chains from the painted roof,
Chatter and scream and flap their wings,
Flinging their gaudy bodies in time
To the ragtime tunes,
The ragtime tunes,
Clots and blobs of
Syncopated melody,
Shooting out in vermilion spirals
Piccolo tunes, trombone glissandos,
Gurgling notes on the big brass clarinet,
Screaming, scraping, violins twanging,
nasally 'Coal-black mammies down in Dixie'
Oh! Oh!
Oh! Kentucky!

Constant's love of jazz was genuine and spontaneous, but also knowingly iconoclastic. Remarkably, his enthusiasm did not lead him to disparage more orthodox kinds of music. His piano teacher Mr Bevan, and his organ teacher, Mr Wilkinson – who also gave him extra-curricular harmony classes – cultivated this breadth of interest. Bevan, in particular, encouraged as wide a knowledge of music as possible, and Constant responded willingly. 'He adored Bach,' Bevan's widow recalled, 'and his face would assume the expression of an angel when anything beautiful appealed to him.' Liszt, Chopin and the Russians – especially Stravinsky – were more than likely to have the desired effect, and during his holidays with Amy in London, Constant was tireless in his pursuit of greater familiarity with their work. In July 1945 he remembered that

I started to take music seriously during the period of the last war when the Proms for the first time were not functioning, and there must have been many older than myself who shared my wild excitement when their re-opening was announced . . . I have often wanted to describe myself as 'self-educated at the Proms'. We are so spoon-fed now by gramophone and the wireless that we forget what the Proms meant in those days, particularly to someone like myself who was at school . . . Had it not been for the Proms I would have been musically starved.

By the eve of the 1920s – the decade for which he was to provide much of the musical colouring – Constant had already developed a coherent artistic personality: rebellious, bitter-sweet, scornful of pretensions, and

enthusiastic. It was a dramatic contrast to his brother's. Like Constant, Maurice had flouted George's advice to eschew a career in the arts, and George, grudgingly, realised that no amount of argument and anger could dissuade him. In 1920, George submitted to the idea of Maurice enrolling as a student at the Chelsea Polytechnic. Once George accepted that he had been presented with a *fait accompli*, he even went so far as to exert his influence in finding Maurice a job as a studio assistant to Derwent-Wood. When the time came for him to concentrate on his own work, Maurice acquired a studio near his mother in Upper Cheyne Row, which he used until he moved in the early years of his marriage to Sussex Place. In the early 1930s he moved again, to Logan Place, and then after the war he took over a disused mushroom shed behind 7 Byfeld Gardens in Barnes.

For all their antipathy at this stage in their careers, George and Maurice remained remarkably alike. The similarity between their temperaments was matched by the resemblance between their looks. Constant – delicate and pale – looked more and more like his mother as the years passed (in spite of having fair rather than black hair). Maurice was taller, broader and had his father's intense, brooding expression. As if to make good the identification, he grew a small jutting beard – which in later life became more shapeless and luxuriant. According to Maurice's friend (whom he saw regularly in London), John Pettavel, Maurice 'billed himself as a worker-craftsman', a plain-speaking, seaman's-pipe-smoking practical artisan. He rejoiced, like his father, in 'the physical labour aspect' of sculpting, and cultivated a self-image which was as masculine and no-nonsense as his brother's was to become unpredictable and decadent. Sculpture, for Maurice, was an affair of pragmatism and honesty, and although much of his work shows an uneasy hankering after abstract forms, his most successful pieces are modestly and academically represen-tational: busts of his brother and his brother's friends (such as Angus Morrison and William Walton); public commissions, such as an eques-trian statue of George V, now in Australia; or ornamental monuments, such as the fountain he undertook to produce for Baghdad. (Several of his works are held in major English public collections – in the Victoria and Albert Museum, for instance, and the Whitechapel Gallery. A large number – piled in gloomy, dusty neglect – are stored in Sussex, in a barn belonging to one of his friends.)

Maurice's judgments on other sculptors, reported by his surviving friends, are entirely in keeping with these achievements. Epstein and Rodin were given 'pretty short shrift' for seeming to him less than expert craftsmen; Donatello, Degas and Despieux (Rodin's plaster-moulder)

were praised for their technical expertise. The emphasis is one which George would have found sympathetic, and so is the underlying emotional motivation. Maurice, like George, worked busily to create the impression of being a straightforward man of the people, in order to protect himself from his own sensitivity. It is a paradox well-summarised by the novelist Anthony Powell:

Tough, bearded, ungregarious, he had a reputation for morosity that might suddenly erupt into rudeness . . . In contrast with his younger brother, Maurice was devoted to pursuits like boxing and sailing, committed to spheres of physical action, while being at the same time personally inward-looking. Constant would have rows with his brother, but was fond of him too, liking to compare what he regarded as the extrovert life of a sculptor with that of a musician: 'the amount of work my brother does is limited only by the hour he gets up in the morning. If you speak to him of constipation, he asks you what you mean.'

There is no doubt that Powell's opinion accurately describes Maurice's temperament in his very early days with Derwent-Wood, even though it was formed at a time when the brothers' careers were clearly defined and their reputations established. Constant, as a boy, was less exactly as Powell found him in later life. When Constant took his first tentative steps as a composer, he too had the creative diligence and fluency which he came half to envy, half to reproach in his brother. In September 1919, while the family were holidaying with Edmund Davis at Chilham Castle in Kent, we get an early glimpse of Constant's commitment. Two acquaintances of the Lamberts', Charles Ricketts and Charles Shannon – moderately talented artists who had been associated with the Decadents in the 1890s, and who had also previously benefited from Davis's patronage when living in a flat above the Lamberts in Lansdowne Road – were installed in the castle 'keep'. Ricketts wrote to a friend: 'Young Lambert is here [he was fourteen] . . . He has grown and is very intelligent. I am threatened with two compositions of his on the piano . . . He is less Stravinsky-esque and seems genuinely interested in Weber and Liszt, the names least mentioned in recent years.' Penelope Spenser, his friend from school in Albert Bridge Road, who by 1920 had begun to make a name for herself as a free-movement dancer, also testifies to his independence of mind.

He would bring me his compositions to see if I could dance to them. I had been taught to feel music 'flow through me', and I think Constant might possibly have been influenced by me . . . I was the only person he knew in the dancing world. He

threw away masses and masses of work, and then would never allow me to talk about it. 'Oh that's no good, I've thrown it away,' he'd say.

As well as expressing an innate gift, Constant's early compositions served another and more protective function. When, in November 1920, his father returned to Australia – Constant was never to see him again – it marked the end of domestic uncertainty, and the beginning of unequivocal abandonment. Within the family, Constant had always sided with his mother, but his silence about his father's departure – not a single remark about it survives – and the infrequency of their subsequent communication, implies hurt almost as strongly as it suggests indifference. His interest in music, during the school holidays as well as term, expanded to fill the gap his father left. In March 1921, he composed an operetta (now lost) for the house concert which the school magazine judged 'the most successful one of recent years' – and at every other concert put on before he left, his name is prominent in the programme. He played Liszt at the Christmas concert in 1921, and a Chopin *Polonaise* at speech day the following year. In March 1922, when he took the Advanced Grade exam with the Associated Board, he was awarded the Gold Medal with the highest total of 140 marks.

Constant's interest in music did not make him conform to any conventional image of a feeble artistic type. By 1922, when he was seventeen, the nervous, sickly figure which had appeared in George's Bluecoat portrait six years earlier had broadened and strengthened into an ebulliently self-confident adolescent. The lingering marks of Constant's illness – his limp and his deafness – gave him a certain amount of prestige among his fellows, and encouraged him to cultivate a personality which was determinedly at odds with the 'hearty' ethos which prevailed in some quarters of the school. Constant grew his hair longer than most of his peers, glossed it down with oil, kept his school uniform – the famous full-length blue coat, gold buttons and white cravat – immaculate, and decorated his study with reproductions of Old Master paintings. While other boys were playing games, he used the time to read and listen to music as often as he could – subsequently airing his opinions in a clear, rapid, clipped voice which made him sound older and more knowledgeable than his years. His self-confidence did not always endear him to his teachers. One contemporary, T. B. Radley, remembers Constant offending the sensibilities of the music master by asking whether he might conduct the school orchestra himself. The response was merely 'irritation and shock'. Another contemporary, Michael Stewart – later a Foreign Secretary –

remembers that Constant introduced him to the works of Ibsen, Shaw and Chesterton, and took pride in calling himself a Communist:

[his] disabilities were exceptionally serious – one ear was a constant source of trouble to him and [one foot] so injured that he could never put the whole of his foot to the ground and had to walk on his toes . . . He couldn't play organised games and in consequence [in the summer terms] held the position of scorer to the Lamb A First XI . . .

The remarkable thing about him was that, at the age of [seventeen], or even earlier, he had the mind and interests of a well-informed adult: there was no affectation about this – it simply was the fact. It made him, of course, a very stimulating but at times a very disconcerting companion; to most schoolboys of sixteen or seventeen the world of school is real, and the world outside only partially realised; in his company one was apt to be frequently and sharply reminded that outside school there was a real world, with manifold problems and interests, and that school life, however enjoyable, could not be more than a preparation for reality.

Even supposing that George had been on hand when Constant left Christ's Hospital, he would have found it difficult to dissuade his son from embarking on a career as a musician. The school, with a long tradition of writers to its credit (Coleridge, Lamb and Blunden, for instance), was pleased by the prospect of adding a musician to their roll call. The unsettledness of Constant's background had, whatever its disadvantages, forced upon him the strength of character which enabled him to make up his mind absolutely. Early in 1922, when he was seventeen, he won a Composition Scholarship to the Royal College of Music, left Christ's Hospital on 3 August, and began his new life a month later.

The gifts that Constant had already shown augured well for his studentship, and so did the opportunities offered by the College, which had collected an outstanding staff. The Principal, Sir Hugh Allen, was, Constant told Penelope Spenser, 'a very formidable but immensely able and an occasionally charming man', and his other Professors included Adrian Boult and Malcolm Sargent. For Ralph Vaughan Williams, who took his composition classes, he had respect but nothing more – he associated Vaughan Williams with the folksy English tradition he was later passionately to deride in his book *Music Ho!* (1934). Vaughan Williams, on the other hand, was impressed. 'It was Vaughan Williams,' according to the musicologist Edward Dent, 'who first discovered [Constant's] marvellous musicianship . . . He called on me one day at

Cambridge glowing with excitement and showed me Constant's first attempt at a fugue, written without any previous knowledge of the rules. It was a most unorthodox fugue on a most unorthodox subject, but there can be no doubt that it was the product of an original and highly intelligent mind.' Only when Constant changed Professors, and went instead to Vaughan Williams's brother-in-law, R. O. Morris, did he find an interest as wide-ranging as his own. His Professors in other subjects were also as struck by his natural abilities and by the forthrightness of his opinions. Constant turned down the chance of studying the piano under Herbert Fryer, at the end of his fourth term, so that he could concentrate on conducting, which was under the control of Boult. Boult's classes had acquired a reputation for their unorthodox brilliance, and for their success in turning out influential exponents: among the original members were Arthur Bliss and Leslie Heward. Many of these had left by the time that Constant arrived, but their reputation lingered, increasing the classes' popularity to such an extent that Boult – who was himself increasingly in demand outside the College – had taken on an assistant: the young conductor of the Leicester Symphony Orchestra, Malcolm Sargent. It was Sargent, not Boult, whom Constant saw most frequently, and from whom, according to one of Constant's contemporaries at the RCM, 'he learned the essential elements of conducting technique, and the necessity to produce a clear, unambiguous beat even in the most complicated rhythmical patterns'.

The contemporary who made this judgment, Angus Morrison, was three years older than Constant, a dark-haired, quick-talking, amusing and clever young man. He was a more accomplished pianist and quickly became his unfailing companion. Morrison was far from being alone among the students in sharing the teachers' sense of Constant's extraordinary gifts – for fun, as well as composition. Constant almost immediately found himself at the centre of a circle of admiring friends – Penelope Spenser said he was 'surrounded by a terrifying group of brilliant young men' – who included Humphrey Procter-Gregg (later a distinguished opera producer), the pianist and composer Gavin Gordon – whose gift for witty caricature entertained Constant – and Leslie Heward (the conductor). Constant's looks and knowing manner distinguished him as much as his talent. Patrick Hadley, another contemporary, described him as 'radiantly good looking'; Edwin Lutyens' daughter, who came across him once in the College library, said he was 'very beautiful, very thin, rather disdainful and arrogant'. He was not tall (under six feet), but his finely sculpted features, high forehead and swept-back hair – which had

darkened since childhood from fair to brown – gave him an appearance of nervous intelligence.

Constant's pride, like his father's, was a protective mask, but it served to remind his associates that he was better informed than most people of his age. With Morrison, in particular – who lived, conveniently, just round the corner from the Lambert home in Glebe Place at 9 Oakley Street – he would tirelessly play and discuss music and, says Morrison,

an even larger part of our time [and most of their small allowance] was spent in visiting exhibitions of painting, hunting out in obscure cinemas and theatres the first showings of the early German films such as *Dr Caligari*, *Warning Shadows*, *Waxworks* etc., and revivals of Chekhov, Strindberg and Ibsen, as well as going to reviews, musical comedies and music halls where his life-long interest in jazz and all forms of popular art and entertainment found continually renewed stimulation and enjoyment.

It was a companionable rather than a gregarious existence, and a studious one for all the entertainment it contained. Although Constant was soon to be known as a *bon viveur*, he was a model student – assiduously attending his conducting and composition classes in the cavernous, rambling RCM, and conscientiously deepening the sympathy for painting and drama which his parents had bred in him. In the College and at art galleries and theatres, his limping figure seemed to his friends to suggest self-containment and forthrightness in equal proportions. He impressed everyone he met with his wide knowledge of the arts, his musical scholarship, and with his decisiveness. He easily combined his pursuit of knowledge with his appetite for fun, and reconciled them both to the constraints imposed by having to return home each night to his mother's house in Glebe Place. It was a life which allowed him to work as hard as he played, and to seem – in intellectual matters at least – more adult than most of his peers.

Constant's special friendship with Morrison was founded on a shared interest in the widest possible range of music. Arrogant he may sometimes have appeared; pompously elitist he was not. Morrison also won Constant's confidence because, within the realms of strictly classical music, their tastes were closely similar. Morrison admired Constant's determination to repudiate accepted views and standards, and shared his wish to extol obscure or neglected composers. Constant made a special point of praising Glinka, Chabrier, the then unfashionable Liszt, and the even more recondite John Bacchus Dykes, who, he claimed, was 'one of the first musicians to make popular use of extreme chromaticism'. These

judgments showed considerable independence of mind, but Constant was happy to admit that he was not quite alone in the wilderness. Before and during the war, the influence of Diaghilev's Ballets Russes had persuaded at least some members of the English musical cognoscenti to re-examine the values that they had inherited from the nineteenth century. The company's own courageously radical preferences had, by the time Constant reached the RCM, returned a general echo. Constant, talking on the BBC in 1946, remembered – for example – that he had first heard Chabrier's *Menuel Pompeus*, scored by Ravel, in the interval of the Ballets Russes when he was fourteen years old. 'With luck I could manage to get to the Diaghilev Ballet on the first night and the last night – the rest of the season being spent, alas, at my school where instead of listening to Chabrier or watching the ballet I was made to spend my time scoring for cricket – a task which I performed with considerable inaccuracy.'

At the Ballets Russes, too, Constant would have made his first acquaintance with the music of Rimsky-Korsakov, Balakirev and Stravinsky, as well as French composers like Debussy and Ravel. Their effect was not simply to make him resist received opinion about who deserved to be considered a minor and who a major composer, but to challenge the dominant contemporary view as to which was the preferable classic tradition. French and Russian music, he sought to convince his peers, were richer than Austro-Germanic music. Strongly as he believed this, his opinions were never so inflexible as to omit exceptions. Morrison insists that one such exception, Schumann, influenced his musical development almost more strongly than anyone: 'What he loved above all in the music of Schumann was the strange, slightly sinister Hoffmanesque quality . . . and the haunting melancholy that underlies the feverish activity of even his quietest movements.' But it was more than an emotive tone that caught Constant's attention; it was Schumann's tendency to combine disparate elements to create an effect that is both subversive and inclusive.

A particularly characteristic trait that appears in Schumann over and over again, and which Constant especially loved, is his habit of making the Trio or Intermezzo sections of a piece not just the well-balanced contrast, still maintaining unity of mood with what has gone before . . . but an interpolation of something as different and as far removed emotionally as possible from the rest of the piece.

The first intermezzo of Schumann's Third Romance from Opus 28 is a case in point: it shows the same spirit of vigorous rebellion that Constant

was to perfect in his first major work, *The Rio Grande*, which he wrote in 1927, when he was twenty-two, and in the slow movement of his piano sonata.

The Rio Grande was not intended to overthrow all existing conventions. Its purpose was to create a harmonious fusion of what had previously been considered to be distinct musical traditions, catering for distinct emotional states. All Constant's early judgments on composers, and the variety of concerts he attended, testified to this. They also distinguish him, it is worth adding, from his more strictly orthodox brother and father. By an appealing coincidence, his father was welcomed into the arms of the establishment – when he was elected ARA, late in 1922 – just as Constant was beginning to struggle free of its embrace.

If Constant needed any reassurance that his was the more exciting course, he found it early the following year. In May 1922, on one of their many joint expeditions, he went with Morrison to see C. B. Cochran's show *Dover Street to Dixie* at the London Pavilion. The first part of the show, *Dover Street*, was an unremarkable ragbag of songs and sketches, but the second half featured a troupe of black singers – the stars were the singer Florence Mills, and Will Vodery's 'Plantation Orchestra' – who had never appeared in London before. Although the show was not a success, and only ran for three months, it made an impression on Constant which is almost impossible to exaggerate, as Morrison describes:

Without doubt this performance was one of the key experiences in his life, beginning not only his long preoccupation with jazz [in fact it had begun to develop at school] and the possibility of fusing and blending many of its rhythmic inventions and subtleties into the texture of more serious music, but also moving him in a far deeper way emotionally than any other music he had hitherto heard . . . I am convinced that the first time he saw 'The Plantations' was a moment of true inspiration – a moment he sought to recapture over and over again in his own music – in *The Rio Grande*, the slow movement of the Piano Sonata, the Piano Concerto, the *Elegiac Blues*, and even that exquisite piece written many years later *Aubade Héroïque* . . .

The arresting start of the whole performance was a sort of fanfare on the tune of 'Carry Me Back to Old Virginny'. The Delius-like harmonies were made to sound even more lush and glowing by the clear uninhibited playing of this magnificent negro band. It was indeed the memory of this opening flourish played by the superb first trumpeter, Johnny Dunn (described in the programme as 'the Creator of Wa-Wa'), that remained with Constant all through his life. Its echo can be heard somewhere in almost all his works, and there is no doubt that the

first phrase of the chorus in *The Rio Grande* was a conscious attempt on his part to reproduce the same effect – that irresistible blend of blatancy and sweetness that had stirred him so deeply when he first heard it.

The show's impact did not make itself felt immediately. A month after hearing the Plantation Orchestra, the first of Constant's compositions that we know in any detail (from friends' reminiscences – the score is lost) was played at the RCM's Patrons' Fund rehearsal by the Royal Albert Hall Orchestra, conducted by Gordon Jacob. It showed no sign of direct jazz influence. The piece was a 'rhapsody' called *Green Fire*, and the liberties it took with convention were less spectacular than Constant's professed theoretical views might lead us to expect. (They were enough, nevertheless, for Vaughan Williams to 'express himself as startled, and even bewildered, by Constant's trick of writing consecutive sevenths and ninths for trombones', and for one reviewer to raise an eyebrow at its 'excessively high spirits . . . like a panegyric to Rimsky-Korsakov, chiefly fortissimo e con fuoco'.)

In his subsequent student compositions, jazz influence began to make itself more obvious, mingling with the influences he had already absorbed from more orthodox sources – 'imitation Stravinsky, imitation Debussy', as Morrison remembers. The most important of these was a 'Realistic Ballet in One Act', called *Prize-Fight*, written for a small orchestra in the winter of 1923 when Constant was eighteen. Syncopated jazz rhythms are an unmistakable feature of the piece, but these take their place beside – and are, for most of the time, overwhelmed by – others. The ballet's staging (a farcical boxing match interrupted by a drunk and eventually closed by the Mounted Police 'who attempt to quell the disturbance, and get into the ring, which under so great a weight groans and collapses'), obviously derives from the example of Jean Cocteau and 'Les Six'; its title echoes Honegger's *Skating Rink* (1922), and its subtitle Satie's *Parade: Un Ballet Réaliste*; and its action recalls the farcical Cocteau-Milhaud 'Boeuf sur le Toit'.

Constant's next effort, *Mr Bear-Squash-You-All-Flat*, a one-act ballet based on a Russian fairy tale, completed in June 1924, is also less impressive for its actual achievement than for its evidence of Constant's familiarity with French modernism. Its lack of plot – Mr Frog, Mr Mouse, Mr Hedgehog, Mr Duck, Mr Samson Cat and Mr Donkey hide in a log in a clearing, which is then sat on and crushed by Mr Bear – devolves emotional interest into jokey displays of technique. (Mr Samson Cat was a character for whom Constant felt a special fondness. Constant was, as

Shead says, 'very fond of cats. He [later] was President of the Kensington Cats' Club and owned a number of cats at various times of his life. One of the last, which survived its master, was called Captain Spalding; the allusion is to a scene in a Marx Brothers film, when Groucho, arriving at a party in a litter carried by four dusky bearers, is greeted with cries of 'Hurrah for Captain Spalding the African explorer!' Three other Lambert cats were named Aimée, Semple and McPherson, after the well-known American evangelist.)

Mr Bear shows an impatience with tradition which borders on downright rejection, yet the fun that Constant poked at convention had a serious purpose. Throughout his career he was determined – in Deryck Cook's phrase – to make the critics' 'surprise look ridiculous'. By debunking the earnest segregation of diverse arts and attitudes, he hoped to achieve the kind of inclusiveness that George, po-facedly, intended to command by projecting himself as a latter-day renaissance craftsman. Constant's ambition, far from being to create an alienating tricksiness, was to produce a direct rapport with his audience.

Although ballet, because it allowed several different forces to unite in a single purpose, claimed most of Constant's attention as a young composer, it was through other work that he was given his first real chance to make a name for himself. As well as trying his hand at strictly instrumental composition (he wrote, but never scored, a piano concerto early in 1924), and accepting several requests to conduct (on 24 February he gave his friend and fellow student Gavin Gordon's *Les Noces Imaginaires* at the RCM), he also, in March, performed his setting of two poems by Sacheverell Sitwell, *Serenade* and *The White Nightingale*, for soprano, flute and harp. In choosing this particular poet, he held true to his earliest artistic inclinations. The Sitwells were among the few English exponents of modernism, albeit of a kind which relied less on complex experimentation than on a popular facetiousness. But Constant also hoped that the effect might bring him securely within the shelter of their influence.

Ever since the young William Walton's setting of Edith Sitwell's *Façade* had been performed – in private, first, at the Sitwells' house at 2 Carlisle Square on 24 January 1922, then publicly at the Aeolian Hall on 12 June the following year – the Sitwells' name had been synonymous with the kind of stylish daring that he admired. At the RCM, his rapidly developing musical gifts, and the self-assurance which his intellectual expertise gave him, had meant that close companions had been comparatively few and far between. Morrison was one of the very small number he could

consider an equal. But the Sitwells offered him a range and glamour he was hungry to embrace. They had, Powell was later to say, 'created a world perceptibly their own': fashionable, controversial and exotic. Constant thought that by attaching himself to the Sitwells he could dispense with the sense of being 'a mere student'.

The year before *Façade* was heard, Constant had made himself known to the family by turning up on Osbert Sitwell's doorstep in Carlisle Square. 'I noticed,' Osbert Sitwell said later, 'that he had a courageous look . . . I said, "Come in, won't you?" And soon we were talking like old friends . . . [though] until at that moment I had never heard of Constant, I had once or twice met his father.' This first encounter − in which Constant's good looks impressed the susceptible Osbert − quickly led to others. In August 1922 Constant stayed with Walton and the Sitwells at Renishaw, their home in Derbyshire, ingratiating himself by his wit and performing 'musical skirmishes' with Walton on the 'Bechstein, an enormous obsolete instrument'. When, two years later, he invited Sacheverell and Osbert to attend his performance of the two settings in the RCM, the family were his firm friends if not yet his firm patrons. Edith, according to Ashton, 'adored him and thought he was the best reciter of *Façade*'; and Osbert fell half in love with him. Constant was, Osbert wrote, 'a prodigy of intelligence and learning, and gifted with that particularly individual outlook and sense of humour which, surely, were born to him and are impossible to acquire'. He was also, Osbert confided to friends, growing increasingly attractive: his hair swept back from his high forehead, his skin clear and pale, his conversation intelligent, humorous and mildly risqué. Like George when a young man, Constant was a fast- talking, cigarette-smoking, outspoken 'job lot Apollo'.

It was the Sitwells' musical friends, rather than their literary ones, that Constant cultivated most assiduously. Foremost among them was Walton himself, whom Sacheverell had met at Oxford in January 1919, when Walton was only sixteen, and who had been installed in the Sitwells' London house as a kind of unofficial composer-in-residence. Walton, like Constant's companions at the RCM, was immediately impressed by Constant's looks, and by his iconoclasm. 'He was, as a young man, of strikingly handsome and distinguished appearance, and with a most pronounced personality . . . His taste in music . . . was unusual. He did not really like the classics, or indeed ever come to care for them, but preferred more the highways and byways of music (the Elizabethans, Purcell, Scarlatti, Glinka, Debussy, Satie).'

Constant, in turn, was similarly taken by Walton's seeming to be a

'cosmopolitan *enfant terrible*'. Later, he came to regard him as 'the successor of Sir Edward Elgar', and referred to him as 'the late Sir William', although he readily admitted – according to the pianist Louis Kentner – 'that his friend had a greater creative gift' than his own. In 1930, for instance, Constant was to call Walton's Viola Concerto 'a quite outstanding piece of work in which a spontaneous and youthful spirit is expressed with a surprising maturity of technique'. The differences between the two men were as pronounced as their similarities. Both abominated the fabricated nationalism of their immediate musical forebears, both looked to jazz for a revitalising influence on English music (Walton wrote and scored foxtrots for the Savoy Orpheans), and both were determined that 'serious' composition should not preclude a sense of zestful fun. On the other hand – and even at this early stage, when he was most obviously under the Sitwell wing – Constant was markedly more unpredictable than Walton: more flippant, and more subversive. Although it often invigorated his compositions, this also threatened to permit a degree of chaos in his social life.

Several of the new friends that Constant made through the Sitwells held this potentially destructive element in check. Fellow composers like Walton himself and Bernard Van Dieren – whom Constant, meaning praise, called 'the most esoteric composer of our time' – set him a high standard of diligence and concentration. So too did their even more eccentric acquaintance, Lord Berners. Berners (the model for Lord Merlin in Nancy Mitford's novel *The Pursuit of Love*) is popularly known today for having lived a life of exquisite whimsy: his fine collection of paintings, and his beautiful house at Faringdon – where he built the last folly in England and kept a flock of pigeons dyed various colours – were legendary.

But this playfulness was an essential part of a wholly serious intention. By the time Berners established himself as a composer, in the mid-1920s, having previously also made a name for himself as an author and painter, he was identified with the same musical ideology as the French modernists such as Satie whom Constant admired and understood. Berners was, in fact, known as 'the English Satie'; he shared with this composer and with 'Les Six' the same love of jokes, often using them as a means of both conveying and concealing the sadness and shyness on which his imagination fed. His early work – the three funeral marches of 1916, for a statesman, a canary and a rich aunt, or the *Fantaisie Espagnole* (1920), a parody of 'Spanish mannerisms' – are small masterpieces of Firbankian tristesse. Their good nature and their defensiveness appealed to Constant

as strongly as the same combination of qualities in Berners's social behaviour. 'A typical example of his desire for solitude combined with his own individual humour,' Constant said in 1946,

was provided by a simple method of keeping a railway carriage to himself. Instead of employing the usual English tactics he would put on dark glasses and slyly beckon in the passers-by. Those isolated figures who took the risk of entering the carriage became so perturbed by his habit of reading a newspaper upside-down and taking his temperature every few minutes that they invariably changed carriages at the next station.

It is in his ballet scores that Berners's sympathetic kinship with Constant is most obvious. Diaghilev put on Berners' *The Triumph of Neptune, an English Pantomime*, on 3 December 1926, shortly after he had staged Constant's *Romeo and Juliet*, and thereafter their careers regularly ran parallel or even crossed on one another's. When Constant became musical director of Sadler's Wells in the mid-1930s, he encouraged Berners to write two works which he then conducted, and they all – and especially the celebrated *A Wedding Bouquet* (1937) – bear a striking resemblance to the spirit of his own compositions. Both men revitalised English ballet by introducing it to cosmopolitan influences, and by demonstrating that grave emotional responses can be achieved without keeping an absolutely straight face.

But Constant's high spirits were not always as well governed as Berners would have liked. As a schoolboy, Constant's commitment to music had always been accompanied by a loathing of pomposity or self-absorption. As his gift developed, so did his wish to avoid any typically 'artistic' behaviour. In the company of Walton or Berners, this tension could be resolved by experiments with comedy or self-irony. But with other friends he made in the early twenties – and particularly with the composer Peter Warlock (Philip Heseltine) – the balance between seriousness and playfulness was less easy to maintain.

Heseltine had chosen to compose under the pseudonym Warlock to protect himself from the wrath of fellow-critics and musicians he had angered with his sharp journalistic pen and his even sharper tongue. An acerbic, witty, prodigiously intelligent man, he had – by the time Powell met him in the early 1920s –

turned himself into a consciously mephistophelian figure, an appearance assisted by a pointed fair beard and light-coloured eyes that were peculiarly compelling. His reputation, one not altogether undeserved, was that of a *mauvais sujet*, but I

always found him agreeable and highly entertaining; though never without a sense, as with many persons of at times malign temper, that things might suddenly go badly wrong.

Powell later preserved some elements of Heseltine's personality in the character of Maclintick in *A Dance to the Music of Time* (D. H. Lawrence also portrayed him as Halliday in *Women in Love*, and Aldous Huxley as Coleman in *Antic Hay*). Like Powell, Constant valued him for his wit (and for his liking for cats), and also respected him deeply for his musical expertise. Heseltine contributed enormously to Constant's musical education. When Constant visited Heseltine's flat in a rundown area of Pimlico, or his cottage at Eynsford, in Kent, he would invariably find himself surrounded by a group of like-minded young musicians, all anxious to benefit from Heseltine's vast fund of arcane knowledge. Heseltine was an authority on Elizabethan music, and Constant inherited from him a fondness for neglected composers of all eras – in particular for William Boyce, whose work he later used in 'The Prospect Before Us' in 1940. Heseltine also helped Constant to clarify his musical tastes by challenging his addiction to Stravinsky. Several attitudes that Heseltine persuaded Constant to adopt were later preserved in *Music Ho!*, and the eagerness with which they were taken up suggest a good deal of youthful malleability on Constant's part. They also – given the independence of mind for which Constant had already become well known – imply extraordinary force to Heseltine's personality. In a commemorative notice written after Heseltine's suicide in 1931, Constant described his friend's achievement in terms which indicate its source: 'His music is a perfect expression of the mood that is common to both [the Elizabethans and Delius], and may be considered the dominant mood of English music and lyric poetry. A mood of definite melancholy, but expressed with such richness of imagery and sweetness of sound that it has in it nothing that is sterile or negative.' This remark implies that Constant's responsiveness to Heseltine derived largely from a recognition that Heseltine embodied the same paradoxical qualities that existed (largely hidden, as yet) in his own personality. Heseltine's romantic love of life was infected with self-doubt.

To start with, at least, this paradox posed no threats to Constant. Whenever it was necessary, he found that he could rely on other members of Heseltine's circle to charm away melancholy. Thomas Earp, for instance, who lived near Constant in London, was rarely disconcerted by Heseltine's gloom, invariably because he was too drunk to notice it. (Earp, a large-faced, thin-voiced art critic and belle-lettrist, habitually

ended his evenings in a stupor, according to Powell: 'Returning from comparatively far afield one night, he felt that state coming on, and took refuge under the tarpaulin cover of a Covent Garden barrow; waking up the following day at an early hour to find that he had been wheeled to a distant part of London.') Like other of Heseltine's regular companions – the musicians Jack Moeran and Cecil Gray, pre-eminently – Constant found their Mephistopheles provided them with a slightly more salacious form of the high spirits that he had enjoyed with his friends at the RCM. Like Constant, Heseltine was happy to spend hours inventing word games, elaborating jokes, and writing limericks. Morrison, who knew Heseltine only a little and found him sinister, remembers, 'Young ladies who frequent picture palaces/Don't hold with psychoanalysis. /Though Mr Freud/Is distinctly annoyed/ They still cling to their long-standing phallacies.'

Morrison realised that there was a 'negative spirit' lurking in Heseltine's personality, and an edge of desperation to his playfulness. Over the years of his friendship with Constant, Heseltine sought to compensate for his steadily increasing melancholy by cultivating a kind of lavishness which, while intended to be life-enhancing, was in fact self-destructive. More often than not, this meant drinking heavily. Constant, for whom alcohol had initially been little more than a medicine, found it difficult to resist Heseltine's example, and followed suit (usually preferring wine and beer to spirits). By giving Constant a taste for drink Heseltine was doing more than making him likely to prove wayward and unreliable. He was setting him on a suicidal course. It was only discovered just before Constant's death that he was diabetic – a condition which, if not governed by treatment, is made deadly by excess alcohol. At the very beginning of his career, when Constant was still not yet twenty years old, and was beginning to make his name at the RCM and to enjoy the opportunities it offered for larger social and professional success, the seeds of his ruin were already taking root.

Two

Constant 'kept his life in compartments', according to Angus Morrison, even as a student. His working time in college, his creative, mildly debauched visits to Heseltine, his respectable home life with Amy, and his socialising with the Sitwells expressed a personality which was both gregarious and defensive – unwilling to show itself in the round to anyone. The division of his life was facilitated and reinforced by the structure of his life at the R C M. The daily routine of attending conducting and composition classes, which had been established in his first term, still held good two years later in 1924, and ensured that however keenly he welcomed the glamorous emancipated life shown him by his new friends, he still worked hard and steadily. He knew, too, that if he erred too far from the straight and narrow, his mother would soon lead him back. The mixture of sophistication and self-discipline is clearly evident in photographs taken of him at the time: although his clothes are carefully unconventional (dark shirts and pale ties), his pose is habitually nervous, and his smile (bright-eyed and with his mouth often slightly open) eager to please.

Constant's diversity, at least at this stage of his career, did nothing to hinder his musical ambitions. The performance of his setting of the two Sitwell poems in February 1924, which itself represented a great musical and social leap forward, was quickly followed by other successes. On 15 July he conducted works by Borodin and Grieg (Symphonic Dance No. 4); on 9 December The Overture to Rossini's *L'Italienne en Algérie*; and, two days later, *Les Noces Imaginaires*. The same concentration on neglected or undervalued composers is obvious in his performances the following year: he played pieces for piano by Patrick Hadley, conducted performances of work by César Franck, and organised an evening of Russian music which included his arrangement of extracts from *Ruslan and Ludmila*.

These achievements, for all the expertise they showed, were not directly responsible for Constant's first and sudden rise to fame. It was caused, instead, by a family connection which had already done much to help him as a boy. Sir Edmund Davis and his two friends Ricketts and Shannon (who had admired Constant's schoolboy performances at Chilham Castle), were acquaintances of the artist and illustrator Edmund Dulac. They were keen that Dulac should be introduced to their brilliant protégé, and arranged a meeting in London. Dulac was impressed by the twenty-

year-old Constant, and showed him off to various colleagues in the musical world, including, when the Ballets Russes was performing in London in the summer of 1925, Serge Diaghilev.

For the previous ten and more years, Diaghilev's company the Ballets Russes had – with productions like *The Three-Cornered Hat*, *La Boutique Fantasque*, *Les Biches*, *Les Noces* and *Le Fils Prodigue*, dancers like Nijinsky, and choreographers like Nijinska – created a reputation for providing what Shead rightly calls the 'newest and most exciting ... contemporary artistic thinking'. But the company's emphasis on innovation and spectacle, and the expense of touring, had drastically overstretched their resources. When Constant and Diaghilev met, the Ballets Russes was in a state of even more dire financial disrepair than usual. The disaster of the 1921 season, when *The Sleeping Princess* had played to poor houses in London, had incurred debts which still troubled Diaghilev, and which had prompted him to search for backers to underwrite his English seasons. In order to woo Lord Rothermere, who seemed a likely source of help, he was anxious to elicit work from English composers, particularly if he could do so without compromising the adventurous spirit with which his ballets had always been staged. Constant struck him at once as an eminently suitable candidate for commission: he was modernist in his tastes, he was good-looking, and his youth, Diaghilev imagined, was not only a potential source of some useful publicity, but also suggested tractability. Constant himself was later to comment on this: 'Diaghilev liked young unknowns (like Dukelsky and Sauguet),' he wrote, because 'he had very much more genius than many of the artists who worked for him ... They were merely the gunmen executing the commands of their Capone, who, like all great gangsters, never touched firearms himself.'

Constant, as his tone here implies, was not prepared to settle for a subservient role, but in the very early stages of his acquaintance with Diaghilev there were few signs that it was the one he would be asked to adopt. Soon after their meeting in 1925, when Constant and Morrison played him a *suite dansée* called *Adam and Eve* which they had evolved together, Diaghilev commissioned a ballet from Constant to be performed the following year at Monte Carlo. Constant's only thought was that his career would flourish. His confidence was later boosted still further by news that Diaghilev had declined to commission anything from Walton. (Diaghilev responded to Walton and Morrison playing him some parts of a proposed score by saying that Walton would one day 'write something better'.)

Constant's student days had always been busy; now, as they drew to their end, they became hectic. In the autumn of 1925 he had to fulfil conducting arrangements he had already accepted (*Ruslan and Ludmilla*, a suite from the *Water Music*, pieces by Rachmaninov and Manuel de Falla), as well as working to complete his ballet score and participating in plans for its production. In order to impress his London backers, Diaghilev persuaded Constant to adapt *Adam and Eve* to 'a more "English" subject'. What he suggested (*Romeo and Juliet*) was no more 'English' than the Bible, but Constant nevertheless set about making the required metamorphosis. A passacaglia for the arrival of an angel was removed – it reappeared in his second ballet *Pomona* – and a new finale was added, replacing one that was revised into an overture, *The Bird Actors*, in 1927. Any reluctance with which he greeted Diaghilev's interference was mitigated, to start with, by excited pleasure in his collaborators. The choreography, Diaghilev told him, was to be done by Nijinska (Nijinsky's sister, and by this stage in her career universally regarded as the leading exponent of her craft), and the sets and costumes were assigned to the young painter Christopher Wood. Wood, by the mid-1920s, was renowned as the only English artist of his day who had been accepted by the French modernists. Cocteau, as much impressed by his looks and sexual ambivalence as he was by his talent, had smoothed Wood's way round Parisian artistic circles, and Picasso had recognised him, if not quite as an equal, at least as a genius in embryo. It was Picasso, in fact, who recommended him to Diaghilev, and Diaghilev responded to Wood's appearance and youth (Wood was twenty-four when they first met) as he had done to Constant's: with gusto.

In Diaghilev's eyes, Constant and Wood had a good deal in common. But Wood's letters home from Paris to his mother indicate that their real personalities were widely different. Constant was beginning to take refuge from his uncertainties in boozy conviviality, Wood adopted (Powell said later) the 'self-assured [appearance of] . . . a young stock-broker who has made a pile before the age of thirty'; Constant had veered away from intimate entanglements, Wood was a committed homosexual; Constant drank, so far in comparative moderation; Wood was a heavy and regular user of drugs.

Although these differences soon exasperated the vain and touchy Wood, they did not prevent him from painting a compelling portrait of Constant. It is one of the most famous and revealing images of Constant to have come down to us: wearing a light brown double-breasted suit, blue shirt and red tie, he is seated – legs crossed, his hands loosely holding

each other in his lap – on a straightbacked chair in a windowless room. A large gin bottle and glass stand over his left shoulder; an ill-defined painting hangs on the wall behind him. Constant's pose is unmistakably coy and tense (because of the positioning of his hands and legs) but it is his head that dominates the canvas. In spite of being slightly elongated by Wood in the manner of Modigliani, the head is strikingly handsome – the brown hair (with a small widow's peak) brushed back from a high forehead, the eyebrows straight, the eyes dark and the thick-lipped mouth lavish. It clarifies the facts of Constant's appearance by exaggerating them: in the painting – as in contemporary photographs – he looks clever, sensuous and effeminate, awkwardly reconciling a rather prim-seeming nervousness with the unconventional bohemianism suggested by his shirt and tie and by the gin bottle.

The painting is admiring, but when Constant went to France in December 1925 and January 1926 to meet Wood, Wood wrote carpingly, 'I have this little musician staying. I took a cheap room in a hotel for him so as not to have the bother of him in the studios. He got dreadfully on my nerves and wanted to be with me all the time, which I found rather trying, and had to be very unselfish.' In spite of the progress Constant had been making in English artistic circles, he obviously struck Wood as provincial. To a regular companion of Cocteau and Picasso, he must indeed have seemed so. Yet Wood's reaction, even allowing for this, smacks of queeny intolerance. If Constant even noticed Wood's attitude to him, his likely irritation was washed away in a tide of hero worship: five years later, when Wood committed suicide on 21 August 1930, Constant was distraught.

The adventure of Constant's early work on his ballet was intensified by an important development at home during the first few months of 1926. Almost exactly as he completed the score of his ballet, and shortly before his twenty-first birthday, his mother left to join George in Australia. Disastrous as her visit was, for Constant it meant enjoying a first taste of complete independence. His private life had up to now taken place entirely in his mother's shadow – he had lived with her ever since leaving school – and had been confined to sympathetic male friends or fashionable socialising. Now he had room for other possibilities. If these were not developed at once, it was partly due to the fact that Amy's extreme protectiveness and his father's coldness had made Constant distrustful of anything more than comparatively uninvolved, comradely relationships with the likes of Morrison and Heseltine.

Constant left no record of his views about Amy's departure. Powell,

who was not to meet Amy until her return from Australia in 1929, found her 'a most devoted . . . mother, keeping the household going . . . in the face of untold worries and difficulties' (the difficulties, that is, of George's absence). Any sense that Constant had of her as a stern guardian was mitigated by his need for her stable love and reassurance. For all the enthusiasm with which he had taken up the social opportunities offered by friends like Morrison at the RCM, by the Sitwells and by the Heseltine circle, he had woven the strands of his new and more gregarious life around the still centre of Glebe Place.

When Amy left, Constant's willingness to heed his mother's advice was strengthened by his commitment to his work, and by the demands that it made on his time. In April, a month before *Romeo and Juliet* opened, he became busier still, when the Sitwells embroiled him in *Façade*. At its first private and public performances, Walton's music – a setting of twenty-one poems, spoken through a megaphone from behind a painted screen – had received a dramatically mixed reception, and Walton had since made extensive changes to his score. Since these were introduced during the first and closest years of his friendship with Constant, it is hardly surprising to find Constant involved in them. By the time the revised score was ready for performance – at the Chenil Galleries, Chelsea, on 27 April 1926 – Constant had in fact proved essential to giving the piece its final shape. Initially, Walton had looked on Constant as a rival: in later life he said that when Osbert and Sacheverell had first suggested he might write *Façade*, he had thought 'it was not a very good idea, but when I said so they simply told me they'd get Constant to do it if I wouldn't, and of course I couldn't let that occur'.

By now, Constant was almost as much a collaborator with Walton as the Sitwells themselves. The piece was dedicated to him, he had actually written the first eleven bars of No. 14 ('Four in the morning'), and the entire structure (the twenty-one numbers bracketed in threes) had been based on his recommendation to parody Schoenberg's *Pierrot Lunaire*. To set the seal on his involvement he shared with Edith the narration at the first official performance at the Chenil Galleries – to such approval and with such enjoyment that he was invited to do it again at regular intervals thereafter. (He repeated his performance for the first recording.) 'He always adored doing *Façade*,' Walton said, 'and he maintained that he was by far the best interpreter – in which I agree with him.' Walton admired what Osbert called Constant's 'clear, rapid, incisive, tireless' voice, his 'extraordinary range of inflection' and his ability to reflect the parodistic tone of the piece. 'He would build in imitations of friends,

common acquaintances and so on,' Walton admitted, 'and you never quite knew who he was going to be imitating . . . though one remembers, in the last number . . . he used this curious, rather sinister hissing voice that Professor Edward Dent the Cambridge Professor of Music used.'

A month after first performing *Façade*, Constant crossed the Channel to begin final rehearsals for his ballet. Even before he arrived in Monte Carlo, trouble was brewing. Diaghilev was worried about signs of a deepening and disruptively exclusive attachment between his new star, Serge Lifar, who was to dance Romeo, and Tamara Karsavina, who was to dance Juliet. (Diaghilev hoped, as Richard Buckle says, 'to conjure up once again the Golden Age, when she had so often danced with Nijinsky'.) This can hardly have bothered Constant much, but other developments affected him more directly. For one thing, Diaghilev decided that the ballet would be a 'cocktail' piece – not a straight recreation of the drama, but a story about a company rehearsing *Romeo and Juliet*. For another, Diaghilev rejected Wood's designs and engaged instead two controversial surrealist painters, Max Ernst and Joan Miró, less for their artistic reputation than for their ability to grab headlines. Wood, in Paris, self-defensively told his mother that he was 'thankful to be well out of it', but Constant was furious: he sent a telegram to Nijinska (who had finished her work and departed), complaining about the changes that Diaghilev had made. He also took the more difficult step of remonstrating with Diaghilev. In the years following, several accounts of their row appeared; the fullest was provided by Constant himself in a letter to Amy in Australia, written two weeks after the first night in May 1926:

When I arrived at Monte Carlo I found that the first performance was in two or three days' time and that far from doing the ballet without a decor Diaghilev had chosen two tenth-rate painters from an imbecile group called the 'surrealists'. I cannot tell you how monstrous the decor is, both in itself and as an accompaniment to my music and the choreography of Nijinska. As you know, I am not academic in my point of view about painting but never in my life have I seen anything so imbecile.

Not only that but Diaghilev has introduced disgraceful changes in the choreography, altering bits that Nijinska declared she would never be induced to change. For example at the end of the first tableau, instead of the dance of three women which Nijinska designed, the lovers (who are supposed to be dragged apart) return and do a *pas de deux*, with all the rest staring at them. Can you imagine anything more stupid and vulgar? Of course I sent Nijinska a telegram immediately. I was so upset by all this that I asked for and with great difficulty

obtained an interview with Diaghilev. Instead of giving it to me alone he had Kochno and Grigorieff (the stage manager) with him. To frighten me I suppose. He started off by saying that my letter to him was so rude that he didn't wish to speak to me but as I was young he would pardon me. After a short pause in which I did not thank him I asked why he had rejected Kit Wood's decor. He became very angry and said 'I forbid you to say a word about the decor'. I then tried to speak about the choreography but he said 'I have known Madame Nijinska for twenty years and I forbid you to mention her name in my presence'! I naturally lost my temper and said I would withdraw the music entirely. I am afraid it was rather a dreadful scene but then it is impossible to remain calm with a man like that. The next morning I went to see a lawyer in Nice who told me that unfortunately there was no way out of my contract. I went back to Monte Carlo quite calm by now and went into the salle d'orchestre to listen to the only rehearsal for orchestra alone. To my surprise they tried to stop me getting in and when at last I 'effected an entry' I found all the orchestra waiting but no music put out. After about half an hour a sort of military funeral came in with the score and parts and all during the rehearsal there were two concierges on each side of me to see I did not tear the work to pieces. After the rehearsal the parts were collected, carefully corded and sealed and taken up into a strong room! This ridiculous business has gone on ever since and now Diaghilev has spread the report that I went quite insane at Monte Carlo and had to be watched by two detectives! The orchestra were so annoyed by all this that they made a special point of cheering me at the dress rehearsal and at the first performance. It went down quite well in Monte Carlo but everyone I met thought that the decor spoiled everything as indeed it does. It is not only a gross mistake artistically but a most dreadful blunder from a business point of view as it will be detested in England particularly as everyone knows that Kit's scenery had been accepted.

After the Monte Carlo performance, Kochno came to see me and asked if I had any music for an entr'acte as they thought it would be more 'vivante' if there was a passage of dancers from the classroom to the theatre. I was very annoyed at their trying to spoil Nijinska's work any more so I said I would give him music for an entr'acte but only on the understanding that not a note of it was to be danced. So they have now added a sort of comic march-past of the characters (without music) in very dubious taste and in a style which is the complete opposite of Nijinska's. It is really too sickening about the ballet, at one time it was going to be the best since *La Boutique Fantasque* or *Tricorne* but now it is just a dismal failure as far as I am concerned. What annoys me is for people to tell me that I am very lucky to have had it done at all and shouldn't worry about anything else except the mere notes! When I get back to England I want it to be publicly known that I tried to withdraw the ballet on account of the decor and the changes in the choreography. I don't want people to think I associate willingly with tenth-rate incompetent charlatans like Max Ernst and Joan Miró.

Constant's opinion that the first performance of *Romeo and Juliet* was 'just a dismal failure' is understandable, in view of the interference his score had suffered. (Less sympathetic is the philistine dismissal of Ernst and Miró which his defence of Wood entailed.) Other contemporary accounts are not so harsh as his own. Lifar wrote later 'our success was tremendous: applause and masses of flowers', and the *Musical Times*, too, reported:

some impressions of delicious grace ... The fortunate youth, Mr Lambert, who has such charming people to interpret his first work, is worthy his fortune. He has written a very pretty, engaging, piquant little score. In form it is a suite of short, self-contained numbers. Mr Lambert has not attemped to overbid the other young Diaghilev musicians on points of oddity and crazy surprises. In that remarkable gallery he must, indeed, be esteemed a person of caution and respectful traditionalism. He has recognised that music was not born yesterday.

This is whimsical, but just. Constant was considered unconventional at Monte Carlo – the young Alicia Markova remembers him at rehearsals 'in navy blue short sleeves when everyone else was in something more conservative' – but his score was far from revolutionary. It relies heavily on fashionable contemporaries – the neo-classical Stravinsky (whose *Pulcinella* was given in the same programme), and 'Les Six'. It also contains echoes of more established composers for whom Constant had already professed his admiration – notably Scarlatti and the Russians. It seems likely that this derivativeness was a major reason for Diaghilev's change of heart about the decor: if the music could not be relied upon to spring many surprises, at least the scenery might be made sensational. But even Diaghilev could not have predicted just how sensational. What Ernst and Miró came up with was, the *Musical Times* said, 'certainly as odd as the seeker after novelty . . . has a right to expect': Ernst's first curtain represented a sunrise at sea drawn by a child with a pair of compasses and coloured chalks, and Miró, in his curtain, depicted the moon as a vast blue gramophone record. In Monte Carlo these designs were received with tolerant amusement; when *Romeo and Juliet* transferred to the Théâtre Sarah-Bernhardt, in Paris, on 18 May, they caused a riot.

Constant, once again, provided the most detailed eye-witness account, although he could not avoid being ignorant of the background circumstances. Ernst and Miró were regarded by fellow surrealists as traitors for working for the 'capitalist' Diaghilev. On the first night in Paris, Louis Aragon (in the gallery) and André Breton (in the stalls) led a protest:

As soon as the curtain went up about fifty men got up and blew on pea-whistles while others threw down thousands of leaflets from the roof. For three movements not a single note could be heard. It soon developed into a free-fight, the most extraordinary scene you can imagine; eventually the police were called in and managed to throw most of the rioters out. Everybody yelled out 'Recommencez' so they started again but this time the leader of the surrealists jumped up and started a speech from one of the boxes, the only word I could hear was 'Merde' at the end. The performance didn't really quiet down until the second tableau. Naturally the ballet was cheered at the end, but that was chiefly reaction.

If the protest against the scenery had been because it was bad I should have heartily sympathised, but as the motive was a purely political one, I was furious, particularly as the protest being of an aural nature merely spoilt the music and left the scenery untouched. At the second performance everything went quite calmly, the orchestra (under Desormière) were much better than at Monte Carlo where Marc Caesar Scotto who conducts like a porpoise in a rough sea didn't help matters much.

The commotion turned the ballet into a triumph. It played to full houses throughout its Paris run, even though the music and decor were far less controversial than the uproar suggested. By the time *Romeo and Juliet* reached London, and opened at His Majesty's Theatre on 21 June, conducted by Eugene Goossens, its reputation as a revolutionary piece had preceded it, and (to Diaghilev's and his backer Rothermere's relief) assured its commercial success. In an enthusiastic review of the first night, the *Yorkshire Post* reported that Constant's 'modesty is such that he was unable to obtain a seat . . . and it was from "Standing Room Only" that he came after repeated calls for the composer to take his share of the applause'. Modesty was not the only reason for Constant's reluctance. His irritation with Diaghilev had only slightly abated since Monte Carlo, and he had broken news of its cause to the Press. Almost every notice contained some covert reference to his row with Diaghilev. The *Sphere*, for instance, accused Diaghilev of having 'taken the music written by Mr Lambert in order to express something entirely foreign from the Romeo and Juliet ballet', and the *Daily Telegraph* said that Constant 'has done his bit, so to speak, in an operation over which he had no control'. Attention to the circumstances surrounding the ballet was so great that consideration of its strictly musical qualities was severely curtailed.

Constant was indeed 'fortunate' to catch the headlines with a piece of such variable quality as *Romeo and Juliet*. In a sense, though, its weaknesses are indistinguishable from its strengths: the score is alert to

prevailing modernist musical tastes, yet is unable to decide how thoroughly it wants to assimilate them. It wavers uncertainly between challenge and traditionalism. The main reason for this seems to have been Constant's mixed emotions about its principal influence: Stravinsky. In later years, and especially in his book *Music Ho!*, Constant was to condemn Stravinsky. Morrison convincingly explains the cause:

The whole section [in *Music Ho!*] called 'Post-War Pasticheurs' has too much of the exaggerated indignation of the reformed sinner castigating his own erstwhile lapses, and . . . in repudiating the early influence of Stravinsky with so many ardent protestations he did not draw on his own mature judgment but merely succumbed with equal blindness of personal vision to the influence and opinion of his admired and close friend Cecil Gray.

Constant's repudiation of Stravinsky implies a stern judgment of *Romeo and Juliet*. For all its youthful defects, the ballet does in fact contain signs of the promise he was soon to fulfil. The last movement is particularly energetic, and the use of a siciliana – a dance, the form of which derives, as the name implies, from Sicily – for the lovers' *pas de deux* shows considerable skill in its construction of a complex form. *Romeo and Juliet* also augured well for him in more general terms: it introduced him to the ballet world at an impressionable age, and the lessons he learnt were to be developed throughout his life. He was, in spite of his anger with Diaghilev, immensely and lastingly influenced by the Russian's tastes and methods. Although he wrote no more music for Diaghilev, and often criticised his later artistic policy, Constant never allowed the sour experience of *Romeo and Juliet* to detract from what he always admitted was Diaghilev's 'genius as a producer'.

In private conversation, Constant mingled purely professional judgments about Diaghilev with more personal views. Powell, for instance, remembers that Constant

bore little ill will, though he always insisted that one of the great impresario's highest claims to fame was in being the only known Russian, of either sex, to restrict himself to only one sex. Lambert would also complain that Diaghilev's habit of greeting a newly arrived guest with the words 'Will you have one drink?' always got the evening off to a bad start.

It is a remark which, in its humorous way, sheds light on the kind of life to which Constant returned when the razzmatazz surrounding *Romeo and Juliet* died down.

When Amy left for Australia, she had hoped that Constant and

Maurice would diligently continue to further their careers. But as soon as her back was turned, Maurice had decided to ignore his parents' counsel, married Morrison's sister, Olga, on 27 July 1926, and moved to Sussex Place. Glebe Place, Amy's home since 1913, was sold immediately before her departure, and Amy recommended Constant to stay with a family friend in Cheyne Place (just round the corner in Chelsea) called Mrs Travers Smith. Mrs Travers Smith's main claim on his interest was that she had worked as a medium. An entire play, she claimed, had been dictated to her by Oscar Wilde's ghost, encouraged, no doubt, by Constant's fellow lodger Thomas McGreevy (like Mrs Travers Smith a friend of W. B. Yeats', and eventually Director of the National Gallery of Ireland). In later life Constant was to develop a genuine fascination with the occult, but now, subjected to evenings with the ouija board, his sense of the ridiculous got the better of him. After a matter of months, he decided to move. Mrs Travers Smith was not altogether sorry to see the last of him – Constant had incurred her wrath when he and Walton had argued with one of her pekineses.

Constant took two rooms in 59 Oakley Street, nearby in Chelsea and close to the notorious Pier Hotel. The house gave him a base for a life which contrasted dramatically with his brother's. Whereas Maurice quickly achieved a respectable stability (Olga was, according to John Pettavel, 'rather trodden on, and very doggy and horsey, reflecting Maurice's anti-artistic side'), Constant sought out a society that was independent and raffish. In the short time since Amy's departure, Constant had begun to rejoice in his new freedom, and to follow the lead given by his fashionable friends in cultivating a life that suited his burgeoning reputation as a dashing young composer. His circle, as yet, was not wide, but he was determined that it should grow. He tried to develop his friendship with Wood, who was in London in July, but Wood was put off by Constant's idolising, and spurned his advances. 'That wretched Lambert turned up,' Wood wrote to his mother. '[He] always brings bad luck, he is an ass also.' Constant continued, more successfully, to dance attendance on the Sitwells, accompanying them in the autumn to Paris with Walton, where they met Cyril Connolly, who only remembered the episode for its disagreeableness: 'We all got very drunk and one of them started to insult me, saying I was Desmond MacCarthy's bum boy.'

With more proven friends such as Morrison and Gordon from the RCM, Constant also kept up the brisk pace of concert-going that he had set before leaving for France. In September, at the Queen's Theatre, he

heard what he had been waiting four years to rediscover: the black jazz musicians The Blackbirds. Florence Mills was top of the bill, but instead of sharing the stage with Will Vodery's 'Plantation Orchestra', she was accompanied now by the black American 'Pike Davies Orchestra'. The earlier reception given to Florence Mills in London had, with the exception of a discerning few, been lukewarm. Now it was rapturous. In chic London, 'Blackbird parties' became *de rigueur*. According to Powell, Evelyn Waugh – who was to become an admiring acquaintance of Constant's during the war – 'on issuing a minor invitation, would add: "It's not a party – there won't be a black man."' The Blackbirds' bitter-sweet exoticism instantly established itself as a principal part of what we now think of as typically smart Twenties life – 'the vertiginous Twenties', as Constant himself called them. But the musicians' influence on him was more than merely fashionable. Morrison goes to the heart of the matter:

Although the later Blackbirds were more sophisticated, Florence Mills still retained an essential simplicity and childlike quality as when, in the earlier 'Plantations', after the pungent, yet softly caressing quality of the coloured voices had plunged one straight into the right atmosphere, she made her first entrance, dressed (rather like a pantomime Dick Whittington) in conventional stage rags with a bundle on her shoulder, singing of the sleepy hills of Tennessee.

As Morrison suggests, the stimulus that Constant derived from the Blackbirds was to narrow the gap between strictly 'serious' music and popular music. Jazz rhythms could be adapted to invigorate what Constant felt was the jaded contemporary English music repertoire, and could combine technical skill with emotional appeal. These were thoughts that he had entertained since he and Morrison had first heard Florence Mills sing in 1922, but the rediscovery of her genius coincided with a chance to put his observations into practice. When *Romeo and Juliet* closed, he found more time on his hands than he had previously known, and he used it to compose. Over the next year he wrote no fewer than five of his most important pieces – and the best of them owed a profound debt to the Blackbirds.

The rate of his production is remarkable by any standards; in view of the fact that this period coincided with his first serious attempts to earn his living, it is prodigious. In order to supplement the small allowance he received from Amy he gave piano lessons and – over the next several years – wrote an enormous amount of musical journalism for journals such as the *Nation and Athenaeum*, the *New Statesman*, *Apollo*, the *Daily Chronicle*, the *Daily Telegraph*, *Figaro*, the *Listener*, *Night and Day*, the

Radio Times, the *Sunday Referee* and the *Saturday Review*. Ever since leaving school, Constant had found that writing came as easily to him as composing, and as a student at the RCM he had read (and visited galleries) as enthusiastically as he had attended concerts. In this he had always had his mother's support. Although the gift for writing which she herself had shown in Sydney as a young woman had been crushed by her devotion to George, she had remained an avid reader, and Glebe Place had a large supply of books. The classics were especially plentiful: Dickens, George Eliot, Hardy and Conrad, whom Maurice held in particularly high regard.

Constant's style of writing, from the first, was confident, decisive and witty – just as likely to illustrate a musical point by reference to a novelist or painter as to compare one composer to another. It was this diversity which Powell admired, and which he stressed in his evocation of Constant's journalism: 'Intellectually speaking, Lambert moved with perfect ease in the three arts, a facility less generously conferred by nature than might be supposed from the way some people talk . . . He had a natural gift for writing, a style individual and fluid, that brisk phraseology so characteristic of those musicians able to express themselves on paper.'

None of Constant's tasks as a journalist interfered at this stage with his composing. On 27 October Constant's pastoral movement *Champêtre* was performed at the Aeolian Hall, conducted by Guy Warrack – only to be absorbed, the following month, into a divertimento in seven movements. This had been written in Glebe Place and with the Sitwells in Renishaw during the previous summer, and Constant clearly felt dissatisfied with its apparent fragmentariness. When his former fellow-lodger in Cheyne Place, McGreevy, heard the divertimento at the Chelsea Music Club, he also expressed doubts about the piece, and recommended that Constant look up the legend of Pomona and Vertumnus in the hope that it might provide the larger and more coherent structure necessary to turn the music into a ballet. The story appealed to Constant (it describes the wooing of Pomona, the Goddess of Fruits, by Vertumnus in a succession of disguises), and he quickly joined the divertimento to the passacaglia that Diaghilev had removed from *Adam and Eve*, to create *Pomona*.

The advance that this ballet represents on *Romeo and Juliet*, as Morrison says, can conveniently be pinpointed by comparing the sicilianas in the two pieces. Both provide the music for the central *pas de deux* for the two dancers, and both encapsulate the central emotional statement:

The one in *Romeo* has quite a charming, slightly acid flavour, but it seems composed in unrelated snippets and the harmony, apart from one or two attractive touches, is static and lacking in a sense of progression . . . The Siciliana in *Pomona*, on the other hand, is a real gem, with a haunting melancholy . . . One hears for the first time certain melodic shapes which were to appear in various forms and disguises all through the rest of his music, and nothing is more utterly personal to his style than the phrase of three notes descending from the seventh that comes twice right at the end of the piece.

Pomona is more romantic than anything Constant had written previously. English critics, though, did not get a chance to appreciate this until *Pomona* was staged in London late in 1930. Shortly after its completion, the score was requested by Nijinska, who had been impressed by Constant's gifts, and by his loyalty to her during the row with Diaghilev, for production at the Colon Theatre, in Buenos Aires, where she was working. It was first performed there, with her choreography, on 9 September 1927.

Constant's second hearing of the Blackbirds came too late for the score of *Pomona* to benefit from their influence. His next work, *Music for Orchestra*, completed in the early part of 1927, is similarly unaffected in all but the most general terms – and also had to wait some time (until 14 June 1929) for its first English performance. Its two-part symphonic movement – an introduction and an allegro of an elaborately contrapuntal nature – is, as the critic Edwin Evans said, 'in the strictest sense absolute music'. It is an exercise in form and technique which seeks nothing so personal as the elaborations of mood shown by Florence Mills. It is clever music, and although Constant himself liked it, its purely stylistic bravura is never likely to attract much more than a specialist interest.

Judging by the works written at the same time, its main purpose was to reassure him that he possessed sufficient formal skill to contemplate a subject which was more emotionally demanding. As if he knew that he needed further preparation for this challenge, he first took the precaution of testing on a small scale the style that he wanted to adopt. When Florence Mills died, tragically young, the year after her London triumph, Constant wrote in her memory a short *Elegiac Blues*. It is an appropriately referential and melancholy piece, proceeding by wry phrases to a climax which recalls the Plantation fanfare he had heard in 1923. When it was broadcast by the BBC on 23 July 1928, the programme note politely affirmed that it covered exactly the range that Constant wanted:

The price of the white man's domination of the Blackamoor is a tribute which is being paid to negro influences by Western poets and musicians. This debt is being

discharged in a common medium of exchange, neither black nor white, for which American slang provides the word 'blue'. From one side comes the gaiety of a simple people, the barbarous rhythm of jungle civilisations, the homesickness of the captive slave carried into a far country; from the other the consolations and harmonies of Western religion, European irony, and the weariness of sophisticated life in modern cities.

In the two other works that Constant produced during 1927 he again tried to create an impression of vigorous inclusiveness. The first, which he began late in 1926, is his setting of eight poems by the eighth-century Chinese poet Li Po. These poems, in a translation by Shigeyoshi-Obata, flattered the contemporary taste for all things oriental. (Bliss had already set 'The Women of Yoeh', and Warlock and Van Dieren had both written music to accompany poems by Li Po.) The songs gave Constant an ideal opportunity to reconcile different cultures and to dramatise diverse aspects of his character. His social inclinations are reflected in the setting of a poem about drink, and his introspective romanticism in other poems about lost love. The voice part in every one is cunningly inflected, always stopping just short of candid melancholy and assuming a declamatory tone which gives the impression of emotion palpably felt, but always guarded. The songs' beauty is inseparable from their economy, and their sadness from their high spirits.

This combination of feelings is strikingly similar to the balance that George had tried to achieve in his paintings. And just as George only realised his ideal occasionally, Constant also found it impossible to hold together diverse elements in his personality for long. The *Li Po Poems*, in their almost-miniaturist way, must therefore be counted among his finest achievements. So too must the piece he wrote next – a piece which was immediately recognised as Constant's popular masterpiece: *The Rio Grande*. *The Rio Grande* is, with *Façade*, the music which most perfectly reflects the character of the period in which it was written – determinedly fun-loving, and modestly iconoclastic, yet instinct with a sadness which suggests that its freedoms are an exception to the general rules of life. Squeezed between wars, and begun in the aftermath of the general strike, it cannot help but contain an element of escapism in its jollity, and of guilt in its melancholy.

Throughout his life, Constant's creative imagination worked best when he set himself to write choral rather than purely orchestral music. Other people's words provided both a release and a disguise for his deep feelings. 'It's no exaggeration to say,' he once proclaimed, 'that the

greatest English music has always been literary in the best sense of the word, just as English poetry has always laid great stress on the purely musical value of sound as apart from sense.' The Sitwells' poetry, though even at the time nobody wished to pretend it was 'great', proved his point. Both Edith and Sacheverell had interpreted the modernists in such a way as to let sound and rhetoric, rather than close observation and argument, carry the weight of meaning in their poetry. It was this quality, as well as the debt of friendship he owed them, which made him turn to Sacheverell's poem 'The Rio Grande' – hoping, no doubt, to build on the success that he had had as a student with 'Serenade' and 'The White Nightingale'. In the event, the first concert performance of *The Rio Grande*, on 12 December 1929, was more than simply a success: it was the popular triumph of his career as a composer.

The Rio Grande, scored for solo piano, chorus and orchestra, animates the poem's evocation of a carnival in a South American port. There is no justification in the text for Constant's central musical idea – the interpolation of North American jazz rhythms – beyond its sense of exotic otherness; and yet, as Shead implies in his description of the score, this is never a cause for concern:

The work opens with an insistent rhythm on strings and percussion which leads to the entry of the chorus on the words 'On the Rio Grande they dance no Sarabande'. After a climax the opening phrases return and there is a piano cadenza of great brilliance, with interjections by side-drum, tambourine, castanets, Viennese Block, tom-tom, cowbell, triangle, tenor drum, bass drum and cymbals. A quiet section in habanera rhythm follows, beginning with the words 'The noisy streets are empty and hushed is the town'. This is succeeded by a scherzando passage led by the piano and a further climax. After a second piano cadenza, shorter than the first, a solo alto voice rises out of the chorus and brings the piece to a quiet end, with the piano gently and nostalgically recalling the opening theme.

In later life Constant was to resent the fact that he was best known as the composer of *The Rio Grande*, largely because its jazz allegiances obscured his other loyalties and intentions. It is, for instance, easy to detect the influence of Stravinsky's percussive style in the opening bars, and, elsewhere, to catch echoes of Delius and Liszt in the harmonies. (Constant refers to bars 188 and 189 of the 'Gretchen' movement of Liszt's *Faust Symphony* three times, covertly introducing, in Morrison's view, 'the symbol of a central female figure, as necessary to him as Gretchen was for Faust', and expressing 'more completely here than

anywhere else in his music . . . the passionate longing he always felt for exotic beauty, and his perpetual sense of the beckoning wonder of distant and unobtainable horizons'.) Yet for all his occasional protests, it would be wrong to deny the predominance of jazz techniques in *The Rio Grande*. It is they that embody the originality of the piece, and they too that most clearly express Constant's temperament. Morrison, to whom the piece was dedicated, tells us that 'It was always Constant's idea that the piano should take the "I" of a novel, a central narrator interpreting and reflecting upon the varied episodes that occur in the course of the work.' In *The Rio Grande*, the piano's syncopated rhythms, its sudden rushes and delays, its thrilling combination of 'blatancy and sweetness', powerfully convey those disparate elements that had already begun to create a complicating variety in his social life.

This variety, and the dangers it held for his work as well as his character, increased rapidly as this marvellously creative period of his life reached its climax. It was licensed by a combination of coincidences and conscious choices. With his mother still away in Australia, his brother preoccupied with the early happiness of marriage, and his own self-confidence boosted by the sudden success of his work, Constant decided to assert his independence. He gave up his rooms in Oakley Street in the spring of 1928 (shortly after his twenty-third birthday – he had lived there for eighteen months), and moved away from Chelsea (which his family had always regarded as home in London) to Bloomsbury, to begin a new and unfettered life. Powell was later to say that Constant 'knew all about the Bloomsbury lot', but it was not their proximity that attracted him to the district. In fact his artistic and social principles were deliberately designed to challenge the Bloomsbury ethic associated with Virginia Woolf, the Bells, Lytton Strachey, *et al.*, which he regarded as inverted and precious.

The rooms Constant took were on the second floor of 189 High Holborn, above the Varda Bookshop. He was to stay there almost exactly a year. Once installed, he set about ignoring his famous neighbours and seeking out instead the company of those now associated – although it confounds any clear sense of London geography – with Fitzrovia. The Varda Bookshop itself was one of their regular meeting places, many being drawn less by the chance to buy books than by the certainty of seeing its owner – 'the beautiful and stormy Varda', as Powell called her – who had formerly been one of C. B. Cochran's 'Young Ladies'. Constant had little to do with her directly, though he did sometimes stand in for her behind the till, and 'complained that he always struck a day when all the

lunatics in London had been let out to buy their books.' But he enjoyed the bookshop's raffish trappings – the prostitutes who hung around in the back yard after closing time; the sign in the lavatory at the back of the shop which said 'Ici s'écroulent en ruines/Les triomphes de la cuisine'.

Constant left no descriptions of the bookshop, but Powell – who was soon to begin visiting him there regularly – later suggested that it distilled the 'idiom of the Twenties'. Varda, says Powell,

was unfortunately incapable of finding tolerable any known pattern of existence, [but could be] wonderfully funny, [even though] desperation with life was her accustomed theme. She was, indeed, unique in her kind. One of her favourite stories was of a former charwoman of hers, who had remarked to a subsequent employer: 'That Mrs Varda wore herself out thinking of others.' Lambert was pretty comfortably situated at the Varda Bookshop flat, but at an early stage of our knowing each other would complain that he had been kept awake until a late hour by Varda's friends carousing in her sitting room, especially by prolonged singing of 'The Hole in the Elephant's Bottom'.

One of the reasons for Constant's comfort at the Varda was the fact that he was able to combine a devil-may-care existence with a kind of defensiveness. Although his appetite for convivial and boozy friends was growing fast, he remained reluctant to form any very intimate relationships – particularly with women. One of the reasons why he liked the bookshop was that Varda had 'a male sense of humour'. The writer Peter Quennell, who lived on the floor above him, remembers that the world Constant created for himself was one in which coarse-grained ebullience was the order of the day:

So long as I knew him, with his shapeless overcoat, his rough scarf and his heavy stick . . . Constant remained a hard-working, hard-living and almost invariably hard-up bohemian, whose powerful voice, whether he discussed the arts, sang a favourite folk song, or recited a lubricious limerick, penetrated to the farthest recesses, and startled the drowsiest habitués of a London bar parlour. He would have been perfectly at home in Paris during the Romantic 1830s.

None of this should be taken to suggest that Constant's preference for bluff male company indicates that he was living a life of a jovially repressed homosexual. In spite of spending a great deal of his life (particularly when he began working for the ballet) surrounded by homosexuals, he seems always to have remained undeviatingly heterosexual. His childhood – at home with his strong-willed mother, and at school with the company only of other boys – bred in him a

shyness, increasingly disguised as ebullience, which never entirely left him. It encouraged a tendency to adopt diehard male chauvinist attitudes – of alternating between disparagement of women, and idealisation of them.

Shortly after moving in above the Varda Bookshop, both attitudes sprang into relief. The idealisation took a particularly graphic form. When still living in Oakley Street in the spring of 1928, he had become infatuated with the Chinese actress Anna May Wong. After first seeing her on screen, he became fixated by her exotic, aloof beauty and took every available opportunity to watch her. His adoration was entirely passive: he never wrote to her, and only met her once, in March 1929, at the first night of *A Circle of Chalk*, when she gave him the brush-off. Initially, the infatuation benefited him: it gave him the emotional impetus to write the settings of the Li Po poems, which are dedicated to her. Gradually, however, her influence became less productive. He drank, in her honour, quantities of Chinese wine, which he kept on top of his piano in earthenware jars. It may have helped to assuage his passion by making him drunk, but it also had another less welcome effect: severe constipation. Eventually, when his passion had subsided, he 'made over his Chinese cellar' to Earp, Powell tells us. 'After the first draught, Earp enquired in his piping voice: "Rather an aphrodisiac effect?" Lambert replied he had never noticed that. Earp thought the matter over. "Perhaps it coincides with my annual erection," he said.'

Although Constant might not have liked to admit it, the Fitzrovian society he had recently joined was directly descended from the one his father had helped to create in London twenty-five years earlier. Towards the end of the nineteenth century artists of all sorts, but especially painters, had gravitated either to Chelsea or to the part of London he now thought of as home, and the community they had created was both a self-sufficient entity, and the forerunner of diverse subsequent groups. Sickert's Fitzroy Street Group, for instance, founded in 1907, was transformed after a short while into the more famous Camden Town Group. By the time Constant went to live at the Varda Bookshop late in 1928, various pubs and cafés had become established meeting places for the subdivided and complicated world of Fitzrovia. The Wheatsheaf (where Augustus John introduced Dylan Thomas to Caitlin), the Fitzroy Tavern, and the Burglar's Rest were particular favourites, and their names flicker through the biographies of most of the painters, writers and composers working in London during the 1920s and 1930s: Evelyn Waugh, William Walton, Thomas Earp, Dylan Thomas, Elisabeth

Lutyens, John Lehmann, Louis MacNeice, Nina Hamnett, Constantine Fitzgibbon and Nancy Cunard. Popular as these pubs were, the place generally recognised as Fitzrovia's principal focus was the Restaurant de la Tour Eiffel, in Percy Street, run by a Viennese called Rudolf Stulik. Here, in 1914, the magazine *Blast* had been launched by the Vorticists, the group of modernist artists led by Ezra Pound and Wyndham Lewis, and in the following decade succeeding waves of artists had ebbed and flowed through its doors – the Camden Town Group, the Bloomsbury Group, and the Sitwells. Nancy Cunard, speaking for them all, called it 'our carnal spiritual home'.

In subsequent years – in his masterpiece *A Dance to the Music of Time* and in his memoirs – Powell has emerged as the subtlest analyst of Fitzrovia, and the most remarkable portraitist of its leading characters. From his flat in Shepherd Market – a self-contained, seedy district just off Piccadilly, comprised mainly of shops, 'down to earth' pubs and brothels – he scrutinised the progress of his fellow-rakes with beady-eyed vigilance. 'The Market's air . . . perfectly suited my own post-Oxonian mood,' Powell said later, and so did Fitzrovia proper. The milieu that he wanted, and found, was one in which artists met regularly to eat and drink together, and discussed each other's work with a mixture of seriousness, hilarity and bitchiness. It was a closely-knit, self-consciously eccentric 'alternative' world – sometimes mutually supportive, sometimes incestuous, and determinedly in love with its own raffishness.

Because Powell's principal interests were literary, his first excursions into this fashionable demi-monde were designed to bring him into the company of other writers. But true Fitzrovians made a point of mingling with artists of all sorts, and within a very short time he encountered Constant. In the autumn of 1927 the publishers Duckworth – for whom Powell was working – had invited their new recruit to ask Constant to 'contribute something with a musical bearing' to a series they were planning. Although this came to nothing, both men found their interests and attitudes were closely compatible. So, judging by their surviving correspondence, were their senses of humour. When not together in London, exploring its architecture, meeting in bars, going to films, they bombarded each other with jokey cards, and even collaborated on a few joint comic ventures. A 'Fragment from a Satire against Scotland', for instance (actually an attack on the Royal Academy of Music):

> Here tottered, tipsy e'er the day begun
> That Prince of bad composers H. MacCum

Here sat, in impotent and senile frenzy
That doddering old soaker A. Mackenzie
And here reclines, in ultimate blue ruin,
That gruff and surly toper J. McEwen.

Constant, Powell wrote, 'was absolutely prodigal with his wit. He never dreamed of postponing a joke because the assembled company was not sufficiently important.' But there was, of course, a serious side to their friendship as well. Powell later referred to Constant as 'the first contemporary of mine I found, intellectually speaking, wholly sympathetic . . . The people I knew at Oxford who practised the arts did so with a self-consciousness of which Lambert . . . was totally free.' In terms of specific influence, Powell – having no musical expertise – had less effect on Constant than vice versa. Constant attacked any trace of artiness or pretension in the young novelist's work, and encouraged him to develop the kind of subversion-within-orthodoxy which became a hallmark of Powell's ironic technique in *A Dance to the Music of Time*. Powell's debts to Constant are paid in that novel most obviously via the character of Hugh Moreland. Powell has been careful to say that Moreland is not exactly modelled on Constant:

'Moreland', friend of the Narrator (himself of equally mixed origins), is a musician, wit, sometimes exuberant, sometimes melancholy. Dark, rather than fair, he has the Bronzino-type features of Lambert's 'blue coat' portrait by his father. There the resemblance to Lambert fades, invention, imagination, the creative instinct – whatever you like to call it – begins. If I have been skilful enough, lucky enough, to pass on an echo of Lambert's incomparable wit, then 'Moreland' is like him; in other respects the things that happen to 'Moreland' approximate to the things that happened to Lambert only so far as all composers' lives have something in common.

This sort of caginess is understandable. Art, Powell means to say, is never an exact transcription of life. Yet Powell's adaptation of the experience and ideas that Constant gave him cannot (and does not want to) obscure Moreland's importance. Moreland is continually presented as a good companion, a *bon viveur*, an energetic and generous friend, and as a source of wisdom. 'So Moreland always said' is a phrase which recurs again and again in the novel, and what he says is the guiding principle of its hero's behaviour.

Constant's friendship with Powell was exceptionally deep, but the grounds for their mutual sympathy were not especially remarkable

Except in one respect. Powell, like Constant, was keenly interested in the occult, and much more knowledgeable about its lore and language at the time of their first meeting. Constant, although always ready to laugh it to scorn, was a willing pupil. He confined his interest, most of the time, to its innocent aspects – relishing ghost stories, and readily accepting evidence of the supernatural. His son Kit remembered that 'He was certainly haunted, but by kindly ghosts. He'd point out a bath mat that had been flung across the room – proudly, though I used to suspect he'd done it. If there was a haunted room he'd sleep in it.'

Occasionally this interest in spooks became more elaborate. Powell remembers an evening in the late 1930s, when he played planchette with Constant and two other friends, Gerald Reitlinger and Wyndham Lloyd:

Suddenly planchette began to move, then to write. The 'influence' transcribed itself in a long sloping eighteenth-century hand, announced itself as Mozart. Neither Reitlinger nor I being much up in musical matters, we asked Lambert to suggest an appropriate question for the great composer.

'Enquire who was his favourite mistress.'

We did so. Planchette wrote a reply.

'*La petite Carlotta.*'

'When did this love affair take place?'

'*A Napoli en 1789.*'

I think that was the date given, but could not swear to the exact year, which was certainly in the 1780s, so far as I remember.

'What was she like?'

'*Comme une guenon.*'

This last word had to be looked up, no one present sure of its meaning. The French dictionary gave: 'she-monkey, ugly woman, strumpet'.

Some of the subsequent replies were in English, some in French, some in German: the last language known to Reitlinger, but not at all to myself, nor to Lambert, who, as the only musician present, seemed in some manner telepathically concerned . . .

The statements about *la petite Carlotta* were noted down, and in due course Lambert looked up the story of Mozart's life to see if the name occurred there. These efforts were unproductive, except in establishing that Mozart could not possibly have been in Naples on whatever date was specified.

Powell has several other stories in his autobiography of a more persuasive kind – one, in particular, about catching with Constant a spectral tram which seems to have entirely convinced them both of a life beyond their understanding. Constant's willingness to believe in such

things obviously reflects a romantic and impressionable side to his personality. It also expressed, less with Powell than with other friends he made or kept up with at this time, a strongly subversive streak. In the company of Heseltine, this could reach dangerous proportions, especially as Constant began to meet – through Heseltine – a number of people whose iconoclastic and potentially self-destructive natures were more fully developed than his own. Foremost among these was the composer and music critic Cecil Gray, whom Constant met during the late 1920s, on one of his visits to Heseltine. When Constant first encountered him, Gray had already ensconced himself as a member of several distinct (but overlapping) artistic circles – Fitzrovian and otherwise. He had, for instance, 'belonged to the D. H. Lawrence circle', according to Powell.

A plump bespectacled rather unforthcoming Scot, Gray possessed considerable acuteness over and above musical matters. He was comfortably off, married (in the event, several times), with a small neat house in Bayswater facing the Park. Unfit for military service, he had inhabited a Cornish cottage near the Lawrences during the first war. He was (as indicated by his marital career) a thorough-going heterosexual, indeed somewhat intolerant of inversion, but was fond of telling the story of how, one afternoon in Cornwall, a knock had come on his cottage door. He opened it to find Lawrence standing there. 'Gray,' asked Lawrence, 'how long have you been in love with me?'

Constant and Gray were drawn to each other initially, as Gray explained in his autobiography *Musical Chairs*, by powerfully sympathetic musical opinions. Like Constant, Gray derided the English folk tradition, admired the mildly modernist experiments of Van Dieren and Walton and the more revolutionary work of Debussy and 'Les Six', and treated any discussion of art with bluff jocularity. This approach masked – as it did increasingly for Constant himself – what Gray admitted was a 'naturally gloomy and sombre temperament', and to avoid depression he relied heavily on the diversions of drink and sex. His life was littered with affairs and – as Powell says – he was married several times: one of his daughters, Perdita, was the result of a liaison with the poet H.D.

Gray's licentiousness made him a problematic friend for Constant. According to Powell, Gray 'hero-worshipped Constant', but he set him an increasingly dissipated example. Opinionated and yet easily led, sensual yet self-chastising, ebullient yet morose, he was ideally equipped to sustain and damage Constant in equal proportions.

The blame for this lies less with Gray himself than with Heseltine, whose spokesman Gray effectively became in his music criticism and

elsewhere. Gray's submission to Heseltine is typified by his willingness to share Heseltine's interest in sinister aspects of the occult. He was prepared, as Constant never was, to set aside the constraints of practical good sense. Gray's daughter Pauline remembers – without being able to provide details – that her father practised black magic, and that he was sympathetic to Heseltine's view that if 'one were to make use of a certain magical formula believing in it implicitly, in order to obtain something which one knew to be otherwise unobtainable, that one's powers of attaining it would be increased and one could almost inevitably attain it'. Gray and Heseltine usually created these formulae to inflict distress on an enemy, or to help further an amorous adventure, but Constant could never quite share the spirit in which they worked. The (to him) ridiculous figure of Aleister Crowley loomed too large in his mind's eye, and any efforts he made to invoke supernatural aid were usually devoted to hilarious ends. Another friend, Tom Driberg, remembered:

Constant had what he believed to be an occult ability to raise . . . happenings. I personally can vouch for an occasion in Albany Street, Camden Town, when Constant challenged those present to put on a show. Well, no one could. 'Watch this,' he said, and round the corner out of the turning out of Regent's Park came a compact group of Negroes of both sexes dressed from head to foot in tartan and all riding bicycles. 'The MacGregor tartan,' said Constant with great satisfaction.

Other forms of Heseltine's and Gray's influence could not be laughed off so easily. During his Oakley Street and Varda Bookshop time, Constant began to drink more heavily than he had done in the early days of his friendship with his 'Mephistopheles', and to put away large quantities of brandy, as well as the beer and wine he had originally preferred. During one of the attempts he made later in life to dry himself out, he 'went down' to a bottle of wine and one or two pints of beer a day; in the late 1920s his evening consumption gradually rose to the level it maintained from the late 1930s on: most of a bottle of brandy, at least one bottle of wine, and several whiskys and pints of beer at lunch time.

Constant started to drink seriously partly because he was encouraged by the example of his friends and partly because he associated boozing with the bohemian manner he wished to adopt. During his student days, his commitment to music and his adherence to the discipline imposed by living with his mother had curbed his appetite for fast living. Furthermore, his willingness to work had been fed by an innate shyness – he had simply not had the confidence to lead a widely gregarious life. But as a young man about town, free of Amy's control while she was away in

Australia, his shyness had changed its nature. Instead of cultivating his finer feelings in solitude, and translating them into music, he hid them in public behind the mask of a *bon viveur*: witty, risqué and outspoken. His drinking strengthened this mask, enabling him to become the 'character' that his friends loved. But they realised that drink did more than boost his confidence as a social performer. It also suggested a darker, self-doubting and potentially self-destructive side to his character. They began to suspect he was worried about maintaining the standard of work he had so far managed to produce. He was still only in his mid-twenties, and had launched his career as a composer so early, and so prestigiously, that the prospect of striving to develop his talent still further seemed to intimidate him. If his friends had been more scrupulously affectionate, they would have found a way to warn him that drink was likely to allay these worries all too completely. Instead of providing temporary relief from them, it might obliterate them altogether by destroying his inclination to compose at all.

Those of Constant's friends who wanted to justify his drinking in ways which disguised its psychological causes, were easily able to come up with reasonable excuses. Several explained that his 'passion for dark and smoky clubs' first developed because they were the only places he could hear jazz played. But he quickly created a large network of bars and restaurants which catered for more than merely professional needs: the back bar at the Café Royal (which his father had also frequented), and the regular Fitzrovian haunts: Pagani's Restaurant, near the BBC, and Castano's ('Foppa's' in *A Dance to the Music of Time*) at the junction of Manette Street and Greek Street, where 'a plateful of minestrone was likely to knock the customer out for the next course'.

Constant's cronies quickly settled into a more-or-less regular group during his mother's absence in the late 1920s: friends like Morrison and Gavin Gordon from his student days; the Heseltine acolytes (Cecil Gray and Tommy Earp in particular); his fellow-Sitwellian Walton; and Fitzrovians like Powell and, later, the composer Alan Rawsthorne and the painter Michael Ayrton. It was an ostentatiously male group. One exception was Elisabeth Lutyens, who regarded Constant as 'the best of all friends', and another, Elisabeth Frank, gave one of the most revealing glimpses of Constant's drinking. Going into a bar she found him slumped drunkenly at a table. '"Hello Betty. Where are you going?" he asked. "To Hammersmith, to hear you perform in *Façade*,"' she told him. When she arrived at the concert Constant was in place, and performed immaculately.

Constant's closest companions were musicians, but poets, painters and even politicians also drifted in and out of his circle. Several of these painters – the camp surrealist Edward Burra, for instance, and John Banting 'also surrealist in tone' (Powell says), 'his shaved head, curious laugh, recalling the madman playing with the piece of rope in the ballet *The Rake's Progress*' – were to collaborate with him in the future. Another acquaintance, with whom painting also constituted the bridge to friendship was Jack Lindsay, the son of George's friend and contemporary, the Australian artist Norman Lindsay. Jack Lindsay used occasionally to meet Constant in a pub off Museum Street, and remembers being taken by him to see a melodrama called 'The Executioner's Daughter'. Lindsay was a committed Communist, and since Constant's political interests had crumbled since his schooldays, and were never again developed to a point of great interest or articulacy, his relationship with Lindsay did not last for long. Wyndham Lewis, though, to whom Constant was introduced by Gray, proved a more rewarding friend. Ever since Lewis had allied himself with the modernists during the early 1910s, he had acted as a kind of acerbic conscience to England's artistic life. Constant, to start with at least, was honoured by the interest Lewis showed in him, and challenged by Lewis's ferocious intellectualism.

Ayrton gave a glimpse of their later meetings:

Wyndham Lewis had regular ten o'clock meetings [in his house in Ossington Street, Notting Hill], but unlike Whistler, p.m., not a.m., and lasting into the early and even late hours of the morning, during which the oracle, talking like the Bailiff in his *Childermass*, would hold forth without intermission on any and every subject under the sun, moon and stars, to an entranced and highly select audience which, in addition to myself, generally included Constant, Earp, William Gaunt and R. H. Wilenski.

Powell, who saw Constant and Lewis together a good deal, gives a more detailed and less idealistic picture of their relationship. 'Lambert seems to have been one of the few from his age group whom Lewis was from time to time prepared to meet. Although within reason an admirer of Lewis's work (the writing more than the pictures) Lambert always treated the relationship as rather a joke, often telling stories to illustrate Lewis's perpetual nervous tension.' Constant did not treat the relationship as so much of a joke that he refused to sit for Lewis, whom he regarded as 'one of our greatest draughtsmen', and Lewis's fine pencil drawing of 1932 makes a fascinating contrast with Christopher Wood's painting of six years earlier. Wood's shows a slim seated figure, with a

beautiful high-domed head; Lewis's is a close-up head and shoulders, and shows the eyes as expressionless (they look like miniature gramophone records), the face already fleshy, the winged collar (which he wore when conducting afternoon concerts) and abstractly patterned tie suggesting both decadence and glamour. Its sharply defined but nevertheless slightly bloated sensuality shrewdly anticipates the compellingly debauched figure who appears in Ayrton's portraits of the mid-1940s.

Lewis's portrait suggests that he detected and disapproved of a certain wastefulness in Constant – and, as time passed, an element of distrust blighted their friendship. 'Lambert has got something against me,' Lewis told Gray in the late 1930s, and he was right: vigorously as Constant defended Lewis's gifts, and sincerely as he tried to understand Lewis's politics ('personally I am extremely anti-Fascist but I am far more interested in the reaction of a man of genius to Fascism than I am in the careers of the innumerable artists manqués and poetasters who have embraced Communism'), he could never get used to Lewis's rarefied seriousness, nor to his own consequent sense of guilt at being strongly addicted to the pleasures of drink and entertaining company.

Constant's regular circle of friends assiduously provoked and happily forgave these pleasures. Indeed, as Constant's success as a musician increased, so did his reputation as a brilliantly entertaining companion. The willingness with which he allowed his friends to take up time that he might otherwise have spent composing may reflect a degree of insecurity about the value of his work. More certainly, it indicates his enormous and straightforward relish for the good life. The hours he spent simply sitting around talking and drinking are ample proof of this, and so, more memorably, is the effort he put into practical jokes, word games and elaborate conceits to keep his company amused. Tom Driberg, whom he met through the Sitwells, was a particularly creative partner in these frivolities. From their first meeting in the 1920s until Constant's death, they stayed with each other frequently – in each other's houses, usually, but also at Tickerage Mill, in Sussex, the home of Driberg's friend the painter Richard Wyndham – energetically swapping jokes, stories, and in particular, limericks. Their principal endeavour was to create a series of limericks about bishops with double sees, and most of these partake of the filthy-but-clever-schoolboy spirit which dominated a good deal of his social life. (Single sees were not altogether disqualified. One of Constant's best limericks appears in Driberg's *Ruling Passions*: 'The Bishop of Central Japan/Used to bugger himself with a fan,/When taxed with his

acts/He explained: "It contracts/And expands so much more than a man."'

Constant took a special pleasure in peculiar names. A list of cathedral organists he knew included Peasgood, Waters, Alcock and Ball; and a top-ranking Siamese minister amused him by being called Bum Suk. These kinds of jokes depend, always, on convivial company; relayed cold, they sound, as his publisher at Oxford University Press rightly said, 'often rather childish in a way, which was interesting because he was such a sophisticated person'. His fascination with bizarre incidents or errors in newspapers yielded slightly less embarrassing results. 'I wish you'd seen the early edition of the *Manchester Evening News* today,' he wrote to a friend in the late 1940s. 'The printer must have been blind . . . under "Public House Scene" you've got an account of some old lady's funeral, under "A Loss to Manchester" an account of someone exposing himself.'

These anecdotes hardly amount to an adequate explanation of why he was regarded by all and sundry as a great and brilliant wit. When attempting to recreate the powerful impact he had on friends in his heyday, we have to imagine the timing and rapidity of his delivery, the tolerance that alcohol gave his audience, and his immense and generous energy. By the end of his twenty-fourth year, his reputation as a *bon viveur* was secure. The stories that flesh out that reputation – many, like those above, dating from the 1930s and 1940s – suggest an easygoing confidence which was less fully achieved than it seemed. In later years, many of his friends were to confirm that the sociable ebullience he showed as a young man was fuelled as much by a wish to disguise self-doubt about the value and durability of his music as it was by natural high spirits. With a handful of memorable exceptions, the bulk of his most original and durable compositions had been completed by the beginning of 1928. He was twenty-two.

Three

Constant hoped that in the spring of 1928 he would be able to strengthen his grip on the fame he had achieved when the season of Diaghilev ballet finished in London. On 27 February, following negotiations with Harold Rutland, *The Rio Grande* was given its first performance at the BBC (Savoy Hill) with Angus Morrison playing the solo piano part. The response was little more than polite, as it was again when the programme was repeated on 23 July. Constant was disappointed, but not to a degree which prevented him from working to find other outlets for his ambition. In the same month as this second performance, he conducted a ballet for the first time – *Leda and the Swan* at the Apollo Theatre, choreographed by the young Frederick Ashton. His intuitive sympathy with the multiple demands of conducting ballet immediately impressed Ashton, who arranged for Constant to collaborate, later in the year, with the Ballet Rambert.

Before undertaking this new responsibility, Constant had old and enjoyable loyalties to fulfil: the International Society for Contemporary Music held a Festival in Siena in September at which Walton had been invited to conduct *Façade*. As well as taking most of the Sitwell clan with him, he invited Constant to recite the text, and Constant jumped at the chance of a holiday, as well as the work. Osbert Sitwell's reminiscence of the trip indicates that the sense of holiday got the upper hand on at least one occasion – during the day of the Palio, the famous Siennese horse-race:

Just as the Campo had been cleared to make the race-course and to allow the horses to enter, the spectators were lined up behind ropes, in addition to cramming themselves into every door and window, William and Constant arrived, after what had plainly been a good late luncheon. They entered the Campo with something of the air of two young bulls entering the arena, and so impressive were they that the Italian crowd, always quick to seize the chance for a demonstration, began to cheer.

As soon as these junketings were over, Constant returned to exploit the opportunities that Ashton had created for him. Constant's work on *Romeo and Juliet* had persuaded him that ballet had a special appeal for him, by allowing him to indulge all aspects of his creative personality. He also felt that as Diaghilev aged and his company ran through its declining

years, its principles needed to be followed. The chances of seeing ballet in England at this time were scanty, and Constant set about making good the lack with crusading zeal, spurred on not only by strictly artistic challenges, but by the immense rapport he discovered with others who shared his interest. Ashton, in particular, he recognised as a kindred spirit. Their capacity for hard work was similarly enormous, and so was their sense of fun. Constant, who used to refer to the witty, fastidious Ashton as 'that old Proustian character', seized upon him as a confidant as well as a collaborator, both learning from and encouraging his sensuous, instinctual understanding of dance. Ashton's attitude to the 'greatest' modern choreographer of all, George Balanchine, illustrates his own beliefs, and crystallises the reasons why Constant found him so sympathetic. Balanchine, Ashton said, 'tended to be a bit dry, refusing to have any emotion in things, which came partly from the influence of Stravinsky. Whereas I don't like dancers to be just mechanical and I can't do anything unless I feel.'

The same qualities were obvious in other pioneering balletomanes whom Constant now met for the first time. On Ashton's recommendation, he was introduced by the dancer Marie Nielson, in the autumn of 1928, to Ninette de Valois. De Valois, who had been a member of Diaghilev's pioneering Ballets Russes, had with Marie Rambert already made magnificent efforts to establish ballet as a respectable and indigenous English art. Her small company regularly performed at Sadler's Wells, and Marie Rambert's attracted loyal, enthusiastic audiences at the Ballet Club. In December, the month after Constant had accompanied performances of *Mars and Venus* for the Ballet Rambert at Hammersmith, he entered upon the first of what turned out to be many collaborations with de Valois. (This first collaboration was *Les Petits Riens*, at the Old Vic, for which he arranged music by Mozart.) To start with, according to Marie Nielson, de Valois found Constant 'exceptionally shy' and although '*very* good looking – what you call a beautiful boy – very *young* looking', also 'very vague'. This shyness may have been partly created by de Valois's reputation: at this stage in her career, as later, she was formidably strict and aloof, as well as admired. During the war, for instance, the dancer Beryl Grey (who like other members of the ballet world would always call de Valois 'Madame') affectionately but firmly insisted that she would rather risk the dangers of the Blitz than share a house with de Valois in comparative safety.

As *Les Petits Riens* extended its run, de Valois changed her mind about Constant: 'most efficient', she reported. In later life she generously and rightly went much further:

Constant Lambert, the architect of English ballet music, was a figure prominent amid all our triumphs and disasters. The domestic picture conjured up by memory [towards the end of his life] shows him in the ever-shabby overcoat, complete with his stick, a score under one arm, a tattered newspaper peeping from his pocket, and the inevitable cigarette spraying his waistcoat with a cloud of fallen ash. Yet resolute and stalwart is the same figure on the rostrum, attired for many evenings of those early years in a morning coat that had once been the property of his father. I have seen him wield his baton on occasions both great and small, with an intensity that no circumstances diminished. . . In [him] lay our only hope of an English Diaghilev.

This last remark is a crucially revealing one. Like Ashton, de Valois recognised at once that Constant possessed the breadth of interest necessary to galvanise English ballet, and make it coherent. To a large extent, and in spite of their famous row, he consciously adapted his innate gifts to follow Diaghilev's example. When Diaghilev died, on 19 August the following year, the way was clear for him to assert the identification that his new colleagues encouraged. For the rest of his life he promoted the same insistence on the unity of diverse arts that Diaghilev had advocated, the same belief that 'choreographic pattern should be derived from the form and mood of the music and not imposed on them', the same sense of pageantry, and the same desire to shake traditions. 'In all future histories of art,' Constant realised, 'the name of Serge Diaghilev will occupy a position equal in importance to that of any composer or painter of our time . . . It is entirely due to Diaghilev that ballet, from being an outworn and conventional form, with little or no intellectual or emotional significance, has been exalted to the level of the finest drama or opera.' His own name, for similar reasons, deserves a position of similar importance.

It took time, in a country so comparatively ignorant of ballet, for Rambert, de Valois, Ashton, and their new ally to create their audience. As the nucleus slowly formed Constant had the consolation of finding time to promote his own career as a composer. Late in 1928, the scores of *Eight Poems of Li Po* (Piano Version), *Elegiac Blues* and *Pomona* (with a cover designed by John Banting) were published, and in 1929, as well as writing a great deal of musical journalism and conducting occasionally for the BBC, he also began work on a piano sonata.

Two years earlier, with the completion of *The Rio Grande*, Constant had been recognised by the musical cognoscenti as a composer of exceptional promise. 1929 was the year in which the general concert-

going public recognised his achievement. It was also the year in which the Fitzrovian bar-crawling fraternity saw his independent spirit harden. The reason was not that he felt a new surge of enthusiasm for his free-wheeling life, but that he suddenly had to protect and justify it. In August, after her bitter three-year absence, his mother returned from Australia. The letters she had sent Constant from Sydney had been properly proud of his success as a composer and conductor, but had shown considerable anxiety about what she called his 'stale and unprofitable' daily existence. She had been especially worried by his obsession with Anna May Wong. Constant knew that if he was to continue his rake's progress, he would have to do so in spite of his mother's disapproval.

Had Constant cared less deeply than he did for Amy, her disapproval would have meant little to him. But when he welcomed her back to London he was dismayed by the damage that her Australian adventure had done her. George's snubs and cold-shoulderings had turned her from a loving and hopeful woman into a wounded and severe one. Constant realised that he would have to help. When she found a house to buy – 42 Peel Street, in Notting Hill – he gave up his rooms in the Varda Bookshop and moved in with her. Compared to her previous home in Glebe Place, the new house was pitifully cramped – a converted 'working man's cottage' of grey brick, on a slope, with only a tiny garden and two storeys of small rooms. After the years in Chelsea, it made her feel that her life in London had come full circle: Peel Street is only a short walk away from where she and George had first taken lodgings in England together, in St Petersburgh Mews.

Constant's decision to live with his mother shows genuine and affectionate concern for her welfare, as well as a surprising degree of dependence on her. He was, after all, now well launched as a composer. The fact that he was spared having to pay rent (he supplemented the income that Amy received from the sale of George's paintings whenever he could) is not enough to explain his move. The role he had elected to play, of surrogate husband, coincided with one he performed instinctively, that of the reliant child. But this reliance was by no means complete and absolute. The comical immaturity of his feelings for Anna May Wong might have shown that he still found it difficult to form loving relationships with women other than his mother, but he had no such problems with men. No matter how blackly Amy frowned on his commitment to the friends he had made in her absence (he managed to conceal from her, at least for a while, the amount they drank together), he steadily refused to let her compromise his independence.

As far as professional commitments were concerned, Amy gave him all the support she could. Shortly before her return, their pace had begun to quicken. On 14 June his *Music for Orchestra* had received its first public performance. It was received, if not with unqualified praise, at least in some quarters with recognition of its originality: 'A jolly essay in fugato writing, syncopated rhythms and the newer counterpoint,' the *Daily Telegraph* said, and the *Daily Express* called it 'a work of great genius'. Elsewhere, its jazz rhythms caused predictable explosions of rage from reactionary critics: 'boring and not even melodious', one wrote, and another called it 'utterly unmelodious and meaningless'. Insofar as Constant wanted to *épater les bourgeois*, this divided response pleased him. But it also led him to feel that his work of the previous three years was unlikely to guarantee him universal appeal. The mixed reaction to the *Eight Poems of Li Po*, first publicly performed on 30 October, confirmed his fears.

On 13 December, however, the first concert performance of *The Rio Grande* in Manchester, with the Hallé Orchestra's conductor Hamilton Harty taking the solo piano part, proved him sensationally wrong. Neville Cardus, in the *Manchester Guardian*, set the tone: 'It succeeded,' he wrote, in 'transfiguring jazz into poetry . . . [The] jazz elements, which are largely confined to the extensive piano part and the percussive section of the orchestra are balanced by other more reflective yet vivid writing for mixed choir, which with interpolations for solo alto, suggests a development from ideas first used with varying success by Delius in "Appalachia" and the "Song of the High Hills".' The following day, when the work was repeated with the same players at the Queen's Hall, the London critics were less detailed, and even more fulsome. The *Daily News* ran as its headline 'Sudden Fame for Young Composer', the *Daily Chronicle* called it 'an extremely clever and attractive work', and the *Daily Express* reported that 'just before the music began, the other young-man-who-has-something-to-say came up and said: "Don't miss a second of this. It's great. Much better than I have ever written." That man was Mr William Walton.' (If this is true, it is, as Shead points out, more significant than appears at first. Walton's Viola Concerto had been performed only two months previously.)

The reputation of *The Rio Grande* spread wide and fast. Almost immediately it became a regular feature at the Proms; a record was made of it in 1930; and it was performed at New York and Boston in 1931, where the *Herald* critic wrote that 'seldom . . . has there been so instant, so spontaneous, so prolonged, so tumultuous recognition of an

unfamiliar composition signed with an unfamiliar name'. Constant realised – and if he had not, there were always finger-wagging critics like Ernest Newman to remind him – that this kind of sudden celebrity had its dangers. Although only twenty-four years old, he was quite experienced enough to comprehend the fickleness of public taste. Encouraged by his friends in general and his mother in particular – she made a habit of attending as many of his concerts as she could afford, as soon as she returned from Australia – he set about trying to consolidate his success.

The following year, 1930, began just as he hoped: with another controversy. The Piano Sonata, which he had begun composing in his rooms above the Varda Bookshop, and finished in Toulon on a short holiday before the first night of *The Rio Grande*, was performed by Angus Morrison on 3 March at a BBC concert of contemporary music at Central Hall, Westminster. (It was later played frequently, and to great acclaim, by Constant's friend Louis Kentner.) *Façade* was performed in the same programme, and Constant's work was frowned on, in some quarters, for being associated with Walton's teasing piece. The *Daily Express* headlined its evening as 'a broadcast of fantastic inanities', and the *Musical Times* called it 'studiedly displeasing'. Elsewhere, as Constant was beginning to anticipate, praise was equally forthcoming. 'Like Stravinsky before him,' one reviewer wrote of the score, 'Mr Lambert shows that when a cultivated musician takes to ragtime, the professional ragtimes are made to look like mere children at the game.' The remark is a just one, in its emphasis on the work's similarities with Constant's other recent compositions, and in the attention it draws to an element of sophisticated deliberation. Several other writers remarked on the same thing, and – with the notable exception of the reviewer in the *Musical Times*, who called it 'purely intellectual preoccupation with style' – they recognised it as an aspect of its modernist sympathies.

They were not to know that this 'ragtime' element was as much a defence for Constant as a positive experiment. In spite of the encouragement he gave to and received from Ashton to convey strong feeling in his work, his preoccupation with the techniques of jazz inhibited the emotional content of his compositions. His habit of writing in a way which turned aesthetic theory into practice, rather than registering a direct lyric appeal, closely paralleled his father's approach to painting. It also closely resembled his brother's academic attitude to sculpture – not that Maurice would have noticed this himself: his interest in music had waned since leaving school, and he and his wife rarely turned out to listen

to Constant's work. Critics who attacked the Piano Sonata for its cold-blooded cerebration were, in effect, pointing out an inherited failure to admit powerful emotions. In the excitement of the moment, though – that is, in their pleasure at encountering something genuinely original – the Piano Sonata's first audiences forgave its sense of impersonality. The jazzy contrapuntal style persuaded them that the truce Constant had called between so-called popular traditions had given English music the life it needed to stand comparison with recent European works.

Constant would never have expected absolute security to accompany his new-found fame. He knew his own disruptive appetites too well. But even he could not have anticipated how swiftly and unsettlingly the pace of his life would change once his compositions of the late 1920s had made his name. In March 1930 he returned to Manchester for another performance of *The Rio Grande*; in April he recited *Façade* at a Festival of Arts in Bath, and in May he began making plans for a concert of British music to be performed in July in Bad Homburg. Reasonably enough, he felt that he deserved a holiday before these preparations began in earnest, and he took himself off to the South of France – to Marseilles and Toulon, which he had first visited when rehearsing *Romeo and Juliet* four years earlier. Not for the first time, he cast a veil over the way in which he intended to behave, when he warned his mother that he was about to depart.

The brief visit that Constant had made to Toulon in the winter of 1928 when writing his Piano Sonata had confirmed his initial impression that the place ideally suited his taste for the exotic (and preferably oriental) low-life. It is a preference which took a large number of different forms – comparatively innocent ones like his passion for Anna May Wong; profoundly creative ones, like his attraction to the world conjured up by the poem 'The Rio Grande'; and simply disreputable and self-forgetting ones like his use of the Hôtel du Port et des Négociants, Toulon, as a place for discreet fits of moral turpitude. In Constant's circles, Toulon was acknowledged as a centre of decadence – the designer and dancer William Chappell described it as 'our dream town, naughty and cheap' – and its reputation had been widely broadcast by many of Constant's friends and contemporaries: Cocteau, for instance, Christian Bérard, Edward Burra and Darius Milhaud. Insofar as Constant's visits to Toulon can be reconstructed with any accuracy, they seem to have consisted largely of drinking, whoring and sightseeing, with occasional bouts of reflection and composition. On two or three later occasions he took with him a black cigarette girl called Laureen Sylvestre from one of his favourite

London night-clubs, the Nest, in Soho. (This club, which was popular with West Indians and specialised in jazz, is described by Anthony Powell's wife Lady Violet as 'raffish-smart, bohemian, mysterious and extremely smoky'. After one of her two visits there, Lady Violet said, 'I had to have my dress cleaned because it smelt so appalling'.)

Laureen deserves more than a passing mention – partly because Constant was genuinely fond of her, and partly because her relationship with him explains a mystery that Shead creates but does not solve in his biography. Rumour has it, Shead says, that Constant had an illegitimate child with a black woman. There is, in fact, no basis for this rumour. Laureen, who lived in Conway Street, was an amusing, poorly educated woman, of much firmer principles than many of those with whom she surrounded herself. She refused to work at The Bag O'Nails nightclub, for instance, because the girls there were expected to sleep with customers as well as work as waitresses. In 1945 Laureen had a daughter, Cleopatra, and Constant has been supposed by some to be the father, largely because he agreed (with Tom Driberg) to act as a godfather. It was a charitable and not a guilty role – and he fulfilled his duties conscientiously, regularly writing to Laureen, taking her out, and doing what he could for Cleo. (He tried to get her cast as the Indian Page in *The Fairy Queen* in 1951, but his efforts came to nothing.) Laureen, in return, could be relied on, he said, 'for information about night life', and for uncomplicated affection. When Constant died, Laureen wrote to Driberg: 'Oh, Tom, I feel so very unhappy . . . Constant and I always had a joke about my wearing a hat which I hate and I always said I hated to attend funerals because I would be compelled then to wear one. I feel so bewildered.'

Constant's visits to Toulon with Laureen did not take place until the late 1940s, but the place was still much the same as when he went there in the summer of 1930. A letter he wrote to Powell during the earlier visit entertainingly conjures up its flavour:

My dear Tony,

As I write I am surrounded by so many negroes and dwarfs that I can hardly believe I am not in the heart of Old Bloomsbury. In fact the only difference between Marseilles night life and a Great Ormond Street party is one of expense. One feels that at any moment the homely figure of Dick Wyndham [the painter and friend of Driberg's] may emerge from a bordel or that Wadsworth [Edward Wadsworth, another painter] will be seen trying to retrieve his hat from some old hag or other. All the female whores look like Greta [Dick Wyndham's wife] and all the male ones like Brian Howard . . . You will excuse the shaky handwriting I'm sure – it's all I can do to hold a pen these days. My obsessions are becoming

more pronounced I'm afraid but not quite so narrow. I feel rather like Walt Whitman – all races, all colours, all creeds, all sexes, etc.

I find smoking Maryland has had an aggravating effect on my vomiting – fortunately nobody minds a bit of retching here.

Constant clearly intended to return to England having submitted himself to a regime of alcoholic and sexual promiscuity which would refresh him by exhausting him. But no sooner had he reached London than news came which sobered and saddened him: a telegram arrived from Australia to say that his father had died in Sydney on 28 May. Amy's grief, in spite of the cruel indifference that George had shown her so often and for so long, was heartfelt and protracted. She added George's name to his father's gravestone in Brompton Cemetery and, for the rest of her life, devoted herself to his memory – defending his reputation as his work fell into obscurity. Maurice, she realised, had already assimilated George's beliefs in the values of technical excellence and diligent craftsmanship. She feared that Constant, being more her creature than his father's, would be reluctant to learn them. In fact, he had too much of his father in him easily to spurn his example: Constant's emphasis on skill, his love of show, his preference for male companions, and his bluff approach to his art, were all things George could have recognised and approved.

No amount of encouragement from Amy could convince Constant that his father had been properly paternal. George, admittedly partly out of financial necessity, had packed Constant off to boarding school at an early age, and later, when he might have helped to steer him through adolescence, had left the country. George's letters to Amy from Australia contained virtually no reference to Constant beyond occasional expressions of pride in his musical achievements – nothing at all intimate, and little which shows interest in his personal welfare.

Such as it was, Constant's relationship with his father survived on a diet of mild disparagement. When he and Maurice were children, George squashed Constant's budding aspirations by pronouncing Maurice the natural musician, and when Constant was a student at the Royal College of Music, what Amy calls 'a fevered state of mentality was intensified by [his] expressed determination to follow music as a profession'. This 'mentality' was more than simply the result of George's conviction – already evident in his relationship with Maurice – that the life of a dedicated artist was exceptionally difficult and demanding. It was also exacerbated by a feeling that Constant's commitment to music took him beyond the pale of parental guidance and control. Although George

shouldered remarkably few fatherly responsibilities, he liked to present himself as a source of wisdom and authority. A letter he wrote to Constant shortly before Amy's arrival in Australia is a pathetic witness to his bossiness:

Dear Constant,

You are now sworn to Music and all the history that the letters suggest to me. Quite a space. Mathematical construction is the human triumph. The space, the margin, the by-way for experiment. This is the great hope and goal today of the good student.

But remember that it is better to bring your records back to humanity than to be killed by the adventure . . .

In the entire bulk of George's correspondence, the only remark which comes anywhere near showing actual concern for Constant is one which unfairly denigrates Amy, seeks to exempt himself from a fault by admitting to it, and predicts a weakness in Constant without suggesting that he might do anything to help him overcome it. '[The boys] have both from you and from me (more from me),' George had told Amy in 1924, 'a temperament which can easily go off the rails into sordid vice. Art is a very slight remove from the great and vital force which sways a *people* sometimes to excess and National ruin. Makes harlots of potential Mothers, drunkards of clever men.' Constant, in turn, treated his father as a remote acquaintance. When the famous dancer Robert Helpmann arrived in England from Australia three years later, and introduced himself to Constant as an admirer of George's, Constant told him, 'Oh yes, I'm supposed to be the son of the famous painter. He was a show-off.'

Constant's concern for his mother was sincere, even though he did not share her sorrow. Since her return from Australia she had turned her small house in Peel Street into a home she was used to running single-handed, and he had no doubts that the routine of her days would continue exactly as they had done before George's death. But the depth of her sadness impressed him, and he discussed the possibility that Maurice and Olga should move in with her. Maurice, whose career as a sculptor was not yet so financially secure that he could afford to pass by the security of living with his mother – who was entirely dependent on money received from the sale of George's paintings – agreed. He and Olga regularly stayed in the cramped spare room at Peel Street, and helped Amy pay the bills as and when they could. Over the next few years, and in spite of her children's care for her, Amy was to wear the marks of her grief increasingly clearly. Her hair was soon completely grey, she continued to

wear the same style of frumpish frocks and earphone hair-dos with which she had greeted George in Sydney in the late twenties, and her manner – as Constant's son Kit was soon to find – became more and more severe.

Before the new routine of Amy's life with Maurice was established, Constant took himself off. She realised that he could not be expected to sacrifice his career to her welfare, but also suspected that, like her late husband, he was reluctant to stay closely involved with emotionally charged and complicated circumstances. More relieved than anxious, Constant fulfilled his plans to visit Bad Homburg in July.

There is no indication that his bereavement dampened his spirits when he got there. He conducted *Music for Orchestra* and Boyce's Symphony No. 4 which he had transcribed from the original parts, as well as works by Arthur Bliss, Bax, E. J. Moeran and Walton. 'The concert went quite well,' he wrote to Powell on 17 July, 'in spite of the fact that German players are actually far worse than English. The platform was draped with the flags of the British Mercantile Marine, most of them upside-down. A week with Harriet Cohen [the soloist] is like being put next to one's bête noire at school lunch and knowing you have to wait until the end of term.'

Once his duties were over, he continued to show no signs of grief. On the way back to England (where he was due to conduct the première of Berners's ballet *Luna Park* in a C. B. Cochran review later in the month), he stopped off in Paris to entertain himself. Unexpectedly he – a Fitzrovian abroad – bumped into Lytton Strachey – a Bloomsburian abroad – about similar business. They met on the banks of the Seine, just after Constant had bought a mildly pornographic book called *Slavey*, by Gerald Reitlinger's brother, written under the pseudonym 'Captain Teach'. Constant, says Powell,

understandably did not wish this recent acquisition to his library to fall under Strachey's satirical eye, and make a good story for spreading about Bloomsbury. Concealment was fairly easy in the street, where he tucked the book well under his arm.

Strachey now complicated matters by inviting Lambert back to wherever he was staying in Paris. Even then *Slavey* might have been kept hidden without too much difficulty, had not something not at all bargained for by Lambert taken place; the making by Strachey of a determined physical pass. Nevertheless, all was well. Lambert managed to repulse Strachey – too concerned with his objective to think of other things – and escape without the detection of what appears to have been Captain Teach's sole publication under that penname.

Back in London, the production of *Luna Park* brought an unexpected benefit: it revived Constant's friendship with Christopher Wood, who had designed the sets. But the friendship was destined to last a cruelly short time. On 21 August, a month after the ballet opened, Wood threw himself under a train at Salisbury station. It was a death which affected Constant more profoundly than his father's, and its impact was deepened, four months later, by the suicide of another and even closer friend. On 17 December, Philip Heseltine gassed himself. Constant looked round quickly for distractions which would prevent him from examining too closely the implications of these disasters: he arranged a memorial concert for Heseltine to be performed at the Wigmore Hall the following February, agreed to undertake more journalistic work for the *Nation and Athenaeum*, and sternly addressed himself to the task of writing a piano concerto in Heseltine's memory.

He had, in fact, made a start on this at Marseilles earlier in the year, but its nature was dramatically changed by his sorrow. 'My musical St Vitus Dance gets worse and worse,' he wrote to Patrick Hadley, making light of his feelings. 'My new concerto has now got out of 11/8 only to get into 13/8.' It is an appropriately angry and jagged work. The use of jazz rhythms is again conspicuous, but their effect is never allowed to become sweetly lyrical. Instead, as Shead says, 'violent harmonic clashes and pungent instrumentation' make for 'an abrasive sound which Lambert makes no attempt to soften'. In the overture (allegro) this tone is created with hectic restlessness by the piano, and its melancholy implications are developed in the intermède (andante recitando) by a bluesy trumpet, then reasserted again before the finale begins. This, in Shead's phrase, is Constant at his 'most profound': the initial 'heavy descending chordal phrase', the interruption of the 'hollow sound of the temple blocks, and the final fortissimo reiteration of the main theme [after which the music begins to die away inconclusively and darkly] . . . recalls, not Delius nor Heseltine nor even Kurt Weill, but – though in technical terms the two are poles apart – the blues singing of Bessie Smith.'

Working on the Piano Concerto gave Constant a degree of solitary relief from his distress. He also devised more public means of assuaging his feelings. Well before the deaths of Wood and Heseltine, he had realised that his ballet conducting would be likely to lead to more permanent involvement with dance, and in the autumn of 1930 the opportunity to prove his commitment at last presented itself. Arnold Haskell, who had been conspicuous in his promotion of ballet in England, gives the necessary background:

Diaghilev died in August 1929 and everybody thought and wrote that ballet had died with him. I happened to be lunching the following autumn with Philip Richardson, editor of the *Dancing Times* . . . and we both of us decided that we would not take this defeatist view . . . we would try and get together all the dancers who – British dancers, and there were many of them – had made a name under Russian names, and try to keep together this wonderfully loyal London ballet public. And so we called a meeting of all the people, musicians, painters, dancers, whom we thought would be interested, and founded what we called the Camargo Society, after the first French modern ballerina.

Haskell was lucky, as well as shrewd, in assembling his committee of management. Edwin Evans, the music critic and former friend of Diaghilev's, was appointed chairman; Maynard Keynes treasurer; and Keynes's ballerina wife Lydia Lopokova, Marie Rambert, Anton Dolin, Ninette de Valois and Phyllis Bedells were all made founder members. Their aim was to perpetuate the principles on which Diaghilev had run the Ballets Russes, by giving, Haskell says, 'four performances of ballet a year [at a West End theatre] to a subscription audience . . . to convince a small section of the public, but a very important section, that British ballet could be something important, something really creative'. Constant was impressed by these aims, and allowed himself to be enlisted as resident conductor.

It is hard to overestimate the importance of the Camargo Society's contribution to English ballet. De Valois said that existing ballet companies regarded it as 'our stage society', and its formation paved the way not only for the Sadler's Wells Ballet, but for the Royal Ballet itself. Everyone on the committee, obviously, deserves to take credit for this, but it was generally agreed at the time that no one deserved more praise than Constant. Maynard Keynes, tellingly, later called Constant 'potentially the most brilliant person I have ever met'. 'Without Constant's enthusiasm and knowledge,' Walton wrote, 'not only of music but of choreography and decor, and his instinct for the theatre, the whole project might have fallen to the ground. Indeed, it may be that he will be best remembered by this, his great contribution to the theatre of our time.'

Walton was right in fact but wrong in his prediction. Constant is now only rarely acknowledged as a founding father of English ballet. To start with, though, his role was clear for all to see, as a general arbiter of taste and method, as a conductor, and as a contributing composer. The centre piece of the Camargo Society's first programme in the New Cambridge Theatre on 19 October 1930 was the first English stage performance of his ballet *Pomona*, choreographed by Ashton, with Anna Ludmilla and

Anton Dolin in the leading parts. Although the rather rarefied and cool atmosphere of the score, reminiscent of the slow opening of *Music for Orchestra*, gives it a feeling of thinness, the production was a resounding success. 'The modern treatment of old forms like the Passacaglia and Rigadoon,' the *Nation and Athenaeum* said, 'was delightful, the scenery and costumes showed that John Banting is one of the most brilliant English decorators, and Mr Frederick Ashton's choreography was most imaginative ... We were able for half an hour to forget that Diaghilev was dead.'

This was precisely the sort of praise that the Camargo Society hoped to attract, and it laid firm foundations for their continuing success. Over the next few years they performed works by a wide range of composers – interweaving well-tried classics like *Giselle* and *L'Après-Midi d'un Faune* with work by unfamiliar names: Grétry (*Cephalus and Procris*), Milhaud (*La Création du Monde*), Walton (*Façade*). A large number of distinguished artists were hired, in the Diaghilev tradition, to design the sets – Sickert, for instance, McKnight Kauffer and William Roberts. Constant became the Society's leading voice in organising the ballets to be performed, and made himself responsible for administrative matters as well as for the more glamorous business of aesthetic arbitration. While he helped to bring the Society fame (the Prince of Wales and the Duke of York attended a performance on 15 December 1931), there was not much that he or anyone could do to bring them fortune. In spite of Keynes's best endeavours, and although performers were miserably paid (in Vaughan Williams's *Job* for instance, in 1931, the dancers got £1 a performance, and the orchestra a total of £100), the costs of each production meant that a company of the Camargo's size could not expect to survive indefinitely.

It would not in fact have lasted as long as it did without help from its sister organisations, the Ballet Club and the Vic-Wells Ballet. Even the briefest summary of their relationship indicates that a pooling of resources was inevitable. At the Old Vic theatre and at the Sadler's Wells theatre (in Rosebery Avenue, Islington) opera and drama were played on alternate fortnights, and although all the ballet classes and rehearsals were held at the latter, every other two weeks the dancers had stage calls and performances at the Old Vic. As if this disruption were not unsettling enough, the rehearsal time itself was regularly under threat: when the *corps de ballet* were not actually dancing, Mary Clarke tells us in her history of the Sadler's Wells Ballet, they were required to assist in the theatre – as train-bearers, pages, 'bodies in sacks in *Rigoletto* or bewitched princes in *Lohengrin*'.

Constant had high hopes of the Camargo Society, but its initial success did not allow him to see how absolutely the ballet would change, govern and disrupt his life. The enormous scope of his abilities – as composer, arranger, conductor, and adviser for designs – suited him ideally for working in ballet, but in personal terms the same diversity could look like a series of complicated tensions. De Valois, for one, also realised (now and later) that while his role as the ballet's artistic conscience was invaluable, his hatred of pomposity infuriated certain quarters of the music business. 'He didn't know the meaning of the word "guile", had no vanity, and a lovely sense of humour which meant that he mixed with everybody. [But] he wasn't able to keep in with the people he should have kept in with. He was terribly funny about the hierarchy of the music world and the hierarchy didn't really appreciate it because it was so near the bone.'

De Valois implies here a duality that Constant actively encouraged in himself: he was devoted to art but deplored artiness; he cherished self-expression but abominated self-promotion. Gray, in *Musical Chairs*, memorably describes this mixture of qualities in a passage which, according to Ayrton, was 'a source of great satisfaction' to Constant: 'Duality is as characteristic of his private personality as of his public artistic activities, for he exhibited in himself a disconcerting blend of the most opposite extremes imaginable – a *fin de siècle* Frenchman with morbid faisandés tastes and a bluff and hearty roast-beef-and-Yorkshire Englishman; Baudelaire and Henry Fielding combined, Purcell and Erik Satie, Ronald Firbank and Winston Churchill.' Constant obviously thought that this combination guaranteed a healthy inclusiveness, and a determination to make art seem part of familiar life. But it also operated as a kind of disguise for his more delicate feelings. His emphatic worldliness even made a few of his more intimate associates wonder whether he was not protesting too much. Louis Kentner, for instance, thought – as soon as he met Constant in 1935 – 'he was disappointed with himself. I think he realised early on that his creative gift was not enough.'

The energy with which Constant threw himself into the Camargo Society was, Kentner rightly implies, at least partly a compensation. But it was not only incipient disappointment that his manner was designed to conceal. During the spring of 1931, as the second Camargo season unfolded, he began to appear in public increasingly often with a young companion, Florence Chuter. Since the season was so hectic, it was not difficult for him to obscure the exact nature of their relationship: in

January he conducted *Cephalus and Procris*, in April *Façade* (in which Alicia Markova danced – 'I adored doing it,' she said), and in May a version of Oscar Wilde's play *Salome*, which ran for thirty-two performances, and for which Constant wrote the incidental music. *Salome* was produced at the Gate Theatre, and Marie Nielson, who took a leading role, later provided an appealing memory of the conditions in which the company worked during its early days. The theatre, she says, 'was so minute that the "orchestra" sat on a shelf above the dressing room. We had to get in early and shut the door so that a ladder could be propped up between stage and orchestra, and Constant conducted perched on one of the rungs. A nerve-racking experience if one knew his habit of stepping backwards.' *Salome* was followed, in July, by the successful first performance of Vaughan Williams's *Job*, for which Constant rescored the music for a smaller orchestra than had originally been intended, and in the interlude of which he conducted his own short piece *The Bird Actors*, which he had written in 1925. No sooner was the run over, than he had to fulfil an obligation to conduct *Music for Orchestra* with the newly-formed BBC Symphony Orchestra at Queen's Hall, and then to give *Pomona* at Oxford. For someone trying to develop a private life, the difficulties were legion.

Constant, however, was determined. This did not surprise his friends, who knew his capacity for diversity. What did surprise them was quite how long he had managed to keep Florence a secret – even from his mother. He had in fact first met her early in 1929, when Amy was still away in Australia. Constant had been asked to play for the Russian pianist Elsa Karen at her house in St John's Wood, and when he arrived, Florence (who at this time in her life was always known as Flo – though Constant's eventual nickname for her was 'Mouse'), showed him indoors. She was, he told Powell, 'the most beautiful creature you ever saw in the world'.

In photographs taken soon after Flo's first meeting with Constant she does indeed look extraordinarily beautiful – a slender, cat-like figure with small hands and feet, a pale olive, high-cheekbone face with arched eyebrows and a loosely sensuous mouth, and a head of thick, slightly curly jet black hair. Her dark almond-shaped eyes especially appealed to him, since they looked not simply exotic, but eastern. Constant, whose passion for all things oriental was well established, was enchanted. (It is difficult not to suspect that he was drawn to her because her looks, in an English context, suggested vulnerability as well as mysterious otherness. They made him want to protect her – to start with, at least.)

In contrast to Flo's delicacy, Constant himself was comparatively thick-set. In the three years since Wood had painted his portrait in 1926, his expression of eager nervousness had been perceptibly dulled by drink, and his slender frame had broadened. His hair had progressively darkened and slightly receded, his jawline had lost its sharp definition, and his limp had become more pronounced as he had put on weight. He was still a long way from the obese, shambling figure he became in the 1940s but – with hindsight – it is easy to see traces of it.

Flo's beauty was immediately obvious to Constant – but her origins, he discovered during their subsequent furtive meetings, were impenetrably obscure. According to the reminiscences of Constant's surviving friends, Flo's mother had lived near London docks, and her father was a visiting sailor from Java or Malaya. Even Flo's surname was uncertain – sometimes she called herself Chuter, sometimes Kaye – and so was her age: according to Shead she was 'probably about fourteen when Lambert first set eyes on her' (Constant was twenty-four). She had been brought up in an orphanage, was penniless, and although naturally intelligent, hardly educated: after leaving school early, she had supported herself by doing a series of odd-jobs, of which housemaid was the latest. In the light of these things, it is easy to see why Constant kept their relationship quiet. For one thing she was under age, and for another he did not want to bewilder her by dragging her at once into the company of his sophisticated friends. He had to be patient and let time pass, and he also had to educate her. He set about doing so with great thoroughness, recommending which books, paintings and pieces of music she should know, so that she developed, Powell says, 'a quite remarkable appreciation of such things'. Her naturally excitable, impulsive and passionate nature quickened in response to his attentions, and soon acquired at least a veneer of sophistication and savoir faire. Constant, in effect, invented her in his own image.

Flo was flattered, entranced, and soon as addicted to him as he was to her. But they did not immediately become lovers. Once, when he was still living above the Varda Bookshop, he kissed her while helping her on with her coat, then apologised, explaining he was really in love with Anna May Wong. It is an absurd scene, but a revealing one. At the time they met, Constant's sexual experience had been confined to adventures abroad. This is not to say that the more profound relationships he had formed with men in England were covertly homosexual. Rather, these friendships – many of them with men who were homosexual – should be seen as the expression of a personality which, like his father's, was gregarious and

187

open-minded, and also uncertain about the best means of showing love to women, and of its likely value. Flo, for the first year or so of her time with Constant, was hardly more definite a personality than Anna May Wong had been for him. By filling her with knowledge, and thereby making her more substantial, Constant was not – as some have said – re-routing fundamentally homosexual feelings, but acting out of a combination of genuine erotic attraction, shyness and narcissism.

The psychological origins for these feelings can clearly be traced to his relationship with his mother. Kind to the point of pampering him, and persistently allowing him to remain unduly dependent on her, Amy set him an example of powerful maternal womanliness which he both desired and wanted to destroy. In the early days of his courtship of Flo, neither could have seen how damaging this example would prove to be: Flo's chances of satisfying his subversive wishes were excellent, but she could never hope to provide him with wise and durable stability.

Flo discovered just how much she threatened Amy when she first met her. Amy was horrified by Flo's youth, her impracticality, and by what, according to Morrison, she called 'the colour side' of Flo: 'Your race,' she told her, 'is an insuperable barrier to my affection for you.' When, early in 1931, Constant told his mother that he and Flo intended to get married, Amy's horror deepened into implacable opposition. She knew that Constant was sufficiently strong-willed to ignore her entreaties, but she was determined that the marriage should not take place without her own feelings being generally known. She invited Flo to Peel Street alone, gave her a glass of grape juice, and told her that she thought the marriage was a mistake. Amy was particularly concerned – it is an emphasis that exactly parallels George's beliefs, and casts a dismal light on her own marriage – that Flo and Constant should not have much sex, since she thought it would drain Constant's creative energies. Flo was unimpressed: in the early years of her marriage, she says, she and Constant went to bed together most afternoons, before he went off to conduct. Clearly, when Constant had shaken off his initial shyness – with women in general and Flo in particular – he made up for lost time. 'He was certainly highly sexed,' one of his friends said later, 'and certainly enjoyed it. I believe he was rather good at it; rather fun. But only when not too drunk, of course.'

Amy's advice was well intended, but it cast her in the role of a fussy spoilsport, and made Constant long to disobey her wishes. On 5 August 1931, spurred on by the receipt of a royalty cheque for £50, he and Flo were married in Kensington Registry Office – no one witnessed the service except Tommy Earp and Gavin Gordon's wife April – but when they

emerged, eighteen press photographers were waiting for them. The day repeatedly lapsed into farce. On the way to the service, Constant stopped to buy a huge bouquet of carnations which Flo – distracted by emotion – clutched, still in their wrapping paper, throughout the service. When the time came for Constant to fill in the licence, and the registrar asked him his late father's occupation, 'painter' was interpreted as 'housepainter', and duly entered as such. When Constant tried to pay for the licence, he found he had left his wallet in the flower shop, so undertook a short tour of London police stations looking for it, before proceeding, as planned, to Stulik's Eiffel Tower Restaurant for a celebration. The party, Constant intended, would involve Stulik drinking too much of his own Tokay, and not minding that the bill could not be paid. The plan succeeded, and Constant and Flo eventually returned to Peel Street to say goodbye to his disgruntled mother before leaving for a honeymoon in Constant's beloved Toulon.

If Constant's wedding – to his more sober friends and relations – seemed ill-advised, the fecklessness of his first few weeks with Flo confirmed their worst fears. Constant's sophistication was exclusively intellectual, and not at all practical, and Flo – who can only have been seventeen years old, if that – was simply too young to have thought much about the demands of married life. But luck, in small things as well as great, favoured them when they returned to London. Constant's wallet turned up, with his money still in it; the actor Charles Laughton and Elsa Lanchester, two of his Fitzrovian acquaintances, lent them their flat in 15 Percy Street on the border between Soho and Bloomsbury (it was shabby, situated over an Indian restaurant, and, according to Flo, had rats on the stairs); and their meagre income was boosted by Constant's being invited to contribute a weekly column to the *Sunday Referee*. These things were a help, but they did not exactly guarantee stability. Soon, though, that too was forthcoming.

Greatly as Constant believed in the aims and achievements of the Camargo Society, he knew that its finances were shaky. He felt that de Valois's company, with its devoted audience and its better-established London home, rested 'on the soundest basis'. De Valois also felt that the sudden proliferation of interest in ballet demanded a more centralised and coherent organisation than any that existed, and after discussions with Lilian Bayliss, decided to pool resources. The result was the Vic-Wells Ballet, soon rechristened the Sadler's Wells Ballet. Ashton was appointed resident choreographer, and Constant was offered, and accepted, the post of conductor and musical director. The salary, though

hardly lavish, was a help – he was paid less than £500 a year for the next fifteen years. But the less tangible rewards were enormous. He was, Mary Clarke writes, 'tickled by the idea that just as ballet had been swallowed up a century ago by the fashion for opera, so might ballet at Sadler's Wells, at first by means of the opera, win its way back into favour.'

When Constant took up his new post his reputation was already high, and during his incumbency it rose steadily. The diversity of his interests was legendary, and so was his sometimes self-destructive generosity. He would always, Driberg recalled, 'drop his own work to put his burning enthusiasm to the service of others'. This selflessness – he was an excellent listener as well as talker – made him a compellingly unifying force in the company, as did his sociable high spirits. One of the company's leading and longest-serving members, William Chappell, remembers, for instance:

At empty matinées, on tour, when we were doing *Coppélia*, Constant used to have a frightful competition with the girl I danced the mazurka with, Gwynneth Jenkinson. He used to get faster and faster to see if we could keep up, fixing a terrible eye on us and grinning all over his face. And if we did keep up, and landed on the last note, we used to look at him with absolute triumph: 'Did it!' But he'd never do anything that destroyed anything.

Similar stories abound, and frequently show the extent to which his sense of fun spilt over the boundaries of work into his colleagues' private lives. Marie Nielson remembers a typical occasion in the early days of the war, when she and her husband were living in a windmill in the country, and had Walter Legge to stay for a weekend.

Late at night [Legge] suddenly asked if Constant was coming . . . and we said no. Shortly after, the door handle banged and although I don't know how he got there at that time of night I wasn't surprised to hear Constant's voice. He had been to a wedding reception, then taken a negress to a swimming bath, and felt a proper conclusion would be to sleep in a windmill – so there he was. Could he have a toothbrush? His case contained a score he was working on and six ties. One never knew what kind of day the next one would be or what mood one would be in and it was necessary to have the appropriate tie.

There was a serious strategic dimension to these antics. Constant knew that his role in the company was at least partly that of educator – and his by turns delicate and Gargantuan sense of comedy sugared the lessons he had to teach. His attitude to many of his colleagues was much the same as his initial attitude to Flo: he wanted to invent them. When Helpmann

joined the company in 1933, for instance, Constant combined innumerable ridiculous escapades (Ashton says, 'He used to adore it when Helpmann dressed up') with a sustained programme of instructions, as Helpmann freely admits: 'He made me a very detailed list of books, pictures, operas and restaurants I should know, and took me to see "The Ring" with Flo.' Michael Somes, who danced in several of Constant's own ballets after joining the company in 1934, emphasises that Constant was 'a fund of knowledge, not only about music but about associated and other things'. Ashton makes the same point more specifically: 'He was incredibly knowledgeable – he'd read everything, he knew all about painting.' This knowledge allowed him to exert an invaluable influence on the look of the company's productions, as well as their strictly musical aspects.

With only a handful of surviving recordings to testify to Constant's gifts as a conductor, it is difficult to enumerate his special strengths. Constant himself usually made light of his role and his abilities: 'I once said the only thing in favour of being a conductor was that you went *on*, and ended up at the age of eighty with a fur coat and a fourth wife.' But his friends knew how extraordinary his talents were – by any standards, but particularly in view of his deafness. Ayrton described his conducting as 'a positive form of self-expression, as much a part of him and as necessary to him as piano playing was to Liszt or Busoni.' His colleagues were unanimous in their appreciation: to Gordon Jacob he was 'always reliable in his tempi'; to Somes 'more than anyone I've worked with, even Ansermet, he had a sympathy for the ballet'; to Helpmann he was 'the most remarkable ballet conductor there probably ever has been. When Constant conducted it sounded as if the orchestra had been doubled'; to Margot Fonteyn he 'was severe with us . . . [but he] could do it because he also had this great sensitivity to the music'; to Alan Rawsthorne he was 'meticulous in the clarity of his scores'; to de Valois he was 'terrifically rhythmical' and '(like Beecham) a terrific one for speed . . . he didn't give whole control to players, dancers or choreography: he was in complete control. He always listened to others' ideas, but he preferred to listen through me. He would not have chitchat with the dancers. But he was marvellous with them. He was the ideal ballet conductor.' Ashton, in paying his own tribute to Constant's mingling of the friendly with the professional, strikes an amusingly sympathetic tone: 'What did Constant give to the ballet that no one else could have done? Very good sense of balance, very reliable tempi, very large cock, wonderful rapport with the dancers.'

All these remarks bear witness to admirable general characteristics, but two people, at least, give the necessary detail. Mary Clarke explains that 'in conducting, he did not impose any inflexible rules, but when asked the favourite question "Do the dancers follow the ballet or does the conductor follow the dancer?" he would usually reply that in classical ballet the customer, i.e. the dancer, was always right, whereas in modern ballet the dancer's task is usually to follow the conductor's interpretation of the score.' Ideally, however, the question would not arise. 'A conductor and a dancer who have worked together for years have such a sense of intimate collaboration that neither stops to analyse who is leading the other at a given moment.' A later friend and drinking companion, Denis ApIvor – a London doctor and composer with an informed interest in ballet – is even more precise:

I think the most remarkable thing is the way in which he held the balance between the conflicting attitudes towards the ballet, which tend to destroy it if either of them gain the upper hand. Is ballet a superior athleticism and are its highest flights decorative abstraction with minimum interference of costume and decor and formal music? Or should ballet simply be an excuse for drama in movement? I don't know to what extent Constant influenced Ashton, or Ashton Constant, but where is there in the world a choreographer like Ashton who can hold the balance between beauty and the virtuosity of movement and emotional impact? Then again, Constant seemed to know the legitimate limits of ballet in the direction of humour. So far as I know although he was the most humorous of people he never went in for the sort of silly ballet aiming for laughs ... though the genuinely amusing work like *Façade* or *The Wedding Bouquet,* he fostered.

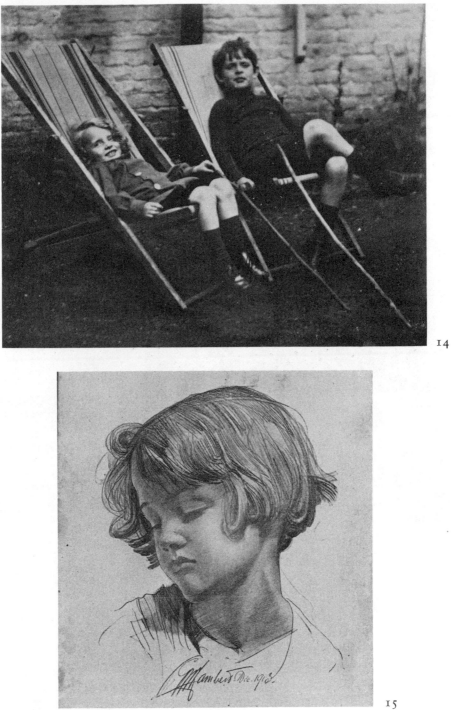

14

15

14 Constant and Maurice, *c.*1912.
15 Constant in a pencil portrait by George, December 1913.

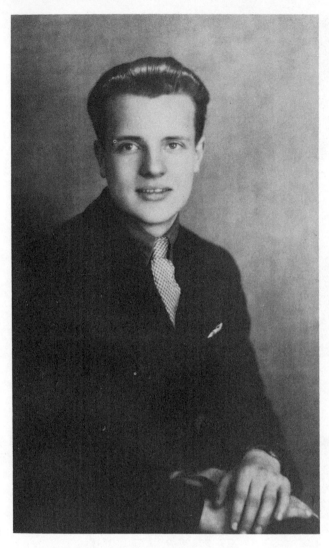

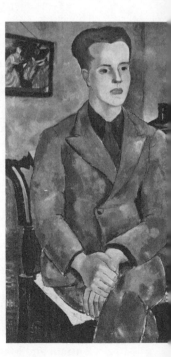

16,17

16 Constant, 1926.
17 Constant painted by Christopher Wood, 1926.

18 Constant and Florence, arriving at Covent
 Garden for the first night of
 Schwanda the Bagpiper, 1939.
19 Florence, the model.
20 Constant drawn by Wyndham Lewis, 1932.

18

19,20

drawing of Constant Lambert

21,22

23

21 Florence and Kit, 1935.
22 Maurice, c.1935.
23 Amy, in the grounds of Chilham Castle, Kent, 1937.

24 Constant at 42 Peel Street, Notting Hill, during the war.
25 Margot Fonteyn as the Young Woman in *Horoscope*, 1938.

26

26 Constant, *c*.1945.

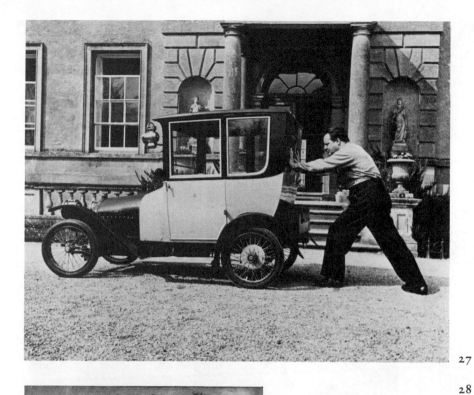

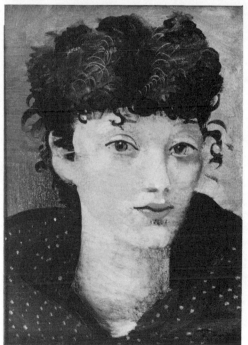

27 Constant, outside Faringdon House,
 pushing Lord Berners' car.
28 'Portrait of Isabel', by Derain.

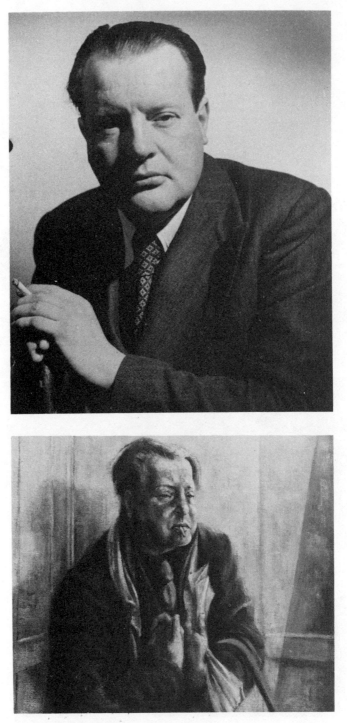

29

30

29 Constant, c.1950.
30 Constant painted by Michael Ayrton, 1951.

Four

Flo was relieved to find her husband in regular employment so shortly after their wedding. But the volume of work Constant now had to undertake, and its attendant socialising, meant that she had to spend a daunting amount of time alone, or trying to cultivate a career. Her sensational looks made it easy to get work as a model. She appeared regularly in glossy magazines, invariably described as Constant's wife, rather than as a person in her own right. In one much reproduced picture, for instance, she pouts enigmatically above just such a description – her hair drawn back under a black hat, her eyebrows theatrically arched, and her beautiful small face luminous with pale make up. (It was a less surprising sort of employment than might appear. At typical Fitzrovian parties, Powell says, 'The girls [were] largely drawn from the all-inclusive (one avoids the word all-embracing) vocation of model – both artists' model, and one who "modelled" clothes, the latter then quaintly known as mannequins.')

As soon as Constant had taken up his post with the ballet, he plunged into rehearsals for *Dido and Aeneas* – the first opera he had been asked to conduct – which opened on 6 November. This was immediately followed by the premiere of the ballet version of 'The Rio Grande' for the Camargo Society, rechristened 'A Day in a Southern Port' and choreographed by Ashton. The adaptation had an immediate impact: the first audience were shocked and titillated by Edward Burra's sets ('a waterfront scene', as Shead says, 'with tarts leaning out of their windows'), and by Markova's performance as the Creole girl, William Chappell's as the Creole boy, Walter Gore's as a sailor, and Lopokova's as 'the Queen of the Port'.

If Constant expected that the flurry of commitments which accompanied his new job would settle into a pattern which left him some time for his own work, he was quickly proved wrong. He did, though, as the Camargo's winter season drew to a close, manage to remind himself of his life as a composer by conducting the first performance of his Piano Concerto in the Aeolian Hall a week before Christmas. (Arthur Benjamin was the soloist). Constant was pleased with his reviews, but was struck by the fact that many of them suggested that the range of his musical personality was already confined. 'The melodic and harmonic material of the work,' wrote the *Manchester Guardian*, 'come recognisably from the pen that wrote "The Rio Grande", but with an added maturity and an

astringency which will probably prevent it from becoming as popular.' The following January, and indeed for the following several months, Constant had to put out of his mind any thoughts of disproving this view. In January 1932, he worked in Edinburgh and Glasgow for the Scottish Orchestra, then travelled to London to conduct the new Camargo programme – with some help from Beecham. The programme, running into the early summer, included *Adam and Eve* – choreographed by Anthony Tudor – which used the score of his own *Romeo and Juliet*, a revival of *Job*, and a new ballet called *High Yellow* to a jazz score by Spike Hughes, with sets by Vanessa Bell. Excited and exhausted, Constant took Flo to Toulon for a holiday in July, as soon as the Society's programme finished – but the town's comparative peacefulness, he told Powell, proved more of an anti-climax than a balm.

I have just torn up a cheaply sensational letter I wrote you in which I said there simply wasn't a single white settler in the whole town. Alas, my pen was too optimistic . . . The only advent of international interest here has been a 'grand Concours de Pyjamas'. The whole town is so quiet in fact that the whores just hang about in bunches in the street without even trying to accost me . . . I expect I shall come home soon as money seems a bit short. Cedric Morris [the painter and horticulturalist] disguised as a beggar has just passed playing the ukelele. Everyone here looks like Cedric Morris or D. H. Lawrence. It is most depressing. I am getting nostalgic for the hectic life of old Bloomsbury (district of laughter, district of tears).

No sooner had Constant returned to England than he began preparing to leave again, this time on a more arduous expedition. The Danish government, seeking to demonstrate its ties of friendship with England, and conscious that its country's fine ballet tradition might provide a useful example, invited a group of dancers from Sadler's Wells to visit the Royal Opera House in Copenhagen during September. Constant was asked to conduct – he shared the job with Geoffrey Toye – and travelled over a week before his colleagues. Letters, he told Powell,

are bound to be censored so don't send any photographs of some such everyday scene as five Guards Officers dressed as housemaids being flogged by five housemaids dressed as Guards Officers . . . I have just received my sailing orders and they read very like the more depressing patches in *Venusberg*. I go in a small boat which takes about three days and arrives in the small hours. The right Nordic note is struck, I think, by the sentence 'Captain Nellemose – whom you will know by his scarred face – will meet you'.

Flo proposed that she might follow with the rest of the company – and their reaction to the idea gives a chilling glimpse of the disjunction which already existed between Constant's work and his home life. He arranged for Marie Nielson to stay with Flo at Percy Street, then accompany her on the boat – but 'the company were,' Nielson says, 'to say the least of it, "snooty" about Florence'.

Constant's popularity with the dancers soon soothed away this awkwardness, and Flo found him waiting for her 'in very good spirits'. But problems of another kind were threatening. A socialist demonstration was expected to interrupt the company's Gala Performance for the Danish king's birthday, and Constant 'was told that a police official would be sitting immediately behind him, in the front row of the stalls, and if trouble started he was to take instructions from the official'. In fact nothing untoward happened, to Constant's relief, but also to his slight disappointment. The entire trip, for him, was marred by a lack of incident. Marie Nielson remembers:

He found Copenhagen 'clean and characterless' and not his cup of tea. After one of the performances a number of us were invited to the most fashionable night club – a very dignified place. Constant suddenly said, 'I'd like to ask you to dance but I can't do these dances – I could if they played Sousa'. Without thinking, I said: 'Well ask them to', and the next minute he was threading his way across the ballroom to the band. The conductor, recognising him, beamed, but his expression changed when he was asked if he knew Sousa and if so would he please play 'The Double-headed Eagle'. However, he did and we set off. The other dancers were completely bewildered but probably out of courtesy to the English, one by one joined in, sedately marching round while Constant charged down the ballroom doing a sharp turn at each corner and charged back again. He actually asked for and got an encore. We missed one of the official functions because he insisted that a Laurel and Hardy picture in the suburbs was not to be missed.

Tame as it obviously was, Copenhagen at least gave Constant a respite from the gruelling work he resumed in England. He had the Camargo's production of *The Birthday of the Infanta* to conduct in the first week of December (with a score by Lutyens, choreography by Spenser, and sets by Whistler), and the revival of his own *Pomona* to prepare for January 1933. This production, for which Vanessa Bell designed new and according to Constant 'excellent' sets, was a great and fashionable success, largely because Anton Dolin, who alternated with Stanley Judson in the part of Vertumnus, attracted an eager and chic audience. 'The best ballet of this season', though, Constant felt, was *The Birthday of*

Oberon, in February, with music by Purcell and a chorus of forty. 'Very good straightforward choreography by Ninette ... people objected to the chorus being in masks but, as I said, had they seen them without? It had excellent notices but wasn't a success after the first night.'

It is not surprising, contemplating this schedule, to find Constant complaining to Nielson in April that the new year had 'passed in a dreary whirl and I never seemed to have a moment' – especially since the demands of his company work were joined by others of an equally taxing sort. Faber and Faber, impressed by his work as a journalist, had encouraged him to write a book on contemporary music – a book that he was to call *Music Ho!*. He was required to finish it before the end of the year, and although always a fast writer, found time exasperatingly short. In June he agreed to conduct Walton's *Belshazzar's Feast* in Holland, and later in the summer he worked for Edward James's recently-formed 'Ballets 1933', conducting, among other pieces, Weill's *The Seven Deadly Sins*. 'I am getting very bored with London,' he wrote in exasperation to Nielson, 'and hope to get away when my book is finished and do some composing.' The composition he had in mind – *Summer's Last Will and Testament*, which was not finished until January 1935 – crept slowly forward. Even when he did manage to 'get away', and took Flo for a short holiday in Spain, work came with them. He wrote the last 40,000 words of *Music Ho!* in four months jam-packed with other duties.

Now as always, Constant's energy was fuelled by more than his Puritan conscience. He had, like his father, committed himself to an uncertain and peripatetic life which could only be financed by accepting most of the offers that came his way. As soon as he had bundled off the manuscript of *Music Ho!* he had to look round for the next means of making ends meet. Reliance on occasional work, he had come to realise, could be as destructive of the time he needed for composition as the more widely recognised frustrations of a regular job. In September, though, an acceptable sort of regularity presented itself. He was appointed Professor of Conducting at the RCM (the money this brought him was increased the following year, by his receiving the Collard Fellowship of the Musicians Company – £300 a year, tax free, for three years). This steady work allowed him to reduce the number of concerts he conducted, and also to set his domestic life on a secure footing. Flo, who had become increasingly distressed by the amount of time he spent away from her, was anxious to establish a more permanent home than their flat in Percy Street, and also keen to start a family. In September both her wishes were granted: she and Constant moved to a flat, 4 Great James Street, in Bloomsbury, the first

floor in an elegant four-storey Regency house, and when she accompanied him to Venice for the performance of his Piano Concerto at the Biennale, she conceived a child. This, she thought, would bind their marriage together; in fact, it tore it apart.

Constant's attempts to strengthen his marriage were genuine and confident. His single-mindedness occasionally caused him to feel irritated by Flo's passionate impulsiveness, but there were, as yet, no signs of real discontent between them. These efforts to put his house in order coincided with the publication of *Music Ho!*, and the book represents – in musical terms – a similar wish to create a world of settled beliefs. *Music Ho!* seemed then, and still does, a hugely entertaining, accessible, catholic, clever, eccentric and enthusiastic book. During the previous few years, Constant had already made a name for himself as an independent-minded critic, and many existing pieces of journalism were re-worked for inclusion in the book. He had made a point of mauling sacred cows (he said, for instance, about the English translation Sargent used when conducting Verdi's *Requiem* in March 1932, 'to refer to Dies Irae as a "day of trouble" is to reduce it to the level of spring cleaning'); he had drubbed unworthy newcomers (at the first night of Donald Tovey's Cello Concerto, performed by Casals, Constant was 'compelled to leave at the end of the first movement, which seemed to last as long as my first term at school'); and he had ruthlessly challenged other critics: Ernest Newman and Eric Blom were stigmatised as examples of 'the average English critic ... hopelessly parochial when not exaggeratedly teutonophile, over whose desk must surely hang the motto (presumably in Gothic lettering) "Above all no enthusiasm".'

Although *Music Ho!** is subtitled 'A Study of Music in Decline', it carries over from his journalism the same unpompous and passionate engagement for which he had already become famous. This, more than anything else, distinguished it from contemporary books with a similar range – Gray's *Survey of Contemporary Music* (1924), and Van Dieren's *Down Among the Dead Men* (1935) – and has guaranteed it an influential

*The title comes from *Antony and Cleopatra*, Act II, Scene v, which opens with Cleopatra restlessly waiting for Antony:

CLEOPATRA: Give me some music; music, moody food
 Of us that trade in love.
ALL: The music, ho!
 Enter Mardian the eunuch
CLEOPATRA: Let it alone, let's to billiards.

The point, obviously, is that the emotional requirement Cleopatra has of music cannot be satisfied by an emasculated performer.

life. It cunningly combines the two sides of Constant's character – the scrupulous technician and the flamboyant dandy – and thereby occupies the middle ground he described in an article published four years later in the *Radio Times*: 'Most books on music published today,' he said, 'are either amateurish or too technical by half. The technician . . . only succeeds in puzzling the layman and irritating the practical musician . . . The other type of writer, sensitive to music without being a professional, at least looks at the wood as a whole instead of tying labels on the trees, but is inevitably hampered as a historian by his lack of technical knowledge.'

Shead gives a useful breakdown of the book's argument:

Neither the aristocratic classicism of the eighteenth century (typified by *The Marriage of Figaro*) nor the romanticism of the nineteenth (*Tristan and Isolde*) nor yet its nationalism (*Boris Godunov*) will serve today. The delicate social balance that supported the first has collapsed, the ardent idealism of the second has evaporated, and the genuinely national (as opposed to political) differences reflected by the third have disappeared. Artificial attempts to cultivate a 'national' style (like the English folk-song school) are false and ludicrous. The great revolutionary upheaval in music which took place before the First World War, and in which Debussy and Schoenberg played crucial parts is over; consolidation is less exciting than revolution, and few composers even try to consolidate. The majority prefer to fall back on devices like pastiche (Stravinsky in his neo-classical period, together with his followers) or on 'mechanical romanticism' (like Honegger's *Pacific 231*) or on facile note-spinning (Hindemith and his 'Gebrauchsmusik', which so far as Lambert is concerned consists in providing music of little or no value in the hope of supplying a need which does not exist) . . . The only hope for music lies in the kind of composer who, unconcerned with fashion, goes his own way, working out a musical style that pleases himself (rather than a coterie), and paying attention to the dictates of form rather than to those of mode. And Lambert gives Sibelius, Busoni and Van Dieren as examples.

The individuality of Constant's tone and the oddity of some of his judgments have occasionally been yoked together by the book's critics to make it sound cranky. A more telling criticism – though it can easily be reversed and turned into a virtue – is to say that the book is inextricably rooted in the period it describes. It is dated, that is to say, but it can also be called archetypal. Although published in the early 1930s, the moods and attitudes it evokes are those of the cosmopolitan late 1920s. In the immediate aftermath of the great modernists' innovations, a preoccupation with style has settled into a preoccupation with stylishness: 'To the seeker after . . . the sensational,' Constant says in Part One, 'to those who

expect a sinister *frisson* from modern music, it is my melancholy duty to point out that all the bomb throwing and guillotining has already taken place.' Schoenberg's *Erwartung*, he reminds us, ('still the most sensational essay in modern music from the point of view of pure strangeness of sound') was finished as early as 1909. What this argument amounts to, as the book develops, is a sustained attack on thorough-going modernists – not for indulging in unnecessary artistic liberties, but for denying in their more extreme experiments the connection between music and strong human feelings. It was an attitude which, though more informed and intelligently phrased than his father's, came close to reproducing George's views.

The difficulties that Constant experienced in making his own music reflect his deep emotion is obviously the basis for this argument, which runs – revealingly – parallel to the one Philip Larkin was to take, thirty-six years later, in *All What Jazz*. Larkin's insistence that Pound, Charlie Parker and Picasso had destroyed art's traditional broad 'pleasure-seeking' audience, echoes Constant's attack on the modernists' absorption in other artists rather than in life: 'The chief fault of contemporary music is that it cannot achieve any lyrical quality without stealing the thunder of the classical composers.' Pastiche, Constant felt, had taken the place of development and experiment, since the war. Pastiche was not to be confused with the parodies of Walton or Satie or Berners, which he approved, but was a sign of self-defeating exclusivity. 'The spirit of pastiche has no guiding principles. Once invoked it becomes like the magic broom of the sorcerer's apprentice, to whom indeed the average modern composer, with his fluent technique, but lack of coordinated sense, may well be compared.'

The modernists' obsession with technique, according to Constant (and to Larkin), was the foundation of their corrupt fascination with pastiche. The year before the book came out, Constant had praised Verdi in the *New Statesman* because Verdi 'did not seek technique for its own sake . . . his technique followed naturally as the servant of his inspiration, as is the case with all genuinely musical minds. If a motorist spends all his time with his head in the bonnet there must be something grievously wrong with either the motorist or the car.' In *Music Ho!* itself, the same emphasis is made with angry regularity – usually by means of attacks on Schoenberg ('cold-blooded and mathematical'), Hindemith ('mechanical and utilitarian') and, especially, Stravinsky. After splitting with Diaghilev, Constant felt, Stravinsky made 'a spectacular conversion. After jazz and cocktails, cold water and a sermon . . . Stravinsky, in his

last works, has achieved the final triumph of fashion, he has created a fashion for boredom.'

This insistent hostility to the modernists threatens, through the course of the book, to become monotonous. But the danger is crushed by Constant's readiness to diversify his rage. German music and English folk music are two particularly popular subjects of ridicule. 'Until this century,' he had written in 1929,

the German romantic tradition was prized, not as a purely national form of musical expression, but as definitely the great classic tradition by which such exotic sideshows as the Russian school were judged (and, needless to say, condemned) . . . What, from the technical point of view, chiefly distinguishes this school is the preponderance of purely harmonic thought. Melody and even counterpoint are very largely based on a solid ground of accepted chord progressions. This trait can clearly be seen in many of the minor pieces (valses, etc.) of Schubert, which are little else but elaborated chords with no independent thematic value.

By slumping into what *Music Ho!* calls 'mechanical eloquence', the Germans had reached the same point of desiccation as the modernists. Even Wagner did not escape – 'Wagner's scene painting is, of course, magnificently but a little self-consciously done' – and only Weill was excepted – 'What a relief to find a writer like Weill, who whatever his merits or demerits, can at least appear in public wrapped neither in cellophane nor a toga but in the clothes of today!'

No such qualifications creep into Constant's feelings about the modern exponents of the English folk tradition. His point is not that attempts to evoke a specifically local mood and temperament are necessarily doomed to prettiness or jingoism, but that as soon as such efforts become part of a coherent general programme, the 'individuation and obstinacy' of the original material is destroyed. The systematic rehabilitation of folk music by English composers was, he felt, 'the gradual transformation of the Rowlandson-like John Bull into the Little Man of Strube, the black-coated citizen at the beck and call of the Press Barons, docile, smiling and obedient, capable only of mass indignation, herd pleasures and community singing'. His former teacher at the RCM, Vaughan Williams, was he believed, a prime offender – 'the second-rate nostalgia of the "Shropshire Lad"' had headed a 'so-called English Musical Renaissance' which was 'fabricated, artificial and sterile'.

For all their breadth, Constant's complaints in *Music Ho!* have a striking consistency: fakery, cerebration, and a suppression of strong

feeling are the charges levelled against all his enemies. Considered in isolation, they seem to express a full-bloodedly romantic temperament. But in fact this is moderated, as it was in Constant's daily existence, by other qualities which reveal a subversive, and sometimes a downright contradictory element in his personality. This is clearly visible in the book's enthusiasms, of which the most obvious is jazz. As well as praising composers like Berners and Satie ('that much maligned and misrepresented figure'), he devotes a good deal of space to jazz proper. But – and again, like Larkin – it is the original exponents of jazz techniques, such as Ellington, and not its more recent practitioners who create his ideal 'rapprochement between highbrow and lowbrow'. He complains that 'Jazz has long ago lost the simple gaiety and sadness of the charming savages to whom it owes its birth, and is now for the most part a reflection of the jagged nerves, sex repressions, inferiority complexes and general dreariness of the modern scene.' The tone here is patronising (and worse than patronising – anti-Semitic – when he discusses jazz 'written and performed by cosmopolitan Jews') but the goal of his affections is clear. What he admires, and created so successfully himself in *The Rio Grande*, is a jazz 'in touch not so much with specifically barbaric elements as with sophisticated elements'.

With the notable exception of Sibelius – who is rather improbably hailed as the person most likely to lead contemporary music out of the modernist impasse – it is composers who actually adapt jazz methods, or who have an affinity with its chic high spirits, that emerge as the heroes of *Music Ho!*. Chabrier is a case in point; Constant calls him

the only writer to give us in music the genial rich humanity . . . the sunlit solidity of the French School that finds its greatest expression in the paintings of Manet and Renoir . . . He was the first composer since Mozart to show that seriousness is not the same as solemnity, that profundity is not dependent on length, and that wit is not always the same as buffoonery, and that frivolity and beauty are not necessarily enemies.

The strength of feeling evident in *Music Ho!*, its quick tongue, and its praise for neglected musical cultures (French and Russian in particular), and despised or misunderstood individuals (Liszt, Balakirev, Glinka, Debussy, Busoni, Van Dieren), struck the book's first readers as fascinatingly iconoclastic. Constant's closest friends, of course, heartily approved of its themes and treatment. Cecil Gray called it 'probably the most brilliant book on music that has yet been written in this country' – as well he might, since many of its opinions were formulated in his

conversations with Constant and Heseltine. Outside the circle of his regular companions, however, attitudes to the book were – and have continued to be – equivocal. While expressing amazement at its individuality and precosity, several critics – such as David Drew – have found that it is 'marked throughout by precisely the same kind of modish superficiality and fashion-consciousness that [it] affects to despise'. Others, like Robert Henderson, felt that 'the whole section called "Post-War Pasticheurs" . . . has too much of the exaggerated indignation of a reformed sinner castigating his own erstwhile lapses'.

Even Morrison has reservations about the book, though he expresses them loyally: 'I have this theory that all the best bits of *Music Ho!* are Constant, and all the bits that wear thin are Gray and Heseltine.' Morrison undoubtedly has a case, but it would be unreasonable to forgive Constant his more contentious opinions by passing them off as someone else's. In particular, his disparagement of Stravinsky seems wrong-headed, his championing of Sibelius over-optimistic, and his advocacy of emotional intensity sadly at odds with a good many of his own compositions. But the motives determining these lapses are the same as those which animate the book's virtues: its ability to find excellence in a wide range of distinct traditions and cultures, its determination to prevent music from becoming a narrowly specialist interest, and its avowed confidence in the value of all emotions, including apparently lightweight ones. 'What an effect the book had when one first read it!' wrote ApIvor, speaking for more than himself. 'The encyclopaedic knowledge of recent musical developments all over the world, the wit, the social observation and satire, the sensitivity to painting, the experience of ballet from the inside. Here was a musician who was in the best sense of the word a European as well as an Englishman.'

Five

In *Music Ho!* Constant presents himself as an *enfant terrible*, and yet also stands as the guardian of time-honoured aesthetic values. If the mixture produced occasional idiosyncrasies, these were matters for discussion – and if they have proved, in some instances, to be indefensible, at least their value as matter for debate cannot be gainsaid. In his private life, the same combination of attributes had more damaging effects. On the face of it, his marriage to Flo was following a properly stable course – when, in 1934, they moved from Great James Street to 7 Park Row (now demolished) in Kensington, and then, shortly afterwards, to a more spacious house in Trevor Place, Knightsbridge – they showed the world a picture of social success and domestic harmony.

They made a striking couple: the feline, exotic Flo, and Constant – whose own good looks had not yet lost their boyish clarity – more fleshy and stocky. Their house in Trevor Place gave an appropriate image of their lives. It was untidy, the table tops littered with newspaper clippings which Constant had cut out because they amused him, smoky and ramshackle – dotted with the rather elaborate Frenchified furniture Flo liked. Soon after their marriage they had begun to keep cats, and these would pick their way amongst full ashtrays, piles of paper and bottles of drink as if they had discovered a domestic jungle. None of Constant's and Flo's friends thought this cosy shambles anything other than a private version of the public world of Fitzrovian bars and restaurants. If it seemed feckless, it was a fecklessness which always teetered on the edge of hilarity. In Powell's photograph album, there appears a sequence of pictures which amusingly captures their skittish, sexy, amiable craziness. In one, taken outside London, Powell and Flo pretend to drive a derelict tractor while Constant tops up the engine from a large can: it is described as 'The Five Year Plan'. In another, Powell and Flo are surprised in a hooded wicker chair by Constant – 'a jealous husband' – wielding a cricket stump. In a third, Constant sprawls on a lawn while Flo sits curled up at his side; she is smirking at the camera while she undoes his fly buttons with both hands.

Their happiness seemed to be confirmed when their child, a boy, was born on 11 May 1935, and christened Christopher – after Wood – Sebastian – after Bach. He was called Kit, as Wood had been. Constant's delight was intense but short-lived. The life that he led with Flo was

hardly well suited to the arrival of a baby. Constant, whose pleasures depended so greatly on sophistication, adult wit, and informed intolerance of fools, resented the invasion. The tenderness of fatherhood quickly gave way to irritation, and this, since Kit could hardly be expected to understand the causes, was usually directed at Flo. In the early years of their marriage, their rows had often been dramatic, but subsided quickly: Powell describes a scene in which Constant actually struck Flo after she had emptied a pan of water over Constant's head. When the police arrived, alerted by anxious neighbours, 'both of them were shaking with laughter although she was complaining of toothache'. Gradually their disagreements became less explosive, and more resentful. Cecil Gray's daughter Pauline remembers, as a very young girl, sitting in her father's garden with all three Lamberts, when a cat crossed the lawn, meowing. 'Did you speak?' Constant asked his wife.

Constant's treatment of Flo, once Kit had appeared, recalls his father's treatment of Amy. Constant, like George, was unable to reconcile his professional career with his home life, and was almost instantly bored by the very domesticity he had sought to create. Similarly, George's neglect of the young Constant parallels Constant's neglect of the young Kit – and so does the sentimental regret that both fathers suffered in later life. Nielson revealingly recalled 'going with [Constant] to a performance of *Boris* at the Wells. I happened to look at him during the scene of Boris and his young son. The tears were streaming down his face. I always see it when I hear people say he hadn't much feeling for Kit.'

'People', though, could be forgiven for accusing Constant of indifference, since his solution to the difficulties at home was, as his father's had been, to spend as much time away from it as he could. In the year of Kit's birth he was away less often than he would have liked, since the money from the Collard Fellowship enabled him to devote time to composition. The demands made by the ballet in 1935 were plentiful but, by his standards, easy to bear: adding *The Rio Grande* to the Sadler's Wells repertoire in March (the part of the Creole girl was danced by the fifteen-year-old Margot Fonteyn, who had recently joined the company); conducting the premiere of *The Rake's Progress* ballet in May; undertaking a short tour of the Midlands and Scotland with the full orchestra during the summer; and performing *Façade* at Sadler's Wells in October. For the rest of the time he was at home, surrounded by the distractions which had arrived with Kit, completing *Summer's Last Will and Testament*.

Summer's Last Will and Testament, a 'masque' (the title punningly

refers to Will Summers, Henry VIII's jester), was Constant's first choral work since *The Rio Grande*. It sets poems by Thomas Nashe to music for orchestra, chorus and baritone solo. Nashe appealed to Constant for several reasons. As an Elizabethan, he enabled Constant to reaffirm the interests and loyalties he had learnt from Heseltine, who was a forceful advocate of Elizabethan music; as a punning, bitter and picaresque writer, Nashe allowed Constant to express both the witty and the sardonic sides of his personality; and as a man afflicted with an acute sense of transience and mortality, Nashe provoked Constant to explore more deeply than he had ever done before the melancholy which underlay his good humour. *Summer's Last Will and Testament* wonderfully combines superficial brilliance with the substantial weight of his emotions. It is dedicated to his wife, but the pleasures and anxieties provoked by his marriage are not its only impetus. It is also instinct with a desperate fear of death. When it received its first performance, on 29 January 1936, Constant was still only thirty.

The depths of sadness touched by *Summer's Last Will and Testament* are, in musical terms, clearly expressed by Constant's publisher at OUP, Alan Frank, who said that the piece 'begins where Britten left off' in the Spring Symphony in its evocation of the oppressiveness and imminence of death. But the lavish harmonies which register the intensity and colour of his feelings are continually braced by precise scoring and rhythmic energy. The intrata – a pastorale and siciliana for orchestra only – opens with a theme which is recapitulated later in the work and sets a mood of tranquil melancholy that soon gives way to a delicately syncopated jazz-like rhythm. It is followed by 'Fair Summer Droops' (for semi-chorus and full chorus alternately), a light, cross-rhythmic setting of 'Spring, the Sweet Spring', which distantly recalls Purcell; the more robust and syncopated 'Trip and Go, Heave and Ho'; 'Autumn'; a gruesome interpolated movement called 'King Pest' for which Constant used Edgar Allen Poe's story of the same title as his inspiration; and finally a heart-rending setting – a saraband – of Nashe's most famous lyric, 'Adieu! Farewell Earth's Bliss':

> Beauty is but a flower
> Which wrinkles will devour;
> Brightness falls from the air;
> Queens have died young and fair;
> Dust hath closed Helen's eye;
> I am sick, I must die –
> Lord have mercy on us!

Summer's Last Will and Testament is by no means flawlessly sustained – the central sections lack both the urgency of the opening and the yearning melancholy of the finale, and sound, in Clement Crisp's words, 'a bit like the youthful Arthur Bliss'. But Constant himself, towards the end of his life, admitted to Ashton that he 'liked *Summer's Last Will and Testament* the best of all my work'. He was, understandably, disappointed when its first audience gave it no more than a lukewarm reception. It was, after all, his first full-scale work to be performed for six years. The lack of enthusiasm was partly attributable to simple bad luck. The first performance was sandwiched between the death of George V (on 20 January 1936), and his funeral, and although the temper of the music might be thought suitable to a mood of national mourning, the papers had little room to consider such things. Among the comparatively few reviews that appeared, *The Times* called the piece no more than 'A very beautiful piece of orchestral writing'; the *Daily Telegraph* found it 'ingenious', but 'somehow distracted and miss[ing] the coherency of inevitableness'; and the *Birmingham Post* felt it was 'curious and interesting rather than satisfying to those who hunger after musical emotion'.

There is a marked disparity between these judgments and the opinion of his friends. Although this might be expected, it says as much about the complexity of *Summer's Last Will and Testament* as it does about Constant's ability to inspire loyalty. Because his friends were better acquainted with the piece than its first night reviewers, they were equipped to judge more accurately the ways in which its formal intricacies and emotional depths give themselves up by degrees. Alan Frank, for instance, announced himself 'convinced it is by far and away his finest work, containing as it does all the elements that promised well in his previous music but now matured by their having acquired what is best described as "body"'. Cecil Gray, similarly, reviewing it in the *Listener*, called it 'not merely the best work that [Constant] has yet written, by a long way, but . . . together with Walton's "Symphony" it represents the highest point which English music has attained in the post-Elgar, post-Delius period'. Its electrifying mixture of bawdy and gentleness, of exuberance and sorrow, make the neglect into which it has fallen seem shameful.

The first-night audience for *Summer's Last Will and Testament* associated Constant, first and foremost, with *The Rio Grande* and *Music Ho!*. Their comparative coolness derives, in part, from their bafflement at finding that he was more prone to melancholy than he had

previously let on. Just as hard work and gregariousness had masked his innate sadness, so now they were required to hide disappointment. Immediately after *Summer's Last Will and Testament* had opened, he immersed himself in preparations for the premiere of the ballet *Apparitions* to a score by Liszt, choreographed by Ashton, and with sets by Cecil Beaton. In addition to selecting and conducting the music, which was orchestrated by Gordon Jacob, Constant worked closely with Ashton (who remembers that during one rehearsal Constant 'ate a whole box of my liqueur chocolates'). The reception given to *Apparitions* almost, but not quite, compensated for *Summer's Last Will and Testament*. It was, in Constant's own words, 'the biggest success we have ever had at the Wells'. Public interest was stirred by the fact that the production coincided with the fiftieth anniversary of Liszt's death, and Constant turned the score into an education, as well as an entertainment. 'The music is chiefly drawn from the last ten years of Liszt's work,' he told Maynard Keynes, 'and contains a number of completely unfamiliar pieces.' But there were other and more secret reasons why Constant especially enjoyed the creation and success of *Apparitions*. For one thing, and most secret of all, he found himself increasingly drawn to the ballerina who took the female lead, Margot Fonteyn. In the short time since she had come to study at the Wells, she had established herself as a dancer of prodigious natural ability and even greater promise. In spite of his domestic disarray, Constant had managed to resist her obvious attractions when she had taken the part of the Creole girl in *The Rio Grande* the previous year. Now the combination of her looks and her mature brilliance comprised a more interesting object for his affections.

Less complicatingly, Constant's promotion of Liszt's work brought him two new and, as it turned out, lifelong friends. One was the pianist Louis Kentner. In the autumn of 1936, eight months after *Apparitions* had opened, Constant heard Kentner – then recently arrived from Hungary – give a Liszt recital in London. 'I saw this man,' Kentner says, 'a great big fellow, shouting and clapping at the end of the concert', and the following weekend Constant turned his enthusiasm into print for the *Sunday Referee*. Shortly afterwards, Margot Asquith, to whom Constant had been introduced by Frederick Ashton, invited Kentner to lunch to meet Constant. Constant and Kentner discovered that they had more than a love for Liszt in common – so much more, in fact, that through late 1936 and early 1937 Kentner became a regular companion on Constant's excursions to nightclubs and bars.

Kentner was with Constant when the second important new friendship

was made – with Humphrey Searle, an undergraduate at New College, Oxford. Searle's enthusiasm for Liszt became passionate (he helped to establish the Liszt Society in 1950, with Constant and Kentner as founder members) as soon as he had read Sacheverell Sitwell's book on the composer, and seen *Apparitions*. To celebrate the 125th anniversary of Liszt's birth, Searle decided to organise a concert of less well-known works in Oxford, and invited Constant to conduct the *Malediction* for piano and strings in the Carfax Rooms on 8 November. The generosity with which Constant responded – not simply accepting the invitation, but offering detailed advice about the programme – was unqualified, and is rightly praised by Shead for being 'rarer among musicians than one would think, or wish'. One might add (without wishing to detract from Constant's gesture) that it was expressive of something other than his better nature. Like his father, he found that charity came more easily to him than intimacy. After the hugely successful concert – Gray, Berners and Sacheverell Sitwell were in the audience – Constant graciously received Searle's thanks, and returned to the family he was finding it increasingly hard to treat with adequate kindness.

Before Kit's arrival, Constant's work had posed few threats to Flo. She regularly went to listen to his concerts, and was always at his side at parties. But the demands of her young baby made it difficult for her to keep up this companionable role. Constant, in turn, was irritated by Kit's yowling, and by the mess he created at home. Kit distracted him from composing, made it difficult for him to have as much sex with Flo as he liked, and continually interrupted their conversations. Even when Constant and Flo did make time to be alone together, Constant began to find Flo's lack of education exasperating, and her vulnerability a trial. When they drank together, the ease with which Flo became tipsy – which had once charmed him – now angered him. Gradually, but increasingly enthusiastically, Constant welcomed invitations from friends in the ballet – and in Fitzrovia generally – to drink out in the evenings, away from the trials and tribulations of Trevor Place. Within a year of Kit's birth, the effects of Constant's drinking were clear. His looks had thickened perceptibly, and lost their definition. In photographs, his florid face seems markedly older than his thirty-one years. His friends began to realise that the qualities which had initially drawn him to Flo – her innocence above all – were starting to alienate him.

The collapse of Constant's marriage was quickened by the very thing he continued to hope would distract him from its problems: work. Late in 1936 he was offered an ideal opportunity to keep himself even more than

usually occupied when Beecham, who was organising the 1936–7 winter season at Covent Garden, asked him to conduct Puccini's *Manon Lescaut*. Although Constant had made his liking for the then unfashionable Puccini well known in *Music Ho!*, and 'love[d]' (as a reviewer of the first night wrote) 'every bar' of the piece, it was nevertheless the first opera he had conducted at Covent Garden, and therefore required particular concentration. Although time for rehearsal was short, and the leading singers – Augusta Ottrabella and Piero Menescaldi – were no more than adequate to their tasks, the energy with which he drove along the three performances in early January managed to convert music which contemporary taste normally considered vulgar into sensuous vibrancy. The standard of the performances seems especially remarkable since Constant's work on the opera overlapped with his preparations for the new ballet season. For this, he arranged several pieces by unknown or neglected composers, and opened the proceedings on 16 February with an arrangement he had made of extracts from two operas by Meyerbeer – *Les Patineurs*.

'From the moment the curtain rose,' Mary Clarke tells us, the audience 'acclaimed it with something little short of rapture.' But it was more than appreciation of the unfamiliar music that they were showing; it was pleasure in a spectacle, too: 'With the simple device of pretending that everyone was on skates, Ashton was able to weld an infectious concoction of lyric and virtuoso dances into a genuine ballet.' This success was followed, ten days later, by the revival of a work which had first been performed late the previous year and which, after a brief but complex process of evolution, was hailed as an even greater triumph. In the late summer of 1936, Lopokova had approached André Derain with a request to provide sets for a Cambridge production of Molière's *Misanthrope*. By December, plans had changed, and it was decided that the play – because of its brevity – should be preceded by a twenty-minute ballet. Constant was asked to provide an arrangement, and suggested music by Rameau. Derain objected, and countered by producing his own ballet to music by Lully. Constant wrote to Maynard Keynes: 'Rameau has wit and vigour and, above all, good dancing rhythm . . . my impression is that Lully is inclined to sound too "etiolated", as my dentist would say, whereas Rameau still retains his original savour.'

In the end a compromise was reached, with Constant suggesting that he might arrange works by yet another composer, Couperin. Derain consented but the first night audience found it unimpressive. Keynes himself thought it was a fiasco, and urged that the proposed London run should be scrapped. Constant, instead, made extensive revisions –

replacing the original two pianos with a small orchestra, and urging modification of the choreography. The opening of the ballet, now called *Harlequin in the Street*, was respectfully received. Shortly after its first run, Ashton revised the choreography yet again, and with Alan Carter as Harlequin the ballet became one of the Vic-Wells' most admired pieces. In the winter season of 1938–9 it was given thirteen times.

Constant's next task was simpler, and more immediately successful: to conduct Lord Berners's ballet, (*A Wedding Bouquet*), choreographed by Ashton, with sets by Berners himself, and words by Gertrude Stein. The camp elegance of the score and the bizarre text coincided exactly with Constant's belief that ballet should appeal to the whole range of the emotions. Stein herself was obviously delighted with his enthusiasm. 'It was very nice,' Mary Clarke reports her as thinking, 'that he had the idea of putting in the programme the description of the characters as [I] had made them . . . like they used to do in melodrama, the first I ever wrote was that, *Snatched From Death* or *Sundered Sisters*.' (In fact Constant was far from feeling that Stein's words were inviolable. When the ballet was revived during the war, in May 1943, and he took the part of the orator himself, he made several interpolations. One night, the dancer taking the part of the maid heard him utter from his stage box, 'Webster, your shoes are creaking!')

The enthusiasm with which the Sadler's Wells audience greeted the new season's ballets, and the lingering memory of his success with *Apparitions*, persuaded Constant that the company had now begun to approach a proper level of excellence. This was a self-contained pleasure, obviously – one which even an unsuccessful trip to Paris in June, to conduct the premiere of Bliss's *Checkmate*, could not alloy. But his expectation that work would act as a compensation for his home life was steadily disappointed, and he knew that a crisis could not be postponed for long. When it came, it was accompanied by a tragic version of the same sort of farce that had attended his wedding. Once the ballet season had closed, he and Flo and Kit (now aged two) were invited with Ashton to spend a holiday in Austria with Raimund and Alice von Hofmannsthal. (Von Hofmannsthal, who was the son of Richard Strauss's collaborator, was a keen patron of musicians, and his wife, whose maiden name was Astor, was a close friend and supporter of Ashton's.) The original idea was that the guests should have the house to themselves, and that Constant and Ashton should work on plans for future ballets. But when Von Hofmannsthal unexpectedly arrived to join the party, he found tempestuous scenes rather than quietly creative ones.

The principal problem, over-riding and underlying the difference between Constant's and Flo's temperaments and backgrounds, was that Constant's feelings for Margot Fonteyn had become unstoppable. Greatly as Ashton admired him, he knew that Constant was 'incapable of being faithful to anybody for long. He had too inquisitive a mind, and being highly sexed, if he saw someone he wanted, he had to have them.' In his later life, this fickleness led Constant to work his way through a large number of girlfriends, but his feelings for Fonteyn were of a more intense sort, and therefore absolutely threatening to Flo. Flo responded with understandable rage, instigating, Ashton says, a series of 'terrible rows', and flinging her wedding ring into a lake. Eventually, back in the house, Constant asked her to leave. When she refused, she was picked up by Von Hofmannsthal and carried to the doorstep with her son and luggage.

Most of the blame for the decay of his marriage must be allocated to Constant himself. Flo was undoubtedly volatile – particularly when, encouraged by Constant, she was drinking – but she had been transported by him from modest obscurity to a world in which he was not prepared to give her the support she needed. Constant left her alone too much, refused to shoulder his share of responsibility for Kit, and was not prepared to curb his attraction to other women. He gave, throughout his time with her, indications that their marriage was really an amusing diversion (brilliant and sophisticated young composer marries ravishing and barely-educated orphan), rather than a serious emotional commitment. Her impracticality at home exasperated him, but he made no effort to help her; her ignorance of the arts – which had once endeared her to him – embarrassed him; and when he felt their marriage beginning to go wrong, he did nothing to hold it together. When she had departed with Kit for England, Constant stayed on in Austria with Ashton working on his new ballet, *Horoscope*, which cryptically described his relationship with Fonteyn, and was, when completed, dedicated to her.

Flo had neither the pleasures of a new affair nor the distractions of work to console her. According to Shead, 'there appears to have been no lasting rancour between [her and] Lambert', but even in the aftermath of her second marriage, her lack of animosity towards him was infused with an undiminished sense of loss. 'Every word he said lifted you up,' she admitted thirty years after his death. On her return to London in 1937, she tried repeatedly to reconstitute the marriage, but Constant was adamant. As soon as he came back from Austria he moved out of Trevor Place into a flat in Hanover Lodge (he called it Hangover Lodge), a

mansion in Regent's Park (Ashton was living in a cottage in the garden), which was owned by Alice von Hofmannsthal. It was a comfortable but impersonally furnished flat, and beyond reconstructing the smoky, paper-strewn shambles he had created in Trevor Place, he did little to make it seem distinctly his own. With his piano in one corner, and his cat prowling among newspaper clippings, he took the house in the same spirit that he lived in all his subsequent homes – as a base from which to work, and from which he could go to bars and restaurants with his cronies. As soon as he had moved in he immediately began divorce proceedings, paying a woman – a stranger – to spend a night playing cards with him in a nearby hotel.

In addition to nursing her own feelings, Flo had to care for Kit. Constant showed little sign of wanting to help her, beyond paying her alimony he could ill afford, and recommending that his mother be involved. Since Flo's relationship with Amy was tense, to put it mildly, the advice was guaranteed to create difficulties. Amy had never warmed to Flo, and when she heard that the marriage had foundered, uncharitably said to her son that she had 'told him so'. But she recognised that her grandson needed help. Until Flo was forced to give up Trevor Place, Kit spent the bulk of his time there with his mother, then suffered the distress of having other members of his family play pass-the-parcel with him. Flo herself, Amy (who often had Maurice staying with her at Peel Street), and Amy's niece Audrey (the daughter of her brother Nat) all took a hand. Maurice, who according to his brother-in-law Morrison was 'allergic to children', was reluctant to play the role of surrogate father; and Amy – severe and self-deprecating, 'with her hair done up like headphones', as Morrison says – never made him feel he could call any one place home.

Fonteyn, to her great credit, was anxious not to hurt Kit, and was slow to respond to Constant's advances. In fact the extent to which she ever responded is difficult to gauge. She has rarely written or spoken about Constant, and now excuses herself by saying, 'It is such a long time since Constant died, and I was so young and involved so totally in dancing all the time that I knew him. Also he was on an intellectual level that was way over my head.' Even Shead is reticent, saying only 'the next eight or nine years of Lambert's life were dominated emotionally by a deep and passionate affair with the dancer already mentioned'

Fonteyn's friends and contemporaries in the ballet are also loyally and absolutely silent on the subject of her relationship with Constant. Her professional reputation as an 'ice maiden' and the universal respect that she commands for her work both in and for the ballet, have surrounded

her with a wall of discretion. Michael Somes, for instance, the partner with whom she has said she most enjoyed dancing, rebuffs any thought of discussing her private life with Constant. 'If I were to read about Margot and Constant in a book I'd put it on the fire and stoke it,' he says. But Constant's colleagues could easily see that he gave Fonteyn special attention. 'He was pushing her but we all agree that was all right,' Markova says. 'She deserved it, she was talented regardless.' This kind of judgment, properly recognising Fonteyn's genius, is also a tribute to Constant's popularity with his colleagues, and helps to explain the state of Constant's feelings. 'He had,' William Chappell says, 'an absolute worship for perfection . . . perfection was to him something sexually exciting.' Fonteyn, more nearly than anyone else in the company, was a perfect ballerina.

Constant intended that *Horoscope*, with Ashton's help as choreographer, would demonstrate this perfection to the public. He made the finishing touches on his return from Austria, and spent the early part of the new year overseeing rehearsals. The first night – at Sadler's Wells on 27 January 1938 – with Fonteyn and Michael Somes in the main roles, sets by Sophie Fedorovitch, and a cast which included Richard Ellis, Alan Carter and Pamela May – had precisely the effect that he wanted. 'The most successful modern ballet that has been produced at this theatre for a long time,' wrote Francis Toye. Other critics agreed: 'A highly successful ballet, which was received with marked favour by the large audience'; 'admirably workable'; 'downright tuneful music with a strong rhythmical interest'.

What none of these reviewers could have known was the extent to which the ballet's emotional energy depended on the coded intimacies of the apparently simple synopsis given in the programme:

When people are born they have the sun in one sign of the Zodiac, the moon in another. This ballet takes as its main theme a man who has the sun in Leo and the moon in Gemini, and the woman who also has the moon in Gemini, but whose sun is in Virgo.

The two opposed signs Leo and Virgo, the one energetic and full-blooded, the other timid and sensitive, struggle to keep the man and woman apart. It is by their mutual sign, the Gemini, that they are brought together and by the moon that they are finally united.

As a disguise for his relationship with Fonteyn, the plot is almost laughably thin. (The sun and moon signs were, of course, their own.) But it did at least have the virtue of referring to Constant's long-standing

interest in the occult – an interest which could be defended if he were challenged about his other and more concealed intentions. Constant claimed that the short prelude – a musical palindrome – had been dictated to him by Van Dieren after the composer's death in April 1926.

The main body of the score is less concerned to evoke thoughts of the supernatural than to concentrate on conflicts between melancholy and exhilaration, and between received ideas of sexual role playing. The ballet's movements oscillate between virile and dynamic set pieces (like the Dance for the Followers of Leo), and more wistful introspective ones (like the Saraband for the Followers of Virgo), before the Invocation to the Moon and the Finale – which reconciles the couple, and their disparate qualities, with a good deal more conviction than Constant was able to do in life.

Horoscope's protestations of imminent happiness, and the excitement of its reception, might give the impression that the end of Constant's marriage marked the beginning of fixed contentment. But his commitment to Fonteyn, intense as it was, could not altogether quell his appetite for a raffish existence. Nor could it undo the harm that he had already inflicted on himself. Photographs of him taken at this time – when he was still only in his early thirties – show that the lean and alert image given by Christopher Wood has thickened into a figure who looks sleek, admittedly, but also distinctly boozy and sybaritic. This was Driberg's impression of him: 'Bulky, untidy, in exuberance and girth a young Chesterton; slight lameness obliges him to walk with a stick, which he usually contrives to drop inconveniently or tangle in his friends' legs.' Since Christ's Hospital, Constant's lameness and deafness in one ear had been his only signs of illness, but his doctor friend ApIvor doubted whether his good health could last. He was, ApIvor realised, drinking more heavily now than ever. Hangover Lodge, without the constraints of a family to bind him, became a base for regular visits to Pagani's – often with Searle and Gray – and for bouts of bar-crawling which were even more damaging to his constitution than ApIvor knew. When, after *Horoscope's* performances ended in March 1938, Constant developed bronchitis and had to be taken into a nursing home for what he later called one of his 'cures', he ignored the warning his illness gave him, returned home as soon as he could, and continued to drink as before.

He also worked hard for the ballet. His commitments to Sadler's Wells during 1938 comprise a daunting list: conducting the first night of *Le Roi Nu* in April, the first performance of the five-movement 'Concert Suite'

he adapted from *Horoscope* at the Proms in August, *Harlequin in the Street* in November, and a trip to Manchester with the Hallé Orchestra in December. In addition, he continued to produce a large amount of journalism, accepted invitations to introduce or talk for the BBC, and completed, before the year ended, a brief Elegy for piano.

The pressures of this schedule were gruelling enough, but there was another and, as yet, shapeless danger to be contemplated – the danger of war. In *Music Ho!* Constant had been at pains to relate music to its social and political context and now that events threatened to disperse the Sadler's Wells audience, he was keen to find ways of adapting his work to suit his times. Before taking any decisions, he had the new season to direct: the first ballet, Tchaikovsky's *Sleeping Princess* (which had previously only been performed by Diaghilev's company), opened on 2 February and was given as a Royal Gala for Queen Mary. The following month a revised programme – only Acts I and III of the *Sleeping Princess* – was given for the President of France at Covent Garden. These functions obviously represent a special kind of recognition for the company, and showily reflected the confidence and expertise it had acquired. Confidence is apparent too in the undiminished energy with which Constant worked through his other conducting commitments: the first performance of *Cupid and Psyche* and *The Judgment of Paris* at Sadler's Wells in April, and *Turandot* at Covent Garden in May (this was his first appearance as a conductor in the International Season). If these engagements gave an impression of nearly normal life, the following month forced him to acknowledge that it could not last. When he was invited to the Frankfurt Festival to conduct *The Rio Grande*, he immediately declined, and tried to stop his music being performed at all. 'I have the very strongest objection to a note of mine being played in Germany under the present regime,' he told Alan Frank.

The incident is a small one, but it serves as a useful reminder that Constant's passionate involvement with his work – and with his pleasure – had not made him careless of the world. Thus far, his sense of impending war had only appeared in limited and rather sentimental ways: he had dug trenches in Hyde Park the previous autumn, and the previous summer, on a short trip to Chinon, in Touraine, with Gray, the usual delight he took in France had been compromised by his visit coinciding with the Munich crisis.

When war was declared Constant, who was now thirty-four years old, transformed these anxieties into practical action. His response, like his brother Maurice's, immediately recalls his father's behaviour in 1914: all

three men recognised their public responsibilities with an enthusiasm made up of genuine patriotism, schoolboyish excitement, and pleasure at being released from familiar habits. All three of them, too, devoted themselves to their war duties with an enthusiasm which turned out to be self-punishing. George, whose work in Palestine exhausted him and significantly shortened his life, was virtually mimicked by Maurice. According to his friend John Pettavel, Maurice 'had a detestation of Germans – he was quite paranoid about it', but it appears that he also had a detestation of himself.

At the outbreak of war Maurice was thirty-eight years old, yet he enlisted into a regiment – the Parachute Regiment – which he could be sure would make the most testing demands on him. Pettavel believes that Maurice, even more markedly than George, suspected some cowardly element in himself which required drastic over-compensation. Parachute jumps fitted the bill; but he could not meet the challenge he set himself. Miriam Wornum, who with her architect husband Gray had been friends of the Lamberts for many years (Gray Wornum was responsible for commissioning Maurice to produce reliefs for the liner *Queen Elizabeth*), describes the result. 'He doggedly had to overcome a more than understandable sense of fear. He was extremely brave but he was far too sensitive a bundle of nerves to be able to continue. He broke down and had to leave.' Miriam Wornum immediately came to his rescue. She encouraged Maurice and Olga to make her home – the beautiful and spacious Manor at Bosham, in Sussex – their own, and helped Maurice to find another and less distressing way of furthering the war effort. Boatbuilding turned out to be the answer – something in which his skills as a sculptor and designer were valuable, and which also satisfied his wish to seem a plain man, and a hard worker, doing a useful job. His patience and conscientiousness as an artist were soon rewarded. In 1941 he was made an ARA. It was his formal, representational work which especially endeared him to the Academy – the busts of friends and famous faces with which he had first made his name in the 1920s. When the war ended, he continued his progress towards respectability by teaching at the Academy School, and eventually received the higher accolade of full RA. 'He would never have admitted to not having had his due meed of praise,' Pettavel says. 'But he was very pleased when he was elected to the RA. He played it down, but fundamentally was extraordinarily pleased.'

Constant's wish to avoid his father's example was as strong as Maurice's desire to emulate it. Yet beneath the dissimilarities, the same instinct for self-punishment is evident. News of the outbreak of war

reached Constant in Liverpool, where he had gone with the company in August to begin a provincial tour, and he immediately returned to London to make plans for the duration. It was obviously out of the question that he should enlist, being lame and deaf, and also obviously important to discover ways in which the ballet could continue to exist. He knew, to judge by a passage in *Music Ho!*, that war would not simply disrupt the company's organisation, but would also encourage resilience. 'When the death of some thousands,' he had written, 'seems to serve no other purpose than to inspire people like Lord Northcliffe and James Douglas to an even purpler prose, and the sound of gunfire can be heard at the breakfast table, it is small wonder that the artist should turn aside to write lullabies for his cat, or to record the adventures of the old colonel who never succeeded in shooting anything.'

This kind of evasion was precisely what he wished to avoid – for its own sake, and because he realised that the war might destroy for ever the role and reputation he had created for ballet in England during the previous decade. After discussions with de Valois and Ashton, he joined in a scheme which was simple and brilliantly effective. The Sadler's Wells Ballet moved its headquarters to Cardiff, and began a series of provincial tours, putting on performances of new and existing ballets to the accompaniment of two pianos (an orchestra was impossible) played by Constant and the company's rehearsal accompanist, Hilda Gaunt. Miss Gaunt endeared herself to Constant by being, in Ashton's words, 'a tremendous drinker. She'd always be on tap. If rehearsals were overrunning he'd *rush* the music if the pubs were open.'

The first tour, although rapidly devised, became the model for a series which the company undertook at regular intervals until 1944. Like its successors, it was – according to all those who took part in it – exhausting (Constant had to drink less in order to play more), creative (Constant and Ashton planned a new ballet, *The Wise Virgins*), exciting and boring by turns (they endured long blacked-out train journeys), and immensely appreciated. Marie Rambert, when the war was more advanced, reckoned that the tours were 'responsible for the enormous spread of love of ballet, and I think the fact that the London audience was scattered through the provinces with evacuation and so on – this mixing of the various layers of population from the point of view of culture was most beneficent.'

By no means the whole of the London audience had been scattered. On Boxing Day 1939, after Christmas with Tom Driberg, Constant returned to the Wells Theatre, as he was to do time and again throughout the war,

to prepare a new season for those who had declined the comparative safety of the provinces. The schedule opened on 23 January with one of the company's most resounding successes – Constant's second Liszt ballet, *Dante Sonata*, with Louis Kentner as the soloist. Constant rescored Liszt's 'Après Une Lecture de Dante, Fantasia Quasi Sonata' as a piano concerto, making it, one reviewer wrote, 'more danceable and also adding to its pregnant acerbities'. What this means, specifically, is that the ballet's depiction of a clash between the children of light (danced by Fonteyn and Somes) and the children of darkness (one of whom was danced by Helpmann) mirrored the mood and preoccupations of the time. Yet Constant's own description of the rehearsals gives a revealing glimpse of the way in which his intention to give the work an obvious symbolic point did not crowd out the more complicated artistic considerations:

The general lay-out, by which I mean not only the dancing as such but the association of various characters with various themes and the general dramatic sequence, was . . . established mutually by Ashton and myself. I played the piano at almost all the rehearsals while the choreography was being created, so that when it came finally to orchestrating the ballet, I had the whole stage picture in my mind. I am certain that, apart from whether people like *Dante Sonata* or not, it has a visual-cum-musical unity which could only have been achieved by this form of collaboration.

Although *Dante Sonata* was well received by the critics, Constant never expected it to reach the audience it deserved. Houses were rarely full, and funds for crowd-pulling spectacular effects were understandably short. For several subsequent war-time seasons, the management had to apply for grant aid. But the standard of performance achieved by the company was, nevertheless, encouraging, and the memory of it heartened them on the tour they undertook between the end of the run and their return to Sadler's Wells in April for the premiere of *The Wise Virgins*. It seemed to Constant, on this second return to Sadler's Wells, that the upheavals caused by the war had been assimilated, and a new routine of work established: occasional and comparatively expensive London productions which would be accompanied by an orchestra, and between them wearying and meagrely accompanied tours. But just as the pattern seemed to be set, it was interrupted.

The company had agreed to give a Gala Performance at The Hague (Holland being a neutral country) on 6 May, and no sooner had they arrived than the Germans invaded. Once back in England again,

Constant gave an account on the wireless of their experiences. The reason for going in the first place was obvious enough: 'It was a successful though belated effort,' he said, 'to counteract the deluge of highly efficient, artistic propaganda organised by Germany since the outbreak of war.' They had crossed the Channel and driven to Arnhem where, Shead says, 'there was a feeling of unnatural calm'. Constant was more colourful: 'As we saw the young troops, resigned but cheerful, going up to man Holland's precarious front line; as we passed the Red Cross wagons stationed outside Doorn; the barricaded bridges; the trees ringed with dynamite; it was easy to believe the papers that said all this was merely a routine precaution.' It still seemed routine for the next two days, in which the company reached The Hague without incident, and settled into their hotel. But almost as soon as they arrived, at three-thirty in the morning, the 'black German bombers' attacked without warning, dropping parachutists, incendiaries and leaflets. (Constant kept one: it advised that 'The German Army protects the life and goods of every peace-loving citizen. However, the German troops will punish every deed of violence committed by the population with a death sentence.')

In his wireless talk, Constant presents himself as watching the raid from the hotel roof, but what he reasonably omits to mention is that he only got there after members of the company had burst into his room to warn him, and found him in bed with Fonteyn. The rest of the company's adventure similarly combines drama and comedy: they spent a few days not knowing what to expect (were they enemies or simply aliens?), in which the nearest Constant came to actual harm was having a bullet smash a restaurant window near where he was drinking. At length they were allowed to head for home. The dangers of their bus ride to Ijmuiden and their fifteen-hour cross-Channel boat trip, sleeping in the hold on bales of straw, were consistently assuaged by their sense of the ridiculous. Each person, for instance, was only allowed one piece of luggage, and Ashton, who was loath to jettison a new and splendid dinner jacket, made de Valois wear it. Less dear to his heart was a bottle of brandy he was endeavouring to bring back to London. Constant, with the true drinker's canniness, detected it, and wanted it. By the time the company reached London it had disappeared, and when Ashton remonstrated, Constant only said, 'You're like Greta Garbo and you've lost your smile.' Fate exacted Ashton's revenge: as Constant came down the gangplank he was the only member of the company to show any sign of injury – a bandaged head. A speck of cigar ash had hit him in the eye.

Six

In their hurry to leave the Hague, the company had been forced to abandon a good deal of their equipment – including the decor, costumes and only complete orchestral scores of *Horoscope* and *Dante Sonata*. Decor and costumes could be reconstructed, and *Dante Sonata*, which Kentner had recorded before the company left for Holland, could be re-transcribed. So too, from Constant's and the dancers' memories, could *Horoscope*, but its enormous personal significance made the loss a hard one for him to bear. Furthermore, the disappearance of so much material plunged the company into a financial crisis. As soon as Constant and de Valois had counted the damage, Constant wrote, 'we held long conferences on how we could retrieve our position to the best economic advantage. I had had, for some time, a new ballet in preparation – an arrangement of music by Boyce bearing the ominous title of *The Prospect Before Us*.' This ballet's success – its premiere was given on 4 July – was further proof that the company and its audience could not easily be discouraged.

Worrying as they were, these difficulties provided Constant with time to think about composing again. Early in 1940 he had completed a short setting of the dirge from *Cymbeline*, 'Fear No More the Heat of the Sun', and in November he travelled to Cambridge to conduct the first performance in the college – Caius – of its dedicatee, Patrick Hadley. Much of the work's emotional power derives from the subtlety with which it relates to Constant's feelings about the war. But in the piece he began working on next, *Merchant Seamen* (originally called *Able Seamen*), subtlety is in noticeably short supply. Once he had returned from Holland, Constant seems to have been afflicted with the idea that he should address himself directly to contemporary events, and the result is so untypical of his sophistication that it is tempting to cast around for extenuating circumstances.

One, at least, can easily be discovered. *Merchant Seamen* was commissioned as a film score for a patriotic documentary about the Merchant Navy, and since his feelings about specifically 'English' music were ambivalent – as he had demonstrated in *Music Ho!* – he felt he had to act out of character. Just how out of character is evident in the score's self-conscious 'folk' elements, which resemble no one so much as Vaughan Williams. In other words, it is probably kindest to approach the

piece – in spite of Constant's own opinions about imitation – as pastiche. It opens with a fanfare to salute 'the heroism and gaiety of the Merchant Navy', moves from 'Convoy in Fog' to 'The Attack', to 'Safe Convoy' (a whimsical sea evocation) to a 'March'. 'The Fanfare,' as Shead rightly says, 'betrays its authorship by its occasional reminiscences of *Horoscope*, but the rest of the Suite might be any one of a number of English composers working dutifully but without inspiration.'

Constant understood that the war required him to make sacrifices, and he knew that accepting so unsympathetic a commission as *Merchant Seamen* was one of them. It was not, after all, a sacrifice which involved very grievous suffering. But there were other reasons for the failure of the piece. Since leaving Flo, and in particular since the start of the war, he had worked more than usually hard for the company, and had rewarded himself by relaxing unusually hard too – drinking a great deal and entertaining himself at bars and restaurants late into most nights. The George (known as 'the Gluepot') near Oxford Circus had become a particularly frequent haunt – it was popular with B B C employees, and his regular circle there included Ralph Hall, the musical editor of the *Radio Times*, his publisher at O U P, Alan Frank, as well as writers like Norman Douglas and fellow composers such as Lutyens. 'At lunchtime,' she was to remember,

one would see Constant, *The Times* under his arm, standing, one hand on the bar rail, the other on his ivory-headed stick. Often he was obviously fighting out some mental Don Quixote battle with the Philistines . . . At other times, he would be shaking with inner laughter, to explode, when joined by friends, in lucid and uproarious descriptions of something ridiculous spotted in a newspaper, or his latest limerick or French poem.

One of the kindred spirits who shared and stimulated this uproariousness was Dylan Thomas, who regularly used The George as a bolthole from the B B C. Their friendship depended on more than their similar senses of humour (they once danced a coranto together): each recognised in the other an underlying romantic melancholy. Frank, too, found Constant – with his 'very clipped staccato kind of voice' – 'marvellous company', but detected an increasingly obvious element of desperation in his behaviour. By those who were not his confidants, this was often attributed to the enormous demands that his work made upon him. But it also had a good deal to do with the unsatisfactoriness of his private life.

Constant was largely to blame for this – when he had found comparative stability with Flo he promptly wrecked it – but the life on

which he had embarked without her was more destructive than he had anticipated. His hard-drinking, peripatetic existence prevented him from having to face too directly, or for too long, the lack of a proper home life. It also made that life increasingly difficult to achieve. Fonteyn could not help him solve the problem: her long working hours, her devotion to her dancing, and her need to maintain a degree of discreet formality with him in the theatre, meant that she could not easily offer herself as a continually supportive companion. Even if she had, he would almost certainly have disappointed her. Before their relationship ended there were, Morrison admits, 'various affairs inside and outside the company'. Ashton provides a revealing gloss on this: 'Like the character in *Apparitions*,' he says, 'Constant was looking for The Ideal One. Whenever he thought he'd found it he got tired of it.'

Constant did not like confessing the damage that his life was doing to his work, but he found it increasingly hard to ignore. Ironically, when he decided to try and sort himself out, he did so in a way which reunited him with one of the principal sources of his difficulties. At the end of 1942 he left 'Hangover Lodge' and moved in with his mother, now aged seventy, in Peel Street. She was able to lighten a little the burden of his financial affairs. He paid her no fixed rent, but chipped in whenever the earnings he received from his job and his journalism allowed. But Amy could do little to lessen the confusion of his private feelings: her overcrowded house made it extremely difficult for him to continue his relationship with Fonteyn. Even for someone used to regarding his home as little more than a base from which he sallied forth each day to rehearse, and each evening to perform and to drink, Peel Street was oppressive. There was no room for his furniture, and only his piano and his cat gave him any sense of his belonging there.

Once the Sadler's Wells company had reorganised itself after its disastrous adventures in The Hague – they moved their London home to the New Theatre – the work Constant had to undertake was more taxing than ever before. The next three years – from 1941 to 1944 – were crammed with series of hectic provincial tours. In 1943–4, for instance, as Shead points out, they danced for forty-eight out of the year's fifty-two weeks, and the previous two years were little better. Constant, realising that the opportunities for boredom and disaffection loomed large in such an existence, took it upon himself to act as the company's entertainer. His colleagues' reminiscences abound with evidence of his good humour. De Valois remembers that he invented a large number of imaginary characters: 'There was the terrible North Country mother "spoilt by the

war" with her son Willie (obligingly played by Constant himself) who droned, groaned and grumbled her way across England on those slow war-time trains. These characters grew more and more alive in their solid topicality and we would await their further eccentricities with the greatest impatience.' William Chappell's memories are of more purely riotous scenes: Robert Helpmann declaiming *Romeo and Juliet* from the circular balcony in the Midland Hotel, Manchester, and Constant roaring back at him from below – no wonder (being 1.30 a.m.) the residents complained; Constant being led into Helpmann's bedroom with the advice, 'Master, she's ready for you', to find Helpmann lying on the bed in elaborate and convincing make-up; and Constant in the summer of 1941, when staying with Doris Langley Moore in Harrogate, persuading Helpmann, Claud Newman and Ashton to join him in dressing up as suffragettes. (Lord Berners's heir, Robert Heber-Percy, has a photograph of Constant and Ashton in their costumes: Ashton immaculate and dapper; Constant square and tremendously upholstered – his youthful good looks changed into those of a blowsy drinker, heavy-jowled and stooping.)

By the beginning of 1942 it was clear that not even someone of Constant's energy could sustain this multiplicity of roles – jester, arranger, player, conductor, director. Julian Clifford was therefore engaged as an assistant conductor (the post was taken by Alec Sherman in 1943, and Geoffrey Corbett from 1944). But the load on Constant's shoulders was still heavy, particularly since Ashton, who had joined the RAF, was only able to assist him occasionally. Throughout the war Constant toured with the BBC Symphony Orchestra and the London Philharmonic Orchestra – refusing to settle for old favourites which would make his job easier, and organising, instead, stringently ambitious programmes, often of little-known French, Russian and English music – and creating a challenging schedule for the ballet company. In January he conducted, at the New Theatre, the premiere of Helpmann's first ballet, *Comus*, for which he arranged seven extracts from Purcell. This was followed in May by *Hamlet*, again with choreography by Helpmann, for which he conducted music by Tchaikovsky. In November came a slighter but nevertheless well-received piece, *The Birds*, with music by Respighi.

In the rare moments that Constant had to himself between these commitments he endeavoured to respond to events in Europe by composing a new work. The result, *Aubade Héroïque* is, like *Merchant Seamen*, and just as surprisingly, reminiscent of Vaughan Williams, to whom it was dedicated in honour of his seventieth birthday. ('A fact,'

Constant told Felix Aprahamian, 'which, to be quite frank, is relished by neither of us.') If the effect is derivative, the intention, at least, was rooted in authentic experience. 'This short piece,' Constant wrote, 'was inspired by a daybreak during the invasion of Holland, the calm of the surrounding park contrasting with the distant mutterings of war.' Morrison expanded on this inspiration and passed an appreciative judgment on the result. The ballet company, Morrison explained,

were marooned for a few hours in a beautiful mansion standing in a park, with trees and lawns and wild deer grazing by a lake at daybreak. The contrast of this idyllic scene and the momentous events that were already shaking the world made a profound impression on [Constant] and out of it he fashioned a flawless little masterpiece. It has the dream-like quality of some exquisite Chinese painting, for although the distant mutterings of war are heard from time to time the urn-like stillness of the surrounding scene is never broken.

Aubade Héroïque was first performed by the London Symphony Orchestra at Golders Green on 21 February 1943 with Constant conducting. The evening was generally considered a success, but the piece is an isolated and forlorn reminder of how brief, and how occasional, his compositions had become. By the spring, he was once again immersed in a routine as remorseless as that which had dominated the previous two years. In April he conducted the premiere of Walton's ballet *The Quest*, for which Ashton, on leave, did the choreography and John Piper the sets; shortly afterwards he revived *A Wedding Bouquet*; in early May he toured the provinces with the London Philharmonic Orchestra; in mid-May he gave three concerts at Northampton and three at Newcastle. In July he took the Sadler's Wells company to Manchester.

Not even this itinerary could exhaust Constant's devotion to the company – or, if a story of his visit to the Belle Vue Zoological Gardens in Manchester is anything to go by, his sense of fun. While George had loved and admired what might be regarded as useful animals – and ones which were traditionally associated with virile prowess, such as horses –Constant's affections were more fanciful. Gerald Iles, the Superintendent at the zoo, left a description of Constant's visit:

Margot Fonteyn and Robert Helpmann had been to the zoo to name two zebras, but after Mr Helpmann had seen a Llama he insisted that he must name that animal, which bore such a striking resemblance to himself, rather than a zebra! . . . The following day Mr Lambert 'phoned me from his hotel to say that the two ballet stars had told him they had had a delightful day at the zoo and that there was still a zebra spare without a name, and he wondered, as he adored

animals, whether he might come along to the zoo and name the remaining animal. I was delighted with his suggestion and so it was arranged . . .

Mr Lambert was particularly interested in small animals and he was very much attached to a ring-tailed lemur called Lena . . . I photographed him holding this animal and, on the same occasion, took one of him holding a python . . . During one of his [later] visits to the zoo he saw our sea-lions go through one of their performances which concludes with a sea-lion playing *God Save The King* on a 'hornchestra', a specially made instrument consisting of trumpets which sea-lions can play by pushing the valves with their noses. Mr Lambert was enchanted and promised to go straight back and write a special fanfare which the sea-lions could play at the forthcoming circus. Unhappily he never lived to do this.

No matter how worn down Constant was by the physical demands of touring, his good spirits remained intact. So, however, did the sadness they brilliantly disguised. This was more evident during his time at Peel Street with Amy and Kit (who was now eight years old) than on tour. For one thing, the small crowded house made it difficult for him to work; for another, it made it almost impossible for him to run his private life in decent obscurity; and for a third, it made it harder than ever for him to justify his neglect of his son, now that they were often under the same roof. When Kit was not away at school, or visiting Flo, or staying with relatives, his very presence reminded Constant of duties he could not find time or patience to fulfil. Furthermore, the news that Kit gave of Flo, who was now on the brink of a second marriage, and more securely based in Chelsea than she had been for many years, made him painfully aware of his own rootlessness. Shead tells 'a favourite family story [concerning] an incident which occurred at about this time: [Kit] came downstairs for breakfast one morning and greeted his father with the words "hello, pompous". The guileless remark completely disconcerted [Constant], who for days afterwards kept buttonholing friends and asking them if there was any truth in the suggestion.' If Constant realised that Kit's greeting echoed his own views about George, he made no mention of it.

Constant's response to his predicament was, again, to replace one kind of impermanence with another. Shortly after his return from Holland in 1940, his bar-crawling had brought him into contact with the young painter Michael Ayrton (Ayrton was nineteen when they first met), who was introduced to Constant by Cecil Gray in the Café Royal. Constant immediately liked Ayrton's mixture of artistic dedication and ebullience, and recognised him as a kindred spirit. Even his looks seemed an amalgam of Lambert family traits: his dark hair sleeked back as Constant's was (though not receding), his small beard groomed and

pointed as George's and Maurice's had once been. They met frequently to drink when Constant was in London between tours, and the tours themselves gave Constant an excuse to write Ayrton letters which graphically convey the zestful, schoolboyish tenor of their relationship. 'Extract from letter from my mother,' Constant wrote from Glasgow in November 1943, '"Kit has been indulging in black magic on Allhallow E'en which he seems to have enjoyed." What a family.' In January 1944: 'What *mouvementé* lives lorry drivers seem to lead. On top of the man who stole (and in my opinion very reasonably) budgerigar seed in order to grow deadly nightshade, there is the lorry driver in tonight's *Standard* (actual cutting lost, alas) who after being married for three weeks got into his lorry and drove it at his wife. He was only given four months which must have been a disappointment.' And again: 'This morning's pub crawl produced two black ATS (and my God what beauties), a lesbian midget in crutches by Dadd, and (believe me or believe me not) outside The Bear and Rummer of all places, a woman in a tartan skirt with *two* bandaged legs both of which were bleeding.'

Constant, clearly, was able to find with Ayrton the uncomplicated companionship which best suited his own combination of sociability and shyness, and was anxious to make it a more permanent feature of his life. In February 1944 he packed up his belongings in Peel Street, and decamped to Ayrton's house at 4 All Souls Place. The prospect of having to pay rent – which he had been spared when living with his mother – was offset by the attractions of Ayrton's company. 'Formal agreement enclosed as requested,' Constant wrote to Ayrton on 27 February. 'I also agree to the comparatively reasonable clauses in the codicil which, however, has certain *lacunae* you may have cause to regret when you are woken up by the sound of "The Entry of the Gladiators" or 'Boy Scouts of Wisconsin, Forward Forever' on the Mariabaphone (not to mention the dozen Singing Mice I purchased yesterday).' He moved his piano and cat – and the pathetically few other possessions he could call his own – and settled down to enjoy Ayrton's company. Compared to Peel Street, the flat was private and spacious – on the second floor of a white and liver-coloured tiled building, tucked up a narrow cul-de-sac off Langham Place, close to the BBC. The atmosphere of the house was – and still is – shabbily obscure: an easily overlooked retreat in the heart of London.

Although Constant never admitted it, the benefits of the change – he stayed with Ayrton two years – were almost exactly matched by its disadvantages. He escaped the critical concern of his mother (though he continued to visit her most weekends), and the guilt-provoking attentions

of his son, and found the independence he had been missing. But this new freedom also gave him the chance to live even more lubriciously. Ayrton, who was flattered and impressed by Constant as well as genuinely fond of him, encouraged his drinking and stimulated his relish for an unpredictable existence. The portraits of Constant that Ayrton produced in 1946 show a horrific deterioration: Christopher Wood's beautiful boy has turned into a slobbish version of Winston Churchill – mountainous, exhausted and decayed. Several of Constant's friends thought that the portraits overstated the case, but some, at least, became seriously worried for him. Denis Aplvor, for instance: 'My view of him medically, so to speak, was that he was at the end of his tether, and on the brink of disaster.'

If Ayrton felt any anxiety about Constant when they first set up house together, he gave little sign of it in the memoir he wrote after Constant's death. Most of what Ayrton has to say concentrates on their collaboration for the ballet (Ayrton's first commission for the New Theatre was arranged by Constant – sets for Andrée Howard's *The Spider's Banquet*, with music by Roussel), and on their appetite for hilarity. This mainly consisted of little more than energetic drinking bouts. 'To walk with him,' Ayrton remembered, 'from one pub to another was a business of continual stops and starts. He would advance on tiptoe at great speed as if, bird-like, he might flap heavily into the air, and suddenly stop to talk to an alley cat, light a cigarette or to recall some exact turn of phrase from among the more improbable paragraphs unearthed from the morning paper.'

Their life was punctuated by peculiar and spectacular instances of what Ayrton called Constant's 'wonderful facility of galvanising circumstances'. Once, at a concert of baroque music at the Wigmore Hall, the 'indescribable' noise gave them fits of such 'dreadful laughter' that they set their row of seats shaking so that a 'whole row of intent music lovers [were] bouncing and trembling like popcorn'. Another story, dating from early 1944, is more memorably ludicrous. The ballet company were touring the Midlands, and Constant and Ayrton (who was working on set designs for *The Spider's Banquet*) travelled up from London to join them in Stoke-on-Trent:

We arrived at the railway terminus exactly one hour and twenty-two minutes before the train was due to leave. Constant insisted on being on time for trains. We seated ourselves in an empty carriage and became deeply involved in a discussion of the relative merits of cats and fish and their representation in

Oriental art. To my surprise Constant pleaded the cause of fish as ideal pictorial material, the reason, it became gradually apparent, being that he had spent many profitable hours while on tour with the ballet, in learning to draw fish. Jealously, I proposed that my mastery of cat draughtsmanship was bound to exceed his amateur efforts, even though he had the advantage of that relatively easy vehicle for virtuosity, the stylised fish.

As the train began to move, Constant produced paper and pencil and executed in outline a small but lively carp. Between us, alternately, we drew cats and fish for some time until the available paper was exhausted. The argument was not exhausted. As dusk fell, Constant inscribed in pencil above the carriage door, a small goldfish, seen head on. Gradually, fish of many varieties and cats posed in numerous ways, came to decorate the available wall space. Night came on and we worked like Cro-Magnon man in total darkness. Occasionally, by the light of matches, we inspected our work. Small cats appeared, riding large fish. Small fish were revealed inside large cats. Fish bit cats. Cats sat on fish.

In due time, only the ceiling remained virgin and it was not without difficulty, for we were both heavily built, that we climbed each into a separate luggage rack to continue, like twin Michelangelos, to draw upon the vault. At some time during this period of creative frenzy, the train drew up at a station and an elderly lady entered. Seeing no seat occupied, she relaxed comfortably and took out her knitting. Poor lady, she assumed the carriage was empty. She was wrong. The luggage racks were filled with reclining draughtsmen, but it was not until Constant observed that the ceiling was overcrowded, that she became aware of this. She disembarked and one can only be thankful that the train was still standing in the station.

Constant and Ayrton enjoyed each other's company so much that they began to seem exclusive. Gray's third wife, Marjorie Livingstone-Herbage, for instance, whom Gray married this same year – 1944 – was adamant that Ayrton was 'a bad influence'. But Ayrton could not monopolise Constant for long. Constant's job meant that his world was always densely and changingly peopled. The months following his move to All Souls Place were no exception: he wrote a short piece of incidental music for the Old Vic Company's production of *Hamlet*, and continued to diversify his work as a journalist – beginning a series of broadcasts for the BBC's 'Music Magazine'. He also continued to work furiously for the ballet: after the premiere of *Le Festin de l'Araignée* in June, he started rehearsing Helpmann's new ballet *Miracle in the Gorbals* (with music by Arthur Bliss).

In late November this pattern of work was complicated still further when Constant was asked to conduct a series of ENSA concerts in

southern Italy. Final preparations for the tour were made in a country house near Lyneham, in Wiltshire, where another member of the group, the poet John Pudney, immediately struck up an amused friendship with him. 'When a heavily-built figure smoking a cigar appeared,' Pudney told Shead, 'the party at first thought it was Randolph Churchill, but it proved to be Lambert in khaki. He took his uniform seriously enough to practise saluting, and was chagrined to discover that the officer to whom he had to report on arriving in Italy was the reverse of military in manner.' It had long been a matter of course for Constant to seek out ridiculous aspects to his serious commitments – and the ENSA tour was no exception. In Lyneham, before leaving, he found the Army forbade him to stray more than a mile from the house and he mitigated his frustration by playing 'Sheep May Safely Graze' over and over again on a nursery piano with, Shead says, 'ever increasing sadness'.

When the company eventually arrived in Naples, the music Constant was carrying was snatched from his grasp by a gust of wind, and he and Pudney scrabbled on the muddy airstrip to recover it. At one concert, his efforts to produce a polished performance of Purcell, Handel and Vaughan Williams were compromised by four unexpected blackouts. Ayrton was kept informed of these and other episodes: 'Naples,' Constant told him, 'occasionally reminds me of a London telephone box and for the same reason'; and again, when he reached Rome via Bari and Brindisi: 'I had idly thought that a journey of some hundreds of miles by 'plane would have transported me to a grove of oranges, lemons, buxom peasant girls and Chianti rather in the style of the paintings near King or is it Duke Street. Far from it. I am sitting in the freezing cold at an ebony wash stand lit only by a dim ship's lantern, pestered by a charming but slightly Baudelairian cat, and surrounded by more books on black magic than I have ever seen before.'

Part of Constant's pleasure in the southern Italian journey derived, obviously, from the fact that it broke the familiar cycle of provincial tours and London seasons. But almost as soon as he returned to England he found that foreign tours themselves were threatening to become routine. In the early spring of 1945 the company were asked to visit recently liberated towns in France and Belgium, and he was required to go on alone to conduct in Poland. Although he reported that the trip was a success, he could not disguise his exhaustion, or the fact that he had combatted it by his customary means: drink. Gray, who saw him shortly after he had reached London again, noticed a marked deterioration in his health, and wrote to Ayrton: 'He still goes up and down in his usual

disconcerting fashion . . . two days ago – he was in great form; the time before very much under the weather. But taking the situation by and large I do not like the look of it at all. His emotional instability is becoming "chronic" as charwomen say. Of course we are all the same, but he takes it a stage further than the rest of us.'

By June 1945, even Ayrton was alarmed, and agreed to help Constant's other friends in persuading him to overcome his scorn of doctors. The doctor they approached was recommended by the Sitwells – Dr Child. 'The meeting between Dr Child and Constant,' Ayrton wrote,

must be effected *at the earliest possible moment*. The middle of next week if possible. He can then be put out to grass for two full weeks. The ballet – the spring season – ends at the end of next week, and his deputy can take over the last few days without difficulty. Constant has agreed to record the whole of *Dido and Aeneas* for Legge, the week before starting the Proms. He *must be prevented* from working in the interim. Margot is frantic; (and a party to our scheme). The old boy is spitting blood and in every way worse.

'We must do something *now*,' Ayrton ended his letter, but he feared that whatever he might achieve would be no more than a temporary measure. Nothing that he or anyone said would make Constant listen to doctors, and no matter how 'frantic' Fonteyn may have been, she could not persuade him to lead a steadier life. What saved Constant from dying in 1945 was not any drastic precaution, but simply the strength of his constitution. After slightly less than a fortnight of reduced drinking he was able, when the Proms opened in July, not merely to fulfil his obligations as Associate Conductor, but to make the series (the first for two years) a huge success. He was responsible for ten concerts, conducting the BBC Symphony Orchestra and the London Orchestra, and performed a large number of standard works, including at least one piece that he loathed – Hindemith's *Cupid and Psyche* – and several (Walton's Sinfonia Concertante for instance) that he admired greatly. The last night, when he shared the honours with the conductors Adrian Boult and Basil Cameron, gave him particular pleasure, since the programme included the Piano Concerto by his friend Alan Rawsthorne. 'The last night,' Constant told Ayrton,

was fantastic – rarely have spectators been so dithyrambic. You have possibly heard of the wild orgy in which 'the three conductors were pelted with flowers' . . . May I point out (in hasty parenthesis) that autumn treasures thrown by enthusiasts at short distance can be more painful than the casual observer

might be led to suppose. My own theory is that the whole thing was led by a gang of highbrows who objected to our *tempi*. I beat a retreat before they got on to the earthenware.

Ayrton knew this kind of joking meant that even if he had not managed to cure Constant altogether, he had at least helped him to recover his vigour. Circumstances conspired to quicken his recovery. The end of the Proms season coincided almost exactly with the end of the war, and so also with an end to the tours which had so nearly worn him out. To say this runs the risk of making Constant sound indifferent to the larger suffering which occurred around him. While his actual involvement with the war had been negligible, he had in fact retained a clear sense of his own comparative comfort, and of the need to be dutiful. His unstinting devotion to high standards during the tours had embodied a conscious effort to perform the only kind of selfless action that was available to him. A letter to Ayrton, written after the atomic bombs had dropped on Japan, shows that the lack of first- or even much second-hand experience of the war did not prevent him from understanding the issues at stake. Typically, his strong feelings are hedged around with self-deprecating ironies:

I hope that you (as a well-known follower of seismographical disturbances) will have had the prescience (to say the least) to observe that the sunsets this week have only been equalled by the ones following that rather grave earthquake in (only the other day) Japan.

It just shows what the atomic bombs can do. I am not being facetious (far from it). I thought you might appreciate this rare example of visuality on the part of a musician.

Constant had no precise idea what the peace would mean for the ballet, but he had no doubts about how much concentrated effort would be required to re-establish the traditions broken by the war. Not even an invitation, in October, from the Australian Consolidated Press to visit Sydney the following spring could deflect him from his work at home. (The chance to see his father's grave, studio, friends and paintings seems not to have tempted him at all.) He had to wait a remarkably short time before the world that he had previously known was reconstructed. On 20 February 1946 he opened a series of concerts with the Hallé Orchestra at the recently inaugurated Royal Opera House, conducting the Sadler's Wells Ballet's new production of *The Sleeping Princess*, with Fonteyn as Aurora, and decor and costumes by Oliver Messel. The production, as

Shead says, was 'one of the greatest triumphs' in the history of the company – and its success was of more than merely intrinsic value. It was also instrumental in establishing Covent Garden as the company's base – the original idea being that Constant should be wholly responsible for conducting ballet performances, and that he and Carl Rankl should divide the work on operas more or less equally.

This new and comparatively clear-cut structure to his working life was confused as the season got under way, when he was engaged to make seventeen appearances as Associate Conductor at the Proms during the summer. He also accepted, when the Third Programme was launched on 29 September 1946, an invitation to conduct for the BBC on a regular basis. The offer came from Humphrey Searle, who had recently joined the BBC, and knew that Constant would be particularly valuable as an interpreter of little-known or neglected works (his first concert was devoted to Liszt) – both as a conductor and as an introducer.

As the BBC concerts got into their stride, it rapidly became clear to Constant that the 'two full weeks' he had been 'put out to grass' in the spring of the previous year had come nowhere near restoring him to full health. Shead shows him weary but heroic:

Often there would be two rehearsals in the same day, followed by a live broadcast in the evening. As the day progressed the atmosphere would change. At the morning rehearsal Lambert would slump in, slightly late and rather gloomy, and things would go wrong. After the mid-rehearsal break [when Constant would top himself up with a few drinks] matters would start to improve, and by the afternoon they would be much better. But he always saved something up for the performance, which would be a great improvement on anything that had happened during rehearsal.

No matter how hard-drinking Constant had been in the past, he had always been vigorous in his work. Now, for the first time, his conducting began to suffer. The fact that the damage was admittedly more obvious in preparation than in performance is partly a tribute to his shortened but no less intense powers of concentration, and partly a witness to his players' extraordinary devotion. Ashton and de Valois both knew that his alcoholism was far advanced, and the orchestras for which he was responsible could not ignore its effects. Not a single player did so much as mutter a complaint. How could they, when everyone agreed they owed him so much, and when the final results of increasingly bleary preparations were usually immaculate?

In mid-1946, Constant put his colleagues' loyalty to the test by

undertaking a massively ambitious production of *The Fairy Queen*. This was to be the first opera performed at Covent Garden since the war, and required a huge range of players, dancers and singers. No matter how run-down and hung-over Constant may have felt, he was determined to make the most of this 'opportunity to present the public with a whole evening of Purcell and to present him not as a museum piece but as a still vital theatrical figure'. Ayrton was engaged to provide the sets – he based them on designs by Inigo Jones; Ashton undertook the choreography, Fonteyn, Somes, Helpmann and Michael Hordern were among the cast, and Constant took charge of the text – editing it to 'an acting edition', cutting Theseus and the lovers, and concentrating on Oberon and Titania. He also made a few minor alterations to the score, dropping the scene of the Drunken Poet, among a handful of others, and collaborating with Edward Dent and Gordon Jacob on the instrumentation. He was, in other words, the production's inspiration, and its presiding spirit. The preparations occupied a full six months, and Ayrton spoke for all his collaborators when he admitted to being, during this time, 'awed by the intensity, the scholarship, and the sheer musical intelligence of which Constant was capable'.

Shortly before the first night, the general administrator of Covent Garden, David Webster, who was more alarmed by Constant's drinking than impressed by his organisational abilities, decided to appoint Carl Rankl as the conductor. If Constant realised that this marked the beginning of the end of his old relationship with his company, he did not show it. His colleagues were not so controlled. Ayrton objected violently, and all the principal performers revolted, saying they would not take part if Constant was not conducting. Webster had no choice other than to climb down, but did nothing to disguise the vulnerability of Constant's position. It was jeopardised still further by the reception given to the opera. As Shead says,

each of the three 'publics' which attended the first night on 12 December wanted something different: the ballet-goers were bored by the singing, the opera audience resented the dancing, and the Shakespeare-lovers from the Old Vic were appalled by the whole thing . . . The production was revived in Festival Year, 1951, with new choreography by John Cranko, and not seen thereafter.

Constant's reaction to this reception was defiant. 'I can well see,' he said,

that some Purcell enthusiasts may accuse me of crimes of omission. All I can claim

is that after a period of neglect lasting 250 years Purcell's major theatrical work was presented at our principal opera house not as a 'period piece' enjoying its brief-lived *succès d'estime* but as a masterpiece of English theatrical art enjoying at last its popular and spiritual due. The greatest and most intelligent tribute I received was not from any academic source but from my local greengrocer, Mr O'Leary of Great Titchfield Street, who said, 'What I liked about it was the balance of the whole thing. Not too much of anything. The right amount of singing, the right amount of speaking and the right amount of dancing.'

In truth Constant was bitterly hurt. As the new year began, seeming only to offer further tussles with David Webster, his solution was not to restrain his drinking, but to indulge it with a ferocity compounded of distress, self-destructiveness, and an irrepressible wish to dare the world to deny him. Denis ApIvor recalled a number of incidents which describe Constant's condition:

[I] had been to the [BBC's] Maida Vale studios to hear him conduct a moving performance of Heseltine's 'The Curlew'. We had a very moderate few drinks and he came out en route for the car . . . [when] he fell flat on his face in the snow. Maggie Dale told me that he had been found I think outside the stage door in Liverpool in the same position . . . [At another time] we had been to hear a performance of Berg's *Lyric Suite* and were in a pub off Trafalgar Square. The conversation turned on theme songs for important historical personages. He suggested the Duke of Wellington and my wife promptly came up with 'Any Old Iron, Any Old Iron'. Convulsed with laughter he suddenly fell off his stool with a crash like a felled oak and lay unconscious while the horrified spectators rushed to pick him up.

Other, and less alarming stories abound. Humphrey Searle, for instance, recalled for Shead

going with [Constant] from the BBC's Maida Vale studios to a pub for lunch, with snow on the ground. Lambert could hardly walk, and as they trudged through the icy wilderness Lambert told Searle that he had always called this part of London 'Average Asia', having once seen a score of Borodin's orchestral piece with the title helpfully printed in three languages thus:

IM MITTELASIEN DANS L'ASIE MOYENNE
 IN AVERAGE ASIA

When not bolstered by his friends, Constant's disillusionment was given a looser rein. He became unguardedly critical of the musical hierarchies and administrations which had merely irritated him before, and increasingly loath to broaden or vary his circle of drinking companions.

The size of this circle, in fact, shrank as the months passed, and he was deserted by those who – unlike Gray or Ayrton – became intolerant of the stupors into which he declined with increasing frequency. The composer Alan Rawsthorne, for instance, whom Constant had always admired, now found himself overpraised so as to fill the vacuum others had left. 'He happens to be one of my closest friends,' Constant snapped to a mildly disapproving colleague, '[and] I consider him to be the best young composer in England.'

Clearly this behaviour reflected, and was responsible for, the unsatisfactoriness of his private life, as well as the insecurity of his professional career. On his regular week-end visits to Amy, the deterioration in his looks and manner alarmed her. Her 'flawed emerald' was a heavy, stooped, prematurely aged figure – his breath usually smelling of drink, his eyes puffy, his clothes streaked with cigarette ash. The frequency of his visits to his mother clearly show his undiminished dependence on her – for love as well as correction – even though he usually tried to disguise this. For the previous eight years or so, Constant had, despite the distractions of numerous brief affairs, looked on Fonteyn as the person best able to bring him the love he almost absolutely wanted. Now his drinking had reached the point at which her power to help him, let alone her patience, was severely curtailed. Constant seemed determined to withdraw from the world in general and her in particular.

But it was more than drink and disillusionment which finally brought about the end of their relationship. During the later part of 1946, Constant's group of regular companions began, occasionally, to be joined by Isabel Delmer (née Nicholas), the recently divorced wife of the war-correspondent Sefton Delmer. She was thirty-four (Constant was forty-one) – a tall, dark and elegant woman, whose naturally thin and beautiful face, with its blue, amused eyes and wide mouth, was already creased with smile-lines. Her past life, in which she had combined working as a painter with assiduous bohemianism, made her an immediately welcome and fascinating friend. She had been born in London in 1912, the daughter of a master mariner of Scottish descent, and as a young woman had studied art first in London, then Paris. In Paris she had consorted with a large number of distinguished artists – among them Derain, Miró, Epstein and Giacometti, whose work had influenced her to paint in a sensuously abstract tradition – and in the course of her to-ings and fro-ings she had already met Constant several times. The first time, she says, was 'when I was very very young, just for a second' when she was a

student at the Royal Academy. 'I told him I thought I would be going to Paris fairly soon. He hoped that the ballet would go one day. When we said goodbye I had a curious feeling of seeing his face exceptionally clearly as though I were about to make a drawing.' Their second encounter – in Paris, as Constant had hoped – was more prolonged. 'The Royal Ballet came . . . for a short season,' she remembers:

Constant was with them. I went to one performance of *Job* . . . with Robert Helpmann in the title role. It was extraordinary to see such a work given before a Parisian audience. The Parisians did not like it. I would have been astonished if they had.

Constant came with me to the City Hotel. He was enchanted with the place, especially the scaffolding, which filled him with interesting and fanciful thoughts. In the café overlooking the Seine it was clear that he was perfectly happy. His great love of France and most things French reduced him to . . . silence.

One evening, without any warning, Margot Fonteyn and Ninette de Valois arrived outside the café. There we both were, sipping what was probably a Pernod, when Margot turned towards Ninette, smiling with glee, saying, 'Enfin il a trouvé son ambiance.' They had brought with them Roland Petit who was astounded to find Constant frequenting such an unfashionable and broken-down habitation as the City Hotel.

Constant stayed on for a couple of days after the ballet had left. We met for dinner and spent whole nights walking about . . . I took Constant to various all-night cafés that I knew. We went to the Halles and along the Sebastopol.

As Constant was lame and walked with a stick I was sometimes a little nervous of those night expeditions in case he was pushed. He insisted on walking. It gave him the greatest pleasure. In fact, two people could hardly be found to share such sweetness in walking about.

As this implies, Isabel's addiction to France, her broad interest in the arts, and her fast living strongly appealed to Constant, even if her politics – which were much more radical than his – left him cold. But Constant's attraction to her was distinctly unlike any he had felt for previous girlfriends. Whereas he had formerly been drawn to women who were young, unformed and ornamental, Isabel was decided and free-thinking, as well as beautiful. For the first time in his life, and almost too late, Constant found himself falling in love with someone he considered his intellectual equal.

Ayrton, who since Constant's illness two years earlier had diligently but discreetly maintained his role of guardian, was delighted by Isabel's

influence. She steadied him at his work (in February 1947 Constant conducted the highly successful revival of the *Three Cornered Hat* at Covent Garden); she encouraged him to become more independent (he left Ayrton's house and moved to South Kensington, to a drab flat opposite the Victoria and Albert Museum at 37 Thurloe Square – even though this meant paying two lots of rent: one for the new flat, and one for the remainder of the tenancy he had agreed with Ayrton); and she sobered him up. But their relationship, at least in its early stages, was far from settled. In February, after the season had closed, Constant and Ayrton went to Ischia for a holiday – and also to visit Norman Douglas in Capri. Ayrton wrote to a friend: 'Constant is . . . in wonderful form. He has given up smoking and only drinks *Lacrima Christi* (no spirits). He is extremely well and coherent if slightly megalomaniac. If he can only remain in this present happy state no one need worry.' What Ayrton did not mention was that Constant was accompanied by a young Japanese soprano called Aki. On the way to Ischia, Constant and Aki had stopped in Paris, and met Isabel by chance. Constant was not yet committed enough to Isabel to make the encounter an embarrassing one, but Isabel remembers an incident which warned her how committed he might become:

While the three of us were sitting in the Deux Magots, one of the young men selling horoscopes and prognostications of various kinds approached our table. Constant, who was deeply superstitious, asked for three. As the young man was placing them on the table [Constant] managed to switch the two destined for Aki and myself.

As soon as Constant returned to his dingy new home in Thurloe Square, he started to send Isabel postcards 'nearly every day. Some were in the form of limericks, some were miniature crosswords, some were musical quotations, some quotations from Beachcomber.' Whatever their value as *billets doux*, these postcards clearly demonstrated that Isabel had helped Constant recover his zest for life, and his ability to do his gifts justice. Several of the administrators at Covent Garden thought it was too little, and too late. When, in May, he began rehearsals for a new production of *Turandot*, in which the lead was taken, as it had been in 1939, by Eva Turner, he received no clear impression that his superiors' faith in him was unbroken.

Turandot received eight performances – the first on 29 May and the last on 1 July – and during its run Constant's unhappy relationship with David Webster reached a crisis. Temperamentally speaking, the two men

had always been opposed to one another: Constant thought Webster was 'a musical businessman', and Webster thought Constant was drunken and unfunny. Webster had no doubt about the excellence of Constant's musical taste, or about the range and depth of his knowledge, or about the devotion he inspired in the dancers and orchestras. But he could not ignore the fact that, in Isabel's words, Constant's 'physical and mental state at this time was such that he could not be relied upon to give *consistently* good performances'. Even Constant's most loyal colleagues realised this. De Valois, for instance, reluctantly recalls, 'You couldn't rely on him. We knew what was coming and there was nothing to be done about it, and we knew that he didn't want anything to be done about it. All his friends knew this, but one hung on for ever because he was such a wonderful man.' Webster, however coldly bureaucratic he seemed to Constant, had good reasons for confronting Constant as he did: 'consistently good performances' were precisely what he had to guarantee. On 2 July 1947 he gave Constant what Isabel called 'the conventional way out' – to resign before he was dismissed. That evening Constant wrote to Webster:

Dear David,
 As I explained to you this afternoon, I have with the utmost regret decided to leave the Sadler's Wells Ballet Company with which, as you know, I have been associated intimately for the last fifteen years and whom, if I may say so, I helped to carry through the very difficult war years at the expense of giving up my composing and conducting career. I feel now that the work is running on its own wheels and no longer needs the help of my experience. Among the many reasons which have induced me to take this decision have been the productions of *The Fairy Queen* and Puccini's *Turandot* in which, in sharp contradistinction to the balletic approach, I have received intimate collaboration and personal gratitude [sic].
 As I told you the other day I have taken on an important film which will involve my being free from the beginning of September to the end of November, so . . . I will obviously be unable to give the hundred per cent support to the ballet which I have been able to give in the past. Since the situation has inevitably arisen I think it better that, howsoever regretfully, I should retire from my position as Musical Director and Conductor of the Sadler's Wells Ballet – though, as someone who has been connected with it intimately for many years, I shall always be pleased to give them my musical advice.
 I am very sorry to have made this heavy decision. Please convey my regrets to the Trustees whom I am sure will appreciate the sincerity of my inevitable action.

 Almost three weeks later, at the next Covent Garden Trustees Meeting, the resignation was accepted. Webster wrote to Constant:

I read your letter to the Trustees at the last meeting and I know that Sir John Anderson is writing you officially as from the Trust.

I just want to add my own private word to the effect that the Sadler's Wells Ballet owes you an enormous amount of credit for the work they have done. Certainly no Ballet Company since Diaghilev has had such an outstanding list of musical works in their repertoire, and as far as English composers are concerned, I am quite sure that never have they had such an innings with any other musical institution. It does you enormous credit.

I remember hearing you many times in the early part of the war thumping on those pianos and I cannot imagine any greater work and labour, nor can I think of anybody else in the country of your standing who would have been willing to have given time to it.

I personally am extremely happy that it is likely that you are going to do more composing and I am sure the whole musical world will be glad also.

The 'important film' to which Constant refers, and which he offers as the main reason for his resignation, was *Anna Karenina*. It was a comparatively light task, and one which in previous years he would have found no difficulty in reconciling with the company's routine. But the implication of his letter – that he wanted more time to compose – was sincerely meant, and Webster was obviously pleased to seize upon it as a way of moderating what would otherwise have seemed, for all its reasonableness, a harsh judgment. Other aspects of Webster's letter – his remarks about Constant's work for the ballet in general, and about 'thumping on those pianos' in the war – are significantly less impressive and less sympathetic. Constant's increasingly erratic behaviour undoubtedly made him unfit to continue as musical director, but Webster gives no adequate appreciation of the work that Constant had done in establishing and educating the company in its early years, and no sign of understanding what the personal cost had been. His efforts to found and then foster in England the tradition of ballet he had learnt from Diaghilev had all but killed him.

Seven

Constant's resignation severely damaged his pride, his reputation and his pocket. It also brought him the freedom he had missed for so long, and he addressed himself to writing the score of *Anna Karenina* with discipline and enthusiasm. In the event, the effort proved unrewarding. The film was alluringly ambitious – it had a screenplay by Jean Anouilh, costumes by Cecil Beaton, and starred Vivien Leigh and Ralph Richardson. But Constant was required to produce pastiche Russian music rather than anything which allowed him to be fully himself. Only occasional cadences, and the use of a siciliana, forcefully expressed his distinct musical personality.

In his private life his hopes of reinventing himself were more successful. In the early autumn of 1947, Constant proposed to Isabel and was accepted: he was forty-two, and she was thirty-five. Constant thought, Isabel says,

if he married me I would bring him back to life. His friends thought so too. He was a sad man, and a sick man, and a lonely man. He had been a public figure since a young man, had acquaintances of all kinds, only few close friends. He was a loner.

This was not apparent to most people. He hid behind the carapace of wit, sharp remarks and great vitality. His life was intolerably rigid. The pattern was one of hard work, which was in his nature, the dreary round of eating in familiar restaurants, returning to sleep in a nasty little house in Thurloe Square.

In spite of Isabel's protestations to the contrary, not all Constant's friends approved when they were married – in October, in St Pancras Town Hall. Ashton, for instance, believed 'it was very bad, in a way, that they got together. They were both terrific topers' – sounding a caution that Amy, who thought no one was good enough for her 'flawed emerald', worriedly endorsed. (When Constant rang Amy to tell her that he was marrying Isabel, he took pity on her feelings by telling her, 'Anyway, she isn't coloured, she's half-Welsh. Nor is she a ballerina.') For all the loyalty that he owed Amy, Constant felt no compunction about overruling her opinion. Neither, apparently, did he have much consideration of how Fonteyn would react. News of his wedding reached her when she was on tour, and the surprise of its discovery goes a long way towards explaining the silence she has subsequently kept about her time with Constant. Once

again, and more cruelly than before, he had proved himself as hurtfully inept as his father at handling the consequences of strong feeling.

Shortly after their wedding, Constant and Isabel moved from Thurloe Square to a flat (the first and ground floor) further north in London, adjacent to Regent's Park, in 197 Albany Street – it was opposite the police station – and began a life of shambolic cosiness. '197,' Isabel wrote later,

became our home. The ground floor was quite large, large enough for two pianos. Upstairs there were two rooms, bedroom and studio. Our piano was a small upright, a Kirman. I believe Kirmans made harpsichords. This one sounded rather like a harpsichord. This is no doubt why Constant was so fond of it. The other was a baby grand, a most extraordinary instrument. It was of an elegant shape, the legs were slender . . . and narrow and curved in a graceful manner. It was of light-coloured wood. Where it came from I do not know. It made a sound like an unstrung harp but it was great fun to have them both. In fact, life now became great fun. Whenever I went out with Constant, it might be a small journey to the market, I always felt something extraordinary and exciting would happen. He carried about with him the aura of a conjurer. I was also conscious of being with a person of great physical beauty. His lameness possibly added to his distinction.

Their surviving friends confirm this impression of happy-go-lucky tenderness. William Chappell remembers, 'They got on awfully well in the most marvellous way, leading the most appallingly slatternly life . . . The whole of the sink was always crammed with washing up which hadn't been touched . . . They had some nice bits of furniture, but they were all battered, and had rings on them that glasses had left.' Denis Aplvor – who also lived in Albany Street – felt the same cheerfulness thriving without many accompanying domestic graces:

In the gloomy front room . . . was tied to his chair a weird witch-doctor's charm of feathers, which was the plaything of Spalding [his cat]. Although unusually sensitive to painting, and married to a painter, the chief decoration of the room was strange faded newspaper clippings containing ridiculous jokes and cartoons which amused him. Also scattered about the room were scraps of paper with cryptic messages to Isabel couched in terms of the profoundest obscurity.

Even Ashton softened his original judgment a little: 'People thought it might be better for them to drink together than alone.' Isabel herself was unambiguously happy – 'the house was an absolute shambles,' she remembers, 'but we were always dying of laughter.' For the first time in

his life, Constant found that the gap between his home life and his social life was abolished. Ayrton, Gray and Rawsthorne (whom Isabel married after Constant's death) were regular visitors; the Sitwells appeared occasionally; and even his friend from the Nest, Laureen Sylvestre, was welcomed. Flo, who was still living in Chelsea, was never seen and seldom mentioned – not because Constant wanted to protect Isabel's feelings, but because in the ten or so years since his marriage to Flo had ended, Constant's own feelings for her – and therefore his thoughts of her – had dwindled almost to nothing.

None of these signs of Constant's happiness beguiled his mother. Although Constant visited Amy 'every Sunday', and continued to write to her regularly when away from London, she disapproved of what she considered his chaotic life (her feelings were shared by Maurice). Constant's treatment of Kit – who had been forced to make Peel Street his more or less permanent home – gave her particular, and particularly reasonable, cause for anxiety. Constant's resignation from the ballet company did nothing to make him spend more time with his son. He saw Kit, sometimes, on his Sunday visits, but made no effort to include him regularly in his new life with Isabel. Isabel, in fact, only remembers meeting Kit 'two or three times', and although she thought 'he was a very strange boy', she liked him: 'I was fascinated by his appearance, which seemed to me to be a half and half legacy of his parents.'

The pleasures of Constant's married life hardly affected Kit. As the first flush of their influence waned, they also seemed incapable of removing altogether the signs of Constant's own underlying insecurity. His neighbour ApIvor was well placed to see how his need for alcohol, which decreased around the time of his wedding, soon grew again. At least, though, Constant was drinking less spirits than had recently been the case, and confining himself to opening hours:

His favourite pub was The York and Albany [overlooking Regent's Park, in Camden Town] which was kept at that time by a brassy-looking theatrical blonde lady who wore an orchid in her corsage. When [Constant] died, and I came into the bar and told her, she was very sad. 'What a nice man he was,' she said, and then in the same breath, 'must have spent five pounds here the other night.' Shortly after she gave up the pub all the clientele disappeared and the place has been like a morgue ever since. The same thing happened to The George in a different way. After the war we used all to go there to meet Constant when he was living in All Souls Place. Now none of us ever enter the doors though I am sure it is still doing good trade from the car dealers and broken-down types from Titchfield Street. [Constant] used to like The Edinburgh Castle a few paces from The York

and Albany, because of an extraordinary Garden of Gethsemane which it possessed and still does. At the end of this dreadful place ran the main line, and whenever a train passed he would totter . . . past the withered flowerbeds, and soot-grimed chairs piled in horrible confusion waiting for a happy event which may never occur, and gaining the edge of the abyss he would peer down at the 7.45 or the 8.10 or what have you, on its way to Edinburgh or Glasgow . . . But on fine evenings, The Edinburgh Castle provided a beautiful view of the sunset, and it may be that he liked it for that reason also, as I remember him pointing out the colour of the sky on one occasion with an almost proprietary gesture.

Even if Isabel's companionship could not stop Constant drinking a large amount, it could at least purge him of the bitterness which had infected him at the time of his resignation. It did not take long for news of his improvement to reach the ballet company in their new home at Covent Garden – most of his friends, after all, still worked there – and for the 'musical businessman' to approach him with offers of work. On 26 November Constant conducted the premiere of Massine's *Mam'zelle Angot*, and early in 1948 after a brief Christmas holiday with Isabel at Tom Driberg's house at Bradwell in Essex, he was engaged by the Hallé Orchestra to conduct a northern tour which ran from 7 May to 23 May and included concerts at Wolverhampton, Sheffield, Preston and Manchester. He wrote to Amy from the latter:

The tour so far has been most successful . . . The orchestra are not only first rate (particularly the strings) but an extremely pleasant crowd to be with . . . Once out of Manchester it is lovely. Here to Sheffield over the moors and . . . to Morecambe through north-west Lancashire are both very good trips, though Morecambe on a Sunday afternoon is not the ideal ambience for *Scheherazade*.

A genuine and new-found stability had entered Constant's life. Judging by a letter written to Amy later on the same tour, it was more than the prospect of work and the knowledge of his happiness with Isabel which produced the change. Constant's finances, which during his time in Thurloe Square during 1947 had been painfully stretched, were also improving: 'As regards finance,' he told his mother,

(which I loathe discussing as you know) your suggested present will be more than welcome and I hope it won't embarrass you in any way. It was unfortunate that I had to pay double rent [for All Souls Place and Thurloe Square] at a time when jobs were falling away. But with your help I shall be able to start on clear ground once again and with my life settled we shall both be able to concentrate on our work without worry or interference. I can't tell you how grateful I am.

'Concentrating on work' meant, in the short term, conducting a programme of English music in London on 3 June, and travelling with Isabel to Paris immediately afterwards for a concert which included *Music for Orchestra*. In the longer term, it meant accepting the offer, which had been made in May, that he should become Artistic Director of the Sadler's Wells Ballet at a salary of £500 a year. He had been away for less than a year. (The job differed from his previous post – musical director – in more than name: its responsibilities were vaguer, and therefore more open to amendment by his colleagues Ashton, de Valois and Webster.) The money, the chance to rejoin his friends, and the implied recognition of his just deserts all pleased him: 'I look forward very much to giving the ballet my utmost help,' he wrote to Webster. But when the first season began – after a brief and unsuccessful visit to Paris with the company in October – he found that he could not easily settle down. 'I feel still slightly ill at ease' at Covent Garden, he told Amy in November, when working on the rehearsals of *Don Juan* (which had its premiere on 25 November). '[I am] received with the mingled welcome and suspicion that greets a cat that has been lost for a week.' Most of his colleagues felt no such embarrassment. They were simply delighted to see him back. Markova, for instance, who had rejoined the company and had been warned that 'I wouldn't find him the same', later said, 'I must say, in my performances he was just the same. I remember I had only two weeks to learn *Sleeping Beauty*, but I had such faith in him . . . He was a great musician; he was so reliable and yet it wasn't boring. It was always alive and fresh and yet I never had to worry about *tempi*.'

Constant's feelings about Covent Garden had changed, but the routine he had to undertake was entirely familiar. The responsibilities he had shouldered in the past, and which he had initially been so relieved to relinquish, were irresistibly attractive to him. So were the opportunities to complicate his life with additional burdens, and in order to brace himself for their demands he took a short Christmas holiday with Tom Driberg at Bradwell Lodge in Essex. Isabel vividly recalls the quality of Driberg's hospitality, on this and other of their visits:

Bradwell Lodge was built in the eighteenth century as a vicarage. Gainsborough was said to have worked there. It was elegant, with a splendid walled garden, a ha-ha, magnificent trees. Nearby there was the sea wall.

Tom insisted on always referring to his address as Juxta-Mare. He took great pleasure in maintaining the house, although this was a costly business, especially as he also took delight in entertaining friends. On one occasion when Constant and I were there, Aneurin Bevan was a fellow guest.

That morning, when we all assembled for breakfast, the Sunday papers were spread out on the table with splendid headlines. One triumphed, with large letters: 'Blood-bath Bevan Won The Day' . . .

Many people spent pleasant days and nights at Bradwell. Always good food and wine, and conversation on all subjects, word games and Lena Horne singing in the evening.

As soon as the new year began, Constant put himself firmly in harness. In January and February he made a northern tour with the Hallé Orchestra, in March he returned to London to conduct a revival of *Apparitions* and in April he set off for Palermo, in Sicily, for the Festival of the International Society for Contemporary Music. Determined to make the best of an exhausting schedule, he first travelled with Isabel to Paris – but any chance of turning the visit into a holiday was removed when he developed acute stomach aches. These weakened him so badly that he was still suffering by the time he reached Rome, where he was due to rehearse the radio orchestra. (Nevertheless, as Shead points out, he still 'insisted on walking all over the Pincian Gardens to find the statue of the one-legged Italian motor cyclist . . . heroically hurling his crutch at the Austrian enemy in the First World War'.) When he arrived in Palermo he was almost well again, and his recovery was quickened by his pleasure in the town. Although he and Isabel had been booked into the luxurious Villa Igiea, which he found dull, he discovered that Palermo boasted an alluringly exotic slum, Acquasanta, where he happily wandered at every available opportunity.

His free time, though, was scarce. In addition to preparing for the concert – which consisted of works by Lennox Berkeley, Mátyás Seiber and Humphrey Searle – he had to complete a work commissioned by the London Contemporary Music Centre. The result, dedicated to the LCMC President, Edward Clark, was three piano duets, *Trois Pièces Nègres pour les Touches Blanches*, which, as the title indicates, only employ the white notes of the piano. For all the trickiness of their structure, the pieces ('Aubade', 'Siesta' and 'Nocturne') are unaffected and ebullient, and reflect his improved spirits. They have strong affinities with the works he had produced at the beginning of his career, particularly in their use – in title and score – of Satie-esque jokes and sophistications. The sense of rejuvenation was confirmed when he returned to London. On 17 May, as part of a programme in the concert hall of Broadcasting House which included Mary and Geraldine Peppin giving the first public performance of *Trois Pièces Nègres*, he was invited to collaborate once again with

Edith Sitwell. The pretext was the first performance of Humphrey Searle's setting of her poem 'Gold Coast Customs'. Searle, who dedicated the piece to Lambert, wanted the two long-standing friends to share the declamation. The evening was a success, but for those who remembered Sitwell's and Constant's former joint appearances it was a melancholy one. Sitwell, unlike Constant, had aged stylishly, wearing a long gold cloak. His energy seemed undiminished – Searle said that he 'appeared to be conducting the conductor of the orchestra' – but his appearance was dismaying. One member of the audience, Christopher Ford, recalled: 'He was no more than forty-four, but the heavy jowl, the uncaringly ugly braces, the walking stick dropped by his feet, made him seem dreadfully older. Until he spoke – and then the voice, as resonant and commanding as that of Dylan Thomas, transformed the image.'

It was just this unexpectedness – the wonderful performance issuing from the wrecked body – that made Constant so rewarding and so alarming to his colleagues at Covent Garden. Towards the end of the year, the rewards became more attractive, and the alarms more potentially damaging than ever before, when the company planned one of the most ambitious episodes of its history – a season at the Metropolitan Opera House, in New York. There was, initially, some resistance from the Sadler's Wells Ballet administrators to Constant's being put in charge of the music for the tour at all. (The American Embassy was antagonistic, too – but for different reasons: the officials wanted to know what he had been up to in Poland at the end of the war. They gave him his visa, regardless, when they found that his father's initials stood for George Washington.)

Once the company had reached America it seemed that any doubts about Constant's suitability were not simply misplaced, but preposterous. He solemnly promised he would not drink at all heavily during the tour, and rehearsed efficiently for the first performance (*The Sleeping Princess*, with Fonteyn in the lead) – partly because he found that New York did not provide him with the sort of temptations he usually found irresistible. (He was given what he considered proof of America's puritanism soon after arriving. According to Isabel, 'A lounging figure [in a bar] shouted in a loud voice on seeing Constant, "throw that man out. He looks like Oscar Wilde."' 'One's first two days in New York,' he wrote to Amy,

leave one with only two feelings – (a) a maniacal and continuous desire for iced water; (b) an even more maniacal and continuous desire to be translated

immediately to some odoriferous slum in the south of Europe . . . The town is extraordinarily beautiful by night, but during the day is rather drab. Not so modern or so chic as I had supposed. Rather suggesting a lot of buildings put up . . . for an International Exhibition and left there after the Exhibition had closed.

The fact that he was visiting, for the first time, the country his grandfather had left nearly eighty years earlier seems only to have depressed him. 'I am miserable in America because my relations came from Baltimore,' he told one interviewer.

Constant's promise of abstemiousness did not prevent his colleagues from keeping an anxious guard on him. De Valois remembers how on the first night, 'I [went] round to the back [of the Met] in my usual appalling agitation, particularly because of this wonderful bar they had there, and [said] to the stage manager, "Mr Lambert, er, have you seen him?" and [got] the reply, "Dead sober madam".' By the end of the evening her simple relief had turned into something like rapture. 'He *made* that first night,' she recalls, and Ashton agrees: 'Nothing was more wonderful . . . He stepped into the pit and started and everyone was electrified.' Lincoln Kirstein, who was in the audience, was less partisan but equally ecstatic:

The hero of the occasion, according to Balanchine and myself, was Lambert; he had a fine band and the score never sounded so well; he is a genius for tempi; absolutely on the note in every variation; no boring bits; and he supports the dancers on the huge stage by giving them assurance with his authority. He whipped people up into applause, purely by sound; when nothing was really happening from a dancer he seduced everyone into imagining that she was divine. Anyway, he got an ovation; many people knew what he had done.

According to contemporary accounts and subsequent reminiscences, the company had rarely had such a resounding triumph, and Constant's role in their success had seldom been so conspicuous. But as soon as the first night was safely over, his relief almost immediately led him to confirm his colleagues' worst fears. He started drinking very heavily – not only as a way of expressing elation, but of fending off boredom. In his work, as in his private life before meeting Isabel, his pleasure lay in preparation and initiation, rather than continuance. 'There are certain things in life,' he told Isabel,

such as birth, fornication, and death which have their ups and downs. The only thing in life which can maintain a continuous level is *cafard*. Talk about *cafard*! Fortunately I am getting acclimatised and can even distinguish between one street

and another (which is more than most Americans do). I live rather symbolically between two avenues (both of which I have explored) – Park Avenue, which tries to be like Gloucester Gate without succeeding, and Lexington Avenue which is vaguely like Camden High Street, and quite frankly lets the whole fucking thing ride. I drink there rather gloomily after the show from time to time . . . Californian Burgundy (sic!) disappointing. Chilean Riesling (no joking) excellent and is my staple beverage.

The tone here tries to play down what it cannot help embodying: a dangerously depressed frivolity. His colleagues in America watched his concentration deteriorate, and tried to cover for him. When he actually passed out, though, in the middle of conducting *Hamlet*, they knew that their support would never be enough. As soon as the company returned to London, it was obvious that he could not be relied upon to direct other tours, and that even his work in England would have to be reduced.

As before, the company tried to avoid hurting his feelings. Webster again suggested that Constant should spend more time composing. Although Constant was involved in a series of concerts in the spring of 1950 – a Command Performance for the French President at Covent Garden on 9 March, the premiere of *Ballabile* on 5 May, and the twenty-first anniversary performance of *A Wedding Bouquet* on 16 May – the rest of the year was left blank. Constant could not ignore the company's ulterior motive for giving him his freedom, but was determined to make the most of the opportunity to prove himself. With encouragement from Isabel, who suggested she might paint the sets, he began thinking about the possibility of writing a ballet about Tiresias. In June, hoping to rid himself of distractions, and to discover the necessary stimulus for composition, he went with Isabel to stay in Valmondois, north of Paris. Soon after they arrived, Kit (now aged fifteen) suggested that he should join them, but Constant demurred. 'Our whole *ambiance* there is far too sophisticated,' he told Amy, in a letter which confirms his intolerance as a father, 'and he wouldn't pick up a word of French from our high-speed high-brow friends. (Though I am all for being thrown head first into sophisticated society at the age of twenty as happened in my own case.)' This rejection wounded his son badly. As Kit grew up he came to appreciate that, while a very young boy, he could hardly have hoped to share much of his father's peripatetic, sophisticated life. When an adolescent, though, Kit expected to provide less troublesome, more diverting company. He was continually disappointed, and thrust back into the company of his mother, or Amy, in their London homes.

If one reason why Constant refused Kit was his wish to concentrate on composing, another letter to Amy shows that his need to relax regularly sabotaged his best intentions. It is a letter which, in tone and reference, seems more likely to have been sent to a lover than a mother:

Work is going slowly but not too badly. I always find it difficult at first to write in a new situation and this extremely lush landscape with its incredible shindy of birdsong is at first a little overwhelming. We have two rooms, a really large studio for Isabel, a spacious bedroom and a smaller room with a piano, presumably Pleyel's experimental model but just good enough to compose on. No modern conveniences, no hot and cold, *unusual* offices in the garden. Life could not be more simple. Brood about work and/or take a walk in the morning. Lunch outside. Then tentative composing in the afternoon. Evening walk down to the village which is not beautiful but very human. The only bistro is filled with a series of characters (much hand-shaking etc.) for which any French film director would willingly sell his soul. Simple dinner and then non-professional music, ranging from Purcell to Chabrier . . . *Tiresias* is only just beginning to breed. Have sketched the Prelude (which for final polishing I shall leave to the last), have finished the opening number (young girls in the nude somersaulting over bulls) and the last number in Scene I (pas de deux for copulating snakes leading to Tiresias' first change of sex). Am pleased with the latter. Still three more numbers to do even to finish Scene I!

Even from his mother, whose age and comparative prudishness he well understood, Constant could not conceal a ridiculous dimension to his project. The idea of using Tiresias as the subject for a ballet was one he had considered during his time with the Camargo Society in the early 1930s, but his colleagues judged it too risqué for contemporary audiences. Whether or not Constant had originally intended a straight-forward and straight-faced treatment of the theme is not recorded, but it seems more than likely that his sense of humour would have demanded at least an element of satire. When the idea was first mooted at Sadler's Wells, many of his colleagues imagined that this element would be conspicuous. 'According to Robert Irving,' Shead says,

the original idea . . . was to produce a thirty-minute satirical piece (perhaps on the lines of those 'send-ups' of classical mythology so beloved of French dramatists) . . . Indeed Constant and Randall Swingler delighted the bar of The George with a mime designed to demonstrate the differences in sexual behaviour between English and French snakes. Lambert took the role of a hearty British snake to whom sex was anathema, while Swingler played a highly-sexed French snake with a taste for erotic subtleties and refinements.

By the time Constant had finished *Tiresias* all trace of satire and self-ridicule had vanished. The story that the ballet retells is as follows. As a young man Tiresias discovered, when walking on Mount Cithaeron one day, two snakes copulating. Tiresias hit the female snake with a staff and was transformed into a woman. Seven years later he came across a similar scene, hit the male snake, and was restored to his former self. This experience subsequently equipped him to act as judge in an argument between Zeus and Hera as to whether men or women had most pleasure in sex. When Tiresias replied that women did, Hera, furious, blinded him. As a recompense, Zeus gave him the power to prophesy, and when Tiresias eventually died he became the only person in Hades to retain his intellect and memory.

The story embodies a complicated and contradictory psychological state. On the one hand, it describes the deprivation and guilt induced by wide sexual experience; on the other hand it registers the power (prophecy) which that experience and its punishment produces. If Constant realised the extent to which the story could be read as a symbolic version of his own life, he never admitted it. Various commentators have interpreted his attraction to the narrative as a sign of repressed homosexuality, but to do so is damagingly to narrow its point. Constant chose the subject in the first place, and then proceeded to treat it with grave concentration, because it provided him with an opportunity to give musical expression to tensions which had crucially shaped his life and his composing. *Tiresias* covertly refers to the guilt induced by a sexual appetite which, when awoken, had blighted but not altogether destroyed his wishes for a stable domestic existence; and to the inarticulate sense that his creativity depended on the very impulses which threatened to compromise or destroy it.

By the time Constant and Isabel returned from France, his absorption in *Tiresias* was intense. But since he was owed only a small fee for it – £250 – he had to interrupt his work by accepting a number of other remunerative tasks during the winter of 1950 and the spring of 1951. Two of these at least had the advantage of commanding his strong feelings. On 16 February 1951, shortly after Lord Berners' death, Constant arranged a programme of his friend's music for the Third Programme, and then another, expanded orchestral concert two days later, for which he arranged the *Caprice Péruvien*. His other commissions similarly combined a recognition of past loyalties with a reinforcement of his self-esteem. On 29 May 1951 *Summer's Last Will and Testament* was revived at the Royal Festival Hall (it was broadcast by the

BBC on 15 July); shortly afterwards he conducted *The Fairy Queen* at Covent Garden; and in August he made two appearances at the Proms – one to conduct *The Rio Grande*. These performances did not diminish his pleasure in *Tiresias*, nor did they compromise his commitment to it. But they did create distractions and turmoils. ApIvor, who saw him regularly in the last stages of its composition, and during rehearsals, remembered: 'I saw a lot of Constant during *Tiresias* as I was working with him doing some of the mechanical side of the scoring, as were Bob Irving and some others.' These 'some others' included Searle, Jacob, Rawsthorne and Lutyens. Their collaboration was responsible for a rumour that Constant had nothing to do with the orchestration at all: in fact he dictated and oversaw all the work they did for him. 'We were merely', Lutyens said, 'extra pens for his tired hands.'

He gave full directions and we just wrote it out for him. There is no doubt that writing this music gave him tremendous happiness. He explored the humorous possibilities of the various situations in private . . . He felt that he was going to *épater les bourgeois* sentiments of certain members of the ballet company and the public, which he certainly succeeded in doing; and he also took infinite delight in the domestic quarrel between Jupiter and Juno which he said reminded him of his first marriage. But the effort of the work was too much for him in his state of health. He became very irritable in the end, and was drinking too much again. Still he was in great form and on the night before the first night I was with him and Alan Rawsthorne at his house until the small hours having a wonderful party with Constant in an uproarious mood when they left for Alan's place ostensibly to write the interludes until dawn. In fact the interludes were written . . . in The Nag at lunchtime next day. I went down . . . to the dress rehearsal . . . and stood with [Constant] on the huge stage as the men were unrolling the scenery. He stood looking up at the roof and then tapping his stick in a gesture of mock vehemence he exclaimed with a grin, 'Whenever I come into the theatre I smell blood.' I shall always remember that remark as it was the closest indication of how much the theatre really meant to him, expressed in this characteristic way before his own last dress rehearsal.

Given the theme of *Tiresias*, the circumstances of its first performance – on 9 July 1951, with choreography by Ashton and Isabel's sets – could hardly have been less appropriate. It was performed as part of a Gala in the presence of the Queen – now the Queen Mother. Constant's programme note coyly disguises the fact that the ballet deals with sex, and persistently refers instead to 'love' – but the cast (Somes and Fonteyn were the male and female leads) made no attempt to moderate their interpreta-

tion for the Royal gaze. Mary Clarke wrote later that Fonteyn 'had a passionate intensity in this ballet which she has not equalled in any other role'. The first of the three scenes was begun with a crack of two whips, and their barbarous connotations echoed throughout the introductory music. Isabel's sets confirmed their message – they showed an approximately Cretan temple, based on Sir Arthur Evans's discoveries at Knossos, garlanded with horned heads and snakes, and a huge bull, from behind which Tiresias appeared, accompanied first by a percussive clash, and then, once a young neophyte had joined him, by a slinky melody. The bull, though stylised to conform to Cretan models, also owed something to Isabel's admired Picasso: the elongated back, massive shoulders, emphatically phallic tail and horns, and prancing hooves are directly and powerfully erotic. (Cretan art, Isabel said later, 'was exotic, quite removed from the central European, the Romano-Germanic ideal. The style of beauty that really turned [Constant] off was the typical Nordic blonde. I think there must have been a connection with his lack of feeling for the classics of German music.')

The first scene of the ballet ends with Tiresias's transformation, and a dramatic repetition of the initial theme. The second scene, in decor (a delicate mountain view) and score (a lyrical melody incorporating a siciliana but becoming increasingly polytonal) concentrates on Tiresias as a woman. Its rhythms create an impression of languidly sensuous melancholy, and when the indolence is broken by a bacchanal, which precedes Tiresias' being turned back into a man, the interruption merely recasts the delights of dalliance rather than banishing them. Much of the third scene elaborates or recalls previous material, but since the action revolves around Tiresias's punishment by Zeus, its memories of pleasure and tenderness are strictly curtailed. At its conclusion a long, gradual diminuendo is played out by cellos, oboe, piano and celesta as the temple girls gather round the blind hero, whose tapping stick provides the final notes. For the lame Constant, the closing moments had obvious and especial poignancy.

Tiresias runs for an hour but is a rigorously organised work, and recalls the hard-driving, angular pieces Constant had written in the late 1920s. As Shead says, 'his fondness for melodic motives moving in triads is noticeable', and the fact that 'an occasional harshness, even brutality . . . arises from the polytonality and dissonance of some of the writing, the absence of upper strings and the abundance of percussion' is strongly reminiscent of the mood established by *The Rio Grande* or the piano concerto. Shead also implies, quite rightly, that by setting the ballet

in Crete, 'which had always been a junction between East and West', Constant was able to rediscover his excitement at the possibilities offered by mixing diverse cultures. It allowed him to play an oriental idiom (in Scene II) against an obviously European one, and so to create an atmosphere which was reminiscent of both but confined to neither. The scoring of *Tiresias*, that is to say, contains a strangeness which powerfully expresses the peculiarities of the narrative.

Few of these intentions and achievements were apparent to those who attended the first night. Even Constant's collaborators had doubts about the piece – Isabel reckoned the score was 'too long for the plot', and Ashton now admits, 'I found the subject very difficult to cope with. How do you explain in a ballet who enjoys sex more? It was too long, possibly, and I think it came before people were ready for it.' Reaction in the press was equally unenthusiastic, even though the second scene, largely because of Fonteyn's performance, attracted some praise. At least two reviewers were candidly appalled. Richard Johnson, in the *New Statesman*, called it 'a total loss', and Richard Buckle, in the *Observer*, agreed:

Did you ever see such a thing in your life? Sadler's Wells has three artistic directors. See how they run. Ninette de Valois is too busy to supervise every detail of production; Frederick Ashton is too easily reconciled to compromise; Constant Lambert, one imagines, looks on occasionally with a musical suggestion. Lambert cannot take all the blame for the idiotic and boring 'Tiresias' . . . although the scenario and music were his, and the designs by his wife. Ashton must have undertaken the choreography of such a work with reluctance and out of duty to his colleague, but de Valois should have forbidden it. Experimental risks must be taken even with the taxpayer's money – and this ballet must have cost £5000 – but certain enterprises are clearly doomed to failure from the start. Such was *Tiresias*.

Constant's friends, as ever, rallied to his support. Osbert Sitwell wrote to the *New Statesman* contradicting Richard Johnson (the obituary Sitwell wrote for Constant in the same journal declared that '[Constant] would be alive today had it not been for the savage onslaughts of the critics'), and Constant himself instructed a solicitor to make Buckle withdraw his insinuations about incompetent Artistic Directorship. Constant was right to feel he had been unreasonably treated. For all the ballet's fault – of length, mainly – it was a genuinely inventive conception, which grappled with profound psychological issues, and contains passages – the siciliana, for instance – of exceptional beauty. It was hailed

in the *New York Times*, when first performed in America on 25 September 1955, as 'a work of unquestioned greatness'.

The strengths of 'Tiresias', as well as its weaknesses, are remarkably consistent with the rest of Constant's work. He was, as Shead says,

a composer who found very early in his career a style which suited him, and he adhered to it throughout his creative life. This is not to imply that his music is monotonous, ranging as it does from the suavity of *Horoscope* to the astringent Concerto. His greatest period of musical creativity came early, from 1926 to 1931, and most of his best music was written then: the Concerto, *The Rio Grande*, the *Li Po Poems* and *Pomona*, for instance. In the 1930s his music grew smoother, and the principal works of that decade lack in the main the urgency of his earlier music. The few pieces that he wrote during the Second World War are not among his most important, but at the end of his life he found form again in two works, the tiny *Trois Pièces Nègres* and *Tiresias* itself.

This is a sensible summary, and one which correctly identifies Constant's outstanding musical achievements. By saying that his most sustained and original works were written in the late 1920s, it becomes clear that Constant's ability to express the bitter-sweet mood of that decade created the firm ground of his lasting reputation. It also provides the explanation as to why he could not expand and diversify. For good and for ill he was a period figure, and he realised this himself. Once the coherent spirit of the 1920s had dissolved, he was keen to find a way of preserving what he considered best in its artistic credo – particularly, its belief that diverse forms and mediums should be mutually supportive. The way he discovered, of course, was to devote himself to the ballet, but the immense and now undervalued amount of work he did for it acted as a licence for him to neglect his composing. The fragmentariness and marked unevenness of his writing throughout the remainder of his life was something for which he clearly felt a passionate regret, but it was also something he could easily justify.

Most of Constant's compositions are now performed or recorded infrequently, and their influence on contemporary musicians is correspondingly slight. His work as what Clement Crisp calls 'the taste man' in the ballet, however, has had a profound and permanent effect, even though precise evidence of his achievement has been ignored, or forgotten as colleagues have died and repertoires have changed, or in one case, at least, hushed up. Margot Fonteyn, in her writing and reminiscences about the ballet, has given nothing like an adequate appreciation of Constant's contribution. Her silence may register the hurt he did her, but it is

nevertheless an unmistakable cause of the obscurity into which he has fallen. De Valois and Ashton have always confirmed that ballet owes an enormous amount to Constant's efforts. For de Valois he was 'an English Diaghilev', and Ashton admits, 'The ballet would never have been the same without him, for all of us. He helped us all. Everyone who was associated with him was enriched by him. I certainly was.'

It was not only Constant's pursuit of Diaghilev's ideals which has proved formative, but his restlessly adventurous choice of composers to arrange and employ. ApIvor gave an inclusive account of its effects – one which intelligently relates Constant's preferences to his writing. Constant's influence, he said,

is bound up with the historical fact of the emancipation or Europeanisation of British music, the liberation from the folksy and the homespun, from the academicism of Leipzig and the emasculated decencies of Hubert Parry . . . It all adds up therefore to a sort of orientation towards the French, the Slav, the Russian, as opposed to the age-old influence of German music and German composers. The historical peculiarity of works like *The Rio Grande* and *Belshazzar's Feast* lies in their utterly unGermanic character . . . With the true composer's genius for arguing from temperament to prove points which are valid for himself, Constant proceeds to hammer home this French-Slav-Russian departure in his *Music Ho!*.

Constant, whose resistance to any kind of artiness prevented him from making high claims for himself, knew that the quality and consistency of his musical expertise and the heroic extent of his labours for the ballet, were cruelly denied by the reception given to *Tiresias*. In an effort to distract himself from the disappointment, he turned even more persistently to drink. As soon as the premiere was done with he doggedly sought out parties and fellow pub-crawlers, and the friends who accompanied him were unanimous in voicing their worries about his health. At one party, shortly after *Tiresias* opened, he was accompanied by Laureen Sylvestre, and is remembered sitting too drunk to remonstrate when a fellow-guest spat in his face for having brought a black woman. At another, with the Searles, he passed out. Isabel, although she insists that 'in many ways [he] appeared to be in a good state of mind . . . and talked of writing an oratorio', was especially and increasingly anxious. Soon after the first night, she accompanied him to Sunday lunch with Amy, who 'was much more troubled by the drink than the critics. I could see she was worried. I was also becoming worried. His conversation was wandering, his manner distant.' Isabel realised she was powerless to help him.

He chose to go out walking, always returned at the exact time arranged, but did not seem to remember where he had been. I believe this was genuine, not an act. Both Elisabeth [Lutyens] and Alan Rawsthorne were aware of his change in behaviour. Elisabeth said, 'He's behaving exactly as he used to before you married him.'

We invited the lovely black Laureen and her daughter Cleopatra to the ballet. Cleopatra must have been seven or eight years old, and was a pupil at the Italia Conti School of Dancing. We were in a box, which was a good thing. When the curtain came down, Constant suddenly collapsed on the floor. Laureen took Cleopatra out and someone fetched brandy. After a few moments he recovered enough to be able to leave the theatre with help and we took a taxi home.

I was now alarmed. I was frightened of the barrier that closed, separating us one from the other. It was his loss of memory. He remembered nothing of his collapse. He became angry when I told him of it.

I thought he would be angry when I told him he must see his doctor. No, not at all. He liked him as a person. The doctor knew it was no good to tell him to stop drinking altogether, but did his best to frighten him into reducing his intake to a bottle of wine during the day, and one beer when out.

'Work,' Isabel knew, 'would be the best help', but Constant did not have the energy to undertake more than a few conducting engagements – among them, at the Proms on 15 August, a performance of *The Rio Grande* and Ravel's *La Valse*. Four days later, on Saturday 19 August, Kit came to stay, and went with Isabel and his father to a party given by Elisabeth Lutyens. 'It was late,' according to Isabel, 'when we got home', but Constant was still restless. A few minutes before closing time, he rang up ApIvor 'and asked me', ApIvor says,

to meet André Howard. We all went down the road for a last round before closing time. Constant bought this, which was indeed his last round. When we got back, there followed a little incident which was extremely pathetic in retrospect. He called for his little old gramophone and put on a record of his own performance of a waltz by Waldteufel called 'Sur la Plage'. He sat there listening to this with a smile on his face, and shortly after we left, as it was midnight. This was undoubtedly the last music he heard.

Isabel takes up the story for its next and final stage:

Kit was off early in the morning. I reminded Constant that [a friend] was expecting us for lunch [on Sunday 20th]. He said he did not feel like going, might come later. I left him asleep, I thought, in bed, and took a seat on the top deck of the 53 [bus]. I enjoyed the journey through south London, the Old Kent Road, up the long hill to the heath, to [our friends'] lovely house in the Paragon.

No sign of Constant, and no telephone. So back home. Opening the bedroom door I heard the most extraordinary noise. Constant was lying in bed with one arm stretched out in front of him, muttering in a voice unlike his own. Listening carefully, I made out the words, 'Don't let them take me away.' Then a look at the window. On the right hand side of the room was a glass door into the conservatory. It was at this that he was looking.

Isabel immediately 'grabbed the telephone' and called ApIvor, who came round with his wife Irene, a nurse, 'in a number of minutes'. 'He was in a state of delirium tremens,' ApIvor remembers, 'seeing fiends and terrible visions and threatening to jump out of the window. My wife did her best for him, and she and Isabel held him in bed while I summoned his own doctor.' Constant was rushed to the London Clinic. Isabel was distraught:

Through my sense of pain and disaster I kept thinking, 'but I have let them take him away.' But then I remembered that before Denis and Irene arrived he had tried to get out of bed and moved towards the window. I had no strength to stop such a strong man, especially one who was mad. Alan [Rawsthorne] and Elisabeth [Lutyens] took me to the hospital where we were told he was in bed, had been sedated and would sleep for some hours. We thought the best thing to do was to go and have something to eat and drink nearby. Elisabeth said she would tell the few people who we thought ought to know. None of us had any sense of what was to happen.

We cannot have been out more than an hour or two before returning to Albany Street. The telephone rang. The hospital told me to come at once or it would be too late.

Arrived there, I was led to the room where Constant lay under a huge oxygen mask. He was still alive but it was obvious that he only just recognised me. In order to say something which sounded normal, I asked who he would like to come and see him; Elisabeth? Alan? 'Yes. We've seen enough of you.'

The horror of these words did not really affect me until later. I was too shocked. I was told that it is characteristic of this form of delirium that it leads the victim to turn against those closest to them. Had he not forgiven me for letting them take him away?

Constant never gave her an answer. On Tuesday, 21 August 1951, two days before his forty-sixth birthday, he died without regaining consciousness. Broncho-pneumonia and diabetes mellitus were given as the official causes of death – the latter, exacerbated by drink, had never been diagnosed as a cause of Constant's illnesses during his life. His doctor must bear most of the blame for this. He had never even tested Constant

for diabetes. Neither Amy, Maurice nor Kit knew that Constant was dying until it was too late, and it was left to Alan Rawsthorne to telephone Maurice, who in turn passed on the news to Olga with the suggestion that she should wait until he returned from his studio before breaking it to Amy. Amy guessed, before being told, and turned herself, with the suffering efficiency she had shown throughout her life, to making the necessary arrangements. Constant's funeral service was held the following Saturday, 26 August, at St Bartholomew the Great, Smithfield, and immediately afterwards he was cremated at Golders Green Crematorium. His ashes were laid in Brompton Cemetery, near the grave of his grandfather, on whose stone the name of his father was also inscribed.

Thirty years later, on 5 December 1981, a plaque to his memory was unveiled in St Paul's, Covent Garden, by Ninette de Valois, as part of a service at which Morrison played the *Elegiac Blues*. It represented a dismally late recognition of Constant's achievement. Immediately after his death, though, tributes were paid with proper alacrity and fulsomeness. So far as the obituaries were concerned, his personal and musical qualities were commemorated with customary decorum. But at a memorial concert held a fortnight after his death, on 7 September, in St Martin-in-the-Fields, and at which Helpmann read the lesson, members of the Sadler's Wells opera sang 'Jesu Joy of Man's Desiring', and John Churchill (the resident organist) played *Aubade Héroïque*, memories of Constant's amused and amusing iconoclasm were revived. The organ broke down during the service (Churchill had to perform on a piano), and failed to start again until the congregation had departed.

Constant's friends, knowing his wry interest in the supernatural, could have been forgiven for imagining intervention from beyond the grave. Their sense of this possibility was quickened by two other incidents. In January 1952, shortly after the BBC had broadcast two memorial concerts, the Society for Twentieth-Century Music performed *Eight Poems of Li Po* and the Piano Concerto at Hampstead Town Hall. 'At the beginning of the concert,' Shead tells us, 'a large black cat appeared on the platform. Throughout the performance there it stayed; and at the end it stalked off and was never seen again.' Anthony Powell, whose career during the 1940s had prevented him from seeing Constant more than sporadically, but who had renewed the ties of their affection towards the end of Constant's life, when the Powells were living in Chester Gate, near Albany Street, recounts a similar episode. It is one which movingly conjures up qualities which had led Powell, like so many others, to

appreciate that Constant's personality, as well as his work, had 'a touch of genius':

[Constant] developed a habit of long telephone calls, made relatively late at night, usually between half past eleven and twelve, particularly on Sundays, when we would discuss at some length things that had amused him during the previous day or two. A subject to which he was very devoted at that moment, because of the esoteric material there contained, was the unsigned column Sacheverell Sitwell . . . was then writing for one of the Sunday papers, a column very different from most journalism of its kind, no holds barred intellectually or aesthetically. Although a wide field was covered, when [Constant] rang up, talk was likely to start with the question: 'Have you read Sachie this week?'

[Constant] was making these calls two or three times a week, when in August, 1951, I went with my family to the country for a fortnight. We came back to town on Tuesday, the 21st, the day [he] died. It was announced in the evening paper. The following day two friends dined at our house. I mention them merely as witnesses. At a quarter to twelve the telephone bell rang.

'It's Constant,' said my wife. I went downstairs, and picked up the receiver. 'Hello?'

There was a click, then the dialling tone.

PART III

Kit

One

'It's no wonder my life has been a disaster. Look at the cards I was dealt: look at my parents.' Immediately before his death in 1981, Kit Lambert's mother and father loomed larger in his imagination than they had ever done during his childhood. But his relationship with them was always more complicated than he admitted. In his heart of hearts, he knew that the chaos which surrounded him as a boy was an indispensable preparation for his apotheosis in the 1960s: he converted his parents' private wrangling into a hugely inventive public challenge to authority. As the manager and producer of the rock and roll band The Who, and as the founder of the first successful independent record label, Track, he profoundly affected the course of popular taste. His career, like his father's, excited, expanded and exalted the middle ground of culture; because the impact of his work was so pervasive, it proved even more influential than Constant's.

Kit appreciated that his father's iconoclasm was the creative model of his own success, and also realised that it required him to pay a high personal price for it. Constant's work for the ballet was the acceptable face of a coin which showed, on its other side, a domestic fidget and a heavy drinker. Kit's involvement with rock and roll was similarly double-faceted. It brought him, to start with, enormous personal and financial gain; in the end it left him addicted to heroin and betrayed.

The complete, short span of Kit's life combined, or oscillated between, gruelling extremes of wealth and poverty, popularity and loneliness, glamour and degradation. The pattern was prefigured long before he had the chance to recognise it. He was, his mother says, conceived in Venice in the autumn of 1934 (Constant was visiting the city to conduct his piano concerto at the Fenice, and had taken Flo with him). In 1972, when Kit bought Palazzo Dario on the Grand Canal in Venice, with money from The Who's rock opera *Tommy*, the city was to become the epitome of his high style and the setting for some of his most acute depravations.

When his parents returned to London from Venice mixed blessings awaited them. Their house in Trevor Place, where Kit was born on 11 May 1935, was ostensibly the home of a successful young couple, but in fact a breeding ground for histrionic quarrels and passionate reconciliations. Constant and Flo were delighted to have a child, but neither of

them was prepared for the ordinariness which necessarily followed. Even the names they chose – Kit (after Christopher Wood) Sebastian (after J. S. Bach) – made him seem an artistic plaything. In the several formal portrait photographs they had taken of Kit, he looks fashionably and expensively pampered: a small, dark-haired baby with a tipped-up nose and a full mouth. It is his mother's mouth: an Absell characteristic, not a Lambert one.

In 1936, the year after Kit's birth, Constant was less concerned with family ties than musical commitments – to the first performance of *Summer's Last Will and Testament*, and to his arrangement of Liszt's music for the ballet *Apparitions* – and apparently more interested in new friendships, with Fonteyn, Searle and Kentner, than with maintaining or improving his marriage. When he decided to leave Flo in the summer of 1937, after their quarrelsome holiday in Austria with Ashton, there is nothing in Constant's letters, and no evidence in the reminiscences of his friends, to indicate that he spared much thought for his son. By removing himself from Kit's life he not only withdrew a father's love, but also left Kit in a world peopled almost entirely by women.

Flo was more considerate but, understandably, also had to think of herself. Angry and distressed at Constant's departure, she tried to establish her independence by pursuing a career as a model, and to win back her husband's admiration by taking dancing lessons. Neither plan worked well enough to bring her the freedom or the attention she wanted, and both meant that she spent a good deal of time away from Kit. It was not only a lack of attention that he suffered. Since Flo was dependent on such small hand-outs as Constant could afford to make, her ability to look after Kit in purely material ways was severely restricted. According to her daughter Annie (who was born after Flo's ill-fated and short-lived second marriage to Peter Hole had taken place early in 1945), Flo seized on the idea of buying, decorating and then selling a succession of flats to supplement her income: 'Every nine months she'd give birth to a new flat' – most of them in Chelsea. This proved more successful than Flo's efforts to get herself a secure and regular job, but its consequence was hardly an improvement for Kit. It simply meant that the neglect he experienced in her absence was replaced by insecurity in her presence.

Amy, who had always been mistrustful and incomprehending of Flo, surveyed the first two years of Kit's life with sorrowing wariness. As soon as Constant and Flo separated, she decided to follow Constant's advice, overcome her antipathy to Flo, and play more than a peripheral role in her grandson's life. Her severe, old-fashioned and strait-laced influence,

she felt, was the only adequate shelter Kit would find from the glamorous, flighty and peripatetic life of his mother. If this makes Amy's involvement with Kit sound cold-hearted, the impression should be balanced by other considerations. For one thing, the grief she had felt when George died in 1931 still burnt fiercely: one of Kit's cousins remembers her saying, as late as the mid-1940s, 'I just can't speak about him, even now.' For another, her small house in Peel Street was under-funded and over-populated: Maurice and Olga often visited her there, ostensibly helping her out but scarcely bringing in enough money or allowing her enough space to make her feel entirely comfortable.

When Amy offered to make Kit a more or less regular member of the household, Maurice made difficult matters worse by refusing to curb his dislike of children. Constant's friend Angus Morrison says that Maurice was stern with Kit in a way which suggested that he projected on to him some of the irritation and jealousy he felt for Constant. A degree of envy also tainted Olga's treatment of Kit. Since Maurice refused to let her have children of her own, she longed to treat Kit as a surrogate, and yet resented him as a reminder of her childlessness. Kit was too young to articulate such things, but they made a profound impression on him.

Since Maurice spent most of his time working away from Peel Street at his studio in Logan Place, Kit was usually left in the care of Olga and Amy. It is tempting to oversimplify their effect on his adult personality, but reasonable to draw certain conclusions. Amy and Olga were both disappointed, strong-willed and strong-minded women who adhered to a moral and ethical code which was flouted by Constant and his friends. They made Kit, according to his Aunt Audrey (the daughter of Amy's brother Nat), 'a precocious child', but an 'excitable' and frustrated one. They were, apparently, strict and dull. 'There was no room at Peel Street for him even to throw a ball.' Audrey's son Jonathan Chadwick, who was born two years after Kit, agrees: 'He was a voluble, volatile, sophisticated little boy . . . not lacking in expression and very involved in the adult world.' Jonathan's sister Jenny (now Jenny Koralek) has taken this a step further: 'He must have had such suffering, he was constantly being pushed into situations which didn't suit him . . . And all those strong women – none of them were demonstrative. I'm sure Amy cared about him, but he never had any hugs.' The conclusion Jenny wishes to draw is clear. The uncertain affection Kit received from the women who dominated his childhood damaged his immediate chances of happiness, and prepared the ground for later difficulties. To put it bluntly, Kit's

homosexuality as an adult – which he had acknowledged by the time he reached Oxford in the mid-1950s, but to which he was never entirely reconciled – was of a kind which his early childhood did a great deal to foster, if not actually to create.

When the time came for Kit to attend his first school – the Town and Country School in Hampstead – in 1939, Flo was better able to meet the demands he made upon her time. Her modelling and her dancing could be confined to the day, as could the war work she soon undertook with the Red Cross, and her responsibilities as a mother resumed in the evening – provided she was willing to slow down the pace of the social life that she enjoyed. In the event, entertainment was replaced by anxiety. During the winter of 1939 Kit developed a tubercular gland in his neck and was taken – on Constant's advice – to Dr Amando Child (the Sitwells' doctor and Constant's own, when he deigned to see him). Child operated on Kit in the Royal Free Hospital, clumsily: Kit was left with a large scar on the left side of his neck, which he never ceased to consider an embarrassing disfigurement. This scar, like Constant's lameness, endured as a sign of early suffering. It is typical of Constant and Kit's entire relationship that they were united by what they disliked or found embarrassing in themselves.

Once the war had broken out and Constant was busily working with the ballet on tour, even the sightings he had of his son when Kit visited Peel Street became less frequent. According to Flo, who by now was well advanced in her sequence of Chelsea flats, Constant was a studiously 'bad father', occasionally sending presents of books, occasionally giving advice, but never involving himself closely. (Constant was amused, though, Flo says, by the news that Kit had disgraced himself during his convalescence at one of the Royal Free Hospital's subsidiary 'homes' by flicking mince onto the dining-room ceiling, and by fiddling so persistently with his dressings that his doctors threatened to coat him in plaster from the neck down.)

In one respect Constant showed that he had his son's welfare at least in the margins of his conscience. The period of Kit's recuperation coincided with the Blitz, and his school, the Town and Country, decided to evacuate to Yarkhill in Herefordshire. Even after the Blitz was over, and Kit recovered, Constant urged Flo to move him to safety in the provinces. This plan suited Flo very well, since she was less than entirely dismayed at the prospect of having more time to herself, and knew that with help from Amy such a refuge could easily be found.

Amy's niece Audrey, as the result of a visit to England from Australia,

had married into a family called Chadwick, and Audrey's parents-in-law, Arthur and Muriel, had founded Forres Preparatory School at North-wood, in Middlesex, in 1910. In 1919, the school had prospered and expanded sufficiently to need larger premises, and a site was found in Northbrook Road, Swanage, on the Dorset coast. Shortly after the move, Arthur died, and the headship was taken over by his younger brother Mackenzie Chadwick (Mac). In 1940, the government declared Swanage a 'restricted area', and Mac decided to evacuate the school. He rented from Earl Howe, at very short notice, the straggling, ivy-covered, Victorian red-brick Penn House, at Penn Street near Amersham in Buckinghamshire, and the move took place during the summer holidays. Since many of the regular staff had been called up, help had to be taken where it was offered. Audrey was soon installed nearby in the Dower House, and agreed to cook for the school's forty-eight boys. In 1943, when Amy and Flo had discussed Constant's recommendation that Kit be moved out of London, Amy wrote to her niece, and asked whether she would have Kit to stay. Audrey, who had already been briefly landed with Kit a few times, agreed.

Forres gave Kit the orderliness he had always lacked at home. It was, according to one of his contemporaries, 'a school with very decided, very middle-class views . . . most of the children were the sons of people in business, the services, doctors and so on.' The school history strikes a note of determined orthodoxy when describing the time that Kit joined:

[The boys] had to settle down to a new kind of school life with no gym, scout room, asphalt courts or playing fields. The grounds were extensive with a variety of trees and the beech woods nearby were large; biking, tree-climbing and other out of door activities were encouraged, and eventually a meadow with regular mowing became quite good for games though there were no proper cricket pitches. Only an occasional match could be played against the local choir-boys or another evacuated school, while for bathing there was an open air swimming pool at Amersham three miles away. The only means of transport was by bicycle.

This kind of existence allowed Kit little chance to show the intellectual precocity his background had thrust upon him. Jonathan Chadwick, Kit's cousin and a fellow pupil, remembers that Kit

didn't enjoy games, or our long Sunday walks, and obviously felt too little stimulation came from lessons or societies to show much interest in them either . . . He had a few solitary pleasures . . . he collected stamps (and swizzled me out of some from Swaziland) and used to go butterfly collecting with a friend

called Gilbert . . . He wasn't conventionally naughty, but he was very emotional. There was a note of protest in his voice, and he cried very easily.

Photographs of Kit taken at the time show a shy and withdrawn boy, dark-haired, plump, with a full sensuous mouth and a downcast expression, who seems abashed at his own enforced conventionality.

Jonathan Chadwick, though not in Kit's set during term, was well placed to evaluate his cousin in the holidays. Kit spent a great deal of time with Audrey at Penn, rather than returning to Flo in London. The happiness of being welcomed into a stable family was offset by the knowledge that he did not quite belong. Jenny accurately recalls the contradictions which beset him: on the one hand 'the ambiance of the huge loving Chadwick clan, huge grounds to play in . . . and a lot of fun and games . . . [meant that] Kit probably was in a normal world – with all the humdrum, jolliness and hurly-burly of family life – probably for the first and last time.' On the other hand not even the regular company of children his own age, nor Audrey's motherliness, could mitigate the influence of those 'tyrannical strong Peel Street women', his aunt Olga and his grandmother Amy. Jenny insists on the force of 'the Absell heredity'. (Absell was Audrey's and Amy's maiden name.) 'If one studies a little while photos or drawings of the Absells,' Jenny has said,

there is a curious droop to their mouths, mocking or petulant depending on their temperament. I think what emerges is the fact, almost indisputable in the light of George's extremely long absence, that Maurice, Constant and Kit were *much* influenced by their Absell blood. Many of the Australian intelligentsia seem to have a sense of inferiority which makes them compensate with a sense of superiority, which can lead to a colossal egocentricity even by ordinary human measure, and above all an *undue* reverence for Art with a capital 'A'! When I saw the film of Miles Franklin's *My Brilliant Career* I recognised these tendencies as familiar from my childhood impressions of the Lamberts.

As long as Audrey lived in the Dower House – which was in fact normally the butler's house, and less grand than its name implies – there was little time or space for Amy to stay with her. But from 1943, when Audrey moved to Mop End, a short distance away, Amy frequently accompanied Kit on his visits there. (Mop End is a two-storey Victorian house, of the same Victorian red brick as Forres itself, but pretty and – with its short flower-lined path to the front porch – 'cottagey'.) The letters that Amy sent to Audrey explaining his needs clearly reveal the well-meant stuffiness of her influence. She had written to Audrey from London when Kit first went to stay with the Chadwicks:

Of course I may see you and Jennifer . . . if you are bringing her to Daniel Neal's, that expensive but very good schools' outfitters – as it is so very near me. I *know* that you had no thought of anything but being of help in a family emergency when you offered to take Kit and it is to that spirit I respond . . . I do not think you will find him difficult to feed – he likes milk to drink or with cereals but not milk puddings, rice, etc. (though I feel sure he eats them at school).

The 'family emergency' to which Amy refers in this letter was nothing new – she simply meant that Kit's parents were unwilling to care for him. Constant, because he was Amy's son, a man, and obviously busy, was easily forgiven by her. Flo was frostily rebuked. Even when Flo exerted herself, and travelled to Mop End to see her son, she incurred Amy's disapproval. On a visit in the later summer of 1943, for instance, Flo turned up in a Red Cross uniform bearing two bags of granulated sugar and the gift was dismissed as 'patronising'. In September, when Kit returned to London for a spell before the winter term began, Amy told Audrey: 'I was relieved when his mother collected him . . . though the entertainment she offered him was a visit to the Labour Exchange.'

When Constant visited his son, that same summer, his lack of due concern created no such *froideur*. The children had heard that he liked cats, so rounded up all those they could find and hid them in a field to be a surprise for him. When he arrived, the cats disappeared: Jenny affectionately recalls 'this limping, overweight man, with a cigar, toiling across a hot field'. But anyone reading the letter Constant wrote to Audrey in the autumn, thanking her for looking after Kit, cannot help recoiling from its tone of distant charity. 'I am immensely grateful to you . . . it must be grand for him to have a real country holiday. I am sure you must be having better weather than we are . . . I hope Kit's chocolate arrived all right. I have got him a nice Chinese book about pandas . . . give him my love.'

To be fair to Flo, it is important to remember that her neglect of Kit was provoked by at least two reasonable considerations. She had to reconstruct her own life after Constant's departure, and she had to spare Kit the danger of living in London. But she and Constant hurt Kit deeply. The treatment he received from them as a little boy – largely unvisited in the term-time, the holidays spent mostly at the Dower House, to start with, then at Mop End, and the occasional visits to London – was repeated without much alteration for the next six years. The following summer, 1944, for instance, Kit returned to Audrey in July and stayed, once again, until September. The more time he spent with the family, the more

outward-going he became. The shyness he had initially shown gave way to naughtiness, which was modelled on the little he had seen of his father in Peel Street. When Amy ticked Kit off for having bad table manners, Kit complained that 'my father always walks round the table during meals', and when Amy told him to follow Jonathan's milder example, he pointed out, 'Well, he has his other side.' (Jonathan had recently eaten Kit's sweet ration.) By the time the summer ended, the Chadwick children had grown sufficiently fond of him to tell their mother, 'It's dunderheaded awful without him.'

The confidence that Kit began to develop during the holidays seems not to have been evident at school, even as his time at Forres drew to its close. Apart from singing in the choir – Constant had been to see the music master, Edwin Farwell, and approved of him – he remained the withdrawn boy who had daunted Jonathan with his cleverness when he joined the school. Kit's reserve was intensified when his mother remarried in the spring of 1945. Flo's husband's name, Peter Hole, greatly amused Constant for its own sake, and because his former pet name for her was 'Mouse'. Hole, it seems, had offered Flo the prospect of greater wealth and stability than she had ever known with Constant. But his promise of 'family money' proved without foundation, and throughout his brief marriage to Flo he had a number of jobs which hardly suited her taste for glamour – one of them was running a London garage. Although Kit's stepfather was willing to include him in the new family circle, the allegiances which Kit had formed with such difficulty elsewhere – with Amy, and with the Chadwicks – were not easily dissolved. He depended on them, and he did not want to risk alienating his father still further by spending much time with the Holes, whom Constant openly ridiculed. Judging by the fact that Kit kept a consistently low profile at Forres, he seems to have reckoned that obscurity was the best policy.

But this could not be maintained for long. In the summer of 1945 Forres moved from Penn House back to the coast at Swanage, and the chances of assuaging the tedium of term time with the neighbouring comforts of Mop End no longer existed. Since Flo was offering at least the appearance of a stable home in London, the need to make visits to the Chadwicks in the country during the holidays also diminished. (The visits that he did make were still overcast by Amy's concern for him: after a half term in July 1948, for instance, she chivvied Audrey: 'You did not say how he appeared to you, or if his teeth were respectably retired behind his lips.') The distance between himself and the Chadwicks was further widened when, in the autumn of 1948, Constant recommended that Kit

be removed from Forres altogether and fill in the year before going to public school by attending Byron House in Cambridge. Constant felt that the new school would sharpen Kit's wits, rather than making him concentrate, as Forres had done, on playing games he did not enjoy. If Constant's plan worked, there is no evidence for it. Kit's quick passage through Byron House is unblemished by achievement of any notable sort. Only one incident from the entire year stands out in the memory of his family and friends. When Constant visited Cambridge to conduct and invited Kit to attend a rehearsal, de Valois heard the bored son say to his father: 'Daddy – I like music that is short and loud, and drinks that are long and fizzy.' The innocent remark predicts two of the prime ingredients in his adult life, one of which was to make his name, the other of which was to help destroy him.

Two

Although Constant refused to act as Kit's regular confidant, adviser and ally, he did at least try to find him a place in a suitable public school, and pay the fees without grumbling. On the advice of Tom Driberg, who had been there himself, Constant chose Lancing College. Lancing was inaugurated at Shoreham near Brighton in 1848. In 1940, under the headmastership of Frank Doberley – who presided over Kit's first three years – the boys had been evacuated to Ludlow in Shropshire, but returned to their original site in 1945. There followed a period of expansion and modernisation, in which the school's close ties with the services – the Navy in particular – were maintained, and its devotion to high academic standards was developed. Evelyn Waugh was an old boy who bore eloquent witness to its literary standards; another, Peter Pears, testified to its musical tradition.

Constant had decided on Lancing in 1945: 'I think it would be fatal,' he wrote to Amy,

to take a sensitive child of his age and try and turn him into a crashing 'hearty'. God knows I don't want him to turn into a dreamy intellectual pansy nor do I want him sent to a crank school. I only want him to develop normally according to his own lights. That is why I have settled on a perfectly straightforward school like Lancing, which is also humane. The only thing which *could* make Kit neurotic would be to shove him into some Kipling-like surroundings, which would warp his life as it has done so many of my friends.

When the time came for Kit to start his first term in the autumn of 1949, Constant's initial bluster of interest had worn itself out. He was in New York, conducting, and made no mention of Kit's new life in his letters.

The house Constant had chosen for Kit at Lancing, Field House, was run by Patrick Halsey, a broad-minded, mild-mannered man whose nickname 'Tiger' had everything to do with physiognomy and nothing to do with character. (Constant came to see him only once during Kit's time there: Halsey remembers him 'drinking lots of sherry'.) In Kit's first year, which he spent in a communal House Room before moving into a single study, Halsey had little contact with him, but formed the impression of a clever, quiet, small and catastrophically untidy boy. His school uniform – grey trousers and grey coat – were always stained with food and ink, and his dark hair was invariably on end, apparently provoking the

matron, nearly every time she saw him, to mutter 'Disgustin. Shockin'.'

By the end of his first year Kit had begun to acquire a more distinguished and distinctive reputation. He decorated his study, Amy told Audrey, with 'a duplicate of the Great Seal, and an original oil painting of his grandmother [painted by George in 1912] to *épater les bourgeois*'; he turned his natural aversion to games playing into an inflexible opposition; he joined the choir; and he started to angle for parts in school plays. The first part he landed was Gluttony in Marlowe's *Dr Faustus*. The play's director, P. E. Thompson, who also taught modern languages, recalls, 'All the Seven Deadly Sins . . . wore grotesque masks, and I remember Christopher [most of Kit's schoolteachers called him Christopher, not Kit] complaining but also being amused by a remark which a master made to him: "Why were you the only one not wearing a mask?"'

Kit was creating a personality which combined ebullience with artistic curiosity. One of his contemporaries, William Yates, says, 'He was definitely glamorous. In fact he was a hero in some people's eyes, his father being who he was, Margot Fonteyn (he said) his godmother and William Walton his godfather. I remember [Fonteyn] coming down to take him out once. We were terribly impressed.' Even towards the end of Kit's life at Lancing, when his image was more cultivated and his confidence greater, it was obvious to some that his fast talk and clever references conspicuously failed to hide his insecurity. John Dancy, who took over as Headmaster of the school in September 1953, remembers

a short fat boy with a puckish smile on a lopsided face. I also remember (and I *think* I am not reading history backwards) an occasional look of *Weltschmerz* which made one wonder, in the light of his heredity, what the future had in store for him. But most of the time he was enormously good fun to be with, and his conversation had a range and a sophistication rare in a schoolboy of that era.

The *angst* which Dancy detected in Kit had in fact made itself obvious at the beginning of his second year at the school. Early in January 1950, Kit stole some money (£5 17s) from the locker of his acquaintance William Yates, and Halsey decided that rather than punish him as a criminal, he would regard the theft as a *cri de cœur* and 'not make a great thing of it'. He simply asked Kit to repay the money. 'The whole business was hushed up in the school,' Halsey says. 'But I did tell his father, of course.' Constant replied:

May I say at the outset how very grateful I am to you and to the Headmaster for

the remarkably humane and understanding attitude you have taken towards the very regrettable lapse on the part of my son (which as you can imagine came as a complete surprise to me).

I have complete confidence that with the help of the school, supported by his parents, that he will get himself out of his psychological tangle for I know that he is not a fool and cannot feel that he is by nature dishonest . . . I told him that in order to get him out of his present situation I was sending you the money out of which *himself* would pay the other boy (whose tact in the situation I admire very much), and that after he had done so he would have to repay the sum gradually to yourself . . . I am sure you will agree that he should feel a direct responsibility to the school which is so very kindly helping him.

Constant's reaction shows several signs of understanding and sympathy, but misses the point of the episode. It was precisely that Kit did not feel 'supported by his parents' that he was prompted to steal in the first place. He rarely saw his father, and his mother failed to give him much sense of security. He admired her looks – and boasted about her at school – but the reserved nervousness she had often provoked in him as a child was becoming habitual. Indeed, he was soon to start complaining that his mother 'frightened him'. Kit's theft, it is clear, was a lapse brought on by neglect. One of his later friends, Daria Shuvaloff, in whom Kit confided a memory of the event, confirms this: 'Although he was [later] extraordinarily extravagant and spendthrift, he was never dishonest.'

Once the incident had been closed, Halsey set about encouraging Kit to draw attention to himself in more productive ways. In 1951 he became involved in the school drama society – taking the part of Eshtemon in James Bridie's *Jonah and the Whale* in the Advent term, and the part of Kate in *The Taming of the Shrew* in the autumn. His voice, now it had broken, had a plummy resonance which can hardly have suited him for the latter part, but he made the most of the former. 'C. S. Lambert', the school magazine said, 'with the aid of an enormous cigarette holder, was . . . a great success . . . His gestures and gait made his ennui perfect and even when Nineveh was on the brink of destruction, Eshtemon refused to don sackcloth and ashes and found pigs such sincere creatures.'

The high spirits which were admired in the school theatre were deplored in the classroom. His teachers agreed that he was beginning to show signs of outstanding intelligence, but they also felt that he might never realise it. His modern language master, Thompson, was particularly irritated by this since French was emerging as Kit's strongest subject. 'His work and attitudes are most disappointing,' he wrote, with flawed eloquence, in Kit's Lent term report (1951):

In spite of repeated promises to improve, he has been persistently handing in his work late, and the work has been far below the sort of thing he ought to have produced. He has the prospect of a brilliant career if he will support his ability with the necessary school discipline, and the alternative, if he will not, of leaving before he achieves the disappointment of not getting anywhere near where he ought.

Thompson decided to encourage Kit with opportunities, rather than goad him with threats, and made plans to send him to a French family outside Paris for part of the summer holidays. But on 21 August, Constant died, and the trip was cancelled. No contemporary record survives of how Kit reacted to his father's death, but its effect is not difficult to judge. As a young child, he had regarded Constant as the only link, apart from his Uncle Maurice, with the adult male world, and since Constant had so frequently ignored or rebutted him, he had general as well as particular reasons for feeling hurt. Yet Constant's fame, and his occasional exhilarating appearances in Kit's world, also made him an especially attractive antidote to the company of 'strong women'. Kit's subsequent attitude to his father was comprised of the same mixed emotions: he railed against him for his indifference, and was impressed by his devel-may-care glamour. The rootlessness, the huge enthusiasm to initiate projects and the withering boredom which accompanied their completion, and the deliberate abuse of his self and his talent, were to be written even larger in the son than they were in the father.

By the time Constant died, Flo's second marriage was already turning out to be a failure. Peter Hole, who had initially seemed an attractive adventurer, turned out to be improvident and impoverished. His garage business failed, the home he had tried to make for Flo and their daughter Annie in Sussex was sold, and the mother and daughter returned again to London – alone – to resume a straitened existence living off alimony and the proceeds of their regular moves from flat to flat. Kit, only sixteen years old, found himself having to contend with Flo's complicated grief for Constant, and with the more straightforward sorrow of his grandmother. (There was little he could do for Isabel. He saw her only occasionally and briefly in London and then – when she married Alan Rawsthorne soon after Constant's death – lost sight of her altogether. The only dealings they had with one another in later life were to do with the royalty payments due to Constant's estate.)

It was not until Kit returned to school that he considered his own feelings in comparative calm. The result was not exactly to make him less

ebullient, but to make him think more pragmatically about the ways in which he might focus his interests. In a single term, the tone of his reports changed (even his modern languages master pronounced him 'greatly improved'), and in the course of the following year he applied himself more seriously to the theatre as well, playing Mr Lofty in Goldsmith's *The Good Natured Man* and, according to the director, 'carrying the play'. He also began writing for the school magazine, and in every piece he strikes the ironically inflated, hyperbolic note Constant frequently used. In 'The Angling Disease', for instance:

'A stick and a string, with a worm at one end and a fool at the other' – a fool indeed. Better by far to crawl from opium den to opium den, and to drink yourself stupid on bay rum and methylated spirits than to catch *virus piscatorium*. For this is the deadly disease that takes you out at five o'clock in the morning to return empty-handed in despair and wet shoes to a breakfast of soggy toast and burnt porridge. This is the play that ruins you financially. Your money will not be spent on doctors for 'there is no cure for this disease', but rather you will fall an easy prey to the 'gilded baits' of worldly fishing tacklists. You are by now definitely *'mens insana'*, and it is not long before you become *'in corpore insano'* as well. Many are the anglers who have caught pneumonia after spending an icy March day waist-deep in some turgid torrent, hurling a bedraggled fly at an obstinate fingerling.

The more prominent Kit became at Lancing, the more difficult he found one aspect of his life there. Vitality and precocity made him notorious, but they did not lead him to make friends easily. For the first time, it became clear that the unsettledness of his childhood had bred a reluctance to create strong personal ties. Insofar as he did want to make these ties, he realised that they were likely to be of a kind which the school absolutely disapproved: he felt homosexually attracted to several of his contemporaries. Initially he confided these feelings to no one. Not only were there the school authorities to think of but – even more dauntingly – his mother and grandmother, whose reactions he knew would be furiously unsympathetic. He cast around, instead, for ways of establishing less intimate forms of society. When he was in the Lower Sixth, in the spring of 1953, his French master has remembered,

he came to me one day with two other boys – a deputation to suggest that we should start a literary society. Christopher was the protagonist and suggested that the society should be called 'The Hollow Men'. No one else was in favour of this and eventually we settled for 'The Elizabethans' . . . The society was very elitist, members being invited to join. There were three meetings a term at my house on

the college estate. Christopher was the first secretary and did a lot to get the society under way. At this time I found him a most delightful person, full of vitality and wit. I associate him with laughter.

Clearly 'The Elizabethans' provided Kit with a structure in which he felt safe because the friendships that it allowed were not complicating. The same is true of the other group that he founded – a House captains' dining club called 'The Library', which had its own stationery printed and a plaque made for its meeting-room. Five boys were members, one was Yates, the boy he had stolen from, and another was Richard Mason, the head of the cross country team. They regularly came together under Halsey's supervision to eat, drink and smoke: Halsey doled out tobacco at the beginning of meetings and recovered what remained at the end.

'The Library' reveals Kit's taste for the same sort of resistance to petty restrictions that his father showed throughout his life. It also demonstrates a version of his father's sophistication. Kit wanted – now and later – to convert whatever threatened to become routine into something risqué. It was a transformation he was later to effect on the grand scale. But Lancing could only offer very limited opportunities to fulfil this ambition: Oxford, Kit reckoned, and particularly the Oxford evoked in *Brideshead Revisited*, would offer him more scope. (The novel was especially admired at Lancing, Waugh being an old boy.)

It was the prospect of Oxford's social life, rather than a pure and simple love of his subjects, which led Kit to work hard in his last year or so at school. In the spring term of 1953 he went to Paris to stay with 'a very intellectual family' and attend the Lycée Henri IV: in the summer he agreed to toe the line sufficiently to be appointed a prefect (he was 'generally regarded,' Dancy says, 'as brilliant but unsound, even a doubtful influence'); and in the autumn, when he was eighteen, he took the Oxford entrance exam, applying to Trinity College to read French. 'I hope his visit . . . has been rewarded,' Thompson wrote in his report. 'He deserves it, because he always had the brain . . . and now he has acquired the academic discipline.'

The hopes were well justified. Kit was awarded an open scholarship, and was told that his place would be ready for him when he had completed his National Service. He wrote to Thompson: 'I intend to steer by my watchword "Couth". Seeing things in perspective and with clarity, I now realise how very great a debt I owe you, not only because the direct value of what you taught me helped me to win my scholarship but because you helped me, perhaps more than anyone else, to help myself – which is

something more enduring than any academic achievement.' Thompson's help was not withdrawn immediately. In order to fill in the time before National Service began, Kit returned to Lancing for the spring term, intending to concentrate on improving his German. The result, Thompson was not surprised to find, was less than entirely successful: 'A last term with an open Award behind one is a rare and wonderful thing. Of course as a result he has fallen into gross sins of dilettantism, not prepared his work, and [produced] fireworks of irrelevancy to cover them up. But he has also learned a lot and made a valuable contribution in many ways to the life of the Department and the school . . . we shall miss him.'

Kit's 'contribution' to Lancing is clear from his Valete: Secretary of 'The Elizabethans', Secretary of the Modern Languages Society, Secretary of the Shakespeare Society, President of the Debating Society, Founder of 'The Library'. It reads like the record of a model pupil. But when Thompson wrote his last report for Kit, in the spring of 1954, and wished him 'all Good Luck, and courage', he did so knowing that Kit's success would need careful nurturing, since it both fed on, and masked, painful insecurity. Twenty-nine years later, when Thompson wrote to Flo to commiserate about Kit's death, she replied, 'I slept with your last report of Kit under my pillow for years.' It is a remark which movingly reveals the combination of powerful love and theatrical sentimentality which comprised her feelings for her son.

Lancing required all its pupils to join the Combined Cadet Force it ran on site. Kit, in spite of being a notoriously shambolic boy – one master called him 'the inkiest boy I ever knew' – clambered to the rank of corporal. Judging by the evidence of his National Service, the principal effect of the CCF was to encourage a talent for opportunism. Immediately before receiving news of his posting (he was assigned to the Royal Artillery), he spent a month in Berlin attempting to recover some of the ground he had lost in his last term at school, and then, in March, found himself transported to Park Hall Camp near Oswestry. After ten weeks' basic training ('I spent most of my time running round the square with my hands on my head,' he told his mother) during which he was required to pass the usual tests of physical fitness and initiative ('leaping over rivers and then giving a talk'), he was seen by the Officer Selection Board, found worthy of elevation, and despatched, via Woolwich, to the Mons OTC at Aldershot. Here he had to submit to six weeks' general training, and then a further ten weeks of more specialist instruction. Towards the end of this course he was required to indicate where he would best like to serve. Kit,

because he thought it would lend a gleam of adventure and exoticism to his routine duties, said Hong Kong.

It was a popular posting, and he considered himself lucky to get it. In December, after a twenty-nine day voyage in 'a rolling bucket', he arrived in Hong Kong to join the 14th Field Regiment of the Field Artillery, as one of the 'lowest of the low' – a Junior Field Officer. He immediately set about reducing the chances of becoming bored by arranging to take driving lessons, and by volunteering to run whatever errands were necessary between the various sections of the forces stationed in the New Territories. On one trip, to Kowloon in May 1955, he struck up an acquaintance with a fellow officer, Robert Fearnley-Whittingstall, which was to blossom into the most important friendship he made in the army, and one of the very few he was to sustain throughout his adult life. Fearnley-Whittingstall was initially drawn to Kit because Kit reminded him of an old school friend. They made a strikingly ill-matched couple: Fearnley-Whittingstall a tall, relaxed, elegant Old Etonian; Kit almost a foot shorter, his face still plump, his cropped hair severely swept back and immaculately parted on the left-hand side of his head, combining the looks of a model public-school boy with sudden flashes of irreverence which suggested that his polished manner was only precariously maintained. When, one teatime, Kit divulged that he was Constant's son, he and Fearnley-Whittingstall each recognised the other as an oasis of civilised values in the midst of the army's tedium. They also discovered that they were both due to go up to Trinity College at the same time.

Far from encouraging them to have upliftingly serious conversations, this coincidence acted as a spur to their finding more frivolous ways of passing the time. On their pay of £1 a day (13s 6d basic, 6s 6d overseas allowance) their means of enjoyment were restricted, so Kit took a job teaching English to a minor Japanese diplomat, Mr Okita, at the rate of ten shillings an hour. He also wrote film reviews for the *South China Morning Post*. The extra money meant that he and Fearnley-Whittingstall could share modest pleasures (drinking, mainly, and going to the cinema), and they soon discovered a more creative distraction. Two rival theatrical companies ran in Hong Kong and for one of them, 'The Stage Club', Kit appeared in Molière's *Le Misanthrope* and Fearnley-Whittingstall in *Dial M for Murder*.

In Fearnley-Whittingstall's recollection, Kit regarded the opportunity to act and the chance to learn to drive as the only benefits of his National Service. It also had one other advantage. It gave him, for the first time, a context in which he could function without feeling overlooked by his

relatives. By the time he reached Oxford, the boy who at school had felt burdened by his past, and too withdrawn to make friends easily, had turned into a young man whose 'force of personality', Fearnley-Whittingstall has said, 'was enough to let him overcome most adverse circumstances'.

As soon as Kit returned from Hong Kong, in March 1956, he went to live with his mother and half-sister Annie in the latest of their flats – in Pembroke Villas, off Edwardes Square in Kensington. It was a small flat but, like all those in which Flo lived, newly painted and furnished in an ornate style. Kit shared his bed-room with the young Annie: 'I was only a fat little horror with pig-tails,' she says. 'But I adored him and thought he was terribly glamorous.' Since money was tight – the bulk of the royalties that Constant's music continued to earn passed to his widow Isabel – he had to cast around for occasional jobs. When Fearnley-Whittingstall returned to London in July, he discovered that Kit's new enthusiasm for cars had provided the solution. 'I found him in greasy green overalls with sump oil all over his face, lying under a chassis at the A1 Garage in the Earl's Court Road.' (This was the first of two jobs: for the second half of the summer he worked for 'The Fairy Milkmen' in Notting Hill Gate. One of the houses to which he had to deliver was his grandmother's.) Fearnley-Whittingstall also found that Kit had bought, for £120, the first car of his own – 'an ancient Wolseley with sporting pretensions. It was typical Kit. It used to blow asbestos out from under the clutch.' The car's career was brief but energetic: one day Kit stopped to give a sailor a lift, and felt so bored that he drove faster than usual to get the journey over with quickly, the big end went, and the car was scrapped. It was probably as well. One of his half-sister Annie's earliest memories is of Kit alarming and exasperating their mother with his driving. 'Bits would always fall off Kit's cars, and people would come to the house holding wings and bumpers and so on, and say, "Is this your son's?"'

When Kit arrived at Trinity College, Oxford, in October 1956, he found that his rooms were on the same staircase as Fearnley-Whittingstall's: Kit's on the first floor, Fearnley-Whittingstall's on the third, of the Garden Quad. On his very first night, Kit struck the note which he wanted to resound throughout his undergraduate career, and invited everyone he knew at the university – and several that he did not know – to drinks. The intention, now and later, was to create an impression of stylishness. He was, Fearnley-Whittingstall says, 'a great snob and a good user of contacts', and immediately abandoned the 'model pupil' image he had cultivated at school and maintained more tenuously in the army. He grew his hair, let it fall uncombed over his forehead, and took to wearing

cravats instead of ties, and rubber- (not leather-) soled shoes. On subsequent occasions, 'all the well-known dons', and anyone with aristocratic or artistic pretensions were asked to his parties. He made, for instance, a special fuss of Billa Harrod, who once rewarded him by bringing Clive Bell to meet him. One of the new friends he made in this way was Daria Chorley, the young wife of a Senior Student at Christ Church, a dark-haired, witty and outspoken young woman, who was so impressed by his talk that she assumed he taught too. 'Good God no,' another guest told her. 'He's someone who's just come up.'

Daria was quick to diagnose the uncertainty which lurked behind Kit's façade, and, like Fearnley-Whittingstall, she related it to more than his upbringing. She realised it also expressed the regret Kit felt that Constant's reputation as a composer had died with him. 'He absolutely hero-worshipped his father,' she has said, 'and feared finding himself similarly ignored.' This motivation made Kit a figure better known for his bravura than for his actual achievements: he was celebrated for drinking more than his peers, for experimenting with drugs such as mescalin, and for never having enough money to live in the manner to which he aspired. The same striving for notoriety was evident in his appearance. 'He dressed loudly,' one friend said, 'because he was worried about being small.' (Another friend said, 'He looked shrunken. He looked like Constant might have done if he'd been put in a washing machine and come out shrunken.') Although Daria was later to become deeply entangled in his life, she says at first that she 'took an instant dislike to him – he was outrageous, bumptious, he had this tremendously loud voice, and he showed off. He made me feel uneasy. On more than one occasion, I said in answer to an invitation, "if Kit is going to be there I'm not coming."'

Kit showed the same nervous and disagreeable ambition in more public walks of university life – writing the gossip column for *Isis*, and noisily involving himself with the Cinema Club and the Experimental Theatre Club. Acting seemed less attractive than it had done at Lancing, but his longing to establish and exploit social connections made him an energetic publicity manager. 'He had enormous enthusiasm,' one contemporary says, 'but then would sit about doing nothing. Once, for a performance of *The Changeling*, he showed no sign at all of fulfilling his responsibilities until two days before the first night. He then had hundreds of leaflets printed, hired an aeroplane, and threw the leaflets out over the town.' The tardiness, and the sensational solution, were typical of the work he would do for The Who ten years later. When Daria congratulated him on the

idea, he told her, 'It's nothing. Once you've rearranged the entire seating of Lancing College Chapel to sit next to the boy you fancy, anything is possible.'

For all its facetiousness, the remark is an important one. Rather than looking on his homosexuality as an obstacle to his social progress, he exploited it as a means of making himself notorious. At school, judging by the reminiscences of his friends, he had confined his activities to crushes and mild flirtations. Soon after reaching Oxford, though, he set about proving his nature to himself more decisively. This involved establishing just how interested he was in women, as well as giving greater freedom to his feelings for men – but the woman he chose to pursue most enthusiastically, Daria, could be safely relied on to discourage him. She was, after all, recently married. 'I'll have to wait until you're fifty and then you'll be hideous and I won't want to,' he complained. 'I like girls, but they're such a lot of work. First you have to send flowers, then you have to shine your shoes, then you ask them out to dinner, and to the theatre. You might get a kiss. With a boy, it's a bottle of whisky and out the door in the morning.'

The main obstacle to his instincts was not a confusing attraction to the opposite sex, but a guilt about what his mother would say about the attraction he felt to his own sex. Although his visits to Flo were now confined to the vacations, the comparatively firm structure this gave their relationship did nothing to steady it. 'He behaved with her,' according to Daria, 'more as someone who has an incestuous relationship with his sister. Sometimes he was never going to speak to her again, sometimes he adored her and showed her off.' Towards the end of his life, when Flo had no choice other than to admit his homosexuality, she still derided him for it – usually blaming Daria's refusal to sleep with him as the cause. Several brief affairs, and a more committed relationship with Jeremy Wolfenden – the son of John Wolfenden, and a student at Magdalen who later worked for the *Daily Telegraph* – could not persuade him that his predilections were entirely 'natural'. He was worried by being able to ascribe them so clearly to his early domination by 'strong women', and for the rest of his life was afflicted by the sense that the sexual pleasures and comforts he most wanted were at best wrong and at worst actually disgusting.

Provided it resulted in nothing more than a wistful and romantic melancholia, Kit's anxiety about sex did nothing to disturb the image he had designed for himself. By the end of his first year, his friends had seen his initial ebullience turn into the kind of decadence which they, and he,

associated with the hero of *Brideshead Revisited*, Sebastian Flyte. One contemporary, Michael Sissons, remembers, 'He was pretty louche and almost perpetually tight. He looked a mess and was very very smelly. There was nothing self-conscious about it; he was just a shambles. But he was fun and he was kind.' Another contemporary, Philip French, confirms this, and emphasises its appeal, as well as its potential dangers.

He was the kind of person I'd never met before. He belonged to a group of people who were openly camp, and was a marvellously funny, bitchy raconteur, for ever joking about his sexual proclivities and activities, saying the sort of thing no one said to me at the time, like 'Jeremy's no good at sex.' He was quite corrupt, in fact . . . his appearance was that of a young Charles Laughton, with thick lips which he used to curl . . . but his charm and force of personality completely overrode that.

Donald Bancroft, who had been involved with 'The Elizabethans' at Lancing, was less impressed: 'I once called on [him] about noon at Trinity. He was still in bed. I have a vague image of a bedraggled, rather dissipated young man, blinking at me from under the bedclothes.'

Part of Bancroft's concern derived from uncertainty about the amount of work that Kit was doing. No sooner had Kit arrived at Trinity than he switched from the subject for which he had won his scholarship, Modern Languages, to History – something in which he had no well-established interest, but which he felt would be less demanding. His tutors were Michael MacLagan and John Cooper, and both allowed him considerable freedom. Cooper, especially, while hugely admired by his pupils, provided much more material for anecdotes than intellectual stimulation. Kit was fond of imitating Cooper's tendency to take the abilities and diligence of his pupils too much for granted. 'You must read this article,' Kit would quote him as saying, imitating his drawl and curious air-swallowing, 'it's in Czech; but it's quite easy Czech'; and again, 'there is a paucity of written sources in Indonesia'. Kit's tutorial companion, Eldred Smith-Gordon, has remained unabashed about the ways in which they exploited the opportunities for laziness. 'Kit was . . . incapable of doing any work, though there were always a lot of papers around and cigarettes. He soon totally gave up, [and sat in tutorials] waiting to see whether Cooper, who sprawled in his chair, wearing an open-necked shirt, would get another word out.' Although Kit failed to benefit from Cooper's tutorials, his stories about them always had Cooper as the hero and helped to create a great affection for Cooper among Kit's contemporaries.

However amusing this sounds – Smith-Gordon credits Kit with

'teaching me so much about humour' – it does Kit a slight injustice. The impression Kit gave of being 'weak and disorganised' was not the result of innate stupidity, but of wanting to save his time and energy for sybaritic delights. Until his Finals, he was well enough in control of his work to satisfy, just, the university's requirements, and well enough aware of the pleasures of the intellect to avoid sliding into mere decadence.

If decadence and the pleasures of the intellect could be combined, so much the better. To prove that they could, Kit spent his first long vacation in Berlin. A sexually energetic night life, and an attempt to revive his knowledge of German, were financed by days spent selling soap for the blind. The proceeds were adequate to support the life he intended to pursue when he returned to Oxford in the autumn – a life which, for the next two years, elaborated the pattern he had created in his first three terms. He gave himself greater freedom by moving out of College to share a house with a friend (not a boyfriend) from Trinity, John Walters. Walters, whom Smith-Gordon describes as 'a key figure' in Kit's undergraduate days, was more a foil than a supporter – a shy, 'almost bright', anorexic, duffel-coated young man, whose evident anxiousness reminded Kit of his own, and yet also provoked him to overcome it. 'Kit always gave the impression,' Philip French said later, 'of wanting to be – and looking – debauched. He thought he inherited this from his father, and spoke about it.' Like Constant, Kit expected alcohol to further his ambitions, and had, according to French, 'more drink around than most people. I don't know how he afforded it.' Smith-Gordon also remembers Kit 'talking about the lethal effects of brandy'.

These and other friends insist that there was nothing in the way Kit drank, at this stage at least, which suggested a self-destructive instinct. It was simply a way of acquiring confidence, and of cutting a dash. (Once, on a binge in London, he drunkenly hailed a cab in Piccadilly and travelled in it all the way to Oxford in order not to miss a tutorial.) The effect, gradually, was to create a convincingly extravagant surface to his personality. This was not only protective but, in a roguish way, lovable. The energy of his conversation, his wit, and the generosity of his attention to people made him popular with his colleagues and attractive to those who might otherwise have thought him a little mad, bad and dangerous to know. Smith-Gordon, for instance, says, 'his sense of fun and his humour seemed to consist in his huge infectious laughter which proceeded from the hole through which tobacco smoke passed simultaneously in both directions. Kit did not laugh at people, only with them. Thus my mother,

who would not, I am sure, otherwise have liked him, appreciated him greatly – and all Kit ever did in her presence was laugh.'

When Kit sat his Finals, in the summer of 1959, the strategies which had won him friends proved disastrously harmful to his work. Fearnley-Whittingstall and Smith-Gordon were alarmed but not surprised as they watched him revise. He stayed up for several nights before his exams began, and fed himself with benzedrine. His chances of excelling, he knew, were non-existent. Midway through his first paper, he rushed out of the examination room, 'chased by the [female] invigilator . . . exclaiming that little devils were perched on his shoulder and attacking him. He was led into a side room by the said female – to whom he later sent flowers – and was calmed down.' But he never finished the course of papers, explaining to the invigilators that if he did he would feel 'vulture-like claws on the back of my neck' again. Charitably, his examiners decided to award him a degree on the basis of what he could tell them in a *viva voce*. The interview was not a success. 'After his viva,' Smith-Gordon says,

Kit and I and others were due to meet for lunch. He arrived very late, having been asked to produce *any* knowledge (other than his single answer) relating to the second paper on English History – and [when] further prompted to consider what Mr Shakespeare had to say he with difficulty provided a modest outline of one reign through the eyes of the Bard. The triumphant award of a fourth followed.

Kit's results were entirely in keeping with the image that he had projected during his time at Oxford. But that image was not so securely based that it could prevent him from feeling disappointed. Now, as in later life, he needed the applause of the society that he seemed devoted to challenging or overthrowing. For Kit to have admitted this would have been to confess weakness and inconsistency, and in subsequent accounts of his Finals, he habitually boasted that he had always intended to fail. He had not wanted to work, so how could he expect to pass, he would say – adding that his interests, anyway, were concentrated elsewhere. The focus of his attention was in fact extremely blurred. He had decided that he did not much mind what career he made for himself, provided that it made him money. His lack of funds as an undergraduate, he felt, had stunted his social aspirations. 'The only important thing is to be rich,' he told Daria. 'It doesn't matter if you're handsome, clever and so on. With money you can do anything.'

Making films, which he had reviewed with some regularity, seemed the best bet. He asked like-minded friends – notably Philip French, who was

later to become a distinguished film critic – to advise him about how best to proceed. The answer lay in tastes he had already formed. 'We shared an enthusiasm for French movies and Hollywood pictures,' French says, 'what we didn't like were English films because they were provincial and middle-class and genteel.' When Kit discovered that two of his heroes, Godard and Renais, taught a course at the Institut des Hautes Études Cinématographiques, which was part of the University of Paris, and situated in the Champs Elysées, he decided to apply. The entrance exams clashed with his Finals, so he opted for admission by reference. He asked Thompson to supply one, and was given a place. The success made good some of the damage he had done to his ego at Oxford. It also persuaded him that at least some of his education had been worthwhile, since what Daria calls his 'good colloquial French' enabled him to live easily in Paris.

As soon as Kit arrived at IDHEC, in the winter of 1959, he found the course gave him less than he expected. The technical instruction was adequate, but, he told Daria, 'Hitchcock-orientated, and stuck in the 1950s mould'. The society of his fellow-students, too, was less glamorous than the world he had recently left, and in order to preserve his connections with it, he made many return visits to London. On several occasions, he stayed with friends – many from Oxford – who had rented a flat in his mother's and Constant's old stamping ground, Oakley Street: Jeremy Wolfenden, Philip French, David Edwards (now Secretary for Legal Aid at the Law Society), Owen Humphries (the son of the former head of British Military Intelligence) and Noel Marshall (now head of the American Department in the Foreign Office). 'When there was no bed,' French remembers, 'Kit would kip on the floor. First thing in the morning a hand would appear from under a blanket and search round looking for a cigarette, so he could have a smoke before emerging into the light of day.' The fact that Kit was, according to Fearnley-Whittingstall, 'a shambles', made these visits to London unduly complicated. On one occasion he left, and lost, all his luggage at the Gare du Nord, and on another he took all his ties to the cleaners before he was due to leave Paris, hastily collected them immediately before boarding his train, and opened the packet to discover 'a very old pale blue lady's woolly', Daria remembered, 'which he took to wearing in bed when he was ill'.

By the spring of 1960 Kit was as bored with the film school as it was with him. He decided to abandon the course and return to London permanently, hoping that the little knowledge he had acquired would allow him to get a job. To start with, he shared a flat with two of his friends from Oxford, John Walters and James D'Albiac, and then, in

October, moved in to another flat, in Tedworth Square, near Oakley Street, with, among others, Fearnley-Whittingstall and John Walters. Tony Palmer, who did not meet him until 1968, says that throughout Kit's life 'he prided himself on his knowledge of films, and had a surface interest in the techniques of filming, and always threw in Godard as an early Master. But he only took the *idea* of film-making seriously, and not much more.'

Kit had neither the expertise nor the devotion to convert his interest into secure employment. The account of his next five years is a history of casual employment, uncertain hopes, unrealised ambitions, and bustling inconsequentiality. His initial efforts to get a job in the film industry were misleadingly successful. He was employed for four months by Worldwide Documentaries, then was made redundant and forced for the next eighteen months to accept a series of lowly and casual posts, none of which kept him occupied for long. His lack of commitment was only one cause of his failure. He also damaged his prospects by refusing – with sympathetic pride – to exploit the opportunities which some of his father's former colleagues could have given him. (He was later to see the folly of this, and ask Constant's friend the film director 'Puffin' Asquith to intercede on his behalf.) He spent a great deal of time idling at home – he and Fearnley-Whittingstall soon moved away from Tedworth Square to Cornwall Gardens in Earl's Court, where the rent was lower: £10 a week – living frugally off a small part of his father's royalty earnings, amusing himself as best he could (Fearnley-Whittingstall remembers an evening when they dressed up as ghosts), and going to parties where he could eat and drink for nothing. It was a footling, obscure period of his life. At school, the rules and regulations which had chafed him at least goaded him into discovering his intelligence; at Oxford, the comparative freedom had licensed him to assert a personality which, while being engaging to others, was damaging to himself; and in the wide world, he seemed unable to settle to anything for long.

In the spring of 1961, his picaresque existence suddenly slewed into a definite and extraordinary direction. At a party in London he met one of the few people at Lancing who could claim to have been a close friend, and whom he had also known at Oxford – his fellow 'Library' member, Richard Mason. Mason, who had distinguished himself at school by combining a love of the arts with natural athletic ability, had retained his diverse interests. On one hand, a contemporary remembers, he was 'intense and sophisticated and had a white dinner jacket which impressed Kit'; on the other, he had converted his athleticism, since leaving

university, into an interest in exploring remote and challenging parts of the globe. In his last summer vacation from Oxford Mason had travelled round the Middle East with a friend from Magdalen, John Hemming, and in 1959 he had driven across South America with Robin Hanbury-Tenison, researching and investigating. The trip had been a success, and he had persuaded the Royal Geographical Society to back his proposal for a new expedition – to map the longest undescended river in the world, the Iriri, in Brazil. The Brazilian government were also keen for this descent to be made since their armed forces, when they lost planes in the thick jungle surrounding the river, did not know enough about the area to recover them easily. By the time Mason re-encountered Kit, his plans were well advanced. He had arranged to make the expedition with Hemming, and had secured a good deal of funding – from the Vestey family, ICI, Unilever and the Brazilian Institute of Geography and Statistics, who also offered a senior surveyor and two helpers to accompany them. When Mason discovered that Kit had time on his hands, and had been to IDHEC, he suggested that he should join the expedition, and shoot a documentary film. Kit accepted without a moment's hesitation, and prepared to leave within a few days.

Kit's adult life was crammed with bizarre episodes, and his journey in Brazil stands out as one of the strangest. The fact that he went at all is remarkable: he had previously shown no appetite for danger or physical exertion, even refusing to play games at school. He did, however, share his father's enthusiasm for the exotic, and it is tempting to interpret his decision to go to Brazil as being a wish to make actual what Constant had rendered impressionistically in *The Rio Grande*. He sailed from London with Hemming and Mason in April 1961, and as soon as they reached Rio de Janeiro, they were flown in a Dakota (with their Brazilian assistants) to Cachimbo, deep in the jungle. It was the only place on the map anywhere near the supposed source of the Iriri and was, says Hemming, 'totally isolated. It was just a runway. The Brazilian government had deliberately crash-landed a plane there, and made this little strip, where they'd built a weather station. It was about as remote as being in the middle of the Atlantic. There were 1,500 kilometers of uninhabited jungle on either side. We were the first people to cut out of that.'

Before leaving Rio, they tried to establish that the jungle really was uninhabited, since any Indian tribes they might come across were likely to be dangerous. They interviewed 'the great Indian explorers', the Villas Boas brothers, and another explorer, Francisco Meirelles, both of whom said that there were no Indians at the source and mouth of the Iriri. They

could not speak for its central section: it would be as well to travel fast, sleep on islands, and not take any chances. Until they reached the river, it was impossible to travel fast, since the jungle had to be cut and cleared in order for them to take a single step towards the source of the river indicated on the map. There were eleven on the expedition – eight Brazilians and three British. Three people at a time did the cutting, and the others carried the food and equipment or built canoes. 'We'd take a sighting with our compasses,' Hemming said later,

then crash through with those following behind opening the path up. Our progress varied according to what type of forest we found: some was tall open rain forest, some tangled. We lived on beans and rice and anything we could shoot. We even ate jaguar one day, and on another tapir. We were doing very accurate survey work, often cutting down trees to get star-fixes. So we knew exactly the coordinates of where we were, yet we didn't know where on earth we were. We were nowhere. But the expedition was going very well indeed. We had surveyed a large, totally unexplored area. We even had permission to name new features on the map.

As well as doing his fair share of cutting and clearing, Kit helped with the boring and tiring business of carrying equipment. 'He was very very good,' Hemming says,

slightly contrary to expectation. We didn't talk a lot. We were so exhausted and hungry. But he was really excellent. He worked very hard and put in all his energy. Very cheerful. Very good sense of humour. I remember that every three weeks or so we'd move our camp forward up the path we'd made and on one occasion I was doing this with Kit, both of us with sixty pounds packs on our backs, when I started to nudge past Kit because he was going slowly. Long afterwards he told me he nearly shot my foot off, he was so angry. But I understood that.

Kit's other task, the filming, was deferred until they reached the river – which they found (or thought they found) forty kilometers from Cachimbo. They brought the bulk of their equipment forward up the trail, instructed their Brazilian helpers to hollow out some trees to use as canoes, and set off. In the photographs Hemming took of Kit at this stage in their journey, the hardships seem to have done him nothing but good. Under a beard he had grown during the trip and a mop of dark hair he looks tough and athletic.

After some weeks, they began cutting fast trails to see the lie of the land and quickly discovered 'another big river – about the size of the Thames

at Windsor' – which they thought really was the Iriri. They decided to move the whole camp over to the new river, 'but now,' Hemming says,

our logistics were getting too extended, and I was sent back to Rio to rustle up an overdrop and get an announcement made to the others on the national radio network, telling them that this was happening, and that they should light smoke beacons. It seemed simple, but everything went wrong. I got a C47, pilots, stores and several parachutes from the Air Force, flew to one of their airports in the interior and sent a message to Richard and Kit that everything was going according to plan. But when we tried to take off on the second day's flight, the plane wouldn't start. As if that weren't enough, news then reached us that there'd been a revolution in Rio following the sudden resignation of President Janio Quadros (this was the lead up to the take-over by the military in 1964), and my pilot was ordered back to base. I morsed a message to Richard, who had gone back to Cachimbo to meet me, then returned to Rio myself in order to try and sort things out. I had no money, and I bribed my way – 1,500 miles – with two bottles of whisky.

Once back in Rio, Hemming discovered that the only planes allowed to fly during the emergency were air-sea rescue flying boats, and with difficulty he persuaded one of these to make the drop. But on the way a message came over the pilot's radio which made his own recent problems seem trivial. Hemming remembers the pilot leaving his cockpit (there was a co-pilot), even though the plane was flying through a thunderstorm, and telling him that it had been announced over the plane's radio that a member of the expedition had been killed. Hemming had no way of knowing who it was, or of how it had happened, until he landed at Cachimbo, and found Kit 'in a very bad way. He was very pale after five months in the shade of the forest, he'd lost a lot of weight, and he was very badly bitten by insects.' Kit explained that Mason, shortly after receiving Hemming's message at Cachimbo, had decided to return to the river camp and had been ambushed by Indians. Kit, when Mason was overdue, went to look for him and found him dead, 'with arrows and clubs all around him on the path,' Hemming said, 'and the top of his head taken off. A long-range hunting party of Indians had just found our path (possibly attracted by the smoke signals) and laid an ambush and got him.' They were, it turned out, an unknown tribe, later identified as the Kren-Akrore, but after contact was made with them in 1971 most of them fell victim to measles.

Kit's ordeal would have been bad enough even if he had been a hardened campaigner. For a young man whose main purpose in life thus

far had been to discover the pleasures of decadence, it was appallingly traumatic. The time that Kit had spent waiting for Hemming to return had been terrifying (would the Indians attack again?), grief-stricken (Mason was, after all, one of his few close friends), and lonely (the Brazilian helpers immediately asked permission to divide up Mason's possessions). According to Daria, Kit 'had nightmares about Brazil for the next four or five years'. Before he and Hemming were able to return to London, further distress had to be borne. When the expedition first set out, English journalists had taken an interest in it, and once news of the tragedy broke, they took up the story again, usually romanticising it a good deal and comparing it, with great geographical inaccuracy, to the disappearance of Colonel Fawcett in 1925, on a trip to the Mato Grosso in search of the lost empire of the Incas. (Flo, who had to rely on these newspaper reports for information about Kit, became so worried that she rang up the Prime Minister, Harold Macmillan, and told him to send a gunboat to rescue her son.) The *Daily Express* and the *Daily Mail* flew reporters out to Brazil, and these reporters inflicted considerable and unnecessary suffering on Kit and Hemming. The first simply invented a story, and the latter, Hemming says, 'really pumped Kit who was in no shape to talk. He was very emotional and was pouring out his thoughts.'

The effect of these intrusions was compounded by the Brazilian government insisting that Mason's body be brought back to Rio for burial. It was a reasonable enough request, but it made Kit feel that he could not distance himself from the tragedy. Although the short time he spent in Rio, while the formalities were completed, was mellowed by the hospitality of the British Ambassador, he was depressed and erratic. According to Daria, his more libidinous efforts to forget the recent past only led to further worries. 'He got a serious anal infection due to over-indulgence in the stews of Rio', and had to go into hospital as soon as he returned to London in October.

The seven months that Kit had spent away from England seem a self-contained nightmare – a random chance for adventure which the shapelessness of his life had made possible, and which had been turned into tragedy by what Hemming called 'totally bad luck'. In fact, the search for the Iriri set a pattern which was to be repeated in a variety of forms for the rest of his life. His impetuosity and his relish for living at risk seemed not to include any fully developed appreciation of the difficulties into which he might be led. Insofar as he deliberately sought out dangers, his behaviour indicates that he was possessed by a wish to challenge fate – to court it, dare it, and throw down his life as a gauntlet. If this can be

construed as a self-destructive impulse, it is one in which the longing for oblivion was, like his father's, inextricably entangled with a passionate love of life.

Once back in London, Kit and Hemming paid their debts to the Royal Geographical Society and to the memory of Mason by giving a series of lectures about their adventure. As these came to an end, Kit drifted apart from Hemming – occasionally meeting him to play bridge – and began looking again for employment in films. His recent experiences had stiffened his resolve, and revitalised the ambition 'to be rich' that he had announced to Daria at Oxford. From his flat in Cornwall Gardens with Fearnley-Whittingstall – and later, when they had moved, from another flat at 9A Curzon Place, off Piccadilly – he made good use of the introductions that he had at last solicited from 'Puffin' Asquith. After a spell working from home for an advertising company, he was engaged as director's assistant in a regular succession of films. Although these brought him less money than he wanted, they satisfied his taste for travel, kept him employed more or less full time for the next three years, and allowed him to feel involved with adventures of a safer kind than the one he had undergone in Brazil.

Among the better-known films on which he worked were *The Moonspinners* which starred Hayley Mills and for which – as production manager – he had to go to Crete in December 1961 to supervise the building of a road needed as part of a set; *From Russia With Love*; *The Guns of Navarone*; Michael Winner's *W11*; and Judy Garland's *I Could Go On Singing*. 'It's awful,' he told Daria, 'I have to fetch and carry for her and empty her po . . . They take two hours to do her make up and they hold her face up with elastic bands . . . It'll come to you yet.' On another film, *The L-Shaped Room*, directed by John Quested, his work was made more rewarding by finding that one of his fellow assistants at Shepperton Studios, Chris Stamp, was someone he felt able to contemplate as a friend. For one thing, he told Fearnley-Whittingstall, Stamp was 'beautiful' – not much taller than Kit, but leaner, more delicate, and, in a dark-featured gamin sort of way, effeminate-looking; for another, the difference between their backgrounds made each romantically appealing to the other. Jonathan Benson, who worked with Stamp on subsequent films, said, 'Chris was a rough boy . . . straight, and Kit was a highly articulate intelligent homosexual. The relation between them was like a marriage when a husband finds a wayward wife that he can't get out of his system.'

Kit was impressed by Stamp's background. He had been brought up in the East End of London – his father was a tugboatman – and although

naturally quick-witted had left school at the earliest opportunity and decided, like his brother Terence, to investigate film-making as a means of bettering himself. Similarly, Stamp was intrigued by Kit's sophistication, and by the agreeable muddle in which he worked. Kit was renowned for having been unable to account for £20,000 of the budget for his road-building in Crete, and there was nothing in Kit's behaviour during the filming of *The L-Shaped Room* which suggested what Stamp would have interpreted as bourgeois rigour. As personal helper to Quested's first assistant, for instance, it was Kit's responsibility to prepare the actors' call sheets, and get everyone on set punctually. This was consistently jeopardised by his inability to get up on time.

Stamp – who, according to Benson, was himself 'an expert at brinkmanship' – realised that Kit's inefficiency was not to be mistaken for lack of ambition. Rather, it was a form of blasé pride which indicated that Kit considered menial tasks to be beneath him. He would only be able to show his worth, Stamp understood, when given more responsibility. Stamp felt the same, and their friendship blossomed in the shadow of their impatience. By the end of 1963 they had taken a small, cheap dark flat together in Ivor Court, just north of the Marylebone Road, and were devoting a good deal of their time, on and off set, to contemplating ways of bypassing the inflexible hierarchy of the film world, and making some money by becoming independent. Since most of Kit's training had been in documentary film making, it seemed sensible to exploit such expertise as he had managed to gain: but what subject could they choose which would have enough general appeal to be profitable? The answer they gave themselves was one which lay outside their experience. They decided to make a film about teenage England's enthusiasm for rock and roll.

Until the late 1950s, most successful rock and roll groups had originated in America, but in 1958, when Cliff Richard and The Shadows had proved more decisively than any of their English forebears that a local version could compete with the sales of Elvis Presley or Gene Vincent (both of whom Richard emulated), the home market had expanded spectacularly fast. By 1963, says Dave Marsh, a biographer of The Who, 'the concept of native British groups playing American-originated music began to sky-rocket . . . Manfred Mann, Downliners Sect, The Yardbirds, Chris Farlow and The Thunderbirds, Ronnie Jones and the Nightimers, the Graham Bond Organisation, Zoot Money's Big Roll Band and The Pretty Things were all playing Chicago-style American blues or some of the lighter soul sounds or a combination of the two.'

Two English groups, in particular, had learnt from Americal models,

assimilated their influences, and begun to produce records which galvanised the English audience: The Beatles and The Rolling Stones. The Beatles' enormous popularity had penetrated Kit's and Stamp's consciousness, but their knowledge of the music was minimal: neither had been to a concert or a club to hear a group perform. Yet their ignorance did not prevent them from seeing that the explosion of public interest in pop music meant that there was money to be made. The market was almost infinitely wide, and therefore capable of being infiltrated by amateurs such as themselves. Without any pretence of wishing to acquire knowledge, or to investigate a social phenomenon, they decided to discover a group, then shoot and sell a film about them.

The enthusiasm with which Kit set about the task, and the intelligence with which he met its challenges, entirely vindicated his feeling that he was wasted as a director's assistant. He realised that most of the groups which had made their name so far were from the provinces (Liverpool, notably), or from the fringes of London (The Rolling Stones, for instance, came from Richmond), and that London proper was likely to be the best hunting ground. In an interview given several years later he announced:

Rock and roll is like football. No London boy is going to stand for Liverpool or Manchester winning all the time. I felt partly from being in the Army that Cockneys had the fastest reactions and the best brains. I didn't feel that London boys would allow a lot of northern 'oiks' like the Beatles or the Merseybeats to put it across them indefinitely. There had to be out there lurking in London *the* group of the future, which would be spawned spontaneously by the fact that London had some hate for the north.

The legacy of Kit's army training gave him a second clue about how to proceed. As if he were planning a campaign, he bought a large map of London, pinned it on the wall in Ivor Court, and staked it out into sections so that he could investigate them thoroughly. Stamp was allocated the East End, and Kit took the south and then the west. 'I used to go out every night after work in the studio, looking for a band,' he said – but his search was more disciplined than this implies. He knew that most groups, before they grew so famous that their following became amorphous, attracted particular kinds of audience, and that several of these could be identified by the uniform of whatever allegiance they owed. One such audience was comprised of Mods, whose Vespas and Lambrettas, usually decorated with squirrel tails, were easily spotted. 'I used to drive around looking for pubs and clubs with the largest number of motor

scooters outside,' Kit later told Tony Palmer. In July 1964 he found a particularly large gaggle outside The Railway Tavern in Harrow:

I paid my few shillings and went into the back . . . On a stage made entirely of beer crates and with a ceiling so low you could stick a guitar through it without even trying, and lit by a single red bulb were The High Numbers . . . [they were] ugly in the extreme. Roger [Daltrey], with his teeth crossed at the front, moving from foot to foot like a zombie. John [Entwistle] immobile, looking like a stationary blob. [Pete] Townshend like a lanky beanpole. Behind them Keith Moon sitting on a bicycle saddle, with his ridiculous eyes in his round moon face, bashing away for dear life, sending them all up and ogling the audience. They were all quarrelling among themselves between numbers. Yet there was an evil excitement about it all and instantly I knew they could become world superstars.

Kit did not speak to any members of the group that night, but he talked to their manager, Peter Meaden, about the possibility of making a film, and was told, 'You can make a lot of money out of this . . . they are the hippest numbers in town.' Meaden later remembered Kit as a 'dapper little man . . . fitted out in a custom-tailored grey suit, posh enough for a Mod but not so radical'. Kit went back to Ivor Court at once, telephoned Stamp – who was in Dublin working as an assistant to John Ford on *Young Cassidy* – and arranged for him to return to London for the weekend to audition the band. By the time Stamp arrived, Kit had begun to change his mind about filming the group. Instead, he wanted to become their manager.

Three

The High Numbers were more accomplished performers than Kit's first impression led him to believe. Whereas many of their contemporaries had been brought to rock and roll by a strong tide of untutored youthful enthusiasm, they themselves had well-established musical ambitions. The group's lead guitarist, Townshend, deserves most of the credit for this. As a child – he was born on 19 May 1945 – he had benefited from the taste and advice of his parents, both of whom were musicians. His father Cliff played alto saxophone in the RAF's band The Squadronnaires during the war, and his mother Betty was a vocalist with the Sidney Torch orchestra. When the war ended, Cliff Townshend stayed with his band, playing mainly jazz, and although this meant he was free to settle with his family in their home in Wood Grange Avenue, Ealing Common, in the west of London, he in fact spent most of his time on the road. Pete, like Kit, was cared for by grandparents for much of his childhood. It was only when he was a young adolescent that his father began to show any real interest in him, taking him to concerts (by Bill Haley, among others) and teaching him to play the guitar that his grandmother had provided. Soon after passing his eleven plus, and moving to the nearby Acton County Grammar School, Pete joined the school band. One of its members was a boy called John Entwistle.

Entwistle was eight months older than Townshend – a child of divorced parents, who had been brought up by his mother. His home – also in west London, in Chiswick – was similarly dominated by grandparents, and accustomed to having music as part of its everyday life. His mother played the piano, and his father – on his occasional visits – taught him to play the trumpet. For a time, at Acton County Grammar, Entwistle played horn for the Middlesex Youth Orchestra. He also played bass guitar, after school hours, for a succession of trad bands, trying to make the best use of the admiration he had developed for recently emerged stars such as Duane Eddy, Eddie Cochran, Buddy Holly and Jet Harris, the Shadows' bassist. The trad band in which Entwistle played with Townshend was called The Confederates, but they made only one public appearance – at the Congo Club, run by Acton Congregational Church. According to Townshend, it was not 'just a place where we got together and entertained the troops. There was a lot of violence and sex and stuff going on.' For all his musical professionalism, Townshend, like

Entwistle, allowed his playing to become confused with his inclination to behave in a way which insulted the manners of his parents' and grandparents' generations. The fact that he had an 'incurable inferiority complex' – largely because his fellow pupils kept telling him, 'You've got the biggest nose in the world, man' – and a filthy temper, made the insults easy to hand out.

Townshend and Entwistle left Acton County Grammar in the spring of 1961. 'I had the choice,' Entwistle said, 'of either going to art school or music school', but because money was tight his mother advised him to get a job instead. He went to work in the local tax office, where he stayed for the next two and a half years. (His mother says his eventual departure was only 'one step ahead of being bounced for . . . napping on the job'.) After work, for 'about five or six nights a week', he continued to play bass guitar. The bands in which he was involved with Townshend were formed and dispersed with casual speed: after The Confederates came The Aristocrats, then The Scorpions – all of them devoting more time to rehearsal than live performance. Just before leaving school, he was approached by a boy a year older than himself, Roger Daltrey, who had recently left Acton County Grammar and played in a group he had formed there called The Detours. 'I hear you play bass guitar,' Entwistle remembers Daltrey saying.

'Yeah.' (After all, I was holding it under my arm. It was pretty obvious.)

'Do you want to try in my group?'

'I'm already in a group.'

'Well, mine's earning money.'

The directness, the unashamed reference to earning, and the implied need for popular recognition were all typical of Daltrey. Like Townshend and Entwistle, he had been born in the vicinity of the school (on 1 March 1944), and like them his parents belonged to what Marsh calls 'the more upscale' section of the working-class community. In 1955, when Daltrey's father became office manager of the local Armitage Shanks works (manufacturers of lavatories), and moved his family to Bedford Park in Chiswick, Daltrey passed his eleven plus exam and was transferred from Victoria Primary School to Acton County Grammar. At Primary School he was, according to his father, 'very interested . . . he got good reports'. But as soon as he left Shepherd's Bush, 'he didn't have the interest . . . he should have had'. Daltrey's own explanation of the change is succinct: 'I was good at school until I heard Lonnie Donegan and Elvis Presley; then I didn't want to know.' Daltrey regarded his new addiction as a way of bettering himself. 'If you come from the streets,' he said later,

'you've got how many ways out? You can either work in a factory and become an ordinary geezer. Or if you've got any spark of wanting to be a total individual, you can become one of four things – a footballer, a boxer, a criminal or a pop singer. I guess that's why I'll still be rocking in my wheelchair. Rock and roll was my saviour.'

Initially 'the way out' looked to his parents like the way down. Daltrey neglected his lessons altogether after the first year or so at school, preferring instead to play guitar – but not to sing – in The Detours. In 1959 he was expelled. 'He's just got music music music,' his headmaster complained, 'that's all there is.' Daltrey was not deterred. He took a job in a sheet metal shop, working with a welding torch all day, and rehearsing with The Detours in the evening. It was shortly after beginning as a welder that he invited Entwistle to join his group, and only a matter of another few weeks before Entwistle advised Daltrey to sack the patently inadequate lead guitarist, Reg Bowen, and hire Townshend instead. Daltrey, little knowing that it would lead to a long and bitter argument about the leadership of the group, agreed. 'The greatest bloody triumph of my schooldays was when Roger asked me if I could play guitar,' Townshend said later – but in fact his time at Acton County Grammar did not have long to run when the invitation was issued. The choices which faced Townshend were similar to those which had confronted Entwistle: to move on to art school, music school, or a job. 'It was probably,' he said, 'the terrible noise I used to make on my first electric guitar [The Detours used often to rehearse at the Townshends' house] that made my father suggest that I go to art school and concentrate on the graphic rather than the musical areas of education.' When he enrolled at Ealing Art School in the autumn of 1961, the pressures that his move exerted on The Detours almost caused the band to disintegrate.

As an art student, Townshend was quite simply resented by other members of the band. Although they respected his talent and valued the support of his family, they envied and distrusted the articulacy that his intelligence and education gave him. Entwistle, because he was a comparatively old and trusting friend of Townshend's, was prepared to accept this. To Daltrey, it constituted a threat. The lead singer Colin Dawson felt the same, and so did the drummer Daltrey had enlisted, Doug Sandom, who was generally agreed to be, musically speaking, 'ten times better than we were'. To start with these conflicts were either over-whelmed by the group's collective desire to make their mark – they quickly established themselves as a popular club band in the Shepherd's Bush area – or rerouted into dissatisfaction with the singer, Dawson. 'He

didn't fit,' says Sandom. 'I mean, Peter hated to see a singer like he was. He'd just stand there and wiggle his bum.' The solution to the problem was in one respect decisive – Dawson was sacked – and in another muddled: the singing was shared between Daltrey and an ex-member of The Bel-Aires called Gabby. Daltrey, as Marsh says, 'was nobody's idea of a subtle song stylist', and the only advantage of this revised line up was to give the five-man Detours a sound which at least made them different from the very large number of four-man groups which dominated rock and roll in the early 1960s. It also, however, prevented them from establishing a proper coherence. They argued, relied heavily on other bands' songs for their material – especially Beatles' songs and Motown numbers – and presented their audience with a fragmented image.

Their audience did not care much, since by luck as well as judgment The Detours had managed to attract a following which was simply hungry for a band to speak for them. One of their most regular venues was the Goldhawk Social Club in the Goldhawk Road connecting Shepherd's Bush with Chiswick, later to be institutionalised as a favourite stamping ground for Mods, but in its early days a haunt for virtually any kind of angry young man. 'The guys in there,' one of the Club's members recalls, 'weren't Mods or Rockers. They were loners . . . [It was] packed with guys who were just coming out of nick.' As English rock and roll became less dependent on America so different kinds of music attracted more easily definable kinds of fans. Where the Rockers, for instance, elected to identify with the impression of squalor and threat cultivated by bands like The Rolling Stones, the Mods created a more stylish image for themselves. 'It was a true cult,' Marsh says, 'with almost religious overtones', and its aspirations were embodied in a code of behaviour which mingled the longing for novelty and independence with the realisation that the means of achieving these things could only be acquired by discipline and hard work. 'It was fashionable, it was clean and it was groovy. You could be a bank clerk and a Mod,' said Townshend.

This version of Mods – a suddenly coherent section of young England which was, in Daltrey's phrase, 'the first generation to have a lot of money after the war', and were using it to have good clean fun – is strikingly at odds with the original flavour of the Goldhawk Social Club. But the Mods' rebellion had a more threatening aspect too. 'The archetypal Mod,' said Nik Cohn, the rock and roll commentator and entrepreneur, 'was male, sixteen years old, rode a scooter, swallowed pep pills by the hundred, thought of women as a completely inferior race, was obsessed

by cool and dug it. He was also one hundred per cent hung up on himself, on his clothes and hair and image; in every way, he was a miserable, narcissistic little runt.'

It was this disruptiveness, mingled with a wish for self-advancement by orthodox means, which The Detours and their audience identified in each other. It did not take their first managers long to realise they could adapt their image to exploit the recognition. The managers were in fact no more than ambitious amateurs. Initially, Sandom's sister's boss, Helmut Gorden (who ran a brass foundry), had tried to turn himself into a version of The Beatles' manager, Brian Epstein, by arranging various gigs, but he soon found that he needed help with promotion, and employed Pete Meaden, who had recently been sacked as one of The Rolling Stones' publicists for being 'a pill-headed Mod'.

Meaden quickly set about sharpening The Detours' image. The change most badly needed was exposed by a recording session he arranged in the spring of 1964 with Chris Parmeinter, who worked for Fontana Records. Parmeinter was impressed by The Detours, but told Meaden, 'If you want to make a record, you'll have to get the drumming sorted out.' The band, supported by Meaden, knew that the Mod audiences on which they depended might be quickly swept away on a new tide of fashion, and rounded on Sandom. He left within a week of the visit to Fontana, and his place was taken by a series of session drummers imported from other groups. In April, though, one of their gigs was interrupted by a drunk who told them he had a friend who could help them out. 'He brought up this little gingerbread man,' Entwistle remembers, 'dyed ginger hair, brown shirt, brown tie, brown suit, brown shoes . . . he got up on the kit and we said, "Can you play 'Roadrunner'?" 'cos we hadn't come across a drummer that could play "Roadrunner" with us. And he played it, and we thought, "Oh this is the fellow." He played it perfectly.' His name was Keith Moon, and he was enlisted at once.

Although younger than his new colleagues – he was born in 1947 – Moon had already created more mischief than they had. At Balham Primary School he had compensated for his riotousness in class by excelling in the school orchestra – playing the bugle and, later, the trumpet. When he moved to Alperton Secondary School in west London in 1957, his teachers were unanimous in their exasperation. 'Retarded artistically', 'idiotic', 'keen at times but goonery seems to come before anything', they wrote in his reports. He was spoiled, easily bored, and insecure. In 1960, the year before he left school – aged fifteen – he had decided, much as Roger had done, to give a shape to his unfocussed

31

32

31 Kit at Forres Preparatory School, April 1949.
32 John Hemming (left) and Kit at Cachimbo, Brazil, 1961.

33,34

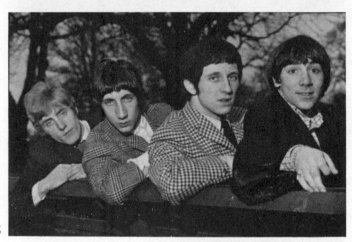

35,36

37

33 Chris Stamp (left) and Kit at the Reading Jazz Festival, 1966.
34 Kit in the recording studio.
35 Roger Daltrey, Pete Townshend, John Entwistle, Keith Moon: The Who, 1965.
36 Roger Daltrey singing *Tommy* at Berkeley, California, 1970.
37 Pete Townshend leaping.

38 Daria Shuvaloff (centre) and Kit (right) in Venice.
39 Palazzo Dario, Kit's house in Venice.
40 Kit's late dash in the Venice Marathon.

41

42

41 Keith Moon and Kit shortly before their deaths.
42 Kit's last passport photograph.

frustrations by devoting himself to rock and roll. Like so many of his contemporaries, he regarded it as the voice of youthful rebelliousness. His father bought him a set of drums for £17, and Moon started to perform with a series of bands with 'ridiculous names' – The Adequates, The Escorts, The Mighty Avengers – usually playing cover versions of whatever they fancied in the charts. Moon supplemented the income this brought by taking day jobs – he had twenty-three between 1962 and 1964 – and perfecting a spectacularly vigorous, theatrical drumming technique. The first band in which he put this to proper use was The Beachcombers. 'Everyone looked up to him,' remembers one fan who followed him round the club circuit. 'He was already flailing his arms around and blowing up his cheeks. At least half a dozen different drummers copied him and that inimitable style he had of crooking his hand down under till the drumsticks pointed at the skins vertically.' By the time Moon joined Daltrey, Townshend and Entwistle, he was, says Nik Cohn, 'a natural psychopathic drummer', and he immediately gave the band the drive and coherent rhythm it had so far lacked.

Moon completed the band's musical jigsaw, and his arrival coincided with the greatest success Meaden was to have as manager. In March 1964 – the month before Moon appeared – the Mods had become headline news when they went on the rampage at the Essex coastal resort of Clacton, on a Bank Holiday, and the bands with which they associated were accordingly thrust into prominence. Meaden had already experimented with ways of identifying The Detours more closely with their audience, considering changing their name to The Who before deciding on The High Numbers. (The Who is an old musical joke: 'They're called The Who'. 'The Who?' 'The *Who*', etc., etc.) Meaden also redesigned the band's clothing, dressing Daltrey as a 'face' and the others as 'tickets'. Pete later explained: 'These were like two phrases that we used . . . "faces" were the leaders – they were very hard to find, very few. "Tickets" were the masses.' The phrase 'high numbers' was itself part of Mod parlance: to be a 'high number' was to be notably hip.

Townshend endorsed and elaborated the changes that Meaden made by suggesting various alterations of his own. Many were derived from ideas that he had come across at art school. He was particularly keen to find ways of performing which might express the same impatience with convention that fascinated him in the work of the 'autodestructive artist' Gustav Metzke, under whose spell he had recently fallen. (Metzke was notorious for the violence of his opinions and techniques. His working methods included painting in acid on metal.) To start with, Metzke's

influence did little more than prompt the band to increase their volume, perform in a way which seemed bound to insult each other and the audience, and damage their instruments. Later, under Kit's management, Metzke's example was translated into scenes of truly barbaric destructiveness. Like Meaden, Townshend was anxious to clarify the band's image to a point which stopped just short of alienating the record companies on whom their success depended. When, in June 1964, Parmeinter at Fontana realised that he could use The High Numbers to exploit the Mod market, the band eagerly submitted to the routine of recording in a studio.

During the first session at Fontana, The High Numbers recorded two R-and-B cover versions – Eddie Holland's Tamla hit 'Leavin' Here', and Bo Diddley's 'Here 'Tis'. Because Meaden felt, according to Marsh, that they needed to make 'a clear statement of Mod principles', the songs were never released, and it was decided to record original material instead. Since no one in the band was yet writing songs, Meaden met the challenge by reworking two little-known American records, Slim Harpo's 'Got Love If You Want It', which became 'I'm The Face', and 'Country Fool' by The Showmen, which became 'Zoot Suit'. They were released on 3 July 1964 with 'I'm The Face' on the A side, were politely but quietly reviewed, struggled to find a lowly place in the charts (which that summer included The Beatles' 'A Hard Day's Night', The Rolling Stones' 'It's All Over Now', The Animals' 'The House of The Rising Sun', and Manfred Mann's 'Do Wah Diddy Diddy'), and vanished.

Not even the appearance in 1964 of the first pirate radio ships – Radio Caroline began broadcasting in March, and Radio Atlantic in July – could create a market for The High Numbers. (However, the stations did radically affect sales of pop music generally: 613,000 singles were sold in England in 1963, 718,000 in 1964). Fontana, not surprisingly, showed no signs of wanting to issue a follow-up, Gorden and Meaden began to argue about how best to proceed, and the band themselves began to feel disaffected. The Beatles had managed to get rich quick. Why shouldn't The High Numbers?

When Kit first saw The High Numbers in August, the month after 'I'm The Face' had been released, The Beatles' example came vividly to his mind. He became fascinated with the story of Brian Epstein's success, and even believed that he looked like him. Kit also, in a late interview, implied other kinds of resemblance: 'Brian Epstein was middle-class . . . he was gay, and always having unsuitable crushes on unsuitable rock stars.' This remark suggests that Kit's decision to involve himself with the band was

prompted by his homosexuality. Although, on his occasional visits to Flo and to his grandmother, he made no reference to this, and suffered their enquiries about his lack of girlfriends with a smile and a shrug, he made no secret of his feelings when amongst friends. As he had done at Oxford, he broadcast his homosexual wants and intentions in order to promote the image of himself as a liberated iconoclast.

It is easy to see similarities between the close ties Kit eventually formed with Townshend and those which existed between Epstein and John Lennon. But the truth is that Kit's friendship with Townshend was charged less by sexual attraction than by the appeal of shaping and directing an as yet unrealised talent. It was an impulse that his father would have understood very well. Kit, in fact, went to some lengths to quash imputations of any sexual dimension to his management. He regularly pointed out how remarkably unattractive the band were, and agreed with a friend who, on first seeing them, pronounced them 'the ugliest in London'. Later, Kit painted a repellent picture of them when they went swimming at Brighton after a gig late in 1964: 'Roger, with his barrel chest and skinny legs and ribs showing, a real short arse. Moon glinting on his crossed teeth. Moonie like a Michelin man . . . Entwistle, holding down his thinning hair in the night breeze . . . Townshend looking like two clothes pegs stuck together with a piece of insulating tape.'

As soon as Stamp arrived from Dublin to audition The High Numbers, he agreed with Kit that the original idea of filming the band should be converted into a plan to manage them. Kit immediately took steps to get rid of Helmut Gorden and Pete Meaden. With the help of one of Stamp's former school friends, Mike Shaw, who was working as a lighting director in Bristol, they decided to take Gorden's contract with the group to a leading music lawyer, David Jacobs, who worked for The Beatles, and have it examined. Jacobs immediately saw it was worthless: all the members of the band were under age, and one of their parents had not countersigned. This disposed of Gorden, but Meaden – although, as a hired hand, he had no contractual rights – was more emotionally entangled with the group, and therefore more difficult to remove. In the event, Kit simply bought him off: over lunch in Frith Street in Soho, he told Meaden: '"I'll give you £150 for them." I learned later that I was supposed to accept £5,000. But I just said, "Yeah, that's all right. That'll do. Thanks a lot."'

Kit's decisiveness impressed the band, even though his qualifications for taking on the job of manager himself were negligible. For one thing, he

knew very little about their music. Townshend remembers that when he went to see Kit at his flat in Ivor Court, and inspected the record collection, he found 'Sinatra, Ellington, a good deal of Italian opera, and a fair amount of baroque music including Purcell's "Gordian Knot Untied", which he played all the time. But not much pop.' Kit himself admitted that 'I knew very little about [it]. The only way I could tell a bass and a lead guitar apart was by counting the number of heads at the top of the neck.' He was similarly ignorant of the music world's business aspects – and as if ignorance were not bad enough, he was chaotic, too. The disposal of Gorden and Meaden had been an act of bravura, and had nothing to do with expertise. For later generations of pop entrepreneurs, who have to deal with a highly organised industry, this lack of knowledge would have been disabling. In the 1960s, when the discipline of rock and roll management had still to be discovered, it was a positive advantage. Benson, Kit's friend from film-making days, put it succinctly:

The way Kit carried on was terrifying because it was as if there was no such thing as authority. There was no record of anything, no fear that somebody might find you out. It was the real rock and roll attitude – and an essential part of the so called revolution. Suddenly a whole lot of uneducated people appeared on the scene and said fuck all the orthodox ways of doing things, let's just do it, *and* drink, *and* take drugs, and we'll get it done in a different way. And for a few of them it was very successful.

Kit's opportunism, and the force that his personality could exert in a world which rarely encountered people from his background, amply compensated for his lack of experience. In Stamp, he found an ideal partner. Benson reckoned that he had 'never met anyone so fearless as Chris', but that Stamp's bravery had an element of pragmatism about it which controlled Kit's extravagant sophistication. 'Kit was an utter maniac who lived off nervous energy,' Nik Cohn says. 'Chris, by contrast, was the voice of sanity, very cool and hard. Together they fitted like Laurel and Hardy.' If Kit's upbringing made him a fascinating rarity to his new colleagues, Stamp's humbler origins were also – according to Marsha Hunt, whom they later recorded – 'a valuable commodity. You sense a class war now, but rock and roll in the sixties wanted to destroy that. People worked genuinely and naively hard at racial and other kinds of community. So Kit's relationship with Chris was not one of a public schoolboy being generous enough to work with a street-level boy. They were being generous to each other.' Together, they represented a miniature and active version of the social integration espoused (in theory,

at least) by many of the musicians who surrounded them. Even in later years, when their mishandlings of The Who's money led to acrimonious distrust, 'Kit and Chris kept face for the public,' says Benson, 'like a married couple.' They managed to do this even though, from the late 1960s on, they spent increasingly little time together. After 1967, when The Who's American market began to increase, Stamp lived for much of the time in New York, organising the band's tours round the States, and confining his dealings with Kit to regular visits and extended, frequent telephone calls.

Kit's success with the band is inseparable from the advice he received from Stamp. Had Stamp but known it, many of the triumphs and the troubles they encountered were due to the even stronger influence of a more remote figure: Constant. In strictly musical terms, Constant's influence was of a most general kind; one of Kit's friends, for instance, remembers him saying that his father had told him, 'Always watch out for pretension in music . . . It doesn't matter what sort of music people like, provided it's good of its sort.' One result of this advice was that Kit responded to the arts with the same open-mindedness that characterised his initial response to the rock and roll fraternity. In music, as in society, he wanted to dissolve received ideas of segregation. In 1970 he told Tony Palmer:

My father . . . brought me up to mistrust musical snobbery of any kind. The music he was writing when he was nineteen and twenty was full of jazz idioms, which was considered unthinkable by the music élite. When his music was played at the Albert Hall, people were shocked. They couldn't understand how someone of his talents could hang around with such as Louis Armstrong rather than with the classical musicians and the whole establishment BBC crowd of Queen's Hall followers. Fortunately the musical frontiers are now beginning to disappear; classical influences are being absorbed by pop and pop by classical. And I really think there is more valid new creative music being made at the pop end. I don't see any good classical composers emerging at the moment. I certainly haven't heard a decent new symphony or a decent new opera in the last eighteen months and I think the whole impetus has passed to the younger generation and to the excitement that is generated in pop.

Constant's influence also exerted itself more intimately. For one thing, he provided Kit with an example of the ways in which his own talent could be used to release or invent other people's greater gifts. For another, his neglectfulness as a father encouraged Kit to translate the terms in which he thought of the band into a domestic idiom. Flo and Amy looked

on his decision to manage The Who with an alarm only slightly mitigated by their belief that it would not last for long. On his occasional visits to see them, he did his best to disguise the style in which he and the band lived, and made no effort to explain – thinking he would not be taken seriously – that, in Tony Palmer's words, 'he had been made to feel part of The Who's family'. Because many of Kit's former friends disliked or distrusted the pop world, Daria says, 'he was quickly driven into it more and more'. (Robert Fearnley-Whittingstall and his wife Jane were exceptions: Jane later worked for a while in The Who's publicity department, calling herself 'Jane Who'.) The band itself, and the team of helpers and contacts he gathered round him, were treated less as employees than friends – the lawyers at Wright & Webb; David Platz, the music publisher and distributor; the Mod Mike Shaw, who acted as a general handyman; Patricia Bell, who was employed as a public relations officer; and Anya Forbes Adam (née Hillman) who defected from the offices of the manager Ken Pitt with Pitt's mailing list, and moved into Ivor Court to help in whatever way she could. 'Chris slept on a bed in the hall,' she remembers. 'I was on the sofa, and Kit was in the main bedroom. I got £8 a week, but Kit always borrowed it back. Theoretically I was doing publicity, but in fact I was cooking, sewing on Daltrey's symbols, and consoling Moon for not being in The Beach Boys. We were a shambles, but we were a happy family.'

Constant's legacy goes a long way towards explaining why Kit, having never thought seriously about rock and roll before the summer of 1964, should have subsequently devoted his life to it. The qualities that Constant found in the ballet were those that Kit adapted and magnified in the band. Their performance required different forms of expression to be mingled; they combined excitement and variety within a loose structure of affections; they could be made to seem classless and unsnobbish; they permitted recklessness without damaging the prospect of riches; and they were challenging as well as popular. Within weeks of appointing himself manager, Kit felt that his inheritance had laid the foundation of what would be his success. According to Townshend, 'He hated the fact that Constant had been a great creative talent but had actually been a bloody arranger for the best part of his working life.' Fear of having to take an obscure back seat, as well as hopes of wealth, provoked Kit into hectic activity on the band's behalf.

His first move was to draw up a contract which put Gorden's to shame: since the members of the band were still under age, they had to obtain written parental consent – and did so without much struggle – to an

arrangement whereby every one of them was guaranteed a wage of £1,000 a year. On top of this, the band would split equally sixty per cent of their earnings – leaving the remaining forty per cent to be divided between Kit and Stamp (who turned themselves into a limited company, New Action). Since the financial risk that the managers had taken on seemed immense, the band thought that the forty per cent was reasonable.

In the early days of their management, Kit and Stamp had great difficulty supplying the wage promised in the contract. Stamp continued to work in films – *The Heroes of Telemark*, to start with – and sent the bulk of his earnings to Kit, so that they could be passed on. In spite of accepting loans from his friends (£100 from Daria for instance, and more from Lord Berners's friend Robert Heber-Percy), Kit spent 'in the next four or five months' everything that he had in the bank.

Some of this money had been saved while he had been working in films. The rest – about £5,000 – came to him more fortuitously, and his gratitude for it was darkened by a complicated sorrow. In the early spring of 1964 Amy died, at the age of ninety-two, and when her will had been proved, Kit learnt that she had left him the bulk of her estate. (The money, that is, which had continued to trickle through to her from George's dealer in Australia.) Since her return from Australia in 1929 – thirty-five years previously – Amy had lived a dull and straitened life, her income decreasing as George's reputation slumped, her pride in her children compromised as she watched Constant, her favourite son, destroy his health. Before she died she had seen his reputation slide as well. Maurice, at least, spared her pain of this sort, but in the last months of her life even he gave her grave cause for concern. His hard-working, childless life with Olga had a severity which George had taught Amy to admire, and its discipline seemed to have been rewarded by his election to the Royal Academy. But as her own strength faded she had to watch him suffer as well. Shortly before her death, she learnt that he had been diagnosed as having cancer of the rectum; a matter of months after her death, when only sixty-three years old, Maurice also died.

Amy had hardened herself against disappointment in old age by clinging to the styles and standards she had known as a young woman. But what had once seemed brave and diligent gradually started to appear stuffy and strict. The careless spirit of the Twenties, which Constant had done so much to clarify, made her look dull; the rebellious spirit of the Sixties, which Kit would shortly promote, alarmed her even in embryo. Pottering round her house in Peel Street, shopping in Notting Hill, going to Constant's concerts, scrimping and saving, worrying about her

indigent grandson, she seemed like a relic from a long-lost age, dressed in its dowdy clothes.

Amy's long life exerted a profound influence on three generations of the family into which she married, but always in a way which meant that she remained a shadowy figure. The pioneering bluestocking who had left Australia in 1900 had steadfastly sacrificed her own talents – to George, first, as a supportive wife and model; then to Maurice and Constant, as a mother seeking to sublimate her own disappointment in pride at her children's success; and finally to Kit, as an anxious, disapproving grandmother who did not live long enough to enjoy his brief and unpredictable rise to fame. She is the unsung and, by dint of her self-effacement, virtually unsingable arbiter of the family's fortunes: a brave, selfless ally to them all; a wise counsellor whose good advice was both needed and ridiculed by those to whom she gave it. However archaic, strait-laced and dull Kit felt her to be, he also knew that the rootlessness of his childhood would have been absolute without her intervention. She would have been appalled to know that her money made it possible for Kit to create one of the world's most dangerously violent rock and roll bands; but the fact that it did is entirely in keeping with the way in which her best intentions, even after her death, were out-manoeuvred by events.

With Amy and Maurice dead, Kit had only his mother and half-sister Annie to rely on for family love and support. (His Aunt Olga, Maurice's widow, was even more alarmed by Kit's choice of career than Amy had been. At her death, in October 1977, she cut him out of her will.) Yet while his mother's restless life in Chelsea had the sort of glamour he admired in his contemporaries, he looked on her with mingled pride and anxiety – pride at her still-startling, dark-haired, fashionably dressed beauty; anxiety at the volatile mixture of affection and hostility with which she viewed his life.

Kit's shortage of funds did nothing to restrain his plans for the band. Within his first few weeks with them, he changed their name to The Who, and continued to sharpen their image. This meant defining – by clothes, mainly – their relationship to the Mod audience, and manipulating that audience in other and less obvious ways. In order to preserve the role of *éminence grise* that he had designed for himself, Kit only slightly adapted his own style and appearance. He persisted in wearing dark suits, kept his hair trim, and cultivated his posh Oxford accent. The sense of physical inferiority which had dogged him as a child – his small size, and the disfiguring scar on his neck – was both masked and mitigated by his

increasing self-confidence. At last, he felt, he had found something to do which suited his intelligence as well as his recklessness.

Since the most successful exponents of the kind of rock and roll that The Who played were The Rolling Stones, Kit told his band to emulate The Stones. He advised them to copy their habit of running rather than walking onto the stage, and encouraged Townshend to elaborate a gesture that he had copied from Keith Richard: playing the guitar with a violent, stiff sweep of the arm. It was to become one of Townshend's trademarks. Simultaneously, Kit also recommended that The Who present a more complicated impression than The Stones. 'Our audience,' Townshend has said,

was a Shepherd's Bush-based bunch of dislocated boys. Kit studied it, and because he was a homosexual and the audience were ninety per cent boys, he picked up that the link between our audience and the band was a sexual one. He never mentioned it, but he recognised it, and used that piece of secret knowledge to make the band – in dress and manner – more androgynous. We treated our boy audience like thirteen-year-old girls.

The image the band presented was never in the least camp; it was, rather, designed so that the audience could expect the band to speak for their own sexual feelings. Kit himself later admitted, 'They have a direct sexual impact. They ask a question: do you want to or don't you? And they don't really give the public a chance of saying no.'

Since the early 1960s, it has become almost *de rigueur* for rock and roll stars to seem sexually ambiguous. But Kit's development of the idea was pioneering. He realised that performance had more to do with image than truth – Daltrey and Moon were married early in the band's career, and Kit suppressed the fact in order to avoid making them seem conservative and unavailable – and cunningly created a whole series of illusions to supplement this erotic one. 'Appearance,' he announced, 'is the most immediate concern', and accordingly made a promotional film of the band which was shown at the beginning of their gigs. In this film the band appeared to be living much more glamorously than was actually the case. Kit also appointed Mike Shaw as Production Manager, and encouraged him to devise special effects which now seem crude but were, at the time, revolutionary. 'We were the first group to have a Production Manager,' said Townshend. 'Mike ran a small light rig for us – just a couple of towers – but it made a hell of a difference. People were used to a single spot, or a naked bulb.' These means of making The Who seem sophisticated were offset by other devices which made them seem

unregenerately raw, and sympathetic to the latent frustrations of their Mod following. Over the years, the band's aggressiveness was to become legendary, and an essential, apparently spontaneous part of their act. Initially, at least, it was carefully nurtured by Kit. He converted their internal tensions – particularly the disputes between Daltrey and Townshend – into theatrical displays of disruptiveness. The most famous of these was Townshend's habit of smashing his guitar. One night late in 1964 at The Railway Tavern, Townshend discovered that if he banged his guitar against the ceiling 'it sounded great'. He did it again the next night, and the guitar broke. 'There were a few laughs, mainly negative reaction; everyone was waiting for me to kind of sob over my guitar . . . I had no recourse but to completely look as though I'd meant to do it, so I smashed the guitar and jumped all over the bits. It gave me a fantastic buzz . . . The next day the place was packed.'

Kit saw at once that this apparent disaster provided the band with a climax to their act. He encouraged Townshend to make it a regular event and recommended the others to join in. Moon was particularly glad to oblige: 'When I smashed me drums, it was because I was pissed off. We were frustrated. You're working as hard as you can to get that song across, to get the audience by the balls, to make it an event.' What seemed to Moon to be merely a personal release was interpreted and then promoted by Kit as something more general. The Who's destructiveness, he realised, perfectly illustrated the mood of their music. It combined a recognition of material values with a scornful disparagement of them, and provided a catharsis which was interpreted by the audience as an admirable scorn of conventions.

Kit also understood that this part of the band's act, while helping to make them notorious, was likely to wreck them. Buying replacement equipment was simply too expensive. After a short northern tour in the autumn of 1964 – Kit had inherited the schedule from Gorden – and the first of what became a regular series of concerts at the Marquee, in Soho, Kit had run up an overdraft of £60,000. 'We were getting £50 a night, and Pete was smashing guitars worth £200 and amps worth twice that.' The only way to avoid disaster, Kit saw, was to turn to yet another area of the music business in which he had no experience, but which offered the chance of enormous wealth: recording.

Four

Armed with copies of 'I'm The Face', and with tapes of The Who's gigs, Kit and Stamp visited London's major West End recording companies in the autumn of 1964. Only John Burgess of EMI, the home of The Beatles, showed any interest, but even he turned them down as soon as he heard the demos, on the grounds that 'We're only taking on groups that can write their own material.' No one in The Who had yet tried their hand at composition, largely because, as Marsh has said, 'Mods wanted original arrangements, not original songs.' When Kit explained to the band that they must start creating their own material, he caused considerable anxiety about which member of the band, if any, should take responsibility for writing, and thereby exacerbated the struggle for leadership. Whoever wrote the music, they all realised, would automatically dominate.

Townshend, who had already experimented in his studio at home with a few songs, was the obvious choice. When Kit urged him to continue composing, he did so with excited curiosity and remarkable fluency. 'I really like my first few songs because they were an incredible surprise,' he said later. 'Through writing, I discovered how to free my subconscious . . . I find writing fairly much an unconscious thing. It doesn't involve that much effort, so I don't need much stimulation. I really don't look round for it.'

It came as no surprise to Daltrey that Kit expected Townshend to become resident composer, but the discovery nevertheless infuriated him. The Detours had been, in the first instance, largely Daltrey's creation, and he felt that he understood their audience better than anyone else. He also thought that Townshend was both too ungainly to front the group on stage, and too outspoken to organise them off it. His opinion was based on more than the daily evidence of Townshend's personality. He also believed that he was the only sensible choice as leader because he was the only member of the band not taking every opportunity to pump himself full of drink and amphetamines.

Kit was well aware of Daltrey's feelings, but knew that he had to encourage Townshend to compose if The Who were to survive. Daltrey understood the necessity, but as the centre of power began to shift within the band Townshend's behaviour did nothing to allay his irritation. Townshend himself admitted, 'I took the band over when they asked me

to write for them . . . and used them as a mouthpiece, hitting out at anyone who tried to have a say in what the group (mainly Roger) said and then grumbling when they didn't appreciate my dictatorship.' When Daltrey saw that Townshend's new duties drew him increasingly close to Kit, he felt doubly excluded. For the next few years, his argumentative resentment continually threatened to destroy the band.

Unpopular as it was, this nurturing of Townshend ushered in one of the most creative passages in Kit's life, and one of the happiest. Ivor Court – scantily furnished, disorganised and untidy as it was – provided him with a home in which he could feel accepted and unthreatened as he had seldom done before. It was a ramshackle existence – everyone except Daltrey encouraging everyone else to drink and dope themselves up – from which he could exclude his mother's criticism by the simple expedient of not seeing her. He felt sure of Stamp's and Townshend's affectionate admiration for him, and confident that he could perform his duties for the band with flair and dynamism. While Stamp became increasingly involved in organising details of The Who's London appearances and tours, Kit concentrated on promotion and production of their music. He exposed Townshend to new musical influences, and advised him to steer clear of writing the sentimental boy-meets-girl love songs which were most bands' stock-in-trade. 'He educated me by encouraging me,' Townshend says, 'it's what made him a great mentor. He could see that I was at my best when I was dealing with my conscience. He'd never sneer at me for saying things which were pretentious, or which had been said before. In fact he'd actually align me with things which had been said before.' Many of these 'things' were ideas or symbols to do with questions of identity: the theme runs throughout his work, and reaches its climax in *Tommy* (1969). 'I'd play him my tapes,' Townshend says,

and it'd be one of the great joys I had to play him something and hear his comments. I'd produce four or five songs a week, and he'd come and listen to them and each would be framed in a new way, experimenting in my studio . . . that's when the conversations would begin; he'd talk about his father, his father's friends [Kit's stories about Constant were nearly all second hand, rather than eye-witness accounts], he'd recommend books to read, music to listen to – great think tank sessions. So when they stopped [in the early 1970s] not only did I lose my Svengali, I also lost all that catalytic stuff. I really missed it.

A matter of days after suggesting that Townshend should start composing, The Who had enough material to renew their approaches to recording companies. Rather than simply cart the songs around indiscri-

minately, as they had done with 'I'm The Face', Kit decided to use the contacts he had established over the last few months. His 'publicity officer', Anya, had a girlfriend who was married to the Chicago-born producer Shel Talmay, who had recently arrived in London and had already scored a huge success with The Kinks. (The Who had occasionally played with The Kinks on the club circuit.) When Talmay heard the tape that Kit took him of a song Townshend had written called 'I Can't Explain', he was immediately enthusiastic. 'They were the first band I'd heard in England who sounded like an American rock and roll band,' Talmay said. 'Funky. They were loud, raw, but they had balls. At that point in time, that was the most difficult thing to find, a really ballsy band. I loved them from the moment I heard them, and I said, "let's do it."' Kit was delighted, of course, but his pleasure was tainted by dislike for Talmay himself, and by the realisation that, when he signed the contract with Talmay, he made what Townshend called 'a really pathetic deal': 2½ per cent royalty, rather than the usual 4 per cent or 6 per cent. The Who had made their breakthrough, but in a way which guaranteed that trouble would soon follow.

The band went into Pye Studios to record 'I Can't Explain' in January 1965, with Talmay lined up as producer and Glyn Johns as engineer. In spite of Talmay's unexpected suggestion that Jimmy Page should replace Townshend as lead guitarist, and that The Ivy League should provide the backing (which, Kit said, produced a fit of 'screaming and shouting'), the session went smoothly. The only problem that Johns remembers was their volume. 'They were unusual to record because they were loud. No recording technique had been developed to record anything that loud.' What troubled the engineer pleased the managers: when the final version was ready, its message of adolescent angst was hardened by an angry delivery from Daltrey and driving support from the players. 'They fused,' said the *New Musical Express*, 'The Kinks' original heavy metal riff with the blocked harmonies of The Beach Boys.' Talmay sold the record to Decca – an American company who traded in England under the name Brunswick. It was released on 15 January 1965, and entered the top fifty at number twenty-eight.

Kit later told Daria that 'I Can't Explain' was 'the slowest climber ever'. After several weeks in the charts, it reached number ten, then slowly dropped away. It was a moderate success, but enough to create an interest in the band. The fact that its lyrics did not entirely conform to the standard sentimentality of pop songs (most of them, as Anya says, 'want to grasp your heart and your willy at the same time') gave it an edge of

originality which was welcomed by the disc jockeys on pirate radios. It also implied an intelligence in the band which Townshend, in particular, justified in interviews with magazines. When these magazines found that The Who's 'pop art' clothes made good graphic copy – Entwistle took to decorating himself with military insignia, Moon wore target T-shirts, and both Townshend and Entwistle wore coats made up from Union Jacks – they fell over themselves to carry articles and photographs. *Melody Maker*, for instance, ran a piece called 'The Price of Pop Art', in which the amount that 'the boys' spent on maintaining their image was grossly inflated. It subsequently became habitual for Kit to describe them as 'the first pop art band'.

Kit did more than perch the band on a wave of popular taste. He persuaded Vicki Wickham, the producer of TV's influential pop show 'Ready Steady Go', to hear The Who at one of their regular Marquee gigs, and when she booked them for a forthcoming programme, rigged the audience. Vicki Wickham gave him 150 complimentary tickets for the show, 100 of which he passed on to the hardcore of their Shepherd's Bush audience, who were known as 'the hundred Faces'. The sight of their euphoric response to The Who's appearance on 'Ready Steady Go's' 'Tip for the Top' slot convinced the public at large that they were watching a band who were already stars by common consent.

Like almost everyone else involved in rock and roll at the time, Kit believed that public interest would soon wane, and was anxious to capitalise on this early success as soon as possible. In order to create an impression of greater profit than they had actually made, he and Stamp moved from Ivor Court to a more stylish, central, spacious, second-floor flat in 84 Eaton Place, Belgravia, announced that it was the band's office, and installed Townshend in rooms on the floor above. 'He took me away from the decadence that was ours to the decadence that was his,' Townshend complained (meaning that Kit was 'bringing back boys and stuff'), 'but I didn't care.' Even Daltrey agreed that 'without Townshend the band would have been nothing', but in March, by which time Townshend had produced enough material for the band to consider recording an LP, Daltrey's jealousy had persuaded him that it should contain more cover versions of other bands' songs than original material. When the magazine *Beat Instrumental* discovered this and ridiculed the idea (the LP was to include Martha and the Vandellas' 'Heatwave', James Brown's 'I Don't Mind', and Bo Diddley's 'I'm a Man'), Kit decided to concentrate, instead, on releasing a second single.

The song he chose 'Anyway, Anyhow, Anywhere' (which was released

in May 1965) had several advantages. Its composition was credited to both Townshend and Daltrey, and therefore helped them to forget their differences at least for a while, and the quality of its demonstration tape was such that it would curtail Talmay's attempts to interfere with the production. 'Kit realised,' said Entwistle, 'that we had to be seen before people could begin to buy our records. "Anyway, Anyhow, Anywhere" was his way of taking a short cut. The intention was to encapsulate The Who's entire stage act on just one side of a single – to illustrate the arrogance of the Mod movement and then, through the [deliberate inclusion of] feedback, the smashing of the instruments.' Although The Beatles had used feedback on 'I Feel Fine', released in November 1964, it was still very rarely heard on records. Talmay himself liked the idea, but Decca returned the tape he sent them as 'defective'. It did not take long to persuade them to change their minds, and when the record was released on 27 May it rose quickly to number ten in the charts, stayed there for twelve weeks, was briefly adopted as the 'Ready Steady Go' theme tune, and provided the excuse for *Melody Maker* to run the headline: 'Every so often a group is poised on the brink of a breakthrough. Word has it it's The Who.'

On the face of it, Kit had achieved for the band, in only five months, the success they had always imagined would be theirs. But the veneer of wealth and creativity was laid thinly over a series of disturbing and apparently insoluble problems. The success of the two singles had come partly from genuine public recognition of their quality, and partly from extravagant promotion. Kit, for instance, always made a point of travelling around London in a hired Rolls-Royce, even when he knew he would have to put the bill on an account he had no hope of settling. As their reputation rose, so did their debts. 'At Eaton Place,' Kit said late in life, 'the bailiffs kept coming and going. I used to have a bust of my father's head [by Maurice] which I used to put down the loo and make Anya sit on top of it. She would have to sit there for ages. I used to say to her, "No. No. Make it look authentic. Take your knickers down."'

Impending bankruptcy was not their only worry. Townshend and Daltrey were still at loggerheads, and everyone at Eaton Place, apart from Daltrey, was egging each other on to become increasingly druggy. This provoked frequent outbursts of spectacular riotousness: Moon threatening Daltrey with an axe, havoc at gigs and at home, and regular, unaffordable spending sprees. The drugs' effect on Kit is immediately apparent in the photographs taken of him at the time. His face is puffy, his eyes are heavily ringed and his hair dishevelled. What his cousin Jenny

had referred to, during his childhood, as 'the Absell pout' had distended into full-blown sensuality. Kit's behaviour was self-protective, as well as defiant. According to Townshend, his more promiscuous drug-taking was matched by his increasingly active gay sex life. He was doping himself up, in fact, as a way of overcoming guilt about the tawdriness of bringing back rent boys to Eaton Place 'night after night. He tried to use all his energy and power and intelligence to divert himself sexually,' Pete says. 'It was tearing: fighting something he didn't like in himself, while knowing it was working very well for him.' Jonathan Benson agrees: 'He thought he was a desperately unattractive creature, physically [because of his size and his scar], and this obviously contributed to his desire to be physically abused. He thought that the only thing to do was to indulge to the point at which he appeared not to care.' Compared to Kit's behaviour in the 1970s, his life in the second half of the 1960s seems positively moderate. During the late 1960s his almost continuous use of drugs was confined, usually, to marijuana and cocaine; his sex life was rampant but not often kinky; and his work for the band was energetic and wholehearted. The effect of his over-indulgence was to exaggerate and dramatise both sides of his nature – the creative as well as the destructive. But the ways in which they nourished each other depended on a balance which could not last indefinitely.

The musical implications of 'Anyway, Anyhow, Anywhere' – that The Who thought of themselves as live performers first and as recording artists second – make it hardly surprising that Kit should have redoubled his efforts, after the single's release, to increase the extent of their touring. In the summer of 1965, their nightly appearances on the London club circuit were interrupted by a visit to Paris, to record a programme for 'Ready Steady Go'. They carried their reputation for mischief with them, and duly acted upon it. 'The show was going out live in both France and England,' Viki Wyckham says, 'and the time came for the finale. [As] the cameras . . . followed, recording the event – into the street go The Who, into the alley and all stop and immediately pee against the wall.' Typically, the commercial rewards of the trip were outstripped by the expenses incurred. When the time came to leave, Kit had not even got the money for the train fare home, and had to be bailed out by Parmeinter. It was an episode which mirrored their life in England. When they got back they found that the bailiffs had become so insistent that Kit was forced to shift the band's offices from Eaton Place back to Ivor Court. His stay there was a brief one; in November he uprooted himself again, this time to an even posher address: Cavendish Square, just north of Oxford Circus. The

move had commercial as well as domestic advantages: Robert Stigwood, the highly successful Australian booking agent, had a flat in the same building. He agreed – for £2,000 – to act for the band.

The decision to set up his headquarters in Cavendish Square turned out to be one of the luckiest of Kit's career. It coincided with Townshend's writing the song which gave the band the 'breakthrough' heralded by *Melody Maker*, at the same time as it put him closely in touch with Stigwood, on whom their fortunes depended. The song was 'My Generation', which Townshend had jotted down 'in the back of a car, without thinking' that autumn, after a meeting in which Kit had exhorted him to 'make a statement'. When Kit heard the first demonstration tape he told Townshend to 'make it beefier', to introduce two upward key changes (he stole the idea from The Kinks) and to use a stutter on the key chorus words 'f-f-fade away', 'c-c-cold' and 'g-g-generation'. The reason for the stutter was this: the personality portrayed in the song was supposed to be an archetypal pill-headed Mod – and amphetamines make their users stammer. It took two months for the song to reach its final shape (during which The Who toured Sweden, as well as continuing to play in London), largely because Daltrey disliked it and was fed up with the band's 'pill thing. I realised,' he said, 'how much the band had deteriorated through playing on speed.'

Stamp decided that the feuding had gone on long enough, and wanted to sack Daltrey. Kit, although at this time he was still working well and closely with Stamp, was more ambivalent. He liked Daltrey's voice, but agreed that the rows could not continue. He called a meeting of all the interested parties, and persuaded Roger to accept Townshend's pre-eminence and the other players' individual tastes. 'I was a bastard, a real cunt,' Daltrey said later. 'But then again, I sat down and thought, "well, the biggest thing in my life is the group". And I literally changed. Anything they ever did from then on never bothered me.' Townshend confirms that the change was sudden and absolute. 'Roger said: "From now on I'll be Peaceful Perce", and he did it. It was a lesson to all of us, if you like, that there is no need to always get your way. That the most important thing is to just stay together.' When The Who recorded 'My Generation' they proved, among other things, that the passionate frustration they wished to express did not need to be cultivated amongst themselves, but could be nurtured in harmony and then turned against the world.

'My Generation' was released on 5 November, entered the *New Musical Express* charts at number sixteen, jumped to number three the

following week, and eventually climbed one place higher before fading. It sold 300,000 copies during its time in the charts (in spite of – or because of – being banned, initially, by the BBC, who thought it ridiculed stutterers). For the first time, The Who had enough money to match the style in which they lived. Hard-driving rock and roll rhythms, and a crisp angry delivery were not the only reasons for the song's success. It revolved around a line – 'Hope I die before I get old' – which, like The Rolling Stones' line 'What a drag it is getting old', has been taken to express a crucial aspect of the Sixties. The song is furiously dismissive of the attitudes associated with the older generation, and proudly insistent about the value of their own youthful alternatives. What is proven, experienced and moderate is rejected; what is innovative, admittedly transient and intense is welcomed. Townshend, who has since been grilled about this line on many occasions, spoke for himself, the band and Kit when he said: 'We did mean it. We didn't care about ourselves or our future. We didn't even really care about one another. We were hoping to screw the system, screw the older generation, screw the hippies, screw the Rockers, screw the record business, screw The Beatles, and screw ourselves.'

However enthusiastically Kit went along with this in public, it was his business to make sure that The Who did not screw themselves too comprehensively. As long as they were tied to Talmay, it seemed to him likely that they would. The band's five-year contract with Talmay entitled them to a small percentage royalty and they were bound via him to Decca, whose penetration of the American market was weak. In December 1965, when the band recorded their first LP, also called *My Generation*, these dissatisfactions repeatedly turned into 'terrible arguments' – Talmay refusing to release the band from their contract, and abusing or ignoring Kit every time he met him. Kit's solution to the crisis was typically cavalier. In March 1966, when he had decided on The Who's next single – 'Substitute' – he simply broke the contract with Talmay, issued the record on the Reaction label (which had recently been established by their agent Stigwood, and was distributed by Polydor), and accepted an offer from Atlantic Records in America, negotiated by Stamp, of a £10,000 advance and a ten per cent royalty. Atlantic did indeed release 'Substitute', but it failed to make the American charts. When Decca threatened to sue for breach of contract, Kit and Stamp were happy to return to the fold, provided that Decca gave them an advance of over £17,000 and a 10 per cent royalty for American rights, and a clause which allowed them to function as free agents for the rest of the world.

In England, Talmay took them to court and won. The settlement agreed that for the next five years he would receive an override of 5 per cent on all Who recordings – which turned out to include *Tommy* (1969) and *Who's Next* (1971). In the light of this, Kit's decision seems disastrous; in fact, it was a gamble which paid off. The re-negotiation of the band's American contract, and the new deal they struck with Polydor in England gave them a better royalty rate than the 2½ per cent they had received under Talmay. The deal suited the managers far better than the players. Kit and Stamp retained their 40 per cent rake off, but each member of the band received only 1¼ per cent of the takings. This was better than the ¾ per cent of their original deal, but, as Marsh says, nothing like 'a fair share of the wealth generated by their recordings'. The arrangement helps us to understand the bitter resentment that The Who came to feel against Kit and Stamp. It also helps to explain why the band let live performances take precedence over recordings at this stage in their career. The popularity of 'My Generation' and 'Substitute' meant that they were able to charge between £300 and £500 a concert – only The Beatles and, occasionally, The Rolling Stones were paid more. As soon as their case against Talmay was settled, they toured knowing that their livelihoods depended on it – in England, throughout Europe, and in Stockholm, where they drew a crowd of 11,000 people.

The money the band made from their tour was not enough to clear their debts. By the end of the spring 1967, largely because of their extremely expensive stage act, they had unpaid bills worth over £30,000. Kit knew that this continuing impoverishment would either destroy The Who by forcing them out of business, or take them out of his control by attracting another and more soundly-based management. During the negotiations with Talmay, Kit and Stamp had already had to fight off attempts by Allan Klein, Talmay's friend and also The Rolling Stones' American business manager, to take control. Now Andrew Loog Oldham, The Rolling Stones' English manager, also tried his luck. Kit, appalled by the threat, and by the occasional sight of Townshend and Moon talking to Loog Oldham (who lived nearby), fended him off in a way which was both dramatically unorthodox and likely to inspire The Who's affectionate loyalty.

One day, to my horror, I saw Moon and Townshend stepping out of Andrew's [Rolls] with Brian Jones, all of them chatting conspiratorially . . . So when the boys got to my flat I drew my old service revolver, an enormous Colt Special, lined the boys against the wall, and asked what's up . . . Andrew with his white Persian

cat, tame joint roller and laced-up fly buttons was obviously impressing them, so I sort of cut in in no uncertain way. Next time I saw the Rolls arrive I jumped in, kicked the cat out of the way, and told him hands off or else.

The story is probably exaggerated, but Kit's decisiveness – whatever its exact nature may have been – did the trick. Andrew Loog Oldham left the band alone. This saw the end, at least for the next few years, of interference from outside but did nothing to assuage what Stamp called the band's 'profitless prosperity'. Touring, Kit realised, could only be really profitable if their reputation as recording artists was increased still further. With Talmay gone, he knew that he would be able to save at least a little money – and a great deal of trouble – by undertaking the production of records himself.

His lack of experience made him hesitate to accept the responsibility. 'Substitute', bridging the gap between Talmay and the unknown future, had been produced by Townshend, and so was The Who's next single, 'I'm a Boy', which was released on 26 August 1965, and their five-song EP 'Ready Steady Who', which followed two months later. The style of production on the new single and the EP unashamedly refers to lightly entertaining pop music, rather than to the more abrasive demands of rock and roll. The massed choirs at the beginning and end of the single powerfully recall the breezy gentleness of The Beach Boys – whom Moon and Townshend, in particular, admired – and one song on the EP was actually a cover version of 'Barbara Ann' which the Beach Boys had already recorded. Another song on the EP was an interpretation of Neal Hefti's theme tune for the TV show 'Batman'. The band's treatment of this second-hand material is strictly ironic. On 'Batman', for example, as Marsh says, they

wreak absolute havoc … Entwistle's bass carries the tune, Townshend and Moon weave chaos all around him. It is a throwaway performance, not two minutes long, yet it is hard to think of anything that more conclusively defines why rock had to change. The ominous growl of Entwistle's bass, the compulsive sting of Townshend's guitar licks, the ceaseless sizzle of Moon's kit, demand more content than this flimsy structure can give.

The implication is clear: The Who's indigency had brought them to a crisis of self-definition. They could think of numerous contemporaries who had made a success of performing blandly unadventurous pop music (Herman's Hermits, say, or the Dave Clark Five): were they to follow that road, and thereby save themselves from bankruptcy? Or were they to

exploit their impatience with what seemed safe and proven, and experiment in ways which threatened them with even greater financial disaster? Kit and Townshend, on whom the choice depended – Kit because he was Townshend's mentor, Townshend because he wrote the songs – had no doubts. They decided to go for broke: to increase the destructiveness of the stage act, force their audience to accept that a 'rock song' is, in Townshend's phrase, 'an artistic event', and concentrate on purer, and even more ambitious rock and roll.

The decision was only made possible by Kit's and Townshend's extraordinary rapport. 'Kit had this enormous output and exuberance that Pete certainly plugged into,' said one of their friends.

I'm sure he encouraged and excited Pete into a whole lot of things. Pete would suddenly come up with the idea and Kit would get enthused and take the thing a step further and say 'fantastic. Let's hire the whole world.' And gradually the thing seemed to snowball and escalate. And from a fairly firm idea you suddenly had a huge global plan emerging from Kit . . . and Pete thought, 'God, maybe that was a better idea than I thought.'

While The Who were recording 'Ready Steady Who', Kit slowly persuaded himself that he could take over as producer. 'He didn't slide naturally into the seat of production,' Pete said, 'he kind of arrived in the position . . . because we desperately needed a producer.' The task that he was expected to perform was ill-defined, with the result that his own (and other producers') contributions to the music of the 1960s has never been properly evaluated. In the earliest days of recording the producer was, as Marsh says, 'the recording company A and R man . . . totally responsible for matching the top performer with his songs, working out the arrangement, arranging all the pre- and post-production aspects of the record-making process.' Over the years, though, certain A and R men began working independently (Jerry Leiber, Mike Stoller, Phil Spectre, are famous examples), retaining their predecessors' responsibilities for controlling 'what transpires during the session itself: which of the available songs and musicians are used, what gets edited out, what's added', and 'making a technical contribution to the sound of a record'. Kit's dearth of studio experience meant that he had to adapt this received idea. Although he always worked closely with Townshend ('there was never any point when Kit knew more than I did about the mechanics of a recording,' Pete says), and was thereby guaranteed at least a modicum of expert help, he was anxious not to let it compromise the raw, direct sound he wanted the band to project. The disadvantage, it transpired, was that

his productions tended to be unfocused; the advantage was that they had, Townshend says, 'a real clangy sound . . . that was very much suited to the Dansette record player with the tin speaker and two watt amplifier'.

The band knew that Kit's greatest strength as a producer did not have much to do with studio equipment. 'The production of our records [had] got nothing to do with sound,' Pete told *Rolling Stone*. 'It [had] to do with trying to keep Keith Moon on his fucking drum stool and keep him away from the booze . . . it was to do with keeping me from fucking up on some other kind of dope . . . Kit was just keeping us from really fighting.' It was, in other words, Kit's skill as a manipulator and guide of talented personalities that The Who most valued. 'He knew the value of saying "right, there's too many takes, they're getting worse; everybody to the pub,"' Pete said:

[He'd] pick everybody up and take them out and perhaps not go back into the studio all night. You'd go home feeling terrible, and you'd think 'oh, we've had a terrible day and why did Kit take us out', but the next day you go in and do that track straight away because you built up to it overnight and you get this great recording. He knew about techniques like that; he knew human nature and he knew about The Who.

Kit's first accredited production was the band's next LP, *A Quick One*, released in December 1966. It is, as Marsh says, 'something of a hodge-podge' – but for interesting reasons. A few weeks before it appeared Kit had arranged for the band to sign a songwriting contract with the eminent firm Essex Music: the deal required that each member should contribute two songs to the next album. *A Quick One* was compiled accordingly, with Entwistle – in 'Boris the Spider' – and Keith – in 'Cobwebs and Strange' – contributing songs of genuine though limited charm. Entwistle remembers recording 'Cobwebs and Strange': Kit

had us marching in band formation around the studio because he wanted that going-away-and-coming-back sound. We were marching around this monitor speaker at one end of the studio which already had the bass guitar, drums and guitar track on it. Pete was leading, playing a recorder, me playing a tuba, Roger was playing bum notes on a trombone behind me, and Kit had strapped on two cymbals.

As this indicates, the most generous thing that can be said for Kit's production is that he was not driven into orthodoxy by his lack of experience. However uneven the quality of the LP's material, it is uniformly zestful. The most imaginative number of all is Townshend's 'A

Quick One While He's Away' — a saga of patience, unfaithfulness and forgiveness written to compensate for the fact that the first version of the LP was ten minutes short of reasonable playing time. Just as Kit had turned the deal with Essex Music to advantage by transforming Moon's, Daltrey's and Entwistle's inexpert compositions into amusing skits, so he also made the most of Townshend's filler. Kit announced to the press that it was 'the first rock mini-opera' — The Who's response to the taste for 'serious rock' which had recently been cultivated by such bands as The Doors (with 'The End'), The Rolling Stones (with 'Going Home'), Bob Dylan (with 'Sad Eyed Lady of the Lowlands'), and Love (with 'Revelation'). Despite Townshend's sparse story, and his song's lack of musical coherence, the press believed Kit. An LP which relied heavily on makeshift effects and gimmicky promotion was turned into an immediate popular success, and a prophecy. The sketchy drama of 'A Quick One' provided the framework for ambitions which were to flower, three years later, in *Tommy*.

No matter how fast Townshend turned out appealing songs, and no matter how furiously The Who toured England and Europe, Kit realised that these things alone could not turn 'profitless prosperity' into substantial commercial success. Analysing the problem, Kit told the journalist John Heilpern three years later, was 'simple', but doing something about it was another matter. Since The Who's recording company grossed as much as 500 per cent more profit than the band themselves on every single, they obviously needed 'to found their own record company'. Once again, Kit cultivated his innocence to overcome the complexities of the task. For two months he studied, he told Heilpern, 'the methods of biscuit and washing powder firms that marketed goods roughly the same size as a box of records . . . and [then] marched into the boardroom at Polydor — one of the biggest companies in the business . . . and offered them a partnership' in the company he wanted to found, Track Records.

Polydor, whose first breakthrough into the pop market had come when they took on The Who, were sympathetic but slow to commit themselves. They appreciated the financial wisdom of Kit's theory, but pointed out that he would only succeed if he were able to record big money-earners. Kit told them that he had discovered, in the famous central London club the 'Scotch of St James', someone who played 'staggeringly well', but who had yet to make a record: Jimi Hendrix. Polydor were unimpressed but Kit, by offering Hendrix a £1,000 promotional film for every record he made, an immediate appearance on 'Ready Steady Go' and substantial

advances on royalties, persuaded him to sign. When Polydor released Hendrix's first single, 'Hey Joe', on 16 December 1966, it climbed quickly to number six in the charts, sold 100,000 copies within the next few weeks, and convinced Polydor that they should formalise their partnership with Track, who would release Hendrix's records thereafter. The arrangement counted as one of Kit's greatest triumphs for Track: although he handed over most of the work on Hendrix's records to other members of the office, the label benefited enormously from his success. Along with The Who, Hendrix created an image for Track which was outrageous, threatening and recklessly inventive.

The business side of rock and roll, because it does not have the appeal of performance, remains a neglected aspect of pop history. Founding Track, though, deserves to be seen as one of the most important moves in Kit's career. For almost the first time his mother – the little-visited but highly-esteemed barometer of his success – was unambiguously impressed. 'Oh yes,' she said later, 'I was very proud of him all right. Even though I was worried about some of the things they were getting up to.' On the one hand, running the label increased Kit's overheads enormously: he set up offices at 58 Old Compton Street in the heart of Soho, and in the first year (1967) spent £8,000 on travel and entertainment, £5,000 on telephone calls, £6,000 on offices, £5,000 on promotion in America, £16,000 on wages and £20,000 on advertising. On the other hand, he succeeded brilliantly in discovering new stars who made the expense worthwhile. The Who and Hendrix were eventually joined by, among others, The Crazy World of Arthur Brown, Marsha Hunt, and Thunderclap Newman.

In Track's first nine months it had seven records in the top ten, and by 1970 it had cornered 6 per cent of the entire British market. The label carried the free spirit in which rock and roll bands had initially formed into a part of their lives which had previously been subservient to established commercial conglomerates. It was a revolution in the means of production, brought about by a revolution in taste, and set a precedent which other bands – often preferring to keep their music thoroughly in their own control – have subsequently turned into standard practice. It also, as Tony Palmer has said, brought about a radical change in standards, as well as organisation. Stamp and Kit 'have begun to revolutionise the recording industry,' Palmer wrote in 1970, 'by demonstrating that quality alone counts. With careful promotion and devoted musical production, quality can bring its own rewards . . . Technically, they were already in the future. While everybody talked about making

stereo singles, Track actually did it. Jimi Hendrix's singles, although the label never admitted it, were in stereo.'

For the first time in his life with The Who, Kit was making money. Track's net profits after its first year of business were £30,000. But while Kit's ignorance of orthodox practice helped to bring him success, it also created problems, and in the years ahead these were to become acute. When Kit moved The Who to Track, he gave them a contract which entitled him to make a profit from their recordings over and above the slice he already took as manager. At the time, the band did not care, thinking that since the label was his idea he was entitled to benefit from it. None of the money he made was hoarded, but spent – often on drugs, drink, boys, cars and parties – with a casualness which indicates that he took it from the band without any criminal or exploitative intentions. 'Money,' Marsha Hunt shrewdly says, 'wasn't respected as a commodity. Having nice things in one's home wasn't important. People wanted to sit on the floor, and you bought a mansion in the country simply because it had lots of rooms for people to come and use as a crash pad. You didn't buy it because it was truly a fine piece of property.'

As the years passed, and the happy-go-lucky spirit which pervaded rock and roll in the 1960s was replaced by something more worldly-wise, Kit's carelessness was judged more harshly. What Marsha Hunt called his 'decadence of spirit, which was thrilling if you were at the right end of it' came to seem greedy, self-serving and wilfully improvident. It provoked angry accusations even from those who had once enjoyed it. Dave Ruffell, for instance, who worked in Track's publicity department, came to deplore Kit's fecklessness with money ('he'd take, like, £400 in petty cash every Friday night'), and with other people's time ('he'd never even show up for an appointment'), and to despise his self-destructiveness:

He was a man that some days was quite mad. Any pill you put in front of him he'd grab and swallow. It was mainly downers. They made him fall asleep all the time. Often when he was smoking. I used to take his clothes to the laundry and they were full of holes. His house was always in a mess too – not that he had many possessions. (Once I helped him move flats and all he had went into two suitcases.) In the end it was awful. Absolutely diabolical. My respect for him just dwindled away.

In the same month that Kit founded Track, he and Stamp arranged another breakthrough for the band: their first tour of America. Most of the preparations had been handled by Stamp, whose management of The Who's American affairs thereby became – and remained – more

influential than Kit's. Henceforth, he spent an increasingly large amount of time in the States. Stamp had arranged the initial deal with Decca, and had also hired their booking agent, Frank Barsalona, at Premier Talent. Barsalona was one of the most powerful agents in America – he had dealt very profitably for Herman's Hermits, Freddie and the Dreamers, and some of Micky Most's bands – but took an instant dislike to The Who because his partner, Dick Freedberg, and not he himself, had signed them up. Barsalona thought that Stamp had presented him with a *fait accompli*, and as far as he was concerned, The Who's reputation in America was worse than simply small. It was bad. They were violent and ugly, and their American recording company was only slowly adjusting to the rock and roll market. Their initial English success, furthermore, had depended on a loyal following – the Mods – for which there was no American equivalent. Worse still, those of Townshend's lyrics which were construed as entertaining social comment in the old world ('I look all white but my Dad was black', for instance, from 'Substitute') seemed unpalatably controversial in the new world.

But Barsalona was too astute to let these things blind him to The Who's potential. He was well aware that the band's image and attitude were similar in several respects to those of other English groups like Cream and The Yardbirds, which had recently created a successful second wave (after The Beatles) of the so-called British invasion of America. The Who had already been featured on American TV a number of times, usually in extracts from films of 'Top of the Pops' or 'Ready Steady Go', and public reaction suggested that the task of promoting them would be far from impossible. By the time The Who arrived in New York on 19 March, to be greeted by 1,000 screaming teenagers who had been rounded up by Stamp and grouped under a ten-foot banner saying I LOVE THE WHO, Barsalona had moderated his initial anger with Freedberg.

Barsalona's first deal for The Who, and the foundation of their American market, was the result of luck as well as judgment. Shortly before the band arrived, the influential American DJ Murray the K had been planning his forthcoming annual stage show at the RAO Theater in New York, and had hired a number of bands, including Cream, through Premier Talent. Barsalona (with mixed feelings) was able to include The Who in this package for a fee of £1,800. At rehearsals for the show the band horrified Murray the K – smashing their equipment, letting off smoke bombs, bullying him about his wig and, as Townshend put it, 'giving him a bit of a bashing . . . we used to actually get daily lectures from him about abusing his personal microphone'. But The Who's

appearances on the show, which ran from 25 March to 2 April, created a sensation which made them, as Marsh says, 'the talk of New York's rock world'.

Al Kooper, a session man who had worked on Dylan's 'Like a Rolling Stone', also appeared on the programme. When 'they launched into "My Generation",' he says,

you could feel it coming. Keith Moon flailed away on those clear plastic drums and it seemed like he had about twenty of 'em . . . Pete Townshend ('he's God in England,' Eric Clapton said to me before they went on) leaped in the air, spinning his arm wildly . . . Roger Daltrey broke a total of eighteen microphones over the full run of the show. And John Entwistle would just lean up against his amp taking it all in . . . I realised my heart was beating three times its normal speed. I figure, as a critic of that show, my electrocardiogram was the best testimonial I could have offered.

The Who's act made their reputation: 'Happy Jack', the single they had released in England in December 1966, reached number twenty-four in the American top forty and sold 300,000 copies. But the wildness they carried with them offstage created havoc, and prevented their earnings from reaching their pockets. In the Drake Hotel, in the first few days of their stay, Moon and Entwistle ran up a bill which exceeded the band's entire payment for the Murray the K show by ordering tray after tray of caviar and lobster, and crate after crate of champagne. When the band moved downmarket to the Gorham Hotel, Moon wrecked his room, and they were thrown out. Kit was later to tell Tony Palmer that on subsequent tours the difficulties of finding the band any hotel accommodation at all was only solved by checking into rooms which the owners needed an excuse to decorate. It was precisely the sort of response Kit expected and wanted: all sociable considerations were swallowed up in his enthusiasm for publicity, and all theoretical justifications (of challenging received convention) were drowned in outrageousness. In the remarks that Townshend made to the press before leaving New York (wearing a jacket covered in flashing lights), Kit's controlling spirit is clearly apparent. 'We want to leave a wound,' he said.

The tour created massive 'profitless prosperity' for the band, but also brought an enormous audience within their sights. No sooner had they left America than they consolidated their European reputation. After a two-week tour of Germany they recorded, in May 1967, a new single, 'Pictures of Lily', which *Melody Maker* judged 'the best they have ever done'. The song's lyrics were designed to shock – they dealt with a boy's

masturbatory fantasies – but its cunningly sweet melody helped it to slide past the English censors and climb to number four in the charts. In America, where it was banned on many radio stations, it only reached number fifty-one, in spite of the fact that the band returned to the States in the same month as it was released to play at the Monterey Pop Festival. As far as The Who were concerned, Kit's only contribution to this performance – and to the short tour of Detroit, San Francisco and Ohio which preceded it – was a rare moment of financial caution. He would not pay for them to take their own equipment over to America, with the result that – according to Entwistle – they 'sounded absolutely crummy' at Monterey. (Entwistle's anger may have been fuelled by the fact that they were playing on the same bill as Hendrix, who had stolen Townshend's guitar-smashing trick. 'He's so fucking great, who cares,' was Townshend's reaction.)

Once the band arrived on the west coast, any savings that Kit had managed to make were rapidly wiped out by their contact with the San Francisco drug scene. The band (except for Daltrey), their hangers-on, Stamp and Kit all hurled themselves into an orgy of decadence. When not dosing themselves with LSD, they consumed large quantities of the more powerful STP. 'We took some on the plane home,' Townshend says. 'It was bloody terrible . . . Eventually it trailed off and then you get like, instead of a week's lovely planing out, nice colourful images, you get about a week of trying to repiece your ego, remember who you were and what you are and stuff like that. So that made me decide to stop taking psychedelics.'

The experience was an appropriate preparation for their life in England. Immediately before they had left for Monterey, three of The Rolling Stones (Jones, Jagger and Richard) had been arrested in London on drugs charges. On 29 June Richard was sentenced to a year in prison, and Jagger to ninety days. Even the more conservative sections of English society were amazed (*The Times* printed an editorial headed 'Who breaks a butterfly upon a wheel'), and the rock and roll confederacy was scandalised. Kit, in order to raise money for The Rolling Stones defence fund, and to keep their music in the public eye, suggested that The Who should record The Stones' songs 'The Last Time' and 'Under My Thumb' – even though Entwistle had recently got married and was away on his honeymoon. In just over a week, the tracks were recorded, and released the same day that The Rolling Stones' sentence was overturned. The energy of Kit's support for the scheme is revealing. In a newspaper advertisement explaining the band's motives he objected to the fact that

Jagger and Richard 'have been treated as scapegoats for the drug problem'. What he meant was not that he wanted to raise money to help cure drug abuse, but that he wanted to establish ways of getting drugs more generally accepted.

As soon as their cover version of The Rolling Stones' songs were released, The Who returned to America for a seven-week tour that Barsalona had arranged. They shared the stage with Herman's Hermits and The Blue Magoos. Once again their destructiveness kept pace with their rising reputation. Tom Wright, an assistant on the tour, remembers that even at gigs packed with Herman's Hermits' fans, The Who's twenty-five minute set would 'spellbind' the audience and end with the band devastating their equipment. 'A lot of times there was no clapping whatsoever, just dead silence. People in the front rows were just sitting there with their mouths open – stunned.' As had been the case in New York, their act created a notoriety which Kit knew would be good for sales.

The tour provided a model for many others which were to follow – performances were unfailingly violent, and their behaviour offstage outrageous. Moon's twenty-first birthday party, which was held at the Holiday Inn, Flint (it was actually his twentieth birthday, but he lied in order to be able to drink legally in every State) is typical. When the hotel manager complained about the noise, Moon threw a huge birthday cake at him and then, according to Nancy Lewis (their American publicist), ran amok. 'Keith grabs a fire extinguisher off the wall and races outside and starts shooting foam into any cars that had open windows. You know, SWOOSH, and these Cadillacs and that were filled with foam.' Eventually she chased him inside, where he threw a lamp at her, then followed him out again to the swimming pool. 'He backed on to the diving board, yelling and shouting "That was a lousy birthday party, I've had enough," and then he just turned round and dived into the pool. Only there wasn't any water in it at the time and he landed on his face. Thump. Blood all over. Knocked his front tooth out. Just right off. Clunk.' Kit spent the next twenty-four hours trying to tidy up: getting Moon to a dentist at three-thirty in the morning, signing cheques to the hotel and to car-owners for 'tens of thousands of dollars', calming down the police, and flying the 'wrecked' band to their next venue.

Because of the deal they had struck with Talmay, live gigs were The Who's only source of substantial revenue. But their audience needed to hear new material. As soon as the band returned to England on 16 December, Kit booked three weeks' worth of recording time, and within a

month – on 4 December 1967 – a new single, 'I Can See for Miles', was released. It was the most sophisticatedly exciting single they had produced – built, as Marsh says, 'around drones and crescendos, Townshend's guitar figure circling Moon's cymbal splashes'. Kit's production, too, is crystalline: the drumming is sharper than he usually managed to make it sound, the bass is restrained, and Townshend's guitar exact. Townshend himself had no doubt about the value of Kit's contribution. Although he was disappointed that the single climbed no higher than number ten in the *New Musical Express* chart, he recognised it as 'the ultimate Who record'. American audiences agreed. When the band toured North America in the last three weeks of October, the song at last brought them the breakthrough they wanted, climbing to number nine in the Billboard chart. Moon, who was required to maintain their reputation for havoc, lived up to expectations by packing his drum kit with flash powder for an appearance on the coast-to-coast Smothers Brothers TV Show. The explosion, when it came, was spectacular: according to Richard Barnes, the author of *The Who: Maximum R & B*, it deafened Townshend for a week and caused Bette Davis, who was also on the show, to faint into Mickey Rooney's arms.

In November, shortly after 'I Can See for Miles' came out in England, The Who released an LP – *The Who Sell Out* – which contained other material recorded during their recent stint in the studio. The album provides a useful means of gauging Kit's recent achievements. In 1967, since the foundation of Track, his management became ostensibly more controlled and certainly more self-contained. The year also brought, with their American tours, their first substantial profits. The image that Kit had helped to create for the band showed every sign of weathering the changes of taste and fashion which swept through rock and roll at regular intervals. As the band's appeal broadened Kit discouraged any further reference in words or dress either to the Mods or to pop art. But as *The Who Sell Out* flagrantly demonstrates, Kit's word about pop art was not his bond, and the discrepancy worked greatly to his advantage. The LP was described by Nik Cohn in *Queen* as 'a pop parallel to, say, Oldenburg's Hamburgers or Andy Warhol's Campbell Soup cans'. The tracks were linked together by jingles used on Radio London, and the cover showed each member of the band interpreting one of these commercials: Moon with a giant tube of Medac, Townshend with a vast stick of Odorono, Entwistle modelling for the Charles Atlas course, and Daltrey sitting in a bathtub full of Heinz Baked Beans.

In an interview given shortly after the LP appeared, Townshend

described it in a way which clearly reflected his wishes to produce an album which was resolutely itself, and yet able to get the best of every available world. The appeal of pop art, he implies, was not confined to one particular section of the pop audience – it could reach out to hippies, advocates of psychedelia, traditionalists and progressives, and it could clothe the social comment of his lyrics in the trappings of pure entertainment. Compared to *The Who Sell Out* even *Sergeant Pepper* (which also appeared in 1967) seemed to take itself too seriously. 'We wanted to lighten the load of the pressures which are facing people,' Townshend said. 'On the one side there's the psychedelia and on the other there's the boredom of the ballad singers. So we came out with an absurd album of melody and humour. Pop music should, we think, be understandable and entertaining.'

In order for Townshend's aims to be realised, he and Kit tried to prevent the band's life off-stage from compromising their professionalism in the studio. Kit, who according to Townshend was still 'practising' record production at the beginning of 1967, was conscientious and expert by the end. The value of his contribution depended on his maintaining a complex and precarious balance. The damage that he was inflicting on himself with drugs and drink was considerable, but it licensed the imaginative freedom which was indispensable to The Who's development. During the following year this balance was to produce its richest reward: almost exactly twelve months after the release of *The Who Sell Out* the band started to record *Tommy*.

Five

Because Kit had always regarded The Who and their hangers-on as a surrogate family, his contact with actual relations had become increasingly sporadic throughout the late Sixties. He dispatched occasional presents to his half-sister Annie – who was now in her mid twenties, had changed her surname to Lambert (thereby giving herself the same name as George's mother) and was beginning to carve out for herself a career as an actress. Though considerably taller than Flo, and fair haired, she had inherited Flo's delicate fine-featured looks, and her elegance. Years later she was to win public acclaim for her portrayal of Zelda in a TV life of Scott Fitzgerald.

With Flo herself, Kit was both more generous and more reserved. His success with Track had done little to moderate the awkwardness he felt with her, and on his visits to see her he still oscillated between loving admiration for her beauty, fear of her criticism of his chaotic life and his homosexuality, and compassion for her circumstances. The handouts she received from Peter Hole, her former husband, and the money received from her repeated redecoration and sale of flats, scarcely matched the style in which she lived. Occasionally she had to take up jobs she considered undignified; she was, for a spell, the cook in André Deutsch's publishing offices. Because she inspired such contradictory feelings in Kit, he preferred to keep his visits to her few and far between, and to mollify her by giving her presents. In the Seventies, when *Tommy* had made him rich, he bought her a flat in Fulham. She was, of course, grateful, and proud of what she considered his triumph. But she was alarmed that it should be inseparable from destructive qualities which so strongly resembled Constant's. For both men boredom always coincided with the achievement of their ambitions.

Kit was quite well enough acquainted with the shape of his father's life to know the similarity between their temperaments, and the dangers implicit in them. Early in 1968 an episode occurred which shows both his apparent carelessness of his family and his obstinate fascination with it. He accepted a two-week booking for The Who to tour Australia – where Mod was a fashion – with the Small Faces, Manfred Mann and Johnny Walker. Professionally, the tour was a disaster: Townshend hit a journalist as soon as they arrived, and when a stewardess on an internal flight later accused the band of assaulting her, the press furiously hounded

them. At the end of the month, after they had moved on to New Zealand, the journal *Truth* announced: 'We really don't want them back again. They are just unwashed, foul-smelling, booze-swilling no-hopers.' When they were in Sydney Kit undertook some private business to satisfy (or rather, partly to satisfy) his curiosity about his grandfather. He declined the chance to visit George's grave in South Head Cemetery, but he did go and see his work in the Art Gallery of New South Wales. George's paintings and Kit's music seem, on the face of it, irreconcilably distanced from one another, but the attitudes which informed them (the hatred of pomposity, the dislike of elitism) were similar.

The month after The Who returned from Australia they left England for America again, for a tour which was initially intended to last three weeks but was eventually extended by Barsalona to nine, and took in Boston, Detroit, Chicago and San Francisco as well as New York. In New York, in the Gorham Hotel, Moon began where he had left off on the band's first visit. He blew up the manager's wife's room. In subsequent hotels, Marsh records, Moon

would create elaborate, almost artistic chaos. Once he nailed all the furniture to the ceiling in the same order as it had been on the floor. Or he would unscrew cabinets and pry them apart. Or pour Catsup in the bathtup and buy plastic limbs from joke shops to stick out of the 'gore' and frighten the maid. Moon could even be philosophical about his destruction. 'In my opinion, Americans would be far better off if they just gave every aggressive person a drum kit or a guitar to smash about and let 'em get rid of all the frustration that way.'

As a 'philosophy' this is plainly ridiculous: the aggression of the band's initial performances, which had been a well-aimed challenge to rigid social constraints, had degenerated, off-stage, into pure destructiveness. This change had been made possible, in general terms, by the extraordinary degree of licence given to successful rock and roll bands as the representatives of the young and commercially exploitable generation. In more local terms it arose from the fact that Moon had isolated and adopted the crazier aspects of Kit's personality (just as Townshend had adopted the more intelligent aspects), and, like his mentor, now had enough money to indulge them on a grand scale.

Tony Palmer, who interviewed the band on this tour, was rightly struck by the lead that Kit gave them. 'His life was spent looking for those situations in which he would be pushed, physically, emotionally, psychologically, to the brink . . . He loved brinkmanship and if you think of Constant, the same was true of him. He lived on the edge of what to other.

people would be a precipitous and dangerous existence.' Kit himself admitted that on this tour he went to 'drugs parties [which] knocked the Boston tea party into a cocked hat . . . The drugs – it was like drug of the week, all with names like New Bands or Movies. Son of Iceberg, Masked Purple, things like that.'

Palmer also saw that Kit's love affair with risk had another and more valuable aspect. It made him tirelessly inventive as a manager and producer:

He was thoroughly modern . . . The Who's first bus in England, and their chartered planes in the States were among the first used by any band . . . They were among the early pioneers of multi-track recording. Even 'Sergeant Pepper' was recorded on four track, but The Who recorded on twenty-four track after their initial success. Pete is still hooked on every sort of mechanical ingenuity, and I'm sure he owed it to Kit . . . Like Constant again, Kit had a very sure instinct for the . . . age in which he lived . . . It's almost inevitable he ended up as the manager of a rock and roll group, because that was a curiously modern phenomenon.

Palmer sensed impending disaster when he met Kit. As soon as the band returned to England in the spring of 1968 (they went back to the States in June for another nine-week tour) it looked as though it might come sooner rather than later. The Who's recent successes had bred complacency, and their drug-taking had made them more than usually disorganised. In June they issued a trivial single, 'Dogs', which even Daltrey reckoned came from 'a real self-indulgent wanking-off period which didn't work'. Moreover, the tensions within the group once again threatened to lead to a breakup. Moon even went so far as to appear on Jeff Beck's album *Truth*. In an attempt to repair the damage done by 'Dogs' (which only reached number twenty-five in the charts) they released, in September, a song from the 'Pictures of Lily' period, 'Magic Bus', but this too only reached number twenty-five in the charts.

The band's sense of decline was emphasised still further by American Decca's deciding to release, also in September, an LP which in title – *Magic Bus: The Who On Tour* – and in presentation – the band climbing on board a bus – suggested a collection of live tracks. In fact, as Marsh says, it was an assembly of 'whatever had been lying around'. It included tracks from the 'Ready Steady Who' EP, and three Entwistle numbers, and it was justifiably criticised. The *San Francisco Express Times*, for instance, complained: 'There are over a dozen fantastic cuts by The Who that have never been released on American LPs. We could have had a classic record.'

These failures were Kit's responsibility, but they were not entirely his fault. Neither were they – in view of his other commitments – altogether surprising. During the second half of the year, most of his time and creative energy had been devoted to planning *Tommy*. In the early 1960s the audience for rock and roll, encouraged by pirate radio, had spent the bulk of its money on singles. But by 1968 the sale of LPs had outstripped that of singles, in America as well as England. In America LPs had come to represent 80 per cent of recording revenue. Marsh explains the reason for the change: it reflected, he says, 'the increasing importance of underground rock and the ultimate economic importance of the hit record. Touring could take one only so far, but the potential impact of a record – which could go into homes in which nobody would ever consider entering a rock hall – was almost limitless.' One might add to this that the young people who had been the first fans of rock and roll singles in the early 1960s had, by the end of the decade, reached an age at which they could afford LPs.

Several groups had already responded to this development by making 'concept' records which would not previously have been considered commercial – The Beatles, most famously, with *Sergeant Pepper*, but also The Moody Blues, The Pretty Things and The Small Faces. Kit's background, and the interests he had inherited from Constant, meant that he was able to follow the lead given by these bands with a better sense of its artistic possibilities. It had been obvious since 'A Quick One' (December 1966) that he wanted Townshend to write on a scale which would make rock and roll seem capable of developing themes normally reserved for more highbrow musical traditions. He now encouraged Townshend more specifically. He suggested that Townshend should develop a coherent narrative, and combine the social sense which had always existed in his songs with a more direct address to personal preoccupations. In particular, he wanted Townshend's recently-acquired interest in the work and teachings of the Indian Guru Meher Baba to be included. Townshend, for his part, was anxious to find a way of creating an LP which demonstrated The Who's strengths as live performers. The tracks, he felt, should not extend the narrative if it meant sacrificing the concentrated energy which was associated with singles. Early in 1968 he had said that he wanted to write 'a series of songs that flashed between my point of view of reality and the point of view of illusion as seen through someone on the spiritual path, a young boy.' This scheme was quickly discarded in favour of 'a series of rock singles, or "cameos"' which would 'tell a story when heard one after another'. Kit insisted that this would lack the necessary element of drama.

The help that Kit gave Townshend in formulating ideas cannot be overestimated, as Townshend himself realises: 'It really is the most incredible thing that after two years of brainwashing himself into being a producer of singles for top ten radio play, Kit actually turned his brain inside out and came up with rock opera. Enigmatic paradox. But good thinking for a group who stopped getting hits.' The more actively Townshend responded to Kit's encouragement, the more tempted he was to become pretentious. It was something that Kit, who had inherited his father's views on this fault, ruthlessly checked. As Townshend slowly accumulated the songs which were eventually to comprise *Tommy* – by May 1968 he was able to tell *Melody Maker*, 'the theme is about a deaf, dumb and blind boy who has dreams and sees himself as ruler of the Cosmos' – Kit ridiculed his more extravagant flights of fancy, argued for a coherent narrative, sifted the material Townshend brought forward, and told him that the music should not simply carry the story, but actually embody it. In an interview given during the summer, Townshend said: 'The deaf, dumb and blind boy is played by The Who, the musical entity. He's represented musically, which begins the opera itself, and then there's a song describing the deaf, dumb and blind boy. But what it's really about is the fact that because the boy is deaf, dumb and blind, he's seeing things basically as vibrations which we translate as music.'

The story that Kit and Townshend evolved is significantly at odds with Townshend's rather ethereal rhetoric. 'Tommy' is the deaf, dumb and blind child of a violent father and a 'precious' mother, whose early years are repeatedly interrupted by invasions from society at large – most memorably when he is 'fiddled with' by his perverted Uncle Ernie. A doctor who tries to release Tommy from his enclosed world is only partially successful: Tommy's escape from himself has to be engineered from within. He broods on the one sound he has heard, his own name, and on the image he sees of himself in a mirror. While this gives him a sense of identity, it also provokes an introspective narcissism which frustrates still further his desire to communicate with others.

The means by which Tommy eventually overcomes this barrier is (naturalistically speaking) implausible, but licensed some of Townshend's most expressive writing. Tommy becomes a pinball wizard – so brilliant at playing that he attracts a huge cult following, uses his fame to peddle the ideas about spiritual wisdom that Townshend had acquired from Meher Baba, and is eventually cured of being deaf, dumb and blind. His cure, however, involves him in admitting that the experience of his

own release is valueless unless his followers can all achieve self-realisation too. 'When it came down to it,' Townshend said in 1975,

what I thought was so incredible about that was that here he was, he was still the same guy, he was still God-realised and all that, but this was now the pain, if you like, and the remoteness and the loneliness and the frustration, plus being God-realised. In other words, Now I've done it, but now I've got to have the patience and the love to drag the rest of humanity through it . . . Deep down inside of every human being is this feeling that nothing is ever going to be complete, that the circle will never connect, and that that in itself is the secret to infinity.

It is easy to imagine Kit's impatience with this well-intentioned speculation – even though he tried to make the best of it. '*Tommy* is just like grand opera,' he once said. 'It's incredibly difficult to follow the story.' In practice, he realised as soon as the band started to record that his job was to keep the songs clear, solid, and clustered round the story's core. This core, he understood, was Townshend's long-running battle with questions of identity – in particular, the question of how a private individual relates to the public world. Kit's confidence in the studio was boosted by the knowledge that his upbringing meant he could advise the band with more authority than he had been able to provide on previous records. It was, for instance, Kit's idea to open the opera with a formal overture, and Townshend admitted that Kit was, throughout, 'much more involved in the overall concept . . . than people imagine', and that he helped him work out 'the sociological implications, the religious implications, the rock implications'. Kit even wrote a script for the opera, which he had printed so that the story would not stray into abstraction.

Short of writing the songs themselves, Kit could not have done more to give *Tommy* its final shape. But his approach was not without weaknesses. In spite of his indispensable energy – which kept a notoriously argumentative band coherent for a remarkably large amount of studio time – there were some areas in which he needed Townshend's guidance. Initially, Kit wanted to justify the idea of calling *Tommy* a rock opera by over-dubbing an orchestra. Townshend persuaded him not simply to moderate his opinion, but absolutely to change his mind. Townshend's piano and organ playing, and Entwistle's French horn, were the only sounds added to the band's usual array, and the recordings were, Townshend says, 'deliberately mixed' to sound 'fairly laid back . . . with the voices up front. The music was structured to allow the concept to breathe.' Entwistle was critical of this: 'The drums always seemed to sound like biscuit tins,' he said, and it is undeniably true that the record of

Tommy, compared to *The Who Sell Out*, sounds flat. The blame for this must lie with Kit: he was more interested in capturing what Barnes called 'the musical essence' than in producing the best possible technical quality.

Although this aspect of Kit's production slightly damaged the reputation of *Tommy* on record, it did nothing to injure its impact in performance. Throughout late 1968 and early 1969 The Who continued to punctuate their studio work with live gigs – they performed 'A Quick One' for The Rolling Stones' TV rock and roll circus in December – which frequently included material from the opera. The musical papers were instantly impressed, and their enthusiasm became even greater in March, when 'Pinball Wizard' was released as a single. It reached number nineteen in the American charts and number four in the English charts, where it stayed for thirteen weeks. Two months later, on 23 May, in a sleeve designed by Townshend's friend Mike McInnery – who was also a follower of Baba, and who emphasised the story's spiritual aspects – *Tommy* itself was released. On publication day The Who were in America, but they gave a preview performance for the English press at Ronnie Scott's club the week before leaving – playing at what Marsh called 'their usual Blitzkrieg volume'. Chris Welch, of *Melody Maker*, claimed that 'scores of people left literally deaf', but no one had any doubt about the value of what they had experienced. 'Who's *Tommy* a Masterpiece,' said the headline of *Disc*.

Tommy was received just as enthusiastically in America, where the band began their tour at Detroit on 9 May. During their first two weeks the LP sold 200,000 copies. By August, when they returned to England, the figure had reached 500,000. The effect of performing the opera (American critics disputed the use of the word more vigorously than their English counterparts) revolutionised their stage act. The demands of playing an hour-long, coherent set made the band forget their differences, and perform with intense mutual sympathy and pride. Barnes followed them on the tour:

Roger had acquired that magnificent male sexual image with his mane of curly hair and his flying fringed jacket. His skill at swinging mikes, hurling them twenty to thirty feet in the air and catching them just in time to sing the next verse was outstanding. *Tommy* had made Roger the front man of the group. Keith was a show in himself, all the time keeping up a one man spectacle, hurling drumsticks in the air and catching them and pulling the most incredible faces. John's bass was fuller and faster than most groups' lead, he kept the whole show together musically and visually. As John said, 'if I didn't keep still and anchor the whole

thing down, they'd all fly off into the air'. Pete was a powerhouse to listen and watch. Jumping, leaping, twisting, swerving, swinging his arm like a rotor, punishing his guitar and forcing everything he could out of it.

The band's reputation as live performers, already enormous, rose still higher. Throughout 1969 they toured almost incessantly – trying to persuade Kit, Stamp and Barsalona to spare them the dangers of blandness which accompanied appearances at large pop festivals, but agreeing to play at Woodstock ('the worst gig we ever did,' Daltrey said) in early August, and at the Isle of Wight later the same month.

Kit spent most of the year in England, preoccupied with the business of running Track, which had hits in the charts that summer by The Who, Hendrix, Arthur Brown, and Townshend's old art school friend Andy (Thunderclap) Newman. (One of Kit's publicity stunts for Thunderclap Newman and their song 'Something In The Air' was, according to Andy Newman himself, to send the DJs at the BBC a pill in a small plastic envelope with a label attached which read 'Take this and it will change your life'. They did take it, 'and it turned out to be a very powerful laxative, which wiped the DJs off the air for about a week'.)

Track's success involved Kit in so much work that he handed over the day to day running of The Who to John Wolff, thereby freeing himself to concentrate on their longer-term plans. His most ambitious scheme was to book a series of gigs in Europe's principal opera houses. The idea was an adaptation of his original intention to launch *Tommy* by having it performed at the opera houses in Moscow, first, then New York. This scheme had fallen through because the director of the Metropolitan Opera House in New York, Rudolph Bing, could not easily be convinced of *Tommy's* merits. Once it had been performed and acclaimed at The Coliseum in London, other cities followed suit, and the band eventually performed in opera houses in Paris, Copenhagen, Cologne, Hamburg, Berlin, Amsterdam and, eventually, New York. It was a triumph of organisation, and a graphic illustration of the distance that the band – and rock and roll – had travelled since its beginnings. Kit and Stamp, who themselves represented opposite ends of the social scale, had combined their energies to produce, in *Tommy*, a piece of music which united distinct and different cultures. The result was immensely significant. *Tommy* is the clearest possible instance of the 1960s' youthful culture forcing received social and artistic standards to revise themselves. Marsha Hunt puts the point, and its commercial foundation, succinctly: 'There are extraordinary things about the Sixties, and one of the most

extraordinary is The Who suggesting that "this Tommy is an opera, and fuck you, we're going to do it at the Met. We're only twenty-four, but we've got a lot of money, and if you don't let us do it at the Met, we'll buy it."'

Six

'We were going down the drain – we needed challenging after putting out singles like "Dogs" and "Magic Bus". But making *Tommy* really united the group and that was the good thing about it.' Townshend's judgment of his opera registers The Who's debts to Kit, but Kit's family-feeling for the band could only flourish while they showed signs of fragmentation. Once he had helped them evolve an integrated style and repertoire, he was less important to them. By creating their greatest success, he had destroyed their need for him to remain centrally involved. His reaction was to make the worst of a good job. Rather than let the band slip away from him, he embarked on a series of actions – some conscious, some not – which ensured that his friends would appear to be treating him badly.

It was a complicated, painful and ultimately fatal process, and one in which Kit's personality fascinatingly reflects the spirit of the age and milieu in which he lived. Ever since the earliest days of his involvement with The Who, his special strength as a manager had been his ability to understand and project the dominant attitudes of rock and roll: opportunistic, disrespectful of received authority, committed (commercially speaking, at least) to the idea that 'the kids are all right', risk-taking, and neglectful of anything (like book-keeping) which might be construed as tedious and 'middle class'. Many of his surviving friends and acquaintances admit that he was an entirely typical Sixties figure. 'It was just good times,' Marsha Hunt says, 'and we were young enough to be only occupied with that. And money flowed. It's so peculiar talking about it now . . . there was more than enough for everybody so there was no desperation about what you were doing. You were doing what you were doing. So the largesse of Kit's character is something you feel could only have existed at that time.' Tony Palmer agrees: 'If you wanted a parody case of that decade,' he says, 'Kit would be the man.'

To say that Kit represents the spirit of the 1960s is to do more than call his iconoclasm and his extravagance 'characteristic'. It is also to make a judgment about the ways in which the risks that he took – particularly the risks of violent stage acts and of insatiable drinking and drug-taking – gradually stopped seeming an innocent challenge, and started seeming foolish. With a cruel precision, the final year of the decade saw a series of disasters which suggest the peace-loving, laid-back, doped-up 'age of

Aquarius' that Marsha Hunt had sung about in *Hair* was ending with the dawning of the age of retribution. 1969 was the year in which The Rolling Stones' Hells Angels bodyguards killed a member of the audience at a concert at Altramont, in which Keith Moon exceeded even his own limits of destruction by accidentally running over and killing his chauffeur, and in which Kit started to use heroin.

The effects of the drug, which he took regularly for the remaining twelve years of his life, illustrated that Kit, who had done so much to create archetypal images of the Sixties, ended up being, as Marsha Hunt says, 'their victim. It's all well and good for the survivors to encourage you to be crazy, but actually they're being entertained by it and it's kind of cruel. Somebody like Kit thinks he's the strong one, living life in the fast lane, and it's only when they start to fall apart at the seams that you realise they've been the fool.'

Kit 'fell apart' too slowly to leave The Who painlessly. His contribution to *Tommy* was widely and properly acknowledged, and however independent the band now felt, they still expected to be able to rely on him as their manager. Kit began the new decade by living up to their hopes: he solved the problem of how to follow up *Tommy's* vast critical and commercial success. Rather than try to exceed the standards of originality set by the opera, he recommended that the band release their first live LP, and package it in such a way as to moderate the 'supergroup' image they had acquired. 'In those days,' Kit said,

live albums were always 'live at the Colosseum in Rome' or 'live at the Palladium', 'Hollywood Bowl' etc. I said, 'live' isn't really like that. Touring is much seedier. So why didn't we think of 'live at Grimsby' or 'live at Mud on Sea' – bearing in mind that my father always said Morecambe on a wet Sunday afternoon is not the best place to conduct 'Scheherazade' . . . I looked at the schedule and said 'You're in Hull on Wednesday and Leeds on Thursday, so it's going to be Live at Hull or Live at Leeds.' Things didn't go too well at Hull, so it had to be Leeds.

Shortly before the LP was released, in May, Kit was rung up by Nik Cohn, then reviewing for the *New York Times*. Kit later gave an account of the call to the journalist Alastair Reilly:

Nik, who had never even heard the album, said 'What would you like me to say? What about: "One of the best live albums ever made"?' I said 'Fine Nik, but why don't you come in here and hear it?'

'Oh that's not necessary,' he said, 'I've got a date.'

Weeks passed and the album is released. I was over in New York . . . Eagerly perusing the paper in Nancy Lewis' flat . . . And having my usual Sunday

breakfast, which consisted of an ounce of the very finest cocaine which was sitting on my left knee, in a barrel, with a spoon dipping ever and anon into the precious crystals ... When I got to the music pages by Nik Cohn, it said 'and now we get to the question of The Who album.' It said, 'I believe it to be the very finest live album to have ever been made.' I was so surprised that he had said this without ever having actually listened to the album, that I sprang into the air crying 'Eureka!', forgetting of course that I had an ounce of precious cocaine on my knee as I did so. It fell down in a thousand tiny snowflakes into the deep pile of the white carpet and vanished without trace. 'Nancy, quick,' [I said]. She had to grab me by the ankles and mow the lawn with me feverishly up and down, as I tried to snort the remaining £1,000-worth of coke from out of the carpet.

There are few details here which would have struck The Who as unusual. Nevertheless, the fact that Kit was alone in New York rather than with the band in London seemed – to Townshend in particular – 'strange and ominous'. Townshend understood the immediate cause of the estrangement very well. As soon as 'Tommy's' success was plain for all to see, Kit had been anxious to convert the opera into a film. He had even prepared a script for it himself and had persuaded Joseph Strick to produce it.

Townshend, however, was unenthusiastic:

I was afraid of what it would do for the band. Kit was always trying to make us do the most outrageous thing possible, which made me – and I'm normally an adventurous person – feel 'no, we must do the conservative thing. We must only do rock and roll, and it must be pure, and straight from the heart, and direct to the street.' Kit would come in and say, 'it's all nonsense Pete. What we need is one hundred strings in the background and fifty-four horseguards to drum you onto the stage, and a bomb going off as you come in, and Kubrick and Ken Russell making the film.' And I'd say 'Oh no, Kit, I can't handle it.' I'd misread him. He was absolutely serious and absolutely right. *Tommy* needed to be expanded. He was disappointed I wouldn't accede. He also got fed up with my evangelising about rock and roll – he thought a lot of my pontificating was bullshit. He wanted things to be fun and get bigger. When he saw that I wanted to spend the next twenty years of my life perfecting my style he thought, 'Fuck this. This is my vehicle and it's gone.' He immediately withdrew, almost like a burnt child.

If Kit hoped that in withdrawing from The Who he could fall back on other friends, he was wrong. When he returned from New York to London – to an expensive and, as usual, very sparsely furnished flat he had recently rented in Hillsleigh Road, off Holland Park Avenue in Notting Hill – the boredom he felt with the band in particular and with

success in general quickly infected every department of his life, and left him isolated in opulent loneliness. He allowed other people in the Track office to assume his responsibilities, and saw little of anybody. More often than not, his days passed in a haze of drugs, and when he emerged from his lair to visit the band, friends or his mother, they were horrified by the rapid change in his appearance: unshaven, waxy-skinned and crumpled. Flo, in particular, was appalled; whenever she saw Kit she subjected him to shocked reprimands which were meant to seem loving but only succeeded in frightening and depressing him. Townshend, his most constant and intimate companion, was hardly more helpful: he was immersed in an ambitious and ultimately abortive project called 'Life-house' (which was intended to be a film interpreting fourteen new songs which would be part documentary, part opera) and only saw Kit occasionally. Stamp was as marooned in drug-taking as Kit himself, though his looks had not suffered as Kit's had done. His 'pretty' face had grown gaunt, but he was still lean and wily-looking. His appearance belied his condition. 'We were well out of it,' Stamp said later. 'We were fucking out to lunch, no doubt about that. There was no need to be around any more.'

Towards the end of his life, Kit admitted that he should have broken cleanly with the band after *Tommy*. 'I should have resigned then. I knew I couldn't do anything better than that. That's the last album I can say I presided at the birth pangs of.' But the decision was impossible for him to take: his pride in The Who, his understandable envy of their success, and the vivid memory of his previous value to them meant that he could not easily share Stamp's opinion that there was 'no need to be around'. His indecisiveness, which was frequently transformed by his drug-taking into sulks and arguments, was guaranteed to irritate The Who. 'We didn't understand him at all,' Townshend complained, 'which put us in a very difficult position. We knew that his pride was going to be hurt if we produced ourselves, but at the same time that was the only thing that could be done.'

Townshend, still fiercely loyal to Kit, was in a difficult position. He knew that the organisation Kit and Stamp had set up at Track meant the daily working life of the band could run smoothly, but he also realised that Kit's contribution as 'a creative manager' could no longer be considered reliable. 'It has got to the point where Kit still has bigger ambitions for us,' he said. 'We are at the point where the last thing we are thinking about is image. Yet Kit's still talking about concerts on the moon.'

Other members of the band had more pragmatic concerns. Daltrey, in particular, began to worry about their finances, and became increasingly angry when both managers tried to make a virtue of disorganisation. Money 'hadn't really gone missing', Stamp said later.

I mean loads of people like Moonie used to grab a big bundle of cash, so did Townshend, so did Entwistle, so did Daltrey, right? None of it had actually gone missing – it just wasn't in the books. You knew there was drugs money, booze money and madness money, and that's where it went. And over ten years – TEN YEARS – there were millions of dollars that had gone missing – this was years of madness on the road, smashed cars and paid off chicks and so on. Anyone in rock and roll knew that.

Daltrey knew it too, but he no longer wished to be judged by the standards of the past, and his sympathetic memory of the band's chaotic origins rapidly hardened into dislike.

On one matter, at least, everyone in the band agreed. The gap left in the Track offices by Kit's increasingly prolonged absences had to be filled. Although Townshend initially resisted the idea, Daltrey encouraged Stamp's friend Bill Curbishley – who was hired as an assistant early in 1971 – to take over the usual managerial functions. Curbishley admits, 'I was intrigued by it all, recording contracts, deals, promotions, touring, the lot. I just threw myself into it.' His enthusiasm was more disciplined than Kit's had ever been. On a European tour later in the year, Curbishley overrode Kit's advice to be cautious and improved the band's royalty split at every concert from 60/40 to 90/10. Not even Townshend could ignore the benefits of this, and neither could he say that Curbishley's relative lack of flair for promotion counted for much: The Who's fame had made Kit's expertise unnecessary. Even Kit's laboriously acquired skills in the studio provided no real barrier to Daltrey's initiative. When Kit accompanied the band to New York in June 1971 to record their next LP, *Who's Next*, he did so knowing it was a last-ditch stand. But Townshend found Kit's doped-up, half-hearted suggestions a hindrance, and returned to England to remix the material with Glyn Johns. 'Up to now Lambert has thoroughly produced all Who records,' Townshend told *Sounds Magazine*, 'to the point of altering things in composition and influencing me in certain directions. At the same time he has his own particular kind of manipulation in the way of getting things he wants in the studio. When it finally got to *Tommy*, I think both of us – Kit and the group – realised that there was very little further we could go using that kind of relationship.'

Townshend's tone here is carefully designed to protect his friend, but Daltrey, as well as other members of The Who's entourage, would not let him overlook Kit's incompetence. Stamp, because of the large amount of time he had spent in America, was deemed to be less obviously culpable, and was less quickly criticised. Throughout 1970 and 1971, Townshend became increasingly alarmed by the accumulating evidence of Kit's financial mismanagement, his apparent lack of interest in mending his ways, and his rapidly deepening withdrawal into drugs. As The Who released new material – *Who's Next* in July 1971, *Meaty, Beefy, Big and Bouncy* three months later – and toured to unfailing acclaim (they visited America twice in 1971, and for the rest of the time were almost continuously busy in England and Europe), Kit's meetings with Townshend became very infrequent. When they did meet, they were sorrowfully affectionate. Kit divided his time between London and America, squandering the royalty percentages which rolled in to him from The Who and Track, obliterating his days with drink and drugs and boys. He was convinced that he was bored by his past, and had no idea what to do with his future. To make matters worse, none of his former friends seemed willing to help him, even supposing they had been able to. They watched his deterioration – his slide down the same path that was taken by Janis Joplin, Mama Cass, Jimi Hendrix, Brian Jones and Jim Morrison – with fatalistic carelessness. When Kit claimed that he 'should have resigned' after *Tommy*, he might equally well have felt, two years later, that he should have died.

His death was postponed – it would be putting it too strongly to say his life was saved – by an inspired version of the same extravagance that was ruining him. During his recent half-crazy meanderings between England and America in the early seventies, he had regularly encountered – as he had done throughout the Sixties – his friend from Oxford, Daria Chorley. Since the earliest days of their friendship, her circumstances had changed dramatically: she had left her husband – the Christ Church Senior Student – and married Alexander Shuvaloff. But her looks and personality had altered only a little: she had remained beautiful, plain-speaking and dynamic. She realised that Kit's energies had become painfully introverted, rather than merely dissipated, and was able to see that his behaviour was meant to protect injured feelings rather than destroy all feeling altogether. She remembers, for instance, an occasion on which he went missing for two days and was eventually discovered behind someone's door, asleep under a rug. 'He was always falling asleep during the day,' she says, 'because he dreaded falling asleep at night, and waking up to find nobody there. He was terribly lonely.'

Without foreseeing where it might lead, Daria decided that a holiday would do Kit good. In September 1971 he visited Venice with Robert and Jane Fearnley-Whittingstall (they rented the Palazzo Vistosi), and in November she took him back to Venice herself. Kit had already fallen in love with it. 'It's so beautiful I think I'm going to be sick,' he said when they arrived. The effect on his spirits was comically evident one lunchtime when he was eating in St Mark's Square and the leaders in the Venice Marathon pounded past his table. Kit leapt up, threw his raincoat over his arm, and was first to the post. A photograph shows him with his cravat flying and his startled competitors gawping in disbelief.

As Daria and Kit explored the city, they passed Palazzo Dario, near the mouth of the Grand Canal, and Kit said, 'Look, it's called after you. I'll buy that house one day.' He was, for once in his later life, as good as his word. Dario is one of the most fancifully beautiful houses in Venice, built late in the fifteenth century by Pietro Lombardo, with an intricate grey and yellow marble façade into which are set exquisite discs, rosettes and plaques. It had been standing empty for several years before Kit saw it, because the previous owner had been murdered. But what had deterred the Venetians excited Kit. The prospect of living in a palace of ill repute in Venice galvanised the snobbery that he had shown as a young man at Oxford. According to Daria, he saw the house as a means of renewing contact with the fashionable society his father had known, which he had courted himself as an undergraduate, and which had been forfeited during his years working closely with The Who. Before he and Daria returned to England, he had already decided how to buy the Palazzo.

Until The Who released *Tommy*, Kit never had enough money in the bank to contemplate more than a day-to-day existence. But the success of the rock opera meant that his profits outstripped even his most gigantic extravagances. During the winter of 1971, these earnings increased still further, when the American impresario Lou Reizner released an orchestral version of *Tommy* in a production which included appearances by Rod Stewart, Maggie Bell, Ringo Starr and Richard Harris. If Kit appreciated that this recording realised many of the hopes he had entertained for *Tommy* himself, he scarcely showed it. Most of the energy that his physical condition allowed him was spent making plans for his palace. His appetite to buy it was both stimulated and thwarted by the difficulties of British currency regulations which existed at the time, and by the need to satisfy Venice's complex financial system – in particular, its system of bribes. Eventually, with the help of his friend and

publicity assistant Anya, he paid £115,000 through the Swiss holding company which owned Dario, distributed generous handouts wherever and whenever the need arose, and declared himself the owner in April 1972.

Anya describes the purchase in a way which makes Kit's success sound little short of miraculous, and is a tribute to her own powers of organisation and endurance. Since the earliest days of her involvement with The Who, she had willingly followed their shambolic and promiscuous example while simultaneously remaining their efficient publicist in England and the States. (She had only broken with them once when – for a short time – she was married to one of The Byrds, and went to live in America.) The years had taken their toll – her beautiful dark-haired face had grown puffy with drugs – but the humorous outspokenness for which Kit had always liked her was undiminished.

'We caught the 8.30 train to Switzerland to do the deal,' she says,

Kit with a terrible hangover, eating filthy sandwiches, and spilling coffee all over himself. We got off at Milan and were met by the lawyer, Giorgio Manera. Kit dropped all the papers, which he was holding, and as they blew down the platform said, 'That's it. That's totally bad luck.' Then we went to a hotel, because Kit said 'I must shave.' Somehow he managed to drop my toothbrush down the loo, and when I asked for it back said, 'What do you expect me to do? Plunge into an armful of piss for it?' Eventually the deal went through in Lugano, at a smart hotel where Kit once again spilt coffee down himself, and walked around with a copy of *The Times* tucked into his waist to hide the stains.

Before Kit moved into Dario, he took rooms in the Gritti Palace Hotel, invited friends – including the Fearnley-Whittingstalls – to stay, and even celebrated his new sense of adventure by taking flying lessons at Venice airport. When the house was ready, he seemed less erratic than he had done for a long time. Anya, who was later to stay in the Palazzo as a more or less full-time housekeeper, says, 'It was a shot in the arm for him and pulled him together.' The allure of a new society, rather than innate self-discipline, was the cause of the improvement: two days after moving in he held an official opening of the house, which was attended by most of the well-connected people of the city – Peggy Guggenheim, notably, and everyone associated with Venice in Peril, including Lady Clarke and her husband Sir Ashley, the former British Ambassador in Rome. Anya persuaded Kit that his new acquaintances should be entertained in the style to which they were accustomed. He brought out, Anya says, 'masses of stuff from London – an enormous set of Spode, for one. I had to

smuggle endlessly. Once I brought out £5,000 in a paper bag, and a silver candelabra in a suitcase.' The city warmed to Kit as enthusiastically as he did to it, particularly since he persuaded Sir Ashley Clarke that he would be a generous supporter of Venice in Peril. Kit even organised a dinner-party at the Gritti to celebrate his first donation, at which a pudding of his own invention provided the climax. It was a model of the 'Salute', and was wheeled in to strains of the 1812 Overture, covered in lights, with fireworks whizzing out of its huge mass.

Other stories of his eccentricity and extravagance became rife over the next few years. Anya for instance remembers an incident involving Sacheverell Sitwell and his wife Georgia who, when on holiday in Cipriani's on the Giudecca were surprised to be visited by Kit, drunk, late one night. Not unreasonably, the hotel asked for the police to remove him. 'On the police-barge back to Dario', according to Anya, 'Kit kept saying "I insist that you arrest me", and when this failed to happen, assuaged his remorse by sitting up all night and flying a message in ships' flags from his window which read "Get well soon". (Georgia had a cold.) A gold record of *Tommy* was suspended from the end of the flag-string.'

Kit's life in Venice obviously satisfied his social aspirations (he was delighted to find himself referred to by the locals as 'Barone'). After a few weeks, however, he began to miss his fellow rock and rollers. According to Townshend, his original intention had been to mingle the two worlds which fascinated him, rather than exchange one for the other. His hope was continually disappointed. 'A lot of the pop sycophants went,' Townshend said later, 'but none of the band. He desperately wanted us to go, but we were not interested, or too busy.' The one pop star who did visit contacted Kit by accident, and before he had actually moved into Dario. Kit himself later told the story frequently and proudly:

I was staying at the Gritti, the best hotel in Europe . . . One evening I go down for a drink and see Mick Jagger and Bianca arriving by motor boat. He has escaped from the world's press after their marriage in the South of France, and come to Venice incognito for their honeymoon. The staff show him into a room like a matchbox. It looks on to a brick wall three feet away on the other side of the canal full of turds and cabbage stalks. So I intervene and say to them: 'Look, if you don't mind sharing a drawing room, I have a spare double room and you can have that.' There they are, billing and cooing, and having shrieked at the sight of their matchbox they gratefully accept when they see [my] fourposter and a balcony. I never see them as they lock themselves in their room most of the time, but soon we get into the habit of having dinner together. When they leave I nip down the night before and say 'I'll pay their bill' . . . The next morning I wake up and think I'm in

Paradise, or at least another room. It's got flowered wallpaper now. But then when I'm fully awake, I realise that I'm surrounded by twenty-four dozen roses, red. They are arranged around the room and must have been put there while I was asleep, in an hour or so. That takes some doing. [Mick] must have exhausted the entire contents of half a dozen flower shops in Venice.

However much this episode helped to bolster Kit's self-esteem, it was the exception to what quickly became the general rule of his loneliness in Venice. The appeal of fashionable parties waned, occasional visits from 'sycophants' disappointed him, and visits from genuine friends such as Daria or Robert Fearnley-Whittingstall were few and far between. At the end of the year his restlessness was increased by the one thing that might have reduced it: Kit fell deeply enough in love with one of his boyfriends to make him a regular companion – at least for a while. The boy, Tito, was the son of a German ambassador, and had met Kit in London the previous year. He was young enough to allow Kit to play a protective role, clever enough to provide intellectual stimulation, and mischievous enough to be fun. ('Kit always had bad taste in lovers,' Daria once said. 'He was very masochistic.') But in spite of his cultured background, Tito was unable to accompany Kit around Venice without embarrassment: although Kit was in no doubt about the nature of his sexual tastes, he was nervous about revealing them to his classy neighbours. 'He was so much an English gentleman,' Townshend says, 'that he couldn't live with the idea that he was a practising homosexual. He was not a low-life character. He had great dignity and couldn't stand the low life of people like Epstein. He was always afraid of what his mother would think.' To make matters worse, Tito was jealous of Kit's few close friends, and of Townshend – even though Kit now saw little of him – in particular. 'They really loved each other,' Townshend says, 'but the boy hated me.'

If Kit had really wanted a stable and permanent relationship with Tito he would have tried to resolve this problem. As it was, he was more interested in fending off boredom than finding love. Not even the evidence of Tito's ability to satisfy Kit's masochistic sexual tastes was enough to outweigh the pleasure of more casual company. According to an earlier boyfriend, Kit's actual behaviour in bed was very different from the wishes he expressed out of it. What he wanted to do was to cuddle up and fall asleep – an ambition which he was usually helped to realise by large quantities of drink.

Kit's relationship with Tito was always prey to the nostalgic feelings he had for The Who. But these feelings were now severely compromised by

the band's attitude to him. When Kit returned from Venice to London in the autumn of 1972, leaving Anya in charge of Dario, he found that Daltrey's investigations into the band's finances had led to the discovery of massive incompetence. By refusing to have anything to do with the daily running of The Who, Kit added insult to this injury – particularly since the Track offices had a competent staff who were ready and willing to take over from him in name, as well as fact. Curbishley was already managing most of The Who's English and European commitments, and another relatively recent employee, Peter Rudge, had taken charge of their American interests. 'The whole situation,' according to Marsha Hunt, 'was very very shaky and uncertain and unpleasant.' Townshend's loyalty to Kit remained intact, but his voice could no longer drown the protests of his colleagues. Even the mild-mannered Andy Newman supported Daltrey: 'I got angry about Kit,' he says, 'because if one had someone who was supposed to be a manager you feel fed up with having to wait six months for an answer to anything, then hang around the office for three days to get it.'

Kit was hurt, dismayed and angered by these accusations, and unable to contradict them. His response was to persist in alienating the band by his indiscipline and incompetence, and to withdraw into sulks. Shortly before arranging to buy Dario, he had given up the rent on his flat in Hillsleigh Road, and bought a house in Egerton Crescent, near the Victoria and Albert Museum in Kensington. He passed his days there in angry confusion. He banished time by obliterating it with drugs; pined with sentimental sorrow for his palace, yet made no attempt to visit it; and (to replace the troublesome company of his band with something more placid) bought two great danes. One of then was called Aida, after the opera he claimed was his 'favourite'. It quickly became apparent that although he 'adored' his dogs, he was incapable of feeding or exercising them properly. Eventually he took on a housekeeper, a Mrs Roberts; but it was all she could do to stop the house smelling of dog shit, as well as dope.

The guilt which had always formed part of his relationship with his mother soon escalated. Whenever he visited her in Chelsea, he had to face her horror at his condition, and admit his own sorrow that he had disappointed her. Everything about her – her looks, her elegant house – seemed to reproach him with its order. The more alarmed Flo became, the more critical she was of him – meaning her accusations lovingly, but inspiring more fear than resolve. Kit's reaction was to avoid her, or to irritate and sadden her by blaming her for his plight. How could he have

behaved differently, he asked her, given the unhappiness of his child-hood?

Flo was not the only potential ally Kit alienated. Early in 1973 Kit excited Daltrey's antagonism still further by refusing to handle his first solo album. Daltrey turned to Curbishley instead. Kit then sabotaged his friendship with Townshend by stopping a cheque that Townshend needed to build a studio in which to record the new rock opera he was writing, *Quadrophenia*. When the recording arrangements were sorted out, Kit persisted in alienating Townshend. Marsh writes,

Lambert would show up in the early evening for a session scheduled for the late afternoon. Then he would have a huge and elaborate dinner sent in or arrange some other form of entertainment after only three or four hours work. In the old days, this might have been acceptable behaviour. But now Lambert was not providing a needed break, he was destroying any hope of continuity and concentration.

Kit's intervention would have been unwelcome under any circumstances, but since the technical problems Townshend had to deal with in *Quadrophenia* were enormous – quadrophonic sound was still in its infancy – it was nothing less than disastrous. 'I had backed him up,' Townshend says, 'talked the band into letting him produce *Quad-rophenia*, fought Glyn Johns on his behalf, and he let me down. He didn't turn up and he left me holding the baby for the production, which was bloody difficult.'

Kit's separation from the band could not be called official until their legal and financial arguments were settled. The process was to take years, and while it contributed to Kit's final decline it also, in certain respects, allowed him to seem wronged rather than merely redundant. That, at least, was the case to start with: when, in mid-1973, The Who arranged a deal with Robert Stigwood for a film of *Tommy* to be made – Daltrey was to take the part of Tommy, Ken Russell was to direct and Columbia were to release it – he felt that he could legitimately claim to have been passed over. But this claim almost immediately seemed useless. Before the plans for the film were finalised, even Townshend was convinced that Kit's confused and injured feelings could be ascribed largely to his increased use of drink and drugs. Once the plans were settled, the drink and drugs became The Who's excuse for not having involved him in the film in the first place. The more 'out to lunch' Kit became, the wiser the band's decision seemed – and by the end of the year it looked as though they had never had an alternative. His drinking was heavy even by his

father's standards – he drank much more spirits than Constant, usually brandy – he was addicted to heroin, and he was consuming large quantities of cocaine. 'I'm amazed he was able to do *anything*,' Townshend says, and, in truth, Kit did very little for the next three years. His life disappears into a haze which can only occasionally be penetrated, and then usually to encounter a scandalous or tragic scene. In an interview given shortly before his death his rambling conversation gives a pathetically vivid glimpse of his condition: bewildered, convinced he was being persecuted, and destructive:

I've always lived in a totalitarian state. I've had plenty of sticks poked at me through the bars I can tell you. Like they come up to you when you are desperate for a cigarette, hold a match six inches away and then drop it blazing to the floor. The worst thing in the world I think is waking up alone on Christmas Day. I used to go to enormous lengths when the money first started to come in not to have to go through this. I bought a pistol and went down to the Speakeasy [one] Christmas Eve. I thought things were pretty dull so I fired a few rounds into the ceiling and ordered champagne cocktails all round and then ordered another round and fired a few more shots into the ceiling and things started to liven up slightly. Then I got the man on the door to order some hire cars as I began to chat up various people who walked in and I plied them with more and more champagne. I said to each one 'why don't you go and wait in the car?' I thought one of them is bound to come across. There were about three of them in this car with the driver. Then the head waiter came down and said, 'Look I'm awfully sorry but we had to carry the last two out and the other guy's snoring loudly and the driver doesn't look too happy either.' I said, 'Well, order another car' . . . About an hour later it was the same story as the next three candidates had been carried out of the club and put into the second car. There were now two cars with so to speak dead bodies. It was getting awfully near the witching hour which I absolutely did not want to spend alone, so firing a few more rounds from my pistol into the ceiling, ordering another case of champagne, things were really beginning to hot up now, the place was going thick and fast. Finally I left with the organist, or was it the bass guitarist, from the group that was playing, in the fourth limousine. He was the last person able to stand. He was very nice. The first and last time I've ever had an organist (tell me about boys in black leather raincoats and eyes like swimming pools, their wonderful featureless smiling faces, their brainless heads rising from their swanlike necks).

If Kit meant to teach The Who a lesson by withdrawing from them, and expected them to discover that he was indispensable to their success, he was consistently proved wrong. Even though Townshend complained, during the recording of *Quadrophenia*, that he had to take 'a lot of the

bad raps that normally Kit . . . would take', the production itself showed no ill effects. Neither did the organisation of the band's life as performers. No matter how depressed Townshend became at the loss of Kit's friendship ('I gave up drugs and became an alcoholic,' he told a friend), The Who's reputation continued to rise, and the tours remained sensationally popular. In June 1974, for instance, when they toured America seven months after the release of *Quadrophenia*, they sold 80,000 tickets to their first four gigs at Madison Square Gardens in a few hours, following a single announcement on New York's rock radio station. The shows were proof, if any were needed, that The Who, with The Rolling Stones, were one of the twin pillars of the rock and roll world, and were well able to flourish without help from Kit.

From mid-1973 until Track was closed down in May 1976, the dealings that Kit had with The Who were mainly connected with their efforts to oust him as their manager. The more completely Curbishley and Rudge took over, the more ramshackle his previous control of the band's affairs seemed. Initially, Townshend discouraged taking legal action against him, but by mid-1975 he could no longer stem the flood of Daltrey's argument. Townshend agreed to follow a friend's advice to 'let Roger win'.

Put at its simplest, Daltrey's case against Kit and Stamp was incontestable: they were doing virtually nothing for the band, but still getting 30 per cent of their earnings – 15 per cent more, as Marsh points out, 'than the managers of most superstars'. In the late summer of 1975, as The Who prepared to tour America again and began recording material for the LP *Who By Numbers* (released in October), Townshend let Daltrey consult lawyers, and was immediately confronted with hard evidence that 'we'd been screwed up the fucking alley'.

Dazed and incompetent as he was, Kit was able to understand the gravity of his plight, and made strenuous efforts to pre-empt Daltrey's initiative. In June 1975 he had given an interview in the *New Musical Express* in which he spelt out his quarrel with the band, and announced that he was himself preparing 'final documents for drastic and far-reaching legal action' against Stigwood in connection with the film of *Tommy*. This had been released in March 1974, with Stamp cited as an 'executive producer', and with no credit at all given to Kit. Stamp's billing was partly due to the simple fact that his drug-taking had made him less 'out of it' than Kit, and partly to The Who's recognition of the work he had done for the film's promotion in America. As far as Kit was concerned, it was work which betrayed their friendship. Stamp, to whom

Kit had been closer than anyone except Townshend among his colleagues, instantly became an arch-enemy. 'Kit claimed he owned the "world copyright" to the piece,' Marsh says, 'and that he had written the original screenplay. He also charged that Stigwood "alienated the affections of my former partner, Chris Stamp, whose resignation I am now demanding from the board of all companies associated with The Who". Kit further said he had fired Bill Curbishley as Track's managing director and was throwing him off the company's board.' (Curbishley had in fact resigned his directorship months earlier.)

In the long term, the evidence of Kit's financial negligence was to prove too substantial for him to have much chance of winning in court. In the short term, it simply increased The Who's disaffection. As soon as proceedings against him started late in 1975, his lawyers froze all the money that was handled by Track, which meant that the band were forced – at a point in their careers when they might reasonably have expected to relax – to tour almost incessantly in order to create their income. During the latter part of 1975, and throughout most of the following year, they were on the road in England, Europe and America virtually without a break.

Even supposing that Kit's case against Stigwood had been watertight, he was hardly in a fit mental or physical condition to argue his points. Furthermore, he was almost entirely without advocates. By alienating Townshend and Stamp he had dispensed with the only two loyal friends he had made in the music business, and by quarrelling so bitterly with Curbishley he had antagonised a level-headed and efficient heir to the empire he had created. In the year after the film of *Tommy* was released, Kit had wrecked any chances of a rapprochement. 'It got really crazy,' says Curbishley, 'with Kit sending strange telexes all the time, saying he wanted his money for the film in gold and things.' In Venice, New York, and in his flat in London, he surrendered to a destructive rage which made his previous behaviour look positively moderate. This not only meant stepping up his use of drugs still further, but insisting that the company he kept should follow suit. On one occasion, according to a friend, a young Irish rent boy he brought home died of an overdose in Kit's spare room. On another occasion, a friend of the famous trans-sexual socialite April Ashley – Kit had lent Ashley £2,000 to found the club AD8 – died of an epileptic seizure while staying with Kit. On yet another occasion, in Venice, a woman friend was given a drug-filled suppository which knocked her out for a day. When she woke up she was naked, and had rope-burns on her ankles and wrists. Beside her on a table were

photographs which showed other guests abusing her while she had been unconscious.

According to Curbishley, Stamp tried to have Kit certified insane late in 1975, but his own unhappy condition prevented him from getting very far with his plan. So, of course, did Townshend's protectiveness – though this was by now confined to personal matters. As far as professional ones were concerned, Townshend had to accept Curbishley's view that 'Kit had gone completely bananas', and to agree to Curbishley taking over as manager. The appointment took effect from May 1976, and within a matter of weeks Curbishley had made changes that Kit's lingering interference had prevented. He increased most of the band's royalties by three or four percentage points, and created more favourable terms and conditions for live performances.

This ensured The Who's future, and also guaranteed Kit's ruin. Immediately before Curbishley took over, Stamp made an already disastrous situation still worse by signing – in a forlorn attempt to keep Track Records under his and Kit's control – a nineteen-year lease for new offices. Since Kit's absence had meant the company had no new ventures to provide a significant income, and since Kit's own money was bound up in litigation, the only result of the lease was completely to undermine their already shaky finances. The bulk of whatever money he and Stamp did receive was spent, as Richard Barnes says, on 'their solicitors, the staff's wages, the office rent, and so on'. In the past, this kind of risk-taking would never have troubled Kit: he had, on numerous occasions, been prepared to run up massive overdrafts in the knowledge that they would be eradicated by Track's earnings. Now that Track was profitless, and The Who were managed by Curbishley, his bank was no longer prepared to support him. By the summer of 1976 his overdraft had reached vast proportions – £56,000 according to Barnes, £165,000 according to Daria. The only material assets the bank could set against this debt was the flat that he had bought for his mother, and his house in Egerton Crescent.

The thought that his own financial ruin might also put Flo on the street made Kit consider every possible answer to the crisis. He did not dare tell his mother about the extent of his misfortune – half-crazy as he was, he appreciated that his condition was cause enough for her grave concern, without adding that she might also soon be even more deeply involved in his ruin. It was Daria who found the solution which, though archaic, seemed his only hope. She had become increasingly alarmed at his physical state; by now, she says,

356

he was living in unbelievable squalor in his house in Egerton Crescent [in South Kensington]. There had been a fire, and he was virtually living under a tarpaulin over the fire damage. He had his two dogs and seven puppies with him, and there was dog shit everywhere. You had to hold your nose when you went in. And it was terribly hot – he had to have heaters on all the time because of his druggy state.

She was appalled by his appearance (his face was bloated and his hair had started to fall out) and by his financial complications – not only by his overdraft, but by the fact that he owed a large amount of back tax, and had incurred innumerable small debts in Venice as well as England. His Rolls-Royce, for instance (it had once been Daltrey's) had been impounded by the London hotel at which it was parked because he owed over £2,000 in garage fees.

Daria understood that there was no time to lose before Kit's bank foreclosed on him. This, she knew, would mean him being declared bankrupt, and losing everything. The short term remedy she decided upon was one which led immediately to another, longer term solution. Because he had no account that his bank would let him use, and because he badly needed funds, she contacted Polydor, made them write out a cheque for £5,000 – the money to go to Kit but the cheque to be made out to her – and put the money in her own account after explaining the situation to her bank manager. In the course of these negotiations she heard from her bank manager of the existence of the Court of Protection, which she was advised Kit could enter as a means of avoiding being declared bankrupt. She had no difficulty in persuading Kit that it might be his salvation. 'It's fantastic,' he told her, 'a brilliant wheeze. It'll stop the bank.'

The Court of Protection, as its Dickensian title implies, is a Victorian creation designed to protect the rights of legitimate heirs from the capricious or actually lunatic whims of those from whom they stand to inherit. Anyone entering the Court of Protection gives it the control of all their assets and business interests. Stamp explained it thus: 'Supposing you've got an eighty-five-year-old woman who's got ten million pounds. This court is so that some eighteen-year-old gigolo can't come along and fuck her to death and take it all.' It was Kit's and Daria's understanding that if Kit put himself under the Court for a while, and appointed Daria to assist the Court in sorting out his affairs (acting as receiver, and carrying out the instructions of the official solicitor), the bank – in Stamp's phrase – 'couldn't touch him, couldn't touch his mother's place'. When his debts

were paid, Kit thought, he could leave the Court and take up normal life again. Daria was pleased to accept the responsibilities her role entailed, since she was anxious to help a friend in need. Flo, who was perhaps the more obvious choice, was reluctant to untangle the complications her son had created, and so was his Aunt Olga, whose sympathy had been overtaken by exasperation. Kit himself was only too pleased to have Daria's assistance, not least because it spared him the embarrassment of having to confront Flo with his incompetence. By appointing Daria he was able to enlist the support of someone who had the strength of character and will he wanted from a mother, but who would not blame or criticise him with a mother's capacity to induce guilt. He realised that the Court of Protection was a desperate remedy, but knew that nothing less would be able to help him. His mother, initially at least, welcomed the intervention when she had got over her dismay at finding that it was necessary at all.

Daria set about her task with extraordinary energy. Even before Kit's application to the Court was accepted, she decided to confine the extent of his liabilities by persuading Polydor to advance him £2,000 and by flying to Venice to pay off his debts there. She had no choice other than to 'give haircuts' to his creditors: that is to say, to explain to them that Kit was bankrupt, and they would have to accept less than full payment, or face the prospect of receiving none at all. Palazzo Dario remained, for the time being, untouched, with Anya 'sitting there with cobwebs in her hair like Miss Havisham'. When Daria returned to London she found Kit 'even worse', and apparently without much will to live. She told him that there was no point in his going under the Court unless he was firmly resolved to live, and that his condition was now so dire it would take more than his own resolve to guarantee his survival. Kit, whose use of heroin had made him hardly capable of independent thought, agreed to accept medical help. In the late summer of 1976 he said he would go to the same clinic in Geneva that Keith Richard, one of The Rolling Stones, had recently attended, but told Daria, 'Don't call it a cure. That's what they used to say to my father. I can't tell you how many "cures" my father had.'

As Kit was packing at Egerton Crescent he was tipped off that the police were coming to arrest him for possession of drugs. To elude them he left three days earlier than planned – but not before hearing that the Court had granted him an interim Order of Protection a few hours before his bank had secured a judgment which entitled them to seize his assets. When he reached Geneva he had little sense of the precise state of his

affairs, only the knowledge that they were no longer his responsibility. His initial reaction was delight, and to Daria's relief he cooperated so wholeheartedly with doctors at the clinic that in three weeks his addiction to heroin seemed to be broken. His drinking, though, continued at an only slightly diminished rate, and he was recommended for transfer to a rehabilitation centre nearby. But 'he wouldn't hear of it,' Daria says, and since she had no choice other than to respect his independence, she cast around for other means of keeping him away from the bad influences she knew would assail him as soon as he returned to London. She appealed to Robert Fearnley-Whittingstall, who took him to Sicily for a holiday, and then handed him back to Daria and Alexander in Naples after a couple of weeks.

Daria found Kit more lucid than she expected but worryingly erratic. On their first night there Daria told a waiter that Kit was an alcoholic in the throes of reform and should be given no more than one sherry. Kit, discovering the plan, whispered to the waiter that Daria was mad and was herself alcoholic. Kit intercepted and consumed all her drinks. Late in the evening he appeared in his underwear with a bottle of whisky in one hand on a balcony overlooking the hall, shouting and cocking snooks at the guests below. He was chased down corridors by outraged staff, captured, and asked to leave.

The Italian holiday was short-lived and, for Kit as well as his keepers, utterly unrestful. Daria had daily evidence that his 'cure' was indeed likely to be as temporary as those taken by Constant, and followed him back to London in November 1976 full of foreboding. Because his own house in Egerton Crescent was still uninhabitable after the fire, Kit decided to move in with his mother, in her flat in Oakley Street. The contradictory feelings she always inspired in him were soon inflamed. When she lovingly begged him to reform he was plunged into guilt, and when she angrily criticised him he rebelled. Within days, according to Anya, 'he had beaten Flo up, smashed up the flat to the tune of £500, and got his dogs out of kennels. The whole thing began to fall to pieces.' Flo was heartbroken, and beseeched Daria to help. Faced with this collapse of Kit's resolve, Daria realised that she had taken on more than she could easily handle. She also knew that Kit had no one else to help him adequately. When the interim Court Order became official, shortly before Christmas, she confirmed her willingness to act as receiver.

It was a decision which almost inevitably filled Kit's mother and half-sister with the suspicion that Daria and her husband Alexander were self-interested. Daria would, they thought, benefit herself as she sold Kit's

properties to pay off his debts. In fact Daria was well-intentioned and efficient throughout her extremely trying association with the Court. It is one of the many sadnesses which disfigured Kit's last years that those relatives and friends who had his best interests at heart were set against each other by his disruptiveness. Even Kit, within a short time, doubted Daria's integrity. Having originally, she says, accepted the decision to enter the Court 'because there was still the frightful mess at the bank', he soon claimed – according to John Edwards, who had married Patricia Bell, one of Kit's earliest assistants at Track – 'that he was in no way properly aware of the nature of the document that these old and trusted "friends" were having him sign. He told me that it was some months later that he looked up the statute for himself and found that he was securely under the jurisdiction of the Court of Protection and at the absolute mercy of Daria.'

This remark crystallises Kit's dilemma. He needed the Court because he was incapable of looking after himself – incapable even of reading the papers of admission – but wanted its protection without the deprivations that this entailed. Initially these deprivations did not seem too painful. Daria was able to supplement the £150 a week that he received from the Court of Protection on Tuesdays by passing him regular payments from Polydor, who were prepared to give her Kit's dues because she was, as receiver, a director of his companies. She also 'did an amazing deal', she says, with Kit's bank, writing off his debt of £165,000 as against £16,000; sold his burnt-out house for £20,000; and found him a flat in Elgin Crescent off Ladbroke Grove in Notting Hill. Kit's response was to complain bitterly about the sale of his house, and to set about turning his clean, smartly-painted new flat into 'a pigsty'.

The final stages of the agreement Kit reached with The Who tell the same chaotic story. By the end of 1975 the band and their managers were approaching the end of their litigation. Until his entry into the Court became absolute, Kit refused to release money owed on records in which he and Stamp had been involved. Even if he had been inclined to pay, he would have found it impossible to raise the amount due. Track, which had blossomed so healthily in the late 1960s and early 1970s, had never, as Marsh says, 'developed any lasting successes: Hendrix had died, Arthur Brown had dropped out, Thunderclap Newman had broken up, the rest of the label's talent roster never sold.' The Who, for their part, had made it impossible for Kit to improve the label's prospects by refusing to sign any papers connected with it.

By mid 1976 the Court's demands that Kit's debts be paid had finally

caused Track to be dismantled in London, which also precipitated a resolution of its overseas affairs. The sum of Townshend's outstanding American publishing royalties, for instance, were decided by Allan Klein, who acted as an intermediary. Townshend, according to Marsh, 'would receive one million dollars in full settlement of his US copyright to date, the rights to the recordings would revert to The Who's companies and both sides would drop their litigation'. Townshend, although relieved that a fair solution had been reached, was in despair that his relationship with Kit had been destroyed. Even after Kit's death, Townshend felt that the rupture was unavoidable, but that the spirit in which Kit had acted as their manager was cruelly misrepresented. The fecklessness with which Kit had handled their money had been a crucial aspect of the band's revolt against convention. In time, however, the sheer amounts involved, and the increasing professionalism of other and newer managements made what had been merely careless appear wicked. 'Kit overspent in all our companies,' Townshend says,

and he treated them all as a private bank. But so did we all. They'd been set up for people to use flexibly. Keith Moon had four times as much as everyone else because he was the publicity machine. He'd get us in the papers *every day*. Kit, on the management side, got a lion's share too because he was a genius. But a time came when the books had to be balanced . . . It was so boring.

What was boring for Townshend was fatal – though not immediately so – for Kit. As the companies crumbled or slipped out of his control, his sense of himself was undermined. The good done to him by his trip to Geneva was destroyed, and his behaviour became increasingly wild. David Platz, at Essex Music, remembers him coming to a meeting in Track's last days and threatening to throw himself out of the window. Another colleague describes Kit's appearance at an office of the Court of Protection with a tape recorder hidden in a plastic bag, intending to record evidence which would prove that he had been maligned. When Kit furtively turned the machine on, it gave him away by emitting a few bars of music at full blast. 'Oh well,' Kit said, 'I never did like the Poynter Sisters.'

Misery and farce were the interchangeable expressions of what most of Kit's companions now recognised, in the glib parlance of the day, as 'paranoia'. But for Daria, at least, the misery dominated. Within a matter of weeks after returning to London late in 1976, Kit had started to struggle against the restrictions of the Court. 'In the spring of 1977 a terrible time began,' Daria says, 'with Kit ringing at all hours of the day

and night, begging for money, clamouring for the release of his dogs from kennels, and so on. Money in fact became a game. He would run up restaurant bills and expect the Court to pay.' The more desperate Kit grew, the more antagonistic friends like Anya and John Edwards became to Daria, saying that 'Kit trembled in front of her in the same way that he trembled in front of his mother', and accusing her of being 'on an amazing power trip'. If these friends had had to bear Daria's responsibility for Kit, they might not have been so sympathetic to him.

In early 1977, Kit decided to apply for release from the Court. He obtained a temporary injunction, wrote to the doctor he had visited in Geneva, then heard from the Court that the doctor had replied saying he was clearly unfit to handle his own affairs. When the injunction was duly removed, Kit's rage and Daria's unpopularity increased. As soon as she came back from a trip to Venice during the summer – to pay off more taxes that Kit's property had incurred – she found that he had, with Edwards, inveigled Polydor into giving him some money on account. 'Polydor knew they weren't allowed to,' Daria says, 'because he was under the Court. But they were desperate to get something out of Kit. He only made one 45, then broke the contract – which didn't matter because he wasn't entitled to make one in the first place.' (In fact, 'one 45' was not the full extent of Kit's activities. He was also involved with a Dutch band, Golden Earring, whose success in Europe led to them appearing as a warm up band for The Who at a number of concerts.) It was not just the illegality of Kit's actions which worried Daria, it was what he decided to spend the money on. Within days of her return, she realised that he was back on heroin. 'He was bananas,' she says. 'He told me I was keeping him like a spider in a box.'

The evidence of Kit's Swiss doctor was not enough to make Edwards abandon his fight. The more passionately he took Kit's side, the more arduous Daria's job became. She was well aware that Kit's family, as well as most of his friends, were arrayed against her, and also knew that the Court itself would only give her cold comfort. When, in the early autumn, she made a formal request for the official solicitor to take over her role, she was told that 'he couldn't possibly undertake it yet. It would need fourteen people to do the job.' For the next year, her control of his affairs remained absolute, and her influence over his thinking negligible.

Early in the new year, 1978, Kit abandoned his flat in Elgin Crescent and went to stay with John Edwards and his wife Trisha in their small dark apartment in a tenement block in Trebovir Road, Earl's Court. According to Trisha they spent a good deal of time consolidating their

dislike and distrust of Daria. 'She put all his father's books up for sale, for instance,' says Trisha. 'We tried to stop it but we couldn't.' Again, when the Edwardses tried to take Kit to the Dordogne for a holiday that summer, says John, 'she behaved in the most cruel and underhand fashion . . . It took us all day to get his passport and I was served with a hastily scribbled admonition to the effect that it was an offence to meddle with the affairs of a person under the Court of Protection.'

The Edwards's rage is understandable, and so is the invidiousness of Daria's position. In order to put Kit's affairs in order, she could not help but seem heartless: how could his debts be paid except by taking drastic action? Any doubts that Kit and his friends had about her integrity only made her position more difficult. Kit frequently accused her of squandering his money to further her own comfort, even though her job as receiver entitled her to do no more than carry out the instructions of the official solicitor. By October 1978, when the official solicitor finally agreed to relieve Daria of most of the burdens of her office, she had managed to reduce Kit's debts in England by a very large amount. (The only time Kit's solicitors confronted her with an accusation that she had mishandled his funds, the Court told them not to talk nonsense.) But several duties remained – among them, the responsibility to untangle Kit's Venetian affairs, which the official solicitor was unwilling to handle on Kit's behalf for reasons of time and distance. Daria's reluctance to continue working for Kit was matched by her increasing anxiety about his condition. Not only was he desperately ill, but the people with whom he had lived suddenly suffered several disasters. These were terrible in themselves, and also seemed to give intimations of his own likely fate. On 7 August Pete Meaden, who had been involved with The Who since their earliest days as The High Numbers, had died of a drug overdose. Exactly a month later Keith Moon also died of an overdose. Since Kit had always admitted that many facets of his own personality had been adopted by Moon, the loss terrified as well as saddened him.

Although the rest of The Who could not disguise the fact that they had tired of Moon's antics, their shock and sorrow was unambiguous. He was, as Daltrey said, 'a bloody institution, he should have been nationalised.' Townshend understood that Moon was irreplaceable, but also realised that there was a chance for regeneration.

We have lost our great comedian, our supreme melodramatist, the man who, apart from being the most unpredictable and spontaneous drummer in rock, would have set himself alight if he thought it would make the audience laugh or

jump out of their seats . . . We are more determined than ever to carry on, and we want the spirit of the group to which Keith contributed so much to go on.

Daltrey, who initially suggested that this continuity was impossible, eventually agreed. When Kenny Jones was chosen to replace Moon, Daltrey said, 'If one journalist says we are not the same without Keith, then I'll personally break his legs.' His enthusiasm was well justified. The difference between the two drummers' styles did nothing to damage The Who's reputation. Indeed, Jones gave the band a more disciplined structure, and enabled them to exploit fully the chances for renewed popularity which coincided with his arrival. During 1979 – the year which saw the appearance of Punk – the fashions and tastes associated with Mod revived, and The Who once again found themselves the mouthpiece for a new generation. At the beginning of the year, the West End stage production of *Tommy* ran to packed houses, and a few months later a film of the band in performance, *The Kids Are Alright* attracted, according to Barnes, 'a huge crowd of 4,000 outside the cinema in London for its British premiere, and was very well received by the critics. Three months later saw the premiere of their [third] film venture, *Quadrophenia* . . . It became a huge box office success.' On tour, too, the new line up was rapturously received. Early in the summer at Fréjus, in the south of France, 8,000 fans packed into a Roman amphitheatre to hear them; at Wembley Stadium, a little while later, 77,000 fans turned up; and at Madison Square Gardens in September the volume of mail requesting tickets for the 100,000 seats was greater than the organisers had known for any previous concert.

Kit saw The Who's increased popularity as an opportunity to restore his own fortunes. Although Daltrey balked at the idea, Townshend was more tolerant. In London after the Fréjus concert Townshend told a reporter, 'Kit Lambert has just spent fifteen minutes telling us what's wrong with The Who and he's right.' Kit's hopes of resolving his own confused condition by associating once more with the reformed band were short lived. In December, when The Who were performing at Cincinnati, eleven people were killed as fans stampeded through the doors of the Riverfront Coliseum. The band, though not directly responsible for the carnage, were profoundly shocked; and Kit, when the news reached him in London, was smitten with a sense of displaced guilt. He insisted that the tragedy would not have happened if he had been organising the event. Although hardly in a state to concentrate on others' sufferings for long, he was well able to interpret the disaster personally:

the new band might be more disciplined, but it was absurd to think that their companionship might stabilise his condition.

Two months before the tragedy at Cincinnati, the demands of the Court of Protection had caused Kit to take a dramatic turn for the worse. As soon as the official solicitor took over most of Daria's burdens she wanted to discharge her remaining responsibilities as quickly as she could. Early in the autumn she went to Venice with a Mr Anderson, the solicitor's assistant, who was unsympathetic to Kit and failed to understand the emotional value of the Palazzo Dario and its contents. 'Why didn't Mr Lambert buy a house in Weybridge?' he asked Daria when they arrived. To a degree, his bafflement was justified: not only had Kit virtually abandoned the house to Anya, but it was in a state of considerable disrepair. It had been burgled three times during Anya's incumbency – 'there were endless staircases and solid marble walls,' she says, 'you couldn't hear from one side of the house to the other' – and the previous Christmas part of it had been destroyed by fire. Anya had returned to England for the holidays and left on a blow heater to keep some plants warm. The heater started the blaze.

As far as the Court were concerned, Dario was underused, impractical and decayed, but an asset nevertheless – and they decided to sell it. To start with, Daria tried to save Kit what she knew would be a crushing sorrow by attempting to rent out the house. But everyone who looked it over decided it needed more furniture, which Kit was hardly in a position to provide. By the summer of 1979, passionately resisted by Anya, she decided she had no option other than bow to the Court's decision to sell. 'All his most precious things were there,' Anya says,

the nucleus of what he owned and loved. Sotheby's came from Florence – it was a sweltering August – evaluating and sticking on labels. She sold everything that had been in the house when he'd bought it, including the library (which her ex-husband catalogued) and the chandeliers. All the good stuff was sold in Florence, and the rest in Venice. I wanted to buy a polar bear rug Kit had – he called it Poly – to give it back to him eventually. I paid £200 for it and later he accused me of stealing it then munificently said 'I give it to you'.

Daria never imagined that she could organise the sale of the Palazzo without making herself unpopular – no one could have expected anything else. But one decision, to involve her own family, provoked particular hostility. She admits that a cousin, for instance, who lived in Italy, 'came and bought everything that Sotheby's would not take for his house by the sea'. The sale of Dario's contents realised £34,000 and that of the house

itself, in November 1979, £360,000. The money was put in a Swiss bank account where Kit, supposing he ever left the Court, could regain what remained when his debts had been paid. The relief this gave his creditors – who now had access to an appreciable lump sum, as well as to the royalties from the records he had made with The Who – meant little to Kit himself. When Daria told him what she had done, he simply felt stripped of his identity, betrayed and vagrant.

Even the temporary home he had made with the Edwardses' was denied to him: towards the end of 1978, the Edwards's marriage had collapsed and Kit had been forced to leave Trebovir Road. His saviour was someone he hardly knew, Louise Fitzgerald (now Burden). She had known of Kit for several years through her work for a record promotion company called 'Greasy Truckers', but had only encountered him briefly and occasionally. In November, when she had not seen him for two years, he 'turned up with two paper bags at my flat' at 12 Eardley Crescent, in Fulham – a five-minute walk from his father's grave in Brompton Cemetery. 'It was shocking that he should come to a mere acquaintance. He looked a tramp, and when I said something about this he said "money burns a hole in your pocket." I told him he could stay for three months, but in fact he stayed longer. The house rules were that there should be no boys.'

Kit was drawn to Louise precisely because she was virtually unknown to him. With a stranger, he could suppress his guilts, errors and disappointments, or at least dress them up to make himself seem an injured party. It helped, too, that she was a woman. Louise, like Trisha before her (Kit by now called Trisha 'Mrs Duvet' because she complained when he set fire to his bedding), could hint at motherly care and interest without filling him with the awe that his actual mother inspired whenever he now visited her.

While Kit's motives in settling himself on Louise can easily be understood, her reasons for accepting him are – in view of his obstreperous and decayed state – more obscure. The demands he made on her time and attention were exhausting. Most nights, he kept her talking until the small hours, and every morning would rise late from his bed on the floor 'full of brandy and DF118s'. His conversation was monotonously obsessed with the same subjects: his dogs, drugs, drink, boys and Daria. Whenever Louise went out alone 'he would get incredibly jealous', and every time he collected his weekly allowance from the Court 'like as not he'd get pissed or mugged or rolled'. In spite of her best efforts – she once extracted £300 from Mr Anderson for a new suit for Kit – he

continued to look a wreck, and to court disaster and injury. Once, when he went to put £20 on a horse in a betting shop, he showered cocaine 'all over the floor' as he pulled out the cash from his back pocket; on another occasion, when he – naively – decided to visit Curbishley and discuss the possibility of his reinstatement as manager of The Who, he came back 'sobbing'.

Louise did more than merely put up with these intrusions into her life: for most of the time she welcomed them. Her tolerance is clear evidence of Kit's continuing if spasmodic charm. Throughout his life he had, like his father before him, managed to lend his disasters a gloss of fun, and to intersperse his destructive episodes with moments of generous good sense. Louise's usually happy-go-lucky and protective nature allowed her to realise that 'with Kit the normal rules could not be made to apply', and to accept whatever sensible advice he might occasionally hand out. 'We loved each other really,' she says, 'and he was so good for me. He browbeat a lot of the hippy shit out of me – he was a winnower.' Once, when Louise slipped in the street and badly injured herself, Kit attended her with affectionate concern. His treatment, however, was hardly orthodox; he nursed her back to health with brandy, grass and cocaine.

Louise was well aware that Kit's gratitude for her help was often mixed with something approaching flirtatiousness, and 'never felt,' she says, 'that he was fundamentally homosexual'. But she also knew there was little danger that he would attempt to take advantage of her. His sex life, as always, was confined to a series of casual and more or less unsatisfactory liaisons with rent boys he usually picked up in The Coleherne, a pub in Earl's Court, or in The Yours and Mine, a club in Kensington.

One more permanent friend that he met when living with Louise was the journalist John Lindsay. As well as enjoying Kit's company, Lindsay realised there was money to be made out of him, and persuaded him to collaborate in the writing of an autobiography. They would, they decided, serialise extracts in a newspaper first, and then publish it complete. To this end, they contacted a journalist who worked for the *Sun* newspaper, early in the spring of 1980. The prospect of the meeting plunged Kit into panic. He stoked himself up with drugs, put on a suit, then said he could not leave the house because his hair was a mess. He poured a milk bottle of water over his head and jumped into a taxi soaking. The journalist, not surprisingly, was unimpressed but intrigued, and gave them £800 as an advance. Kit spent his share 'in a matter of days', Lindsay says, and the stories never materialised, though Lindsay

eventually succeeded in selling several stories to the *Star* in May 1981. The same incompetence hampered their hopes of publishing the autobiography as a book. Kit went to see his former friend from Oxford, Michael Sissons, now a literary agent: 'The message was that he was all right again,' Sissons says, 'but when he came to my office he just sat there with his head going backwards and forwards like a rag doll.'

Kit's attempts to organise an autobiography were prompted by various and conflicting motives. He wanted, most obviously, to reaffirm his status, but in doing so he indicated that he knew one distinct stage of his career was over. Disappointment at his failure to fulfil the project made him feel that his life might be finished completely. As if to test this possibility, he made one more attempt to extricate himself from the Court of Protection, and instructed his solicitors to help him provide medical evidence that he was fit to be released. In June they told him that the doctors he had consulted – one at the Westminster Hospital, and one at Roehampton – had supported his appeal, and urged him to 'cooperate with the doctors, to avoid any unnecessary delays or complications'. At the same time, Kit discovered that even if he were to 'cooperate', it would take eighteen months for the order of release to become absolute. According to Louise, the prospect of such delay – and of extended abstemiousness – was more than he could contemplate. 'It was then,' says Louise, 'that he decided to die.'

Seven

'Deciding to die', for Kit, meant resuming old habits rather than adopting new ones. He jeopardised his health still further by increasing his use of heroin, and alienated himself from Louise by breaking her house rules. When, in August 1980, she asked him to leave, he turned once again to a mere acquaintance for help: Deirdre Redgrave. In what now seemed to Kit like the remote past, he had seen Deirdre fairly regularly when she had lived with Speedy Keen, who had written Thunderclap Newman's hit 'Something In The Air', before her ill-fated marriage to Corin Redgrave. After the group split up, she and Kit had met only occasionally at parties. She had formed an impression of him as being quick-tongued, aggressive and brimming with dislike for women.

But the figure who arrived at her flat off the Brompton Road, in Earl's Court, offering her £45 a week for a room, was pathetic – prematurely grey, balding, and derelict. Although Kit knew perfectly well that his mother and half-sister were acutely concerned about him, he could not persuade himself to ask Flo to put him up. She provoked as much guilty unease in him as she did tenderness. 'He had this extremely ambivalent relationship with his mother,' Deirdre said later, 'who used to ring me up and accuse me of corrupting him.' His father, safely dead, was a less demanding object of affection. Soon after moving in with Deirdre, Kit took her to see Constant's grave in Brompton Cemetery, pulled the weeds back from the stone and 'said he wanted to tidy it up. But he never did anything about it.'

Deirdre herself was treated to even more jealous and hyperbolic shows of feeling than Louise. Once, and only half joking, Kit chased her round the flat brandishing a belt, shouting, 'I suppose you think I fancy you.' On another, he told her, 'I fall in love with a woman every seven years and I'm going to marry you.' He rang up the *Daily Mail* and announced that he and Deirdre were engaged, and when the paper ran a story proclaiming the fact – 'A Who Boy and a Redgrave Girl', the piece was headed – appeared at her front door on his knees, clutching champagne and flowers, and begging for forgiveness. He told her that he was desperate for publicity.

Deirdre, like Louise, felt that Kit's intemperance and exaggeration stemmed from the fact that 'he really hated being homosexual', and would 'really have liked to have a family'. But he was incapable of

shouldering the responsibilities that a family entails: 'I remember, for instance, when my daughter had a history exam,' Deirdre says, 'Kit sat up with her helping her revise, and filled her up with speed.' Kit's wish for security was precisely matched by his longing to live in scorn of conventions. Because Deirdre's house rules were more relaxed than Louise's, the scorn was more energetically expressed. He was allowed to bring rent boys home 'only in the afternoon, when the children were at school', and spent most of the rest of each day recovering from the excesses of its predecessor.

He would wake up at eight thirty, demanding bacon and eggs, then would get stuck into the brandy and DF118s. He never went to the opera or anything, just to the pub. He got banned from The Coleherne, so usually went to The Boltons. He'd often come home with some hilarious stories. Once he sidled up to two Punks in The Boltons – both of them dressed in full Nazi rig – and overheard one saying to the other, 'I see zinc went up five points today.' They were stockbrokers.

No matter how determined Kit's self-destruction had become, it never entirely eclipsed his sense of fun. 'However down he was,' Deirdre says, 'he was always funny. When he was here I thought he was the wittiest person in the world. He made you spark. He was one of the biggest life forces I've ever met.' While Deirdre gave generous attention to this 'force', she could never be anything except an audience of one, and she knew Kit was used to – and needed – more than that. As day succeeded befuddled day into the winter of 1980, she sensed that he was slowly losing his battle against boredom. Her own feelings were well put by Edwards after Kit's death: 'Much as I didn't want my good friend to burn himself out and die, it was his and only his business if he found the rest of life dull . . . but he went right ahead on his own chosen collision course.' To a large extent Kit felt bored because he was denied the glamorous fast-living he had known with The Who. The reckless ebullience he had channelled through Townshend and the others, and which had transformed destruction into an art, had nowhere to turn but inwards.

As Kit was driven into himself, he saw with increasing clarity how closely his own plight resembled his father's. In the last few months of his life his identification amounted to an obsession. He spent a great deal of time listening to records of Constant's music, and even visited Frederick Ashton to propose that a performance of *The Rio Grande* be mounted, which should be identical to the first production. Furthermore, he tried to persuade Townshend to help him organise new recordings of all Constant's music. He wanted to do this for the music's own sake, and also

because by reviving his father's reputation he imagined he would be able to rewrite the disastrous script from which he felt he could not depart himself. But as his plans came to nothing – either because help was not available or because his own capabilities were impaired – his hopes of escaping his father's fate diminished. As they did so, he resolved, according to the pop entrepreneur Simon Napier Bell, to make 'some sort of triumphant exit'.

In fact Kit's death was not triumphant but sensational, and then only by accident. During the spring of 1981 his condition worsened dramatically: he began to inject heroin rather than merely snort it; his erstwhile colleagues still showed no sign of wanting to help him; and his new friends expected nothing more than confusion illuminated by flashes of his former self. Even Daria, who saw him rarely now, admitted later, 'he was immensely lovable, underneath – though it was difficult to see at the end. He had the remnants of wonderful good manners . . . It was like seeing a tramp with a white tie on. You could always bring him up short by saying "that's a very ill bred remark." ' Daria's ability to control Kit depended, in part, on her being able to refer their relationship to the more optimistic and clear-minded days of Kit's youth. More cogently than Deirdre, she could make him see how far he had fallen. It was for this reason, as well as for other and more pragmatic ones associated with the Court of Protection, that he avoided her.

Kit's feelings for his mother similarly, but even more complicatedly, mixed fear and love. Although he blamed Flo for creating the circumstances in which his uncertainties first took root, he nevertheless felt ashamed in her company: ashamed of his homosexuality, of the collapse of his career, and of his inability to form any durable friendships. In the last few months of his life, when he was trying to resurrect Constant's reputation, he also made regular efforts to resume what might be considered normal relations with his mother. Flo welcomed the attempts, but was horrified by his deterioration. She remembers him, on one occasion, coming to see her when she was making mince pies. He wandered round the kitchen, shivering and dazed, talked increasingly wildly for a long time, then suddenly seized the filling for the pies and patted it all over his face.

Neither his mother nor any of his friends expected him to survive for long, but they continued to insist that if he were released from the Court of Protection he would recover his wits at the same time as he gained his independence. Even as they said this they knew that the chances of his being released were remote. Insofar as they predicted any future for him,

371

it was one of continued submission to the Court, which might be ended at any moment by his death.

The end was more brutal and confused than their worst imaginings. On the evening of Saturday 25 April, Kit appeared at his mother's front door 'in a terrible state, saying he'd been mugged and had no money'. Flo paid off his taxi, sat him down, and heard his story. He told her that he had been to The Yours and Mine and had been beaten up by four men in the lavatory. As he spoke, he 'kept falling out of his chair – he was really in a terrible state – his face was bruised and cut. He asked me for a brandy and I told him "you're asking me to kill you." He insisted, and when I gave it to him he dropped it.' Kit's account of the evening was inarticulate, but Flo's subsequent interpretation is plausible. While he was talking, she says, he produced 'some white powder drugs wrapped in silver paper from a cigarette packet'. Flo knew that his weekly allowance from the Court, which was paid on a Tuesday, had invariably been spent before the weekend. She therefore also knew that when he had been to The Yours and Mine earlier in the evening, he was unlikely to have had much or indeed any money on him. Flo supposed that he had been beaten up because he had been unable to pay for the drugs he had got. When the 'four men' discovered this, Kit said, they had pushed him heavily against the lavatories, and banged his head.

Flo sensibly decided that the best thing was to get him to bed. Before doing so, she rang the police to report the attack, but they were too familiar with Kit's reputation, and with The Yours and Mine, to take him seriously. 'Do you think we're nannies?' they asked her. The lack of concern frightened her, particularly since Kit, who was now showing signs of recovering from the shock of his assault, was becoming unruly. He begged her to let him drink more brandy, and when she denied him he ran upstairs, flung himself into a bath, clambered out and eventually went to bed. Flo told him that he was 'on no account to go downstairs again', fearing that he might disobey her instructions about the brandy, then went to bed herself. A short while later she was woken up by the sound of him falling downstairs, and when she went to see if he was hurt, discovered him unconscious at the bottom step 'bleeding from the nose and mouth'.

Kit was taken by ambulance to Charing Cross Hospital, where he was diagnosed as having suffered a brain haemorrhage, and put on a life support machine. He showed no sign of regaining consciousness and his doctors decided that more specialist care was needed, so moved him to the Middlesex (Central) Hospital in Acton where such care was available. As

the news of his accident spread, only a very few people showed enough interest to visit him – his mother, of course, Daria, Anya and Stamp, who happened to be in London. According to Marsha Hunt, Stamp said to her later, 'I looked at him and I could see he was going and the cunt was going to fucking leave me by myself.'

By Monday morning, 27 April, more scrupulously-formed opinions were unanimous. The damage to Kit's brain was irreparable, and his life support machine was turned off. He died almost at once: he was forty-five years old, and within a fortnight of living as long as his father had done. Initially, at least, Flo's grief was hardly mitigated at all by the commiserations of anyone who had known Kit well. Louise, who went to stay with her for the next five days, says that not a single friend rang during that time; Deirdre, when she went to The Yours and Mine in the hope of establishing the exact circumstances of Kit's mugging, was shouted at by the manager: 'Where were Kit's friends when he died? He was always welcome here'; Townshend, who was in New York 'on a binge', admits 'I didn't feel very much at the time'; and the Court of Protection, which Daria says 'was always hoping Kit would drop dead', telephoned with ill-concealed insincerity to say 'well . . . what we always feared has happened.'

The press were more attentive. Kit's life had been sufficiently scandalous to secure their interest, and the manner of his death was guaranteed to retain it. When Flo spoke to the *Standard* on 29 April, shortly before Kit was cremated, she insisted that he had been murdered. If the official cause of death was given as cerebral haemorrhage, she argued, who was to say that it had not begun in The Yours and Mine, and had only been accelerated by his fall downstairs? 'He was so dizzy from the attack that he slipped and fell down my stairs,' she told the reporter. If Kit had been incapable even of sitting in a chair when he reached her house, had he in fact already started to die? The police, knowing that the question could not be precisely answered, preferred not to make an attempt. Flo, scornful of their indifference, has subsequently stood by her story. In the flats in Chelsea where she has lived since Kit died, she has remained – like her daughter Annie – his passionate advocate. As the years have passed the rancour which Kit often provoked in her has died down, and her pride in him has taken its place. A photograph of Kit 'winning' the Venice marathon stands on her chimneybreast, pieces of china from his palazzo stand on lit shelves, and several of The Who's gold records wink from the walls.

By the time Kit was cremated, the murmur of questions about the cause

of his death had been drowned by other voices analysing his achievements. 'Kit's real contribution,' Townshend told the *New Musical Express*, 'will never be known because of course it wasn't production at all, it was far deeper.' Although this was well meant, it is less than entirely fair. From his discovery of The Who until the release of *Tommy*, Kit steadily developed his technical knowledge, and introduced all those involved in Track Records – Townshend, especially – to sophisticated means of production. (Track itself, of course, initiated a revolution: it broke the monopoly of large conglomerate record companies.) Kit's other achievements were less tangible but unmistakably influential. As a publicist and a provider of ideas he did more than any manager apart from Brian Epstein to make rock and roll part of general culture. 'He was one of that rare breed of present day entrepreneurs,' Tony Palmer wrote in *The Times* obituary,

for whom the pursuit of excellence was paramount . . . [*Tommy*] was and is a contribution to popular culture of lasting significance, perhaps unequalled at that time or since. Although the words and music were by Pete Townshend . . . it was Lambert's idea, and he alone possessed the vision and energy to make that idea live. His proudest moment, he liked to boast, was when in 1970 *Tommy* became the first work of contemporary popular music to be performed to a capacity audience in the Metropolitan Opera House, New York . . . His father would have savoured the occasion.

Kit's genius was to understand and reflect the spirit of the 1960s; his tragedy was to find himself beached by the changing tides of fashion. And not only fashion: Kit was as much a victim of his own personality as he was of external circumstances. The appetite for exaggeration – which profoundly influenced The Who in their dress, performance and self-definition, and which was integral to their popularity – rapidly declined into destructive excess when it had no outlet. Similarly, his hunger for novelty, which created so many of The Who's most spectacular and lucrative gimmicks, contained the seeds of its own ruin. As soon as he had engineered what he reckoned was the band's masterpiece, *Tommy*, he was prey to boredom. He invented, in fact, a world by the very means which made it impossible for him to maintain it. The Who's rise to stardom depended on Kit's enthusiastic disrespect for received conventions in general, and financial ones in particular, but once their stardom had been achieved, Kit was not interested in accepting the responsibilities which accompanied it. Recklessness was the essential ingredient of his success, and the inevitable

cause of his downfall. Like his father and grandfather before him, he was never less than half in love with disaster.

Bizarre as it is, the story of his life has an element of predictability about it: violent delights often have violent ends. They also often have lonely and miserable ones, and even by the most stony-hearted standards, Kit's final years seem pathetic. His cremation was entirely in keeping. According to Anya, he would have liked to have been buried in Venice. Instead, he ended up in Golders Green. 'It was awful,' Anya says. 'Typically, Kit was late – by three quarters of an hour. The place was full of people that I'd never seen before, in boas and sparkles. They'd just come because he was him. There were no Who. And there was some sort of cock up. We all had to move from one chapel to another then back. Flo was there at the front with long white gloves on.' Another guest remembers her pitifully calling out 'Kit!' as the coffin disappeared. Deirdre describes how, at the same moment, she found herself ducking behind her pew. 'I thought he'd go off like an atomic bomb, with all that dope and booze inside him.'

Those who refused to wear black for Kit's funeral no doubt did so because they thought it would be inappropriate to the style in which he had lived. In Louise's eyes, at least, they simply 'looked like highly dressed-up fag-hags'. Glamour, she judged, was more appropriate at the memorial service, which was held on 11 May at St Paul's, Covent Garden. The day would have been Kit's forty-sixth birthday, and it was almost exactly twenty years since Constant's memorial had been held at the same place. Townshend, who had flown back from New York shortly after hearing of Kit's death, helped Annie, Stamp and Fearnley-Whittingstall to arrange the service. He organised 'about a hundred' members of the London Symphony Orchestra to perform – they played 'some of *Tommy*, music by Constant, and Kit's favourite piece of Purcell, "The Gordian Knot Untied"' – and gave one of the two addresses. The other address, concentrating on Kit's earlier life, was given by Robert Fearnley-Whittingstall. Townshend, like Fearnley-Whittingstall, had been one of Kit's most loyal friends, and immediately became one of his most eloquent champions. 'Kit was knocking on heaven's door for some time,' he began his address. By the time he finished there was not, according to Deirdre, 'a dry eye in the place'.

One of the characteristics that Townshend and Kit had most admired in each other was straight-talking, and it is fitting that Townshend's account of events after the service should combine a sense of tawdriness with an affirmation of Kit's inspirational energy. The paradoxes which

had governed his life were as evident in the aftermath of his death as they are in the music he helped to create. When the congregation dispersed, some went back to Louise's office where they had 'a proper big wake and sang happy birthday to Kit through the ceiling', and some, including Stamp and Townshend, 'had a bash in a studio in Covent Garden. We went from this beautiful elevated atmosphere,' Townshend says,

to this seedy place with cheap wine and beer and all the low lives together snorting coke in some back alley. Chris was saying 'it's what Kit would have wanted', but I wasn't sure. Something around that time happened to me, and I turned away from the light and faced the darkness. I felt I had to experience a shadow of the suffering and isolation that Kit had had. When he died I felt I'd lost the last sense of everything coming into my life; I felt from now on I was never, never going to get topped up again. On one hand it made me want to kill myself, on the other it made everything come together. It was so beautiful.

Index